THE ART OF
C.G. JUNG

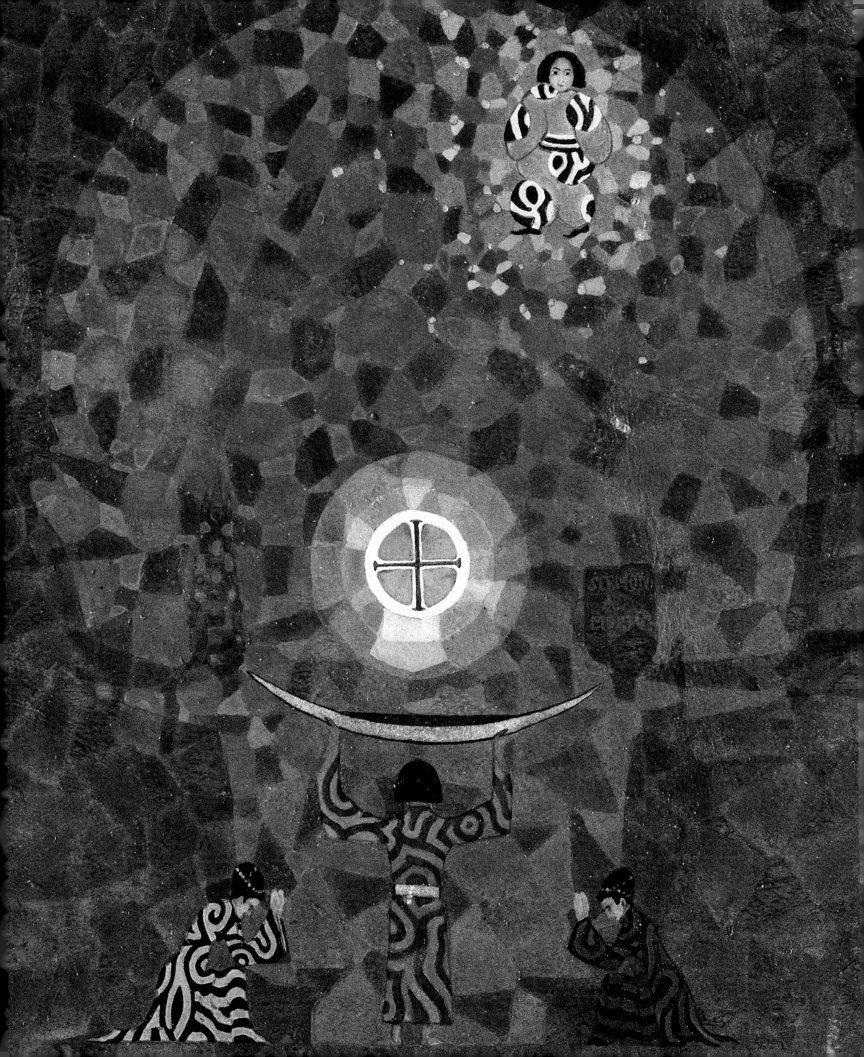

THE ART OF C.G. JUNG

Edited by the Foundation of the Works of C.G. Jung

Ulrich Hoerni · Thomas Fischer · Bettina Kaufmann

Translated from the German by
Paul David Young and Christopher John Murray

W. W. Norton & Company

Independent Publishers Since 1923

New York | London

CONTENTS

FOREWORD by Daniel Niehus 7

IMAGES FROM THE UNCONSCIOUS:
AN INTRODUCTION TO THE VISUAL
WORKS OF C.G. JUNG by Ulrich Hoerni 10

C.G. JUNG AND MODERN ART
by Thomas Fischer and Bettina Kaufmann 19

C.G. JUNG'S CONCEPTS OF COLOR
IN THE CONTEXT OF MODERN ART
by Medea Hoch 33

GALLERY
 1. Castles, Towns, Battle Scenes 52
 2. Landscapes 66
 3. Paris and Its Environs 81
 4. Seascapes 88
 5. The House in Küsnacht 92
 6. Inner Images and *The Red Book* 100
 7. Anima 105
 8. *Systema Mundi Totius* 109
 9. Mandalas 119
10. Phanes 122
11. Spheric Visions 131
12. Stars 138
13. Cabiri and the Winged Snake 141
14. Philemon 143
15. Atmavictu and Other Figures 148
16. Snakes 154
17. The Stone at Bollingen 160
18. Memorials 166

INTIMATIONS OF THE SELF: JUNG'S
MANDALA SKETCHES FOR *THE RED BOOK*
by Diane Finiello Zervas 179

MATTER AND METHOD IN
THE RED BOOK: SELECTED FINDINGS
by Jill Mellick 217

C.G. JUNG THE COLLECTOR
by Thomas Fischer 233

A SELECTION OF ILLUMINATED
INITIALS IN *THE RED BOOK*
by Ulrich Hoerni 245

CARL GUSTAV JUNG—LIFE AND WORK 259

SELECTED BIBLIOGRAPHY 263

CONTRIBUTORS 265

ABOUT THE TRANSLATORS 265

INDEX 267

vocatus atque non vocatus deus aderit

C.G. Jung

FOREWORD

The success of the facsimile edition of *The Red Book*, published in 2009 by W. W. Norton, is proof of an enormous interest in Jung's visual and creative works. For the first time Jung became visible to a wider audience not only as a founding figure of modern psychology, but also as an artist in his own right. Exhibitions of *The Red Book* itself in renowned art institutions in the United States and Europe, culminating in its showing as the centerpiece of the Venice Arts Biennale 2013, attracted attention from far beyond the circles already familiar with Jung's life and work. Realizing the growing demand for more complete and informative documentation of Jung's creative legacy, the Foundation of the Works of C.G. Jung decided to undertake a new publication presenting this material in a volume dedicated exclusively to Jung's visual work.

The cover illustration from *The Red Book* chosen for this volume highlights some of the unique features characteristic of Jung's artwork: the combination of freedom in color, motif, and perspective displaying similarities to the development in modern art of the early twentieth century; the play with light and shadows to create perspective and dimensionality; the use of transparent and opaque techniques to create plasticity and light effects as seen in the central symbolic abstraction seemingly suspended in midair depicted against a dark background; the working in a very free and unrestricted manner exemplified in the use of mosaic patterns for the modeling of the tree bark, lending the object almost animistic qualities.

Here is an imaginative language that for many opens up a new way of knowing the work of this exceptionally creative man. The inclusion of previously unpublished drawings, paintings, and sculptures in *The Red Book* and related exhibitions lifted the veil on the remarkably broad spectrum of visual works produced by Jung. Further searches have since led to the discovery of early drawings from childhood and adolescence.

Jung himself never wanted to be considered an artist. While he included illustrations in some of his texts during his lifetime, he always ensured that he remained anonymous as their creator. Most of these works remained unacknowledged until the publication of *The Red Book* brought their authorship to light. For a book called *The Art of C.G. Jung* ever to be published is remarkable and, finally, allows us to present the substantial corpus of Jung's creative work in the context of his intellectual and personal development.

There are many people to thank for making this publication possible, yet one person stands out in particular: the presentation of this material would not have been possible without the dedicated work of Ulrich Hoerni, grandson of C.G. Jung and Emma Jung-Rauschenbach, the first director of the Foundation of the Works of C.G. Jung and longtime chairman of the former Society of the Heirs of C.G. Jung. As far back as the early 1990s he started to pick up the pieces and began compiling an inventory of all of Jung's surviving visual works. Over the course of two decades he travelled widely and interviewed many people, including members of the family and

Ex Libris C.G. Jung, 1925 (cat. 63)

7

those close to Jung who were still alive, the aim being to document the whereabouts of works and to collect information on them. Particularly helpful were comments by Jung's close collaborator Marie-Louise von Franz and his son, Franz Jung. After the publication of *The Red Book* in 2009, Ulrich Hoerni returned to completing the task with a view to laying the ground for a publication of Jung's remaining visual works.

In 2013, Thomas Fischer took over as director of the foundation, and, together with the foundation's new collaborator, Bettina Kaufmann, joined Ulrich Hoerni on the project. With the support of the foundation's board, they coordinated and advanced what has now become the first-ever editorial project under the full responsibility of the Foundation of the Works of C.G. Jung. Along the way they were assisted by Lorenz Homberger, former curator at the Rietberg Museum Zurich, who acted as a consultant to the project, as well as Medea Hoch, who, as well as contributing an essay to the book, worked closely with the editorial committee to bring all the texts, commentaries, and the selection of images into shape. I would like to thank wholeheartedly everybody involved with the Foundation of the Works of C.G. Jung for the work and dedication they have put in this project.

Another person who has been key to this undertaking and deserves special recognition is Andreas Jung, another grandson and the owner of the Jung Family Archive, which preserves large parts of the works included in this volume. He signaled full support for the project early on, and he and his daughter Susanne Eggenberger-Jung, together with Eva Middendorp, provided access to information about the items presented, whenever needed. They are joined by a number of institutional and private owners of individual visual works by Jung, which we would all like to thank for their help and agreement in obtaining high quality photographs of the objects in their possession. Their names are listed in the catalogue entries, unless they have asked to remain anonymous.

Along with the essays and catalogue entries written by the members of the editorial committee, Diane Finiello Zervas and Jill Mellick each contributed an essay on specific aspects of Jung's visual work. We are particularly grateful to them for their willingness to share the results of their ongoing research for this publication.

Photographers Alex Wydler and Rainer Wolfsberger in Zurich produced most of the new image material for this volume, and Laura Lindgren in New York has done a wonderful job on the design of the book. We would like to thank all three of them for their excellent work. A special mention is also due to translators Paul David Young in the U.S. and Christopher John Murray in the UK who have worked with the editors and the publisher on bringing the English version of the texts for this publication into fine shape. Others that lent a hand or assisted with information in the production of the catalogue include Christian Huber and Yvonne Voegeli from the ETH Zurich University Archives (C.G. Jung Papers collection), Vicente de Moura from the picture archive at the C.G. Jung-Institut Zurich in Küsnacht, Monika Metzger and Andreas Schweizer at the library of the Psychology Club Zurich, the members of the C.G. Jung Stiftung Bollingen-Jona, Jost Hoerni, Hans Hoerni, Andreas and Marianne Fischer, Felix Walder, Eric Baumann, Christine Benz, Carl C. Jung, Sonu Shamdasani, Martin Liebscher, Daniel Minder, Taddeo Lozano, Robert Hinshaw, Reto Brunner, Hsin-Mei Chung Messmer, Corina Fisch, Susanna Wettstein, Giampaolo Russo, Peter Fritz and Annkathrin Wollert from the Fritz literary agency in Zurich, Alex Anderfuhren and Jann Jenatsch at Keystone, as well as Hugh Milstein from Digital Fusion in California.

Without a dedicated publisher, finally, nothing would have come of all of this. We are particularly grateful for the keen interest shown by Jim Mairs, late editor at large at W. W. Norton, New York, who strongly supported the project from the very first presentation of the idea all the way to the very last days before his passing away in summer 2016. We are equally grateful for the services of his colleague Elisabeth Kerr, who took over the project after Jim's death with great professionalism and dedication. We will remember Jim Mairs as an exceptional editor who was the first person in the publishing world to see the full potential of Jung's visual work with the facsimile production of *The Red Book*. We would like to thank everyone involved at Norton for ultimately bringing this new volume to publication.

<div style="text-align:right">

Daniel Niehus, president of the Foundation of the Works of C.G. Jung
Zurich, April 2018

</div>

IMAGES FROM THE UNCONSCIOUS
An Introduction to the Visual Works of C.G. Jung

Carl Gustav Jung's first publication, in 1902, was his dissertation in psychiatry for Zurich University's medical school.[1] It was the beginning of a lifetime of literary work that stretched beyond psychiatry and psychotherapy to religious studies and cultural history, encompassing more than two dozen widely translated books, with the release of further unpublished material still ongoing. Jung's international reputation as a successful writer and skilled lecturer is irrefutable, yet, for decades, few suspected the vital role that visual art played in his oeuvre.

In 1929, together with the German theologian and Sinologist Richard Wilhelm, Jung published a book on a mysterious ancient Chinese text. Published in English in 1931 as *The Secret of the Golden Flower*, it contained Wilhelm's translation of the treatise and a psychological commentary on it by Jung, "Examples of European Mandalas," which was intended to provide the Western reader access to Chinese thought.[2] Jung explained that the linguistic images in the Chinese text were to be understood as symbols for psychic processes with which he was familiar from his practice. According to Jung, Europeans would spontaneously create similar images for psychic processes, especially in the form of circles, flowers, crosses or wheels, so-called mandalas. In his view, "by these analogies, an entrance is opened a way to the inner chambers of the Eastern mind."[3]

Examples of European mandalas illustrate the commentary, Jung noting: "I have made a choice of ten pictures from among an infinite variety of European mandalas, and they ought, as a whole, to illustrate clearly the parallelism between Eastern philosophy and the unconscious mental processes in the West."[4] He described the characteristics of the individual mandalas in short captions, without naming their makers or identifying himself as the creator of three of them.

In 1947, Jung contracted with the Bollingen Foundation in New York to publish his writings in a collected edition: *The New Edition*, today known as *The Collected Works*.[5] The agreement defined the contents of the edition as "works and writings [. . .] written or made by the author," but the attached schedule did not mention visual works.

A volume of essays published in 1950 contained, under the title "Concerning Mandala Symbolism," an expanded version of the "Examples of European Mandalas" with extended and more specific commentaries.[6] Jung as the creator of four of the mandalas was still not acknowledged, the works being attributed to an anonymous "Middle-Aged Man."

In 1955, to accompany Jung's text "Mandalas" and a picture of an ancient Tibetan mandala, the Swiss periodical *Du* published a "Mandala of a modern man" entitled *Systema Mundi Totius* (Structure of the whole world).[7] Again, the reader could only suspect that Jung was the creator of this mandala, as well as the author of the elaborate commentary. In Volume 9/I of the *Collected Works*, published in 1959, the *Systema Mundi Totius* appears as the frontispiece, again without revealing the identity of the mysterious "modern man"[8] credited as its maker.

Among Jung's acquaintances, however, it was no secret that he sometimes produced visual works. In the garden of his home in Küsnacht stood a sculpture of a bearded man with many arms. Furthermore, Jung had given some of his close friends paintings or wooden figures. He even showed some of them *The Red Book*—a thick folio volume bound in red leather containing Jung's own calligraphic texts and intensely colorful images—and in the 1950s, at his retreat at the upper end of Lake Zurich, the Tower at Bollingen, he could be seen carving stone. Yet Jung died in 1961 without having published any of his visual works under his own name.

One year later, *Memories, Dreams, Reflections* appeared,[9] which for the first time allowed a view of Jung as a private person. Among other insights, he described in some detail the making of some of his mandalas, paintings, and sculptures, and—in the chapter "Confrontation with the Unconscious"—the origins of *The Red Book*. However, with the exception of one page from *The Red Book* and the Stone at Bollingen (a stone cube Jung covered with symbols and inscriptions [cat. 74]), no visual works were reproduced in *Memories*. Nonetheless, this open account of his creative engagement with the arts attracted great interest.

THE VISUAL WORK BECOMES VISIBLE

For the one hundredth anniversary of Jung's birthday in 1975, the City of Zurich organized a biographical exhibition in the Helmhaus. Besides manuscripts, letters, photographs, books, and the like, the exhibition included a number of original paintings by Jung, facsimiles of nine pages of *The Red Book*, and photographs of stone carvings. This show gave a first, albeit incomplete, overview of his creative work. Based on material in this exhibition, in 1977 Aniela Jaffé published an illustrated biography of Jung that included a number of his visual works.[10]

This aroused further interest. After 1961, the authority to publish Jung's work rested with the Society of the Heirs of C.G. Jung. The Society hesitated considerably before making further visual works public, respecting Jung's endeavor during his life to avoid identifying as an artist. But with publication of his *Memories* he himself revealed his hidden creative endeavors. In 1984, the heirs had five photographic facsimiles of *The Red Book* produced, which made it possible for members of the Society to acquaint themselves with this precious work in greater detail. Under President Ludwig Niehus, in 1993 it was finally decided that an inventory of all accessible visual works should be compiled, though with no commitment to publication, and I received the assignment to carry out this task. Our aim was to identify, locate, and authenticate items, to inventory them, and to collect as much additional information as possible about each item.

Accomplishing these goals was more difficult than expected. To be sure, there were items in well-known locations that could be accessed routinely. Yet there was no list of all existing visual works, and it became clear that there must be unknown pieces. Authentication proved to be a challenge, because Jung signed very few works. Others were known to exist, but could no longer be located. Various published and unpublished sources were closely scrutinized for insight into the significance and dates of the items. Some questions simply remain unanswered, and the titles of many of the works in this book derive at best from indirect indications by Jung.

By 1998, the inventory featured approximately one hundred items beyond *The Red Book*. While this material identified more of Jung's visual works, it became increasingly clear that *The Red Book* was the single most important work in the oeuvre—its gravitational center—with several independent works seemingly connected to it in style and/or content. At the time, *The Red Book* was still terra incognita, for after Jung's death it had not been studied systematically.

A decision was reached to prioritize the publication of *The Red Book*, and in 2000 Sonu Shamdasani was entrusted with the assignment. Through detailed research, Shamdasani contextualized *The Red Book* within Jung's life's work and made it accessible to today's readers. A large-format facsimile edition became available from W. W. Norton in New York in the fall of 2009.[11]

On the occasion of publication, the Rubin Museum of Art in New York organized an exhibition featuring the original *Red Book*, a series of mandala sketches, and a dozen other visual works by Jung. The exhibition traveled to the Hammer Museum in Los Angeles in 2010 and subsequently to the Museum Rietberg in Zurich, where additional works, in particular sculptures, were shown. The Rietberg show was later mounted at the Musée Guimet in Paris. The original *Red Book* attracted considerable attention, moreover, at the Library of Congress in Washington, DC, in 2010, at the Fondation Bodmer in Geneva in 2011, at the Venice Biennale in 2013 and at the MASI in Lugano in 2017.

Even through publication and exhibition of *The Red Book*, work on the inventory continued and the number of identified items increased, and in 2012 the Foundation of the Works of C.G. Jung decided to embark on separate publication of the breadth of the visual works. The present book includes the material presented at the Rietberg exhibition, complemented with newly discovered works and fresh commentaries by the editors.

A CHRONOLOGICAL AND THEMATIC GROUPING OF JUNG'S VISUAL WORKS

Several distinct phases occurred in Jung's visual works:

ca. 1885–1895 Drawings of fantasies: castles, cities, and battle scenes in graphite pencil or pen and ink, mentioned by Jung in his *Memories*.[12] As a schoolboy at the Gymnasium in Basel, he was dismissed from the drawing class because of what was seen as a complete lack of ability; nevertheless, he still claimed for himself "some talent," though with a condition: "I could draw only what stirred my imagination."[13]

ca. 1895–1905 Landscapes in watercolor, gouache, or pastel. An expressionistic choice of colors in some of these works goes beyond a mere representation of nature. In several pieces, dramatic clouds are noteworthy. According to published and unpublished written sources, a number of these works on paper were made during Jung's stay in Paris 1902–1903.[14]

ca. 1907–1908 Drawings of his future home in Küsnacht in graphite pencil, ink, or colored pencil. Abundant documentation exists for the house and its history.[15] The sketches already show Jung's interest in architecture, which later manifested in the Tower at Bollingen. Aside from these sketches, it appears that he created no other visual works during the period 1905–1915, probably due to the demands of his profession.

ca. 1915–1928 Inner images in different media, such as gouache on paper or parchment, as well as sculptures in wood, some of them painted. This phase is of central importance in Jung's visual work and is described in detail in *Memories* in the chapter "Confrontation with the Unconscious."[16] During this time, Jung developed a new method for accessing psychic processes, which he called Active Imagination. The most important and substantive work from this era is *The Red Book*, comprehensively documented in the facsimile edition.[17] Selected images from *The Red Book* are included in this volume in reference to other works by

ca. 1920–1961 Jung, while, conversely, additional objects presented in this volume, in particular the sculptures, are a necessary complement to *The Red Book*.

ca. 1920–1961 Items specific to his home, family, and intimates, executed in various media—paper, wood, stone—and often including literary allusions. They represent neither the outer world, nor the inner world in the sense of Active Imagination, but rather personal or philosophical ideas. Compared to inner images dating from 1915–1928, they are more conventional in character yet profound in meaning. Jung's reworked family coat-of-arms is representative of this category. In it, Jung saw not only an inherited allegorical theme, but also symbolism that belonged to the historical context of his life and thought.[18]

1923–1958 The Tower at Bollingen: a phased construction and decoration with wall paintings, stone sculptures, and reliefs. Jung laid the foundation stone of the first round tower in 1923, the beginning of several building and design stages that would last until 1956. Jung himself speaks in detail about the Tower in *Memories*.[19] With very few exceptions, it is not the subject of the present publication.

Several works that once existed, according to Jung's own recollections (for instance, in *Memories*) or other sources, cannot be found. It is possible that some of them lie undiscovered in some unknown place and may one day resurface.[20]

JUNG'S CRAFTSMANSHIP

The question arises of where Jung initially acquired skill in different techniques and media. It was not necessarily in the family: there are no artists to be found among his ancestors. His father, Johann Paul Achilles Jung (1842–1896) had a brother, the architect Ernst Jung (1841–1912), who was talented at drawing and ran a well-known architectural firm in Winterthur, Switzerland.[21] But no evidence indicates that Jung's interest was kindled by this uncle, or by drawing classes after secondary school. It must be assumed that Jung gained technical proficiency through experimentation with various materials. Two essays in this publication, Jill Mellick's "Matter and Method in *The Red Book*: Selected Findings" (pp. 217–31), and Medea Hoch's "C.G. Jung's Concepts of Color in the Context of Modern Art" (pp. 33–49), document the importance of his engagement with media and techniques.

It seems that, with the exception of pencil, pen, and watercolor, Jung preferred slow techniques in which the work took form through careful crafting, for example, in gouache on paper and parchment, and later in sculptures and reliefs in wood and sandstone. The work of carving stone in particular must even have had a meditative character. Jung himself once noted: "Building [with pebbles and clay] was just the beginning. It released a stream of fantasies, which I later carefully transcribed. [. . .] Whenever I got stuck in later life, I always painted a picture or worked with stone. [. . .] Everything that I have written this year (1957) [. . .] grew out of the work with stone that I did after my wife died."[22] Working with his hands clearly stimulated Jung's mind and unconscious. Jung described two alternate strategies for confronting these emerging fantasies: either to turn them into images, or to try to understand their meaning. For Jung himself it was often both. Diane Finiello Zervas's contribution to this volume, "Intimations of the Self: Jung's Mandala Sketches for *The Red Book*" (pp. 179–215), explores the first step of this process.

JUNG'S APPROACH TO IMAGES

A remarkable feature of Jung's visual work is how closely it is intertwined with his literary output, as well as with his private and professional life. He was originally trained in analytic thinking and scientific methods of expression in the course of his medical studies, his activity as an assistant doctor and supervising physician, his teaching, and his collaboration with Sigmund Freud. In the first chapter of his *Psychology of the Unconscious: A Study of Transformation Symbols of the Libido* (1916), "Two Kinds of Thinking," however, he differentiates between directed thinking in words and non-directed thinking in images. The former corresponds to conscious, the latter to unconscious thought processes, such as dreams. Dream images and fantasies are to be understood *symbolically*. He supported this with references to rich mythological and historical material.[23]

Jung's *Psychology of the Unconscious* initiated a series of works in which Jung concerned himself with inner images. In 1913, he began a self-experimentation, a process that led to the creation of *The Red Book*. In *The Transcendent Function*, written in 1917 (but only published in 1958), he elaborated on the method he used to generate inner images, Active Imagination,[24] which facilitated stimulation and recognition of psychic processes and therefore offered both diagnostic and therapeutic insight. Thereafter, Jung encouraged his patients to record dream motifs and fantasies in pictures. Concurrently, he formulated the hypothesis of the Collective Unconscious and its Archetypes, psychic patterns that are abstract and similar to instincts and that manifest in dreams and fantasies through symbolic images. In 1925, he reported for the first time on his self-experiment,[25] and in 1929 published the commentary referred to at the beginning of this introduction, on *The Secret of the Golden Flower*.

From 1930 onward, Jung held a number of seminars using visual material from patients, most prominently in the *Visions* seminars, a cycle that lasted four years.[26] In 1932, together with the Indologist Jakob Wilhelm Hauer, he conducted a seminar on the psychology of Kundalini yoga, which is shaped by both linguistic and visual imagery.[27] At the Eranos Conference in 1935, he demonstrated the similarity between modern dream images and characteristic alchemical imagery,[28] and he presented the same material again in 1936–37.[29] In 1937, he spoke in connection with newly collected images specifically regarding the mandala theme.[30]

From 1938 to 1941, in a large, extensively prepared lecture series, Jung presented various forms of image-related meditations or contemplations and compared them with his method of Active Imagination.[31] In 1940, he delivered, in front of an art society, the lecture "An Introduction to Comparative Symbolism/Fundamental Ideas of Humanity/An Overview of Various Cultures and Individuals."[32] And in 1946, he discussed the difficult psychological concept of transference by way of the four-hundred-year-old series of illustrations to the *Rosarium Philosophorum*, a key picture cycle in old alchemical literature.[33]

Jung made a number of contributions on the theme of psychology and images and the role of the image is of central importance to Jung's scholarly work. He stressed the significance of images as a way of expression, the method of Active Imagination, the individual therapeutic application of dream and fantasy images, collective image-related psychic processes, specific visual motifs, and much more. Throughout his writings, there are continuous references to the symbolic meaning of inner images and their connection with the archetypal motifs common to all cultures and periods in history. Doctors cannot directly observe or examine a patient's unconscious, they must rely upon indirect manifestations, which for Jung also included images. Sometimes, Jung was confronted with the question of God. He had a habit of replying that he

had nothing to say about God, though an image that someone had made of God would be a psychological fact, to which he could speak as a psychologist.

JUNG AND THE VISUAL ARTS

"Suddenly I was standing before these marvelous figures! Utterly overwhelmed, I opened my eyes wide, for I had never seen anything so beautiful."[34] Toward the end of his life, Jung used these words to describe his first childhood experience of art, as well as his expectation of it: the representation of beauty. Art was his companion all his life. Regarding his choice of profession, he noted: "Then again, I was intensely interested in everything Egyptian and Babylonian, and would have liked best to be an archeologist."[35] For practical reasons, however, he chose medicine and psychiatry. Around the age of forty, he formulated the concept of the Collective Unconscious, which in his opinion manifested in similar forms in all cultures and epochs. For a comparative historical basis, Jung called upon not only texts, but also, to a large extent, works of art and architecture.

In Jung's writings and seminars, there are many references to the visual arts, a field in which he had wide knowledge despite having undertaken no formal study. Symbolic, archetypal qualities interested him much more than stylistic aspects. His library contained a small but many-faceted collection of art-historical literature. He formulated important ideas concerning individual works and the creative process in general. On various occasions, he commented on the many exhibitions and museums that he visited, and on his lecture and study trips, he took advantage of opportunities to visit places of art-historical significance, notably in Italy (Verona, Ravenna, Florence, Pompeii), in Greece (Athens), Turkey (Istanbul), Egypt (Cairo), and India (Sanchi, Agra, Fatehpur Sikri, Konarak).[36] In Jung's view, a work of art does not exist as a singular expression, but is rather a manifestation of the unconscious foundation of a person or an entire culture; in that sense, he once stated, art serves as an instrument capable of reflecting the collective psyche.[37]

Given his views on the key role of images in psychic development, Jung maintained a highly ambivalent attitude toward modern art. In 1957, he wrote:

> The development of modern art with its seemingly nihilistic trend towards disintegration must be understood as the symptom and symbol of a mood of universal destruction and renewal that has set its mark on our age. This mood makes itself felt everywhere, politically, socially, and philosophically. We are living in what the Greeks called the Καιρός— the right moment—for a "metamorphosis of the gods," of the fundamental principles and symbols. This peculiarity of our time, which is certainly not of our conscious choosing, is the expression of the unconscious man within us who is changing.[38]

Jung's critical perspective on modern art is further elaborated in the essay by Thomas Fischer and Bettina Kaufmann in this volume, "C.G. Jung and Modern Art" (pp. 19–31).

A constant search for deeper insight into the meaning of art and its symbolic representations led Jung over the course of his life to procure a fascinating assemblage of objects, paintings, crafts, and other works that furthered his investigations. The essay by Thomas Fischer published here, "C.G. Jung the Collector," provides a first presentation of this collection (pp. 233–43).

<div style="text-align: right">

Ulrich Hoerni
Foundation of the Works of C.G. Jung

</div>

NOTES

1. C.G. Jung, *Zur Psychologie und Pathologie sogenannter okkulter Phänomene* (Leipzig: Oswald Mutze, 1902); *On the Psychology and Pathology of So-called Psychic Phenomena*, CW 1, §§ 1–150.

2. *Commentary by C.G. Jung*, in *The Secret of the Golden Flower: A Chinese Book of Life*, tr. Richard Wilhelm, Commentary by C.G. Jung, tr. into English Cary F. Baynes (London: Kegan Paul, Trench, Trubner & Co., 1931); revised CW 13, §§ 1–84; first published as "Europäischer Kommentar," in *Das Geheimnis der Goldenen Blüte: Ein chinesisches Lebensbuch* (Munich: Dorn, 1929), pp. 7–88.

3. *Commentary by C.G. Jung*, p. 136.

4. Ibid., p. 149.

5. C.G. Jung, *The Collected Works of C.G. Jung*, 21 vols., ed. Herbert Read, Michael Fordham and Gerhard Adler, exec. ed. William McGuire, tr. R.F.C. Hull (New York: Bollingen Foundation/Pantheon Books, 1953–1967: Princeton: Princeton University Press, 1967–1978).

6. C.G. Jung, "Concerning Mandala Symbolism," in CW 9/I, §§ 627–712; first published as "Über Mandalasymbolik," in *Gestaltungen des Unbewussten* (Zurich: Rascher, 1950), pp. 187–235.

7. *Du: Schweizerische Monatsschrift* 4 (April 1955), p. 16. Jung himself nowhere provided a translation of the image title *Systema Mundi Totius*. It is a combination of the Greek word "*systema*," which can be translated as "composition" or "structure," and the genitive singular of the two Latin words "*mundus*" and "*totus*" (translated as "world" and "whole" respectively). That the Latin part of the term in Jungian context and literature has so far mostly been transcribed in one word as "*munditotius*" probably has to do with the fact that the space between the words "*mundi*" and "*totius*" in the original image is barely recognizable. A feature that is reminiscent of antique and medieval scripts, where blank spaces between words were much narrower than in today's writings to save valuable parchment.

8. CW 9/I.

9. C.G. Jung, *Erinnerungen, Träume, Gedanken von C.G. Jung*, recorded and edited by Aniela Jaffé (Zurich and Düsseldorf: Walter, 1962); C.G. Jung, *Memories, Dreams, Reflections*, recorded and edited by Aniela Jaffé, tr. Richard and Clara Winston (New York: Pantheon Books, 1963).

10. Aniela Jaffé, ed., *C.G. Jung: Bild und Wort* (Olten/Freiburg im Breisgau: Walter, 1977); *C.G. Jung: Word and Image*, tr. Krishna Winston (Princeton: Princeton University Press, 1979). In a later work on Jung's artistic creation, seven more pieces were published for the first time: see Gerhard Wehr, *An Illustrated Biography of C.G. Jung* (Boston: Shambhala, 1989).

11. C.G. Jung, *The Red Book: Liber Novus*, edited and introduced by Sonu Shamdasani, tr. Mark Kyburz, John Peck, and Sonu Shamdasani (New York: W. W. Norton, 2009).

12. Jung, *Memories*, pp. 33, 45, 100–103.

13. Ibid., p. 45.

14. Protocols of Aniela Jaffé's interviews with Jung for *Memories, Dreams, Reflections*, 1956–1958, Library of Congress, Washington, DC, p. 165.

15. See Andreas Jung et al., *The House of C.G. Jung: The History and Restoration of the Residence of Emma und Carl Gustav Jung-Rauschenbach*, ed. Stiftung C.G. Jung Küsnacht (Wilmette: Chiron Publications, 2008).

16. Jung, *Memories*, pp. 194–225.

17. Sonu Shamdasani, "Liber Novus: The 'Red Book' of C.G. Jung," introduction to *The Red Book*, pp. 193–221.

18. Jung, *Memories*, p. 259.

19. Ibid., pp. 250–65.

20. Some of the lost works are documented by a detailed description or a photograph (cats. 64 and 65). Perhaps the most famous lost work is the small wooden man which Jung, as a schoolboy aged ten, carved from a ruler and detailed with black ink (*Memories*, pp. 36–39). In 1913, at a time of uncertainty and disorientation, Jung remembered that in his childhood he had built houses out of stones and clay. He reprised this kind of play on the banks of Lake Zurich, and as he did so realized that his thoughts grew clearer and he could fully grasp the fantasies he glimpsed within himself (*Memories*, pp. 197–99). This started the developmental process that led to *The Red Book* and formed his lifework. These objects of stone and clay have not been preserved. It is known that Jung at one point also modeled sculptures out of clay, but he discovered that they easily came apart and so stopped working in this technique. While Jung was working on *The Red Book*, a figure appeared to him in a dream that would prove to be of expansive meaning, Philemon: "Suddenly there appeared from the right a winged being sailing across the sky. I saw that it was an old man with the horns of a bull [. . .]. Since I did not understand this dream image, I painted it in order to impress it upon my memory" (*Memories*, pp. 207–8). There is a sketch and a photograph of this picture (cat. 64), but the original has been lost. Somewhat later, Jung painted in the same way an image of the Ka-Soul, which, in a fantasy in 1917, appeared to him "in his earth-bound form, as a herm with base of stone and upper part of bronze" (*Memories*, pp. 209–10). It is not known if this picture has survived.

21. See Moritz Flury-Rova, *Backsteinvillen und Arbeiterhäuser: Der Winterthurer Architekt Ernst Jung, 1841–1912* (Winterthur and Zurich: Stadtbibliothek Winterthur and Chronos-Verlag, 2008).

22. Jung, *Memories*, pp. 198–99.

23. C.G. Jung, *Wandlungen und Symbole der Libido* (Leipzig and Vienna: Franz Deuticke, 1912); revised CW 5.

24. C.G. Jung, *Die Transzendente Funktion* (Zurich: Rhein-Verlag, 1958); CW 8, §§ 131–32.

25. C.G. Jung, *Analytical Psychology: Notes of the Seminar Given in 1925*, ed. William McGuire (Princeton: Princeton University Press, 1995).

26. On images in dreams: *Bericht über das deutsche Seminar 1930*, ed. Olga von Koenig-Fachsenfeld (Stuttgart: privately published, 1931); on images in dreams that excite fantasies: *Bericht über das deutsche Seminar 1931*, ed. Olga von Koenig-Fachsenfeld (Stuttgart: privately published, 1932, publication in preparation with the Philemon Foundation); on a series of fantasy images: C.G. Jung, *Visions: Notes of the Seminar Given in 1930–1934*, 2 vols., ed. Claire Douglas (Princeton: Princeton University Press, 1997).

27. C.G. Jung, *The Psychology of Kundalini Yoga: Notes of the Seminar Given in 1932*, ed. Sonu Shamdasani (Princeton: Princeton University Press, 1996).

28. *Traumsymbole des Individuationsprozesses*, in *Eranos-Jahrbuch*, 1935; *Individual Dream Symbolism in Relation to Alchemy*, CW 12, §§ 44–331.

29. *Dream Symbols of the Individuation Process: Bailey Island Seminar 1936 and New York Seminar 1937* (publication in preparation with the Philemon Foundation).

30. C.G. Jung, *Bericht über die Berliner Vorträge*, ed. Marianne Stark, 1937 (unpublished typescript).

31. C.G. Jung, *Der Individuationsprozess*, Lectures at the ETH Zurich 1938–1941 (publication in preparation with the Philemon Foundation).

32. C.G. Jung, unpublished concept for the lecture "Einführung in die vergleichende Symbolik. Grundideen der Menschheit. Ein Bild durch versch. Kulturen und bei Individuen," dated December 4, 1940, ETH Zurich University Archives, Hs 1055: 245.

33. C.G. Jung, *Die Psychologie der Übertragung* (Zurich: Rascher, 1946); *The Psychology of the Transference*, CW 16, §§ 353–539.

34. Jung, *Memories*, p. 31.

35. Ibid., p. 104.

36. Ibid., pp. 266–319.

37. C.G. Jung, "After the Catastrophe," in CW 10, § 430.

38. CW 10, § 585.

THE ART OF
C.G. JUNG

Kennst du das Land?

C.G. JUNG AND MODERN ART

THOMAS FISCHER AND BETTINA KAUFMANN

At one time I took a great interest in art. I painted myself, sculpted and did wood carving. I have a certain sense of color. When modern art came on the scene, it presented a great psychological problem for me. Then I wrote about Picasso and Joyce. I recognized there something which is very unpopular, namely the very thing which confronts me in my patients.[1]

In 1932, C.G. Jung published a much-discussed article on Picasso in the *Neue Zürcher Zeitung*.[2] In that same year, his essay "Ulysses" on James Joyce appeared in the *Europäische Revue*.[3] Both contributions led to heavy criticism of Jung's psychological interpretation of modern art. In particular, his statement that works by Picasso and Joyce reminded him of pictures from his patients that suggested schizophrenic tendencies was harshly criticized in readers' letters and by art historians and literary critics and greeted as a complete misjudgment of modern art and literature. For his part, Jung thought that he had been misunderstood and felt obliged to add an explanatory footnote in the new edition of the Picasso article in 1934.[4]

Even if contemporary criticism was hostile to Jung's point of view, his 1932 statements were not unfounded. His realization that noticeable similarities existed between the forms of expression of modern art and the observed phenomena of his patients rested on fifteen years' experience with Active Imagination,[5] the method he developed to teach his patients to gain access to hidden psychological content by unlocking their inner symbolic images.

The Picasso controversy led to Jung's firm refusal to write another, longer study of contemporary art from the point of view of a psychologist. In 1947, in reply to his colleague Adolf L. Vischer in Basel, he declined an invitation to write about the Swiss painter Hans Erni:

The few times when I expressed myself to some extent psychologically and also somewhat critically regarding modern art (Picasso and James Joyce) I let loose a storm of misunderstandings and a flash of anger. There is no pleasure for me in that kind of experience. If people want to listen to out-of-tune or atonal music or they take for beautiful a jumbled colorful drawing, half infantile, half pathological, I won't take away their pleasure. I see that our time must also even let its artists preach a thoroughgoing upheaval of the old world. In my opinion, it is quite interesting, but I don't find it beautiful—and besides, *de gustibus non est disputandum*.[6]

That Jung had difficulty with the "masters of the fragmentation of aesthetic contents and accumulators of ingenious shards,"[7] is a continuing theme in many of his later statements, but he did

C.G. Jung, detail from *Landscape*, 1899 (cat. 10)

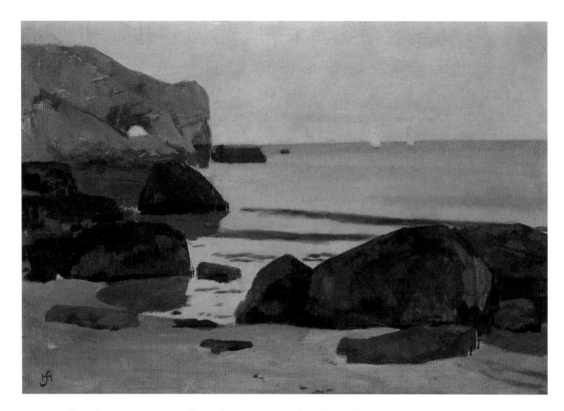

Fig. 1. Hans Sandreuter, *Seashore*, 1882–1884, oil on canvas, 31 × 45 cm (12 × 17¾ in.). Kunstmuseum Basel, bequest of Dr. Karl Hoffmann 1945, Inv. 1946

not simply refuse to engage with modern art, as is clear from his many private conversations and his correspondence with artists, art critics, and colleagues, even after 1932. Jung's focus was on the visual content of art rather than on its aesthetic and formal aspects.[8]

Notwithstanding the controversy, this essay is more concerned with the possible sources of Jung's cultural education and its influence on his understanding of art than with specific arguments about Jung's Picasso essay or discussions that ensued after publication. With which artists was he in contact? About which artists did he speak? What art and directions in style interested him? How and in what context did Jung come upon the idea that, as a doctor and a psychologist, he should take up the theme of modern art?

Jung's interest in art blossomed during his youth in Basel and throughout his education, most intensively during his stays in Paris and London in 1902 and 1903 (visits to the Kunstmuseum Basel, the Louvre, and the British Museum), where he began to engage more deeply with painting and sculpture, from antiquity to modern times. He not only studied the visual and aesthetic aspects of art, but also began to paint watercolors.[9] As a young assistant physician at Burghölzli in Zurich, he wrote in a letter of 1901 about his small collection of pictures, which he had had framed and which adorned the walls of his room:

In my isolated, work-filled life [I have] an indescribable need for the beautiful and the elevated; if I have before me the whole day long the work of the destruction of the psyche and body and have to immerse myself in all sorts of painful feelings, have tried to penetrate often abominable and tortured thought processes, I need in the evening something from the highest level of nature.[10]

It is therefore not surprising that pictures selected for his home, built in 1909 in Küsnacht, display traditional artistic taste. At the time of his stay in Paris, Jung hired copyists in the Louvre to paint reproductions of pictures by Filippo Lippi, Domenico Ghirlandaio, and Frans Hals.[11]

In the 1910s, Jung appears to have become increasingly interested in the works of Symbolist artists such as Odilon Redon and Giovanni Segantini, books about whom are to be found in his library.[12] Moreover, Jung must have known two Basel painters who worked in the Symbolist style, Hans Sandreuter (1850–1901),[13] a student of Arnold Böcklin, and Ernst Stückelberg (1831–1903). Sandreuter painted many façades in Basel (for example the *Bären-zunft*) and interior walls (*Schmiedezunft*). Several of Jung's own paintings show remarkable similarities in motifs and symbolic content to Sandreuter's pictures.[14] It seems that Jung also owned a painting by Sandreuter: An old photograph of the library in Küsnacht[15] shows a small painting that is very like Sandreuter's painting *Seashore* (fig. 1), now in the Kunstmuseum Basel.

Similarly, Jung collected reproductions of Symbolist motifs and landscapes from periodicals, including images by Hans von Marées, Hans Thoma, and artists little known nowadays, such as Carl Strathmann, Fritz Mühlbrecht, Eugen Ludwig Hoess, and Reinhold Koeppel. These reproductions, too, appear to have inspired his own pictures.[16] Carefully collected pages from the journal *Jugend*[17] from the years 1903 to 1912 are preserved in the family estate.

During a trip to New York in March 1913, Jung confronted radical forms of modern art on visit to the Armory Show, mounted from February 17 to March 15 of that year. The first comprehensive exhibition of modern art in the United States, the show greatly influenced American artists. It was in New York that Jung first encountered original works by Marcel Duchamp and Pablo Picasso, as he later recalled in a letter to the Czech art historian Joseph P. Hodin. Regarding Duchamp's painting *Nude Descending a Staircase* (fig. 2),[18] which provoked conservative art criticism, Jung wrote:

> It looks like a cigar store after an earthquake. If one moves the photograph of the picture quickly back and forth, so that a stroboscopic effect is produced, then one actually sees "La Nue" on the stairs, but it's not clear if, nude as she is, she wants to get into the kitchen or the dining room.[19]

Jung had a similar response to Picasso's pictures:

> The principal theme of the pictures [from the period following the Armory Show] was the harlequin, who dissolves in a bombed porcelain shop.[20]

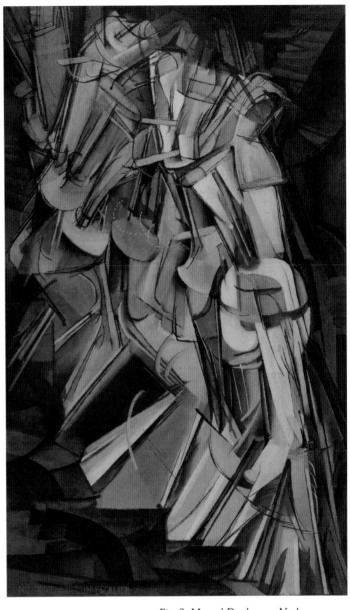

Fig. 2. Marcel Duchamp, *Nude Descending a Staircase*, 1912, oil on canvas, 147 × 89.2 cm (57⅞ × 35⅛ in.). Philadelphia Museum of Art.
© Succession Marcel Duchamp / 2016, ProLitteris, Zurich für Werke von DUCHAMP MARCEL

Subsequent to his visit to the Armory Show, Jung delved deeper into the question of the aesthetic and psychological meaning of art in both theoretical and practical terms. Two books in his library bear witness to his engagement with the aesthetic and development of the modern: Max Raphael's *Von Monet zu Picasso: Grundzüge einer Aesthetik und Entwicklung der Modernen Malerei* (From Monet to Picasso: Essentials of an Aesthetic and Development of Modern Painting [1913]) and Wilhelm Worringer's *Abstraction and Empathy* (1908).[21] Raphael's book[22] inspired keen debates when it appeared; his professor, Heinrich Wölfflin, had rejected it as a dissertation on the grounds that it was too contemporary.[23] As Jay Sherry has correctly remarked, reading Worringer may have exerted significant influence on Jung's psychological view of modern art.[24] Jung's closely studied copy of the book contains copious underlining and handwritten notes.[25] Worringer did not see art as an isolated field; rather, he discussed it with regard to the psychological situation of a people during a particular era, offering clear connections to the theory of Archetypes and the Collective Unconscious that Jung formulated while working on *The Red Book*. According to Worringer, during times of confidence in the world, an art of "empathy" dominates, as exemplified by the "realism" seen in European art since the Renaissance. By contrast, the urge to "abstraction," as found in Egyptian, Byzantine, primitive, or modern art, expresses a totally different response to the world, one that articulates man's insecurity. Thus, in historical periods of anxiety and uncertainty, man seeks to abstract objects from their unpredictable state and transform them into absolute, transcendental forms.

Jung's library further included nineteen volumes of *Handbuch der Kunstwissenschaft* (Handbook for the Study of Art; 1913–1939), founded by Fritz Burger,[26] and nine volumes of *Künstler-monographien* (Artist Monographs), published by Hermann Knackfuss.[27]

Paul Häberlin's (1878–1960) lecture from 1916, entitled "Symbol in der Psychologie und Symbol in der Kunst"[28] (Symbols in Psychology and Symbols in Art), also appeared in Jung's library. Häberlin, born likewise in Kesswil, knew Jung from their time in the student fraternity Zofingia in Basel. A professor in Bern by 1912, from 1922 Häberlin held the chair of philosophy, psychology, and pedagogy in Basel. In his lecture, Häberlin investigated the commonalities of art and psychology through an analysis of symbols. Häberlin posited that the effect of a work of art depends on three things: the technical ability of the artist, the beauty of expression in the artwork, and the symbol as an expression of a particular experience of the artist. The third characteristic is diametrically opposed to Jung's conception, which understands the symbol as arising from a transpersonal, deeper level of consciousness in the psyche, and thus as a message from the Collective Unconscious, communicating to consciousness something still unknown, often archetypal.

Just as in his extensive studies of comparative cultural history, mythology, and ethnography, Jung was interested in modern art less for its aesthetic aspect and more for what it illuminated about the individual psyche and collective Archetypes. He summarized his views in a letter from March 1958 to the philosophy student Andras Horn:

Art is no doubt a very complicated expression of the human soul. It is, in the first instance, as with animals, the effect of a corresponding instinct, which—like all instincts—rests upon exterior and interior conditions. In humans, this instinct of interior perception expresses itself in the form of Archetypes. That is its interior condition. Its exterior condition exists in the relationship of the artist to his environment and in the

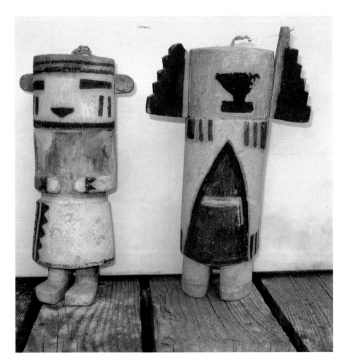

Fig. 3. Two kachina figures (I'she and Angwusnasomtaqa), made between 1900 and 1920, painted wood, c. 20 × 10 × 6 cm (7⅞ × 3¹⁵/₁₆ × 2⅜ in.). In 1925, C.G. Jung brought these kachinas home from his trip to the Pueblos. Private collection

Fig. 4. Sophie Taeuber-Arp, *Costume Design* (No. 60), with the inscription lower right: "Sophie Arp/Design (Indian)/f[or] the costume ball/executed/premiere Kunsthausball," ca. 1925, gouache and colored pencil on paper, 35 × 50.3 cm (13¾ × 19¹³/₁₆ in.). Arp Museum Bahnhof Rolandseck

materials available to him as means of expression. Whether the historical development of art can be satisfactorily formulated with respect to other manifestations of individual development is a question which can only be answered by art history itself. Whether art is an expression of the constellated Archetypes at particular points in the course of history is a question for comparative psychology.[29]

Although his interest in modern art lay primarily in its psychological content, it is remarkable that Jung often, in his research into comparative culture and depth psychology, consulted the very same sources that drew the attention of modern artists, who themselves discovered, in a search for unused precedents, the traditional art of "primitives" and, employing this elementary language of forms, found their way to aesthetic solutions.[30] Nowhere is this direct connection more striking than in the Hopi costumes that Sophie Taeuber-Arp (1889–1943) designed presumably for the Kunsthaus Ball (figs. 4, 5), based on two small kachina figures (fig. 3) that Jung brought back in early 1925 from a research trip to the Pueblo Indians in New Mexico.[31] Taeuber-Arp and her sister Erika Schlegel,[32] the first librarian of the Psychology Club Zurich, modeled costumes copying every detail on the kachina figures, as Schlegel's son Leonard recalled:

From his visit with the Hopi and Pueblo Indians in the United States, C.G. Jung had brought home two colorful ritual puppets, made of wood, which I was allowed to play with, when I accompanied my mother to the library of the Psychology Club. Sophie and Erika shaped their masks exactly after these puppets.[33]

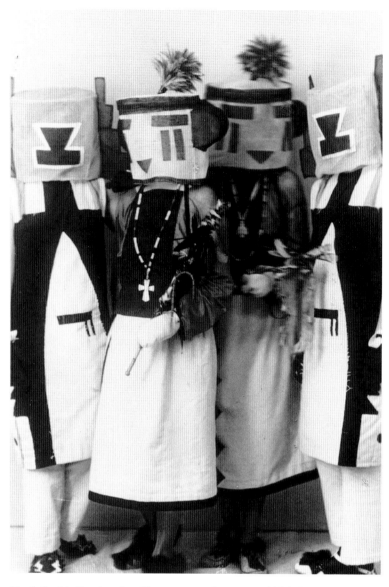

Fig. 5. Sophie Taeuber-Arp, Hopi costume designs, ca. 1925. © Archives Fondation Arp

Jung's connection to the Zurich arts scene in the 1910s and 1920s has been known since at least the 2004 publication of Rainer Zuch's *Die Surrealisten und C.G. Jung* (The Surrealists and C.G. Jung).[34] Close personal relationships existed through Erika Schlegel, specifically to Sophie Taeuber-Arp and her husband Hans Arp (1886–1966), and through him to the Dada scene, Hugo Ball (1886–1927) and Tristan Tzara (1896–1963). Founded at practically the same time in Zurich in 1916, the Cabaret Voltaire and the Psychology Club both played an important role in the cultural life of the city.[35] The meaning of modern painting and poetry was intensively debated at the Psychology Club,[36] and various members, like Jung in his experiment with *The Red Book*, sought forms of artistic expression for their inner experiences.[37] Jung on various occasions discussed themes of modern art with Erika Schlegel, herself a gifted artistic craftsperson and a writer of short stories. In her diary, she reported that Jung spoke vividly about the work of Ferdinand Hodler and Michelangelo. Of an evening at the theater with Eugen Schlegel, Carl and Emma Jung, Toni Wolff, Hans Arp and Sophie Taeuber-Arp, she wrote: "Eugen, I after the performance with Emma Jung, Toni, Carl, Arps in the [Hotel] Bellerive. Jung is enchanted with Arp, [just as] he is by him."[38]

Jung's understanding of his own creative endeavors in the context of the creation of *The Red Book* underwent a defining experience through grappling with the artistic path of Franz Beda Riklin. Riklin was also a member of the Psychology Club. He had been close to Jung since their studies as associate physicians at Burghölzli, and Riklin was married to Sophie Fiechter, a cousin of Jung's. In addition to his psychological work, Riklin began to study painting with Augusto Giacometti (1877–1947). Giacometti saw the purpose of his art less as the capture of a specific image and more as a representation of a mood or a feeling, expressed by means of a self-developed color theory. Riklin developed into a well-regarded painter in Zurich, and in 1919 joined the group Das Neue Leben (The New Life), with Giacometti, Hans Arp, and Paul Klee, which led to exhibitions in the Kunsthalle Basel, the Kunsthalle Bern, and the Kunsthaus Zurich.[39] Riklin spoke on abstract art at the Psychology Club on May 31, 1919, and is known for the frescoes he painted for Giacometti in the hallways of the new Zürcher Amtshaus I during the years 1923 to 1926.[40] In conversation with Erika Schlegel, Jung revealed that he was impressed with the aesthetic worth of Riklin's smaller works, but that he saw a tendency in the large-format works for Riklin to "quite simply lose his way."[41]

As Sonu Shamdasani writes, Riklin seems to have acted as a sort of doppelgänger for Jung, though Jung came to believe that Riklin took the wrong path when turning from doctor and

psychologist to artist.[42] In contrast to Riklin, Jung came to the conclusion that his own self-experiment, *The Red Book*, was valuable not as art, but primarily as an expression of his nature and soul.[43]

Correspondingly, Jung became increasingly negative about the art of Dada, which he considered to be nothing but senseless, disordered, or even lost nature.[44] Ultimately, he lacked the ability, in Worringer's sense, to empathize with these abstract forms of artistic expression:

> Since antiquity, our general attitude to art has always been empathetic, and for this reason we designate as beautiful only those things we can empathize with. If the art-form is opposed to life, if it is inorganic or abstract, we cannot feel our own life in it.[45]

This statement reiterates what Jung found so distressing in the pictures of Duchamp and Picasso at the Armory Show: that the Cubist style, in contrast to traditional painting or the pictures of the Symbolists, truly intended to *dissolve the represented object*.[46] In notable contrast, Jung applied more favorable words to the works of modern artists in whom this tendency was not apparent. He spoke, for example, of the "genius" of Salvador Dalí as evidenced in his painting *The Sacrament of the Last Supper* of 1955:

> The picture could have been painted by someone who knew something about the secret developments of our unconscious minds during the last 1000 years. The genius of Dalí translates the mental background of the symbol of transformation into a visible picture.[47]

In his Eidgenössische Technische Hochschule (ETH; the Federal Institute of Technology) lectures of January 1934, Jung advised his listeners to visit the exhibition of work by the Swiss graphic artist and painter Otto Meyer-Amden, who had recently died, in the Kunsthaus Zurich. He drew special attention to small, mandala-like works that, according to Jung, derived immediately from the inner images (visions) of this important representative of avant-garde painting in Switzerland.[48]

Jung's dismay with "decadent" tendencies in modern abstract painting and literature should be understood in relation to his belief that he recognized in them much of what he and his colleagues had come to know as typical expressions of neurotic and psychotic disturbances in their patients, examples of which Jung hardly lacked. In 1921, his colleague Walter Morgenthaler, who came from a family of artists and worked at the psychiatric institution Waldau in Bern, published a monograph on the artist Adolf Wölfli (1864–1930), then living at the asylum.[49] In the same year, Hans Prinzhorn delivered a lecture at the Psychology Club about his recently published book *Artistry of the Mentally Ill*,[50] at which Jung was present. Having for years employed art therapeutically and creatively with his own patients through his Active Imagination,[51] Jung may never have been able to view modern art independent of its psychological and symbolic aspects.

Beginning in the mid-1920s, Jung became increasingly familiar with Anglo-Saxon artists, including Herbert Crowley (1873–1939), a self-taught British painter and designer known for the comic strip *The Wiggle Much* (fig. 6).[52] He was the first husband of Alice Lewisohn Crowley (1883–1972), a member and benefactor of the Psychology Club, art patron, and patient of Jung's.[53] Also notable during this period is Jung's contact with the American stage designer Robert Edmond Jones (1887–1954). During the time that Jones spent in Zurich, Jung invited

him to the Tower at Bollingen, where the two would work on a mural together.[54] Jones introduced Jung to the American portrait painter Mary Foote (1872–1968),[55] who after 1928 stayed in Zurich for thirty years and made herself useful to analytical psychology by translating and copying records of individual seminars by Jung. Jung viewed works by Herbert Crowley and Mary Foote at the 1913 Armory Show. Barbara Hannah, who came to Zurich from England in 1929 to work with Jung and to take part in his seminars,[56] was another painter connected to Jung through an interest in analytic psychology.

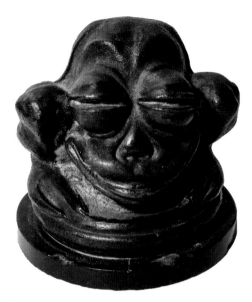

Fig. 6. Herbert Crowley, *Bronze Grotesque,* ca. 1913. Collection of C.G. Jung

When the big exhibition *Abstrakte und Surrealistische Malerei und Plastik* (Abstract and Surrealist Painting and Sculpture) took place at the Kunsthaus Zurich from October 6 to November 3, 1929,[57] Erika Schlegel had trouble convincing Jung to join her for a visit.[58] It is therefore surprising that Jung acquired from the exhibition Yves Tanguy's *Noyer indifférent* (fig. 7).[59] Later, Jung discussed the painting along with two other contemporary artists, Peter Birkhäuser and Erhard Jacoby, in his text *Ein Moderner Mythos: Von Dingen die am Himmel gesehen werden* (A Modern Myth of Things Seen in the Sky; 1958).[60] Jung examined all three pictures thoroughly. In a letter to Birkhäuser, he wrote that Riklin had made him aware of the picture "of the city and the monster in the background."[61] He further emphasized that, because of his limited competence, his remarks should be taken purely "from the psychological point of view."[62]

In 1932—interestingly, the same year his Picasso and Joyce essays were published—Jung was awarded the first iteration of the literary prize of the City of Zurich. With his prize money, he bought a head of a young woman in bronze by Hermann Hubacher. He had most wanted to acquire a bronze by Hermann Haller, but Haller asked 2,000 Swiss francs more than Hubacher.[63] In addition, Jung chose a piece of stained glass by Ernst Rinderspacher with a depiction of the Pietà. The remainder of the 4,000 Swiss francs he donated to the Swiss writers' union.[64]

Two further titles from Jung's library on the subject of modern art from these years bear mentioning. Both seem to have come into Jung's possession as gifts. In 1934, he received as a birthday present a small book on the work of Paul Klee from Erna Naeff, Toni Wolff's sister, which made an ambiguous impression on Jung.[65] The second was the exhibition catalogue *Fantastic Art, Dada, Surrealism* from 1936. The exhibition, organized by the Museum of Modern Art in New York under Alfred H. Barr (December 7, 1936–January 17, 1937), contained more than seven hundred works from between 1450 and 1936. Works by Bosch, Arcimboldo, Dürer, Blake, Redon, Duchamp, Picasso, Arp, and Ernst, as well as thirteen works by Tanguy and two heads by Taeuber-Arp, were exhibited.[66]

While through his fundamental research into Archetypes and symbols Jung was intensively involved with visual material, there are few documented examples of Jung speaking publicly to an audience interested in art. One of the very few exceptions is Jung's lecture to the Davos

Kunstgesellschaft [Art Society] in 1940. In a lavishly illustrated talk on circle and quaternity symbolism, Jung focused on the aspects of symbols in art with which he was very familiar.[67] In 1941, he was asked by Johannes Itten to give a lecture at the Arts and Crafts Museum in Zurich on the occasion of the exhibition *Asiatische Kunst aus Schweizer Sammlungen* (Asian Art in Swiss Collections), but he declined.[68] He also politely turned down many requests from the periodical *Universitas* for an essay on art from his pen. He spoke to the art historian Doris Gäumann-Wild about her manuscript *Entwicklung der Malerei seit dem Impressionismus* (The Development of Painting since Impressionism);[69] Gäumann-Wild was president of the Lyceum Club in Zurich and was related to Wilhelm Wartmann, director of the Kunsthaus Zurich. She sometimes wrote for the *Neue Zürcher Zeitung* and in 1946 organized an exhibition at the Helmhaus Zurich, in which she showed the Rosa Gerber-Hinnen wall hanging owned by Jung.[70] Between 1945 and 1950, the museum society of St. Gallen sought in vain to get Jung to deliver a lecture,[71] and J.R. Geigy asked Jung for a contribution to the periodical *Kunst und Naturformen* (Art and Natural Forms) in 1957, without success.[72] In 1958, Jung was invited by the Institute of Contemporary Art in Washington to give an informal talk about his work. The invitation was initiated by Herbert Read, Mircea Eliade, and Martin Buber.[73] Despite a generous honorarium of $4,500, Jung rejected the offer, in part because of his age.

Interestingly, in 1957 Jung could no longer recall that forty-one years earlier, namely on February 26, 1916, he had given a presentation at the Psychology Club on Ernst Barlach's graphic cycle and drama *Der tote Tag, 1. Akt* (The Dead Day, Act I). In correspondence with Werner Hollmann, Jung claimed that he had never given talks on Barlach.[74] However, Jung was demonstrably in possession of correspondence with a German colleague who was in contact with Ernst Barlach about the psychological aspects of his work, and Jung owned a portfolio of twenty-seven lithographs from *Der tote Tag*.[75]

Even thirty years after the Picasso controversy, Jung felt that he had been misunderstood and remained reluctant to offer additional commentary on the work of a representative of modernism. He said so quite frankly in the interview with the Czech art historian Hodin cited at the beginning of this essay.[76]

It is notable that responsibility for overseeing the edition of Jung's *Collected Works* was given to Sir Herbert Read, a director of the publishing house Kegan Paul and the most well-known British art theorist of his time. Read dedicated a portion of his book *The Art of Criticism* (1957)—a text that has been much discussed—to Jung's understanding of art. It was later included as a separate essay in German in the *Festschrift* for Jung's eighty-fifth birthday.[77]

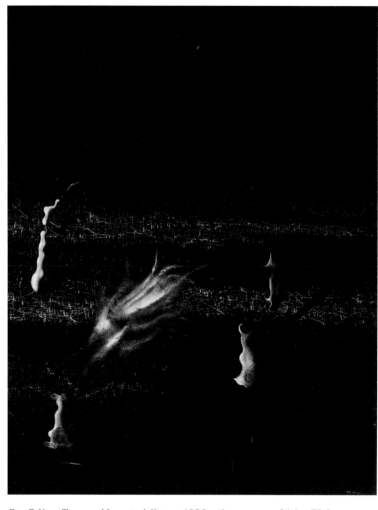

Fig. 7. Yves Tanguy, *Noyer indifférent*, 1929, oil on canvas, 91.1 × 73.2 cm (35⅞ × 28¹³/₁₆ in.). Private collection © Succession Yves Tanguy / 2016, ProLitteris, Zurich für Werke von Yves Tanguy

The essay occasioned from Jung a comprehensive letter to Read on September 2, 1960, in which he once more elaborated upon his basic views on modern art and his own criticism of art criticism.[78]

It may be argued that Jung did not engage superficially with modern art, but rather immersed himself in it on many levels during his lifetime. Jung's understanding of art bore four important influences that shaped his view of modern art: the collection of art and a library of cultural-historical literature about ethnological and contemporary art; visits to exhibitions and the study of art publications; personal contact with artists and art historians; and picture material from patients, in which he saw strong analogies to abstract art.

In all this, Jung clung to his basic psychological observation that many modern artists remained completely unconscious of the content and meaning of their art.[79] In correspondence with the publishing house Brunnenhof, Jung agreed that modern art could only succeed if it reunited itself with content.[80] He wrote to the British painter Ceri Richards in 1958: "I must confess, however, that I have no relation whatsoever to modern art unless I understand a picture."[81] The Symbolist art of an Odilon Redon or Giovanni Segantini corresponded more readily than modern art to Jung's idea of art as a psychological expression. Contemporary literature, art, and painting fascinated Jung only insofar as he could perceive human experience in them:

As you may not know, it is very difficult for me as a psychologist and a human being to find any connection to new art. Insofar as feelings appear to be an especially unsuitable vehicle for judging this art, one calls upon reason or intuition to find some kind of access. [. . .] These strange messages fit our times, which are characterized by mass culture and the extinction of the individual. In this respect, our art appears to play an important role, namely as compensation for a vital deficit and anticipation of the loneliness of humankind itself. The question that presses itself upon me when I look at modern pictures is always the same: what is it that [the artist] can't say?[82]

NOTES

1. Quoted in Joseph P. Hodin, *Modern Art and the Modern Mind* (Cleveland: The Press of Case Western Reserve University, 1972), p. 88.

2. C.G. Jung, "Picasso," in *Neue Zürcher Zeitung*, November 13, 1932. Revised edition 1934; see C.G. Jung, *The Collected Works of C.G. Jung*, 21 vols., ed. Herbert Read, Michael Fordham and Gerhard Adler, exec. ed. William McGuire, tr. R.F.C. Hull (New York: Bollingen Foundation/Pantheon Books, 1953–1967: Princeton: Princeton University Press, 1967–1978), *CW* 15, §§ 204–14. An exhibition of 460 works by Picasso took place at the Kunsthaus Zurich, September 11–October 30, 1932.

3. C.G. Jung, "'Ulysses' – Ein Monolog," in *Europäische Revue* 8 (September, 1932), pp. 547–68; *CW* 15, §§ 163–203.

4. On the footnote that was added later, see *CW* 15, § 208, note 3. In at least one instance, a critical reader's letter caused Jung to defend his position personally. See Jung to Dr. Hanns Welti, December 23, 1932, in C.G. Jung, *Letters*, vol. 1, ed. Gerhard Adler, tr. R.F.C. Hull (Princeton: Princeton University Press, 1973), pp. 114–15.

5. Jung first described his method of Active Imagination in 1916 in the essay "Die transzendente Funktion," which however appeared in print only in 1957/58; *The Transcendent Function*, *CW* 8, §§ 131–93. Jung's 1929 commentary on Richard Wilhelm's translation of *The Secret of the Golden Flower* contains not only a detailed description but also ten black-and-white plates to illustrate the method of Active Imagination. See C.G. Jung, *Commentary on "The Secret of the Golden Flower,"* in *CW* 13, §§ 1–84.

6. Jung to Dr. A.L. Vischer, November 10, 1947, ETH Zurich University Archives, Hs 1056: 14615.

7. Jung to Herbert Read, September 2, 1960, in C.G. Jung, *Letters*, vol. 2, ed. Gerhard Adler, tr. R.F.C. Hull (Princeton: Princeton University Press, 1975), pp. 586–92.

8. E.g., Jung to Oskar Dalvit, December 16, 1940, ETH Zurich University Archives, Hs 1056: 9187.

9. See cats. 23–28.

10. Note by C.G. Jung of February 8, 1901, private archive.

11. See Andreas Jung et al., *The House of C.G. Jung: The History and Restoration of the Residence of Emma and Carl Gustav Jung-Rauschenbach*, Stiftung C.G. Jung Küsnacht (Wilmette: Chiron Publications, 2008), pp. 68–70, 74–77.

12. Odilon Redon, *Oeuvre graphique complet*, 2 vols. (The Hague: Artz & De Bois, 1913); André Mellerio, *Odilon Redon. Peintre, dessinateur et graveur* (Paris: H. Floury, 1923); Giovanni Segantini, *Schriften und Briefe* (Leipzig: Klinkhardt & Biermann, 1909). The Kunsthaus Zurich held an exhibition of Redon's work March 8–April 5, 1914.

13. The Kunstmuseum Basel had a Sandreuter retrospective from mid-March to mid-May, 1902, which Jung could have visited. The Kunsthaus Zurich presented a further, larger Sandreuter exhibition, in which works by Hodler were also to be seen, June 8–July 13, 1913.

14. E.g., Hans Sandreuter, *Evening*, oil on canvas, 124 × 180 cm (48¹³/₁₆ × 70¹³/₁₆ in.), private collection, reproduced in *Fin de Siècle in Basel. Hans Sandreuter 1850–1901*, exh. cat., Kunstmuseum Basel, 2001, Fig. 55; *Sunset: Wagenhaus bei Stein am Rhein*, watercolor. 26.3 × 35.5 cm (10¹/₈ × 14 in.), Kunstmuseum Basel, Kupferstichkabinett, gift of Hans Martin Ulbricht, Zurich 2014. Jung's related works are cats. 14, 15, 20, 21, and 28.

15. See photo in A. Jung, *The House of C.G. Jung*, p. 80.

16. See cats. 19–21.

17. The art and literature periodical *Jugend: Münchner illustrierte Wochenschrift für Kunst und Leben*, founded in 1886 in Munich, shaped the art historical debate of Jugendstil (Art Nouveau).

18. In a letter to J.P. Hodin, Jung mistakenly attributed the picture to Picasso and also mistook the title of the painting. Duchamp's painting is considered an icon of classical modernism.

19. Jung to J.P. Hodin, September 3, 1955, ETH Zurich University Archives, HS 1056: 21965.

20. Ibid. In the Armory Show, six paintings, one drawing, and one bronze bust by Picasso were on display. The Harlequin pictures to which Jung refers here were created in the years 1914 to 1917.

21. *Abstraktion und Einfühlung. Ein Beitrag zur Stilpsychologie* (Munich: Piper Verlag, 1908); *Abstraction and Empathy: A Contribution to the Psychology of Style*, tr. Michael Bullock (New York: International Universities Press, 1953). Besides *Abstraction and Empathy*, Jung had three other publications by Worringer in his library: *Formprobleme der Gotik* (1912; *Form Problems of the Gothic*, New York, 1920); *Die altdeutsche Buchillustration* (1919; Old German Book Illustration); and *Ägyptische Kunst: Probleme ihrer Wertung* (1927; *Egyptian Art*, London, 1928).

22. Max Raphael studied the work of Vincent van Gogh, Paul Cézanne, and Pablo Picasso. In 1932, he responded critically to C.G. Jung's article on Picasso; see Max Raphael, "C.G. Jung vergreift sich an Picasso," in *Werkausgabe. Aufbruch in die Gegenwart. Begegnungen mit der Kunst und den Künstlern des 20. Jahrhunderts* (Frankfurt am Main: Suhrkamp, 1989), pp. 21–27.

23. How the book (third edition, 1911) came into Jung's hands cannot be reconstructed. The copy in his library does not have annotations.

24. Jay Sherry, "A Pictorial Guide to *The Red Book*," 15ff., https://aras.org/sites/default/files/docs/00033Sherry.pdf (accessed October 14, 2017).

25. Jung used various citations from Worringer's dissertation in his lecture at the Fourth Psychoanalytic Congress in Munich in 1913. This piece was later included in Jung's *Psychological Types* (*CW* 6) under the title "The Type Problem in Aesthetics."

26. Fritz Burger (1877–1916), professor of contemporary art history and teacher at the Akademie der bildenden Künste in Munich, sought to create a new systematization of the study of art with his *Handbuch der Kunstwissenschaft* (Handbook of the Study of Art), which saw artistic activity as a process of discovery, both intellectual and sensual. Jung owned the following volumes: *Die Malerei und Plastik des Mittelalters in Italien* (Italian Painting and Sculpture in the Middle Ages), *Malerei der Renaissance in Italien* (Italian Renaissance Painting), *Die deutsche Plastik I & II* (German Sculpture I & II), *Die Kunst Indiens* (The Art of India), *Antike Kunst I* (Ancient Art I), *Deutsche Malerei der Renaissance I* (German Painting in the Renaissance I), *Altchristliche und byzantinische Kunst I & II* (Ancient Christian and Byzantine Art I & II), *Die Baukunst des 17. und 18. Jahrhunderts in den romanischen Ländern I* (Architecture of the Romance Countries in the Seventeenth and Eighteenth Centuries), *Die Baukunst des 17. und 18. Jahrhunderts in den germanischen Ländern* (Architecture of the German Countries in the Seventeenth and Eighteenth Centuries), *Die italienische Plastik des Quattro Cento und Plastik des 18. Jahrhunderts in Frankreich* (Italian Sculpture of the Quattrocento and Eighteenth-Century Sculpture in France), *Die Kunst der islamischen Völker* (The Art of the Islamic Peoples), *Baukunst der Renaissance in Frankreich und Deutschland* (Architecture of the Renaissance in France and Germany), *Einführung in die Moderne Kunst I* (Introduction to Modern Art I), *Skulptur und Malerei in Frankreich vom 15. bis zum 17. Jahrhundert* (Sculpture and Painting in France from the Fifteenth to the Seventeenth Century), *Baukunst des Mittelalters* (Architecture of the Middle Ages).

27. Jung owned monographs on the following artists: Antoine Watteau (1896), Hokusai (1904), Hans Holbein the Younger (1902), Wilhelm von Kaulbach (1900), Max Klinger (1901), Joshua Reynolds (1908), Veit Stoss (1906), and Giovanni Segantini (1904).

28. According to the dedication, Jung received the book as a Christmas gift from the author.

29. Jung to Andras Horn, March 17, 1958, ETH Zurich University Archives, Hs 1056: 26270.

30. E.g., Carl Einstein, *Negerplastik* (Leipzig: Verlag der weissen Bücher, 1915); tr. Patrick Healy, *Negro Sculpture* (November Editions, bilingual ebook, 2014).

31. See figs. 3, 4, and 5. The two kachinas (fig. 3) represent I'she kachina and Angwusnasomtaqa. I'she kachina (mustard green kachina) represents the wild vegetables and herbs that bring a change in diet in the spring. Angwusnasomtaqa (crow mother) is wearing the traditional wedding dress of Hopi women. She gives the villagers beansprouts (symbolic of sufficient food). A highly regarded figure, who is treated with a great deal of goodwill.

32. Erika Schlegel-Taeuber came to Jung for analysis through Toni Wolff. She and her husband, Eugen Schlegel, were friends of the Jungs.

33. Unpublished recollection by Leonhard Schlegel, typescript, Collection Fisch.

34. Rainer Zuch, *Die Surrealisten und C.G. Jung: Studien zur Rezeption der analytischen Psychologie im Surrealismus am Beispiel von Max Ernst, Victor Brauner und Hans Arp* (Weimar: VDG, 2004), pp. 219–23.

35. According to Erika Schlegel, starting at the end of May 1916 the Psychology Club hosted "the beginnings of a sort of cabaret," which took the form of singing concerts, readings, group viewings of pictures, and presentations of craft work. Later, apart from the presentations, the Psychology Club also organized dance courses and various costume evenings and masked balls.

36. On June 9, 1922, Jung gave a lecture at the Psychology Club entitled "The Relationship of Analytical Psychology to Poetic Artwork."

37. Sonu Shamdasani mentions the example of Alphonse Maeder, who in 1916 wrote a monograph on Ferdinand Hodler and also published his own waking fantasies and visions anonymously. On February 26, 1915, Maeder gave a lecture at the Psychology Club on Hodler and the Question of Types in Art. In addition, Hans Schmid-Guisan, a member of the Club with whom Jung exchanged an extensive correspondence on the question of psychological types, wrote and painted his visions in a book. Sonu Shamdasani, Introduction, *RB*, p. 204.

38. Entry of February 2, 1925, Diary of Erika Schlegel, Collection Fisch.

39. *Das Neue Leben*, Kunsthaus Zurich, January 12–February 5, 1919. In that same year Giacometti signed the *Manifesto of Radical Artists*, along with Hans Arp, Marcel Janco, Hans Richter, Helmuth Viking Eggeling, plus the Swiss artists Fritz Baumann, Walter Helbig, and Otto Morach.

40. The frescoes of Amtshaus I with their Freemason symbols were created from 1923 to 1926. See Erwin Poeschl, "Die Fresken von Augusto Giacometti im Amtshaus I der Stadt Zurich," in *Das Werk* 6 (1926), pp. 333–40. Also see Hans Rudolf Wilhelm, "Der Psychiater und Maler Franz Beda Riklin: eine Spurensicherung," in *Schweizer Monatshefte* 6 (2001), pp. 19–22.

41. Entry for March 11, 1921, Diary of Erika Schlegel, Collection Fisch.

42. Sonu Shamdasani, Introduction, *RB*, p. 204. As Jung later let it be known, it was principally Maria Moltzer who actively tried to persuade him to follow Riklin and make his creative work known publicly. Moltzer belonged to a small circle of trusted persons from the Psychology Club to whom Jung had shown his works in *The Red Book*. As he said in an English-language seminar in 1925, Analytical Psychology, it was only with great difficulty that he was able to overcome the inner voice not to do so. In the end, he never showed his pictures in an art context. See C.G. Jung, *Introduction to Jungian Psychology: Notes of the Seminar on Analytical Psychology Given in 1925* (Princeton: Princeton University Press, 2012), p. 45.

43. In a 1921 conversation with Erika Schlegel on Riklin's art, Jung expressed his conviction that "art and knowledge are but servants of the creative spirit. One must serve it [that spirit]." See Sonu Shamdasani, Introduction, *RB*, p. 204.

44. In his 1918 essay The Role of the Unconscious, Jung very explicitly criticized Dada: "The further we remove ourselves from it [the world of primitive feeling] with our enlightenment and our rational superiority, the more it fades into the distance, but is made all the more potent by everything that falls into it, thrust out by our one-sided rationalism. This lost bit of nature seeks revenge and returns in faked, distorted form, for instance as a tango epidemic, as Futurism, Dadaism, and all the other crazes and crudities in which our age abounds." *CW* 10, § 44.

45. Jung, *Psychological Types, CW* 6, § 488.

46. Jung used the example of Duchamp's picture in his English-language seminar of 1925, Analytic Psychology, in order to formulate his basic views on modern art: "[The painting *Nude Descending a Staircase*] might be said to present a double dissolution of the object, that is in time and space, for not only have the figure and the stairs gone over into the triangles and squares, but the figure is up and down the stairs at the same time, and it is only by moving the picture that one can get the figure to come out as it would in an ordinary painting where the artist preserved the integrity of the figure in space and time. The essence of this process is the depreciation of the object." Jung, *Introduction to Jungian Psychology*, p. 59.

47. Jung to Frances Wickes, December 14, 1956, *Letters*, vol. 2, pp. 38, 341.

48. C.G. Jung, ETH lecture of January 26, 1934 (forthcoming, Philemon Edition); the commemorative exhibition for Otto Meyer-Amden (1885–1933) in the Kunsthaus Zurich took place from December 22, 1933, to January 28, 1934, and was subsequently shown also in Basel and Bern: see *Gedächtnisausstellung Otto Meyer(-Amden)*, exh. cat., Kunsthaus Zurich, 1933. Meyer-Amden, who had twelve pieces in the show, was also featured prominently in the exhibition *Abstrakte und Surrealistische Malerei und Kunst* (*Abstract and Surrealist Painting and Art*) in 1929 in the Kunsthaus Zurich, which Jung had seen. See note 58.

49. Walter Morgenthaler, *Ein Geisteskranker als Künstler* (The Mentally Ill Person as an Artist) (Bern and Leipzig: E. Bircher, 1921). Walter Morgenthaler himself came from a family of artists and writers. See *Der Kontinent Morgenthaler*, exh. cat., Kunstmuseum Thun, 2015, especially Katrin Luchsinger, "Künstlerbild und Rezeptionsgeschichte. Die frühe Rezeption Adolf Wölflis und der Monografie Walter Morgenthalers," pp. 153–61. As early as 1911, Jung was sent a report by a fellow physician who had visited Wölfli at the Waldau asylum in Bern. The report included a drawing by Wölfli with a few notes on his life story on the back. Letter from H.W. Itten to Jung, November 26, 1911, ETH Zurich University Archives, Hs 1056: 29795 (drawing no longer included in the file).

50. Hans Prinzhorn, *Bildnerei der Geisteskranken: Ein Beitrag zur Psychologie und Psychopathologie der Gestaltung* (Berlin: Julius Springer, 1922); tr. Eric von Brockdorff from the second German edition, with an introduction by James L. Foy, *Artistry of the Mentally Ill: A Contribution to the Psychology and Psychopathology of Configuration* (Vienna: Springer-Verlag, 1995). Prinzhorn gave his lecture in the Psychology Club on March 12, 1921. Jung had a copy of Prinzhorn's book in his library.

51. Jung gave detailed examples of his psychological work with the method of Active Imagination in his English-language seminars Analytical Psychology (1925) and Interpretation of Visions (1930–1934).

52. Justin Duerr, *The Temple of Silence: Forgotten Works and Worlds of Herbert Crowley* (Philadelphia: Beehive Books, 2017).

53. At least three bronze sculptures by Herbert Crowley remained in the estate of C.G. and Emma Jung. Crowley's works from the time when he was around Jung demonstrate a pronounced symbolic visual language.

54. On Robert Edmond Jones's analytic work with Jung, see Dana Sue McDermott, "Creativity in the Theatre: Robert Edmond Jones and C.G. Jung," in *Theatre Journal* 2 (1984), pp. 213–30.

55. Mary Foote did the portrait of Jung that is the frontispiece of Gerhard Wehr, *An Illustrated Biography of C.G. Jung* (Boston: Shambhala, 1989).

56. Barbara Hannah is known to have been in Jung's closest circle in Küsnacht and, like Mary Foote, became a translator and promoter of Jung's work after her training as an analyst. Hannah's early Jung biography is still one of the most important sources on Jung's life: Barbara Hannah, *Jung, His Life and Work: A Biographical Memoir* (New York: Putnam, 1976).

57. *Abstrakte und Surrealistische Malerei und Plastik*, exh. cat., Kunsthaus Zurich, 1929.

58. Jung saw the exhibition with Erika Schlegel and her sister Sophie Taeuber-Arp, Toni Wolff, and Fanny Bowditch-Katz. Entry for October 11, 1929, Diary of Erika Schlegel, Collection Fisch: "It was so important to me for him [Jung] to see how, in the outside world, [psychological] processes known to us were represented. Otherwise, he only sees pictures by his patients and his own."

59. See the correspondence with Tanguy's widow, ETH Zurich University Archives, Hs 1056: 24361, 24362, 25052, 25053. Regarding the picture, see also Tjeu van den Berk, *Jung on Art* (London: Routledge, 2012), pp. 122–23.

60. Translated as *Flying Saucers: A Modern Myth of Things Seen in the Sky* (Princeton: Princeton University Press, 1964); *CW* 10, §§ 724–56.

61. See Peter Birkhäuser, *The Fourth Dimension*, illustrated in *CW* 10, fig. 3.

62. Jung to Peter Birkhäuser, June 13, 1957, ETH Zurich University Archives, Hs 1056: 24512.

63. Hermann Hubacher, together with the sculptor Hermann Haller, Karl Geiser, and Hermann Hesse, was among Walter Morgenthaler's closest artist friends.

64. Jung to Dr. Balsiger, December 13, 1932, ETH Zurich University Archives, Hs 1056: 1499.

65. Jung to Erna Naeff, July 26, 1934, ibid., Hs 1091: 435: "It was very kind of you to remember my birthday and to give me the book on Klee. I think it gives a very good overview of his oeuvre. There are some things missing, but what can you do, since art historians today still lack the categories that would fit the artist's chaotic material. I can only look inside from time to time because sometimes the injury to reason is too great. One wishes, however, that it had the colors, but it seems to me that formal considerations are overwhelmingly dominant with Klee." The book is Hermann von Wedderkop's *Paul Klee* (Leipzig: Klinkhardt & Biermann, 1920).

66. *Fantastic Art, Dada, Surrealism*, exh. cat., Museum of Modern Art New York, 1936. Jung was in America twice, in 1936 and 1937, for seminars and lectures, but not during the exhibition. If he did not acquire the catalogue himself, it could have entered his library through Erika Schlegel.

67. Jung to Jos. Hartmann, Davoser Kunstgesellschaft, September 4, 1940, ETH Zurich University Archives, Hs 1056: 1230, as well as the manuscript of the lecture "Einführung in die vergleichende Symbolik.

Grundideen der Menschheit. Ein Bild durch versch. Culturen und bei Individuen" (An Introduction to Comparative Symbolism/Fundamental Ideas of Humanity/An Overview of Various Cultures and Individuals), dated December 4, 1940, ETH Zurich University Archives, Hs 1055: 245.

68. Johannes Itten to Jung, May 31, 1941, ETH Zurich University Archives, Hs 1056: 9520.

69. Gäumann-Wild's question referred expressly to Jung's position on the "Picasso Problem" in 1932. The conversation took place on June 2, 1945, at Jung's house in Küsnacht. Doris Gäumann-Wild to Jung, May 15, 1945, ETH Zurich University Archives, Hs 1056: 11389. The book appeared in 1950 under the title *Moderne Malerei: Ihre Entwicklung seit dem Impressionismus* (Modern Painting: Its Development Since Impressionism).

70. Jung received Rosa Gerber-Hinnen's wall hanging *The Sermon on the Mount* (*Bergpredigt*) as a seventieth birthday present from the members of the Psychology Club. He wrote a two-page analysis of it. See ETH Zurich University Archives, Hs 1056: 12439–442. See fig. 96 in Thomas Fischer's essay "C.G. Jung the Collector" in this publication.

71. See ETH Zurich University Archives, Hs 1056: 13725, 11420, 11907, 14290, 17149.

72. See ibid., Hs 1056: 24663.

73. Ibid., Hs 1056: 25489.

74. Werner Hollmann to Jung, May 31, 1957, ibid., Hs 1056: 24036; Jung to Werner Hollmann, June 4, 1957, ibid., Hs 1056: 24727. For the Barlach series, see *CW* 4, § 780; *CW* 5, § 566, note 110; *CW* 6, § 436; *CW* 9/I, § 396.

75. Two original letters, as well as a copy of a third letter from 1916 by Barlach on *Der tote Tag*, survived in Jung's private papers, private collection.

76. Hodin had originally asked Jung by letter if he would be willing to write an article from his point of view on the work of the painter Oskar Kokoschka. Jung declined, giving the following reasons: "I would first have to work my way into the oeuvre of this artist, which would be a heavy task. [. . .] I do not imagine that I have much to say about modern art. It is inhuman and alien to me for the most part and painfully reminds me very much of what I have experienced in my practice." Jung to J.P. Hodin, September 3, 1955, ETH Zurich University Archives, Hs 1056: 21965.

77. Herbert Read, "Carl Gustav Jung," in *Zum Geburtstag von Professor Dr. Carl Gustav Jung, 26. Juli 1960*, pp. 7–29.

78. Jung to Herbert Read, September 2, 1960, in *Letters*, vol. 2, pp. 586–92. This letter is also to be seen as a reaction to Read's *The Forms of Things Unknown: Essays Towards an Aesthetic Philosophy* (1960), in which Read discussed the works of, among others, Pablo Picasso, Henry Moore, Jackson Pollock, Piet Mondrian, and Kurt Schwitters.

79. "It is rather conspicuous that creators of modern art are unconscious of the meaning of their creations." Jung to Lloyd W. Wulf, July 25, 1959, ETH Zurich University Archives, Hs 1056: 27864.

80. Ibid., Hs 1056: 9187.

81. Jung to Ceri Richards, May 21, 1958, in *Letters*, vol. 2, p. 440.

82. Jung to Heinrich Berann, August 27, 1960, ibid., pp. 585–86.

C.G. JUNG'S CONCEPTS OF COLOR
IN THE CONTEXT OF MODERN ART

MEDEA HOCH

ON THE PSYCHOLOGICAL ASPECTS OF COLOR

"Color = feeling":[1] this is what Jung pointed out in his only essay on visual art, which he published on November 13, 1932, in the *Neue Zürcher Zeitung* on the occasion of Pablo Picasso's first solo museum exhibition at the Kunsthaus Zurich, and which was of course discussed among the avant-garde.[2] The correlation of color and feeling may be the reason that so many have concerned themselves with color, from physicists and artists, to polymaths like Leonardo da Vinci, Johann Wolfgang Goethe, and Rudolf Steiner, philosophers such as Arthur Schopenhauer and Ludwig Wittgenstein, and psychologists like C.G. Jung.[3] "Color stimulates philosophizing. Perhaps that explains Goethe's passion for color theory,"[4] remarked Wittgenstein; whereas Hans Eduard Fierz-David, professor of chemistry at the Eidgenössische Technische Hochschule (ETH) in Zurich, in his lecture on Goethe's color theory at Jung's Psychology Club, explained: "It is fairly plain that the problem of color was for Goethe a psychological question."[5]

"Experience teaches us that particular colours excite particular states of feeling,"[6] Goethe wrote in his 1810 *Theory of Colours*.

> Since colour occupies so important a place in the series of elementary phenomena, filling as it does the limited circle assigned to it with fullest variety, we shall not be surprised to find that its effects are at all times decided and significant, and that they are immediately associated with the emotions of the mind.[7]

Goethe came to the conclusion that the colors of what he called the "plus side" (yellow, red-yellow, and yellow-red) inclined the emotions to be "quick, lively, aspiring," while the colors of the "minus side" (blue, red-blue, and blue-red) had the effect of being "restless, susceptible, anxious." In green, the eye and the mind rest.[8] In 1809, he painted a color wheel to symbolize the life of the human mind and spirit (fig. 8). In the inner circle, each color corresponds to a human trait, while in the outer circle, pairs of colors are identified with reason, understanding, sensuousness, and imagination. These correspondences refer to Karl Philipp Moritz's essay *Über die bildende Nachahmung des Schönen* (On the Visual Representation of the Beautiful) of 1788.[9]

By freeing color from its imitative function, held since the Renaissance, modern artists discovered its potential of aesthetic effects. A hundred years after Goethe, Wassily Kandinsky investigated the specific psychological effects of colors as well as the resulting form/color

Detail from *The Red Book*, fol. iv (v)

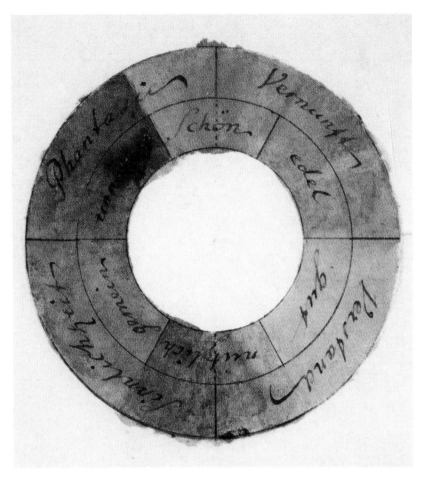

Fig. 8. Johann Wolfgang von Goethe, color wheel symbolizing the "mental and spiritual life of humans," 1809. Frankfurter Goethe-Museum

correspondences and synesthetic phenomena. His color research, published in 1911 in his book *On the Spiritual in Art*, is the most detailed in the field of artists' theories and, with respect to the investigation of the psychological, on a par with Goethe's color theory. In his review of an edition of Goethe's color theory in 1928, Walter Benjamin missed links between "Goethe's color interpretation and the extraordinary in Kandinsky's work."[10]

"Therefore, colour is a means of exercising direct influence upon the soul,"[11] Kandinsky noted in the chapter "Effect of Colour," and continued: "Yellow is the typical earthly colour." "Blue is the typical heavenly color." Yellow moves toward the observer, blue moves away. Green is the most peaceful color, an "immovable, self-satisfied element." Red has an "inner, highly vivid, lively, restless appeal" that creates a strong note of "tenacious immense power." Red characterizes movement in itself. In orange, "the movement in itself of red begins to become the movement of radiation." Violet "possesses an element of frailty, expiring sadness." White "affects us with the absoluteness of a great silence," but a silence "full of possibilities." And black, "like a nothingness after sunset [. . .] sounds like an eternal silence, without future or hope." Gray "can offer no outer appeal or movement." Kandinsky also refers to how forms influence the effect of color, whether increasing or decreasing. "In any event, sharp colours sound stronger in sharp forms (for example, yellow in a triangle)."[12]

Even if Kandinsky's book cannot be found in Jung's library, he might have heard the following about color research in Hugo Ball's talk on Kandinsky on April 6, 1917, in the Galerie Dada in Zurich:

> Kandinsky has thought a lot about a theory of color harmony, about the morality and sociology of color. He communicated his results in tabular and theoretical form in *On the Spiritual in Art*. He provided a literary interesting psychology of color following Delacroix, van Gogh and Sabanejeff, the critic of Scriabin who had tried to devise a musical scale of color. Kandinsky knows the somatic, animalistic and motor power of color. He collects elements for a *basso continuo* of painting, but his final word is not a catechism of color, but always the liberal principle of inner necessity, which remains the only guide and seducer.[13]

Years before the Picasso exhibition mentioned at the beginning of this essay, Zurich was a hothouse of modern art; during the First World War, the Dadaists showed not only their own work, but art from all over Europe. At the Cabaret Voltaire and the Galerie Dada, they exhibited works by Hans Arp, Heinrich Campendonk, Augusto Giacometti (fig. 9), Jacoba van Heemskerck, Johannes Itten, Wassily Kandinsky, Paul Klee, August Macke, Georg Muche, Gabriele Münter,

and Arthur Segal, all of whose works revel in color. The Kunstsalon Wolfsberg in the 1910s showed the likes of Cuno Amiet, Max Beckmann, Paul Gauguin, and Giovanni Giacometti. Sophie Taeuber-Arp presented works of applied art in exhibitions of the Schweizerischer Werkbund (Swiss Werkbund) and at the Kunstgewerbemuseum (Arts and Crafts Museum). Jung's explicitly colorful pictorial work developed in this environment.

Books on colorists such as Giovanni Segantini, Odilon Redon, and Paul Klee are found in Jung's library.[14] Jung knew the great colorist painter Augusto Giacometti, who in 1921 decorated the hall of the Zürcher Amtshaus I with wall and ceiling paintings and in 1933 designed radiant stained glass for the choir of the Grossmünster. Jung was introduced to Giacometti by the psychiatrist Franz Riklin, who studied painting with Giacometti from 1914 to 1918. In his *Die Farbe und ich* (Color and I) of 1934, Giacometti expresses insights into how the Impressionists, Neoimpressionists, and Expressionists used color.[15]

Sophie Taeuber-Arp, whom Jung knew through her sister, Erika Schlegel, also dedicated a chapter to color in her 1927 *Anleitung zum Unterricht im Zeichnen für textile Berufe* (Instructions for Teaching Design in the Textile Professions):

Fig. 9. Augusto Giacometti, *Formation II*, 1918, oil on canvas. Private collection

> We open up unsuspected riches in the perception of color if we occupy ourselves with a color for a good long time, letting it work upon our feelings in all its light and deep tones, and observing how it changes when it is put in context of another color. Quite new combinations of color spring up. Colors that previously could not be used together become enchanting through the differentiations of tones and proportions.[16]

Like Sophie Taeuber-Arp, Johannes Itten, who led the introductory course at the Bauhaus from 1919 to 1923, and after posts in Berlin and Krefeld from 1938 to 1943, taught at the Kunstgewerbeschule in Zurich, was taken with color as a painter and teacher. In 1966, he published *Kunst der Farbe* (*The Elements of Color*), in which he writes that the truest secrets of color effect are beheld by the heart alone.[17]

Although Jung never developed a true color theory, he speaks of color in his writings on alchemy, dream interpretation, Archetypes, and the functions of consciousness. Some clues to his conception of color can be found in his discussion of Active Imagination:

> We have only to look at the drawings and paintings of patients who supplement their analysis by Active Imagination to see that colours are feeling-values. Mostly, to begin

with, only a pencil or pen is used to make rapid sketches of dreams, sudden ideas, and fantasies. But from a certain moment on the patients begin to make use of colour, and this is generally the moment when merely intellectual interest gives way to emotional participation. Occasionally the same phenomenon can be observed in dreams, which at such moments are dreamt in colour, or a particularly vivid colour is insisted upon.[18]

Furthermore, Jung explains the connection between dreams and colors in a letter to the dancer Romola Nijinski of May 24, 1956, where he says that the unconscious manifests itself in colorful symbols:

The question of colours or rather absence of colours in dreams, depends on the relations between consciousness and the unconscious. In a situation where an approximation of the unconscious to consciousness is desirable, or vice versa, the unconscious acquires a special emphasis, which can express itself in the colourfulness of its images (dreams, visions, etc.) or in other impressive qualities (beauty, depth, intensity).

If on the other hand the attitude of consciousness to the unconscious is more or less neutral, or apprehensive, there is no marked need for the two to make contact, and the dreams remain colourless.

When Huxley[19] says that a symbol is uncoloured, this is an error. "Yellowing," "reddening," "whitening," the "blessed greenness," etc. play an important role in the highly symbolic language of the alchemists. You can also find the symbolism of colours in quite another field—that of Christian liturgy. You have only to think of the significance of the variously coloured garments used in the Mass.

The intense perception of colours in the mescalin experiment[20] is due to the fact that the lowering of consciousness by the drug offers no resistance to the unconscious.[21]

HEAVEN AND EARTH

"I have a certain sense of color,"[22] Jung remarked in a conversation with the art historian Joseph Paul Hodin in 1952, in which he recalled his interest in art and that he painted and carved wood and stone. Jung's sense of color first manifested in the landscapes in gouache, watercolor, or colored pastel on paper that he made around 1900. Most show dark hills in the foreground and mountains in the background against a backlit sky featuring a panoply of gradated colors, which, in some of the works, is reflected on a stretch of water. Because the horizon is mostly lower than our everyday view of the world, the sky has lots of open space. The juxtaposition of "high heaven" and "low earth" often also appears in early personal notes.[23] The pictures seem to have less to do with landscape than with the manifold appearance of color in the heavens as experienced at sunrise or sundown. The palette can vary from pink to orange, yellow, and green to light blue (cats. 19–21). Pastel was perfect for the subtle gradations between colors.

The changing colors of the heavens give each sheet its own mood. Two works in gouache are especially expressive and modern (cats. 10 and 11)—reminiscent of the works of the Nabis, who at this time painted landscapes of essential simplicity in oils on cardboard, a combination that brightened colors. Looking for new qualities of color, modern artists like Henri Matisse and Marc Chagall no longer reserved gouache for sketches, as in the Renaissance. Used both to glaze

and to cover, gouache combines the characteristics of watercolor and oil, although with more intense effects than watercolor and a more matte finish than oil color. It is not only the inscription "Kennst du das Land?" ("Do you know the country?") on cat. 10 (*Landscape*, 1899) that makes Jung's golden yellow sky a landscape of longing, but also the condition of the light. It evokes a feeling, as Jung describes from a childhood memory, of the distant Alps in the glowing red sunset—"an unattainable land."[24]

Jung's personal notes from the years when these images were created also contain impressive descriptions of landscapes that refer heaven and earth to each other. Elements of the landscape pictures may be recognized here, such as drifting clouds that allow the sun to shine through.

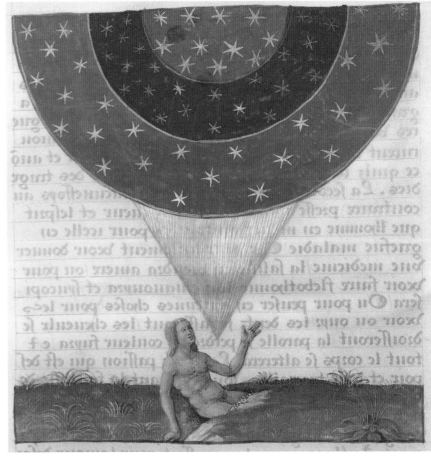

Fig. 10. Manuscript illumination, Jean Thenaud, *Traité de la cabale*, sixteenth century. Paris, Bibliothèque nationale de France

> With the setting sun, the heavens surrounded themselves in a golden color, below a shining green that shaded into a dark blue. The storm cloud hanging toward the south, at first a deep blue, began to glow gradually with the fieriest red. In the distance, light thunder, a few cool raindrops.
>
> With the coming night, the east and north of the sky a black-blue. The blue mountains in the south were separated from the sky by a glowing, golden edge of the sky. To the west, a clear, translucent, saturated gold. In front of that, as black shadows, groups of spruces in sharp contrast, the sky visible between their trunks.[25]

> The forests beamed in the most magnificent colors, fiery light green. The sky was filled with monstrous cloud masses between which the deep blue of infinity could be seen and let the sun through: the banks of clouds running parallel to the horizon increased the feeling of the measureless extension of the earth. On its surface, the shadows of the clouds wandered like ships, everything small disappeared, and I found myself in the middle of immense forms, in the middle of an immense world.[26]

The landscapes are empty of people. They create a space for psychological processes, which later take form in mandalas and visions. Jung's remarks in *Traumsymbole des Individuationsprozesses* (Individual Dream Symbolism in Relation to Alchemy) contain a miniature from Jean Thenaud's *Traité de la cabale* (Treatise on the Cabala) from the sixteenth century, which shows a person between heaven and earth (fig. 10). Jung noted under it: "Heaven fertilizing Earth and begetting mankind."[27]

ON MEDIEVAL ART AS A SOURCE OF INSPIRATION FOR JUNG'S SYMBOLIC PAINTING

Although the inner pictures Jung created for *The Red Book* from 1914 to 1930, and those related to it, are quite distinct from the landscapes, they also appear as if backlit. These mandalas and visions are exceptionally colorful. They are illuminated in clear blue, red, green, and gold.[28] Wittgenstein designates the pure colors as simple colors: "Simple as psychological phenomena."[29] Rudolf Steiner calls them lusters. "Yellow, blue and red: these are the outward aspects of an inner reality."[30] Colors lead human beings from the material to the spiritual, Steiner wrote. As the editor, from 1883 to 1897, of Goethe's scientific writings, he immersed himself in the phenomena of color, and in 1921 he gave a series of three lectures dedicated to the essence of color.[31] Symbolic meanings were in general accorded to these pure colors. Goethe describes the symbolic interpretation of color as follows:

> It has been circumstantially shown above, that every colour produces a distinct impression on the mind, and thus addresses at once the eye and feelings. Hence it follows that colour may be employed for certain moral and aesthetic ends. [. . .] Such an application, coinciding entirely with nature, might be called symbolical, since the colour would be employed in conformity with its effect, and would at once express its meaning.[32]

Johannes Itten noticed the link between symbolic meaning and pure color also evident in the art of the Middle Ages: "The Romanesque and Early Gothic artists, in their mural and tablet paintings, used colors as symbolic expression. Therefore they endeavored to produce unequivocal, unclouded tones."[33] This observation also describes Jung's pictures, in which colors have symbolic meaning. "Psychology and art work with symbols; only in the symbol can the former grasp and the latter represent what reality is for each of them,"[34] stated the philosopher Paul Häberlin in his 1916 lecture "Symbol in der Psychologie und Symbol in der Kunst" (Symbol in Psychology and Symbol in Art), which can be found in Jung's library. Franz Riklin, too, in a letter to his wife, Sophie Riklin, also from 1916, considered symbols to be essential, but nonetheless held that Jung overvalued them in the art.[35]

In his 1916 essay *The Transcendent Function*, Jung for the first time mentioned Active Imagination, the method he developed as a possible way to become conscious of images from the unconscious. Those who are imagining exclude critical awareness and allow inner images to arise. They then enter into a dialogue with the observed matter and record the perceptions as, for example, pictures. Jung called the function transcendent because "it makes the transition from one attitude to another organically possible, without loss of consciousness."[36] In his commentary to Richard Wilhelm's *The Secret of the Golden Flower* of 1929, he detailed this dialectical approach:

> As I have pointed out, the union of opposites on a higher level of consciousness is not a rational thing, nor is it a matter of will; it is a process of psychic development that expresses itself in symbols. Historically, this process has always been represented in symbols, and today the development of personality is still depicted in symbolic form. If the fantasies are drawn, symbols appear that are chiefly of the *mandala* type. *Mandala* means

"circle," more especially a magic circle. Mandalas are found not only throughout the East but also among us. The early Middle Ages are especially rich in Christian mandalas.[37]

Finally, Jung refers to the role of Active Imagination in the investigation of Archetypes in his essay *On the Nature of the Psyche* of 1954. The color violet he accorded to the Archetype, which "as well as being an image in its own right, it is at the same time a *dynamism*":[38]

> By means of "Active Imagination" we are put in a position of advantage, for we can then make the discovery of the Archetype. [. . .] If we remember our colour symbolism, then, as I have said, red is not such a bad match for instinct. But for spirit, as might be expected, blue would be a better match than violet. Violet is the "mystic" colour, and it certainly reflects the indubitably "mystic" or paradoxical quality of the Archetype in a most satisfactory way.[39]

On the symbolism of colors, Jung's library included Frédéric Portal's *Des couleurs symboliques dans l'Antiquité, le Moyen-Age et les Temps modernes* (1837), which explained the meaning of each color in divine, sacral, and profane terms. Even if Jung referred to cultural differences in the symbolism of color, it must have interested him that Portal looked at colors as, so to speak, Archetypes: "One great fact governs these researches, which I submit to the learned, viz., the unity of religion among man; in proof of which, the signification of Symbolic Colours is the same in every nation and every age."[40]

Jung's library also contained Leonardo da Vinci's *Treatise on Painting*. In the detailed chapter on color, Leonardo discusses the symbolic meaning of the six colors that he has designated as simple. "We shall set down white for the representative of light, without which no colour can be seen; yellow for the earth; green for water; blue for air; red for fire; and black for total darkness."[41] Symbolic interpretations of individual colors in Jung may be variously found in connection with the analysis of dreams:

> Red is the color of fire, of blood, of wine, the color of embers and of inebriation. In the *Handbook of German Superstition*, red stands for life and death, for fertility and danger. According to the Hermetic tradition, red is the color of the spirit, of gold, and of the sun.[42]

> The pure clear water is blue, the mountains are blue, the sky is blue, Romantic longing searches for the "Blue Flower." The little boy described by Maeterlinck searches for the bluebird and finds the way to the primordial images.[43] Blue coats are worn by the wise women who, as swan virgins, are linked to the water, to the mist, and to the sky. Mist rises from the water, rises up into the blue sky, to fall back on earth as rain. In alchemy and tarot, blue is the color of the moon, of silver, and of the soul.[44]

> Yellow is the colour of envy, jealousy, anger, all things negative with us, but in the East just the opposite.[45]

> Green is the colour of the Holy Ghost, of life, procreation and resurrection.[46]

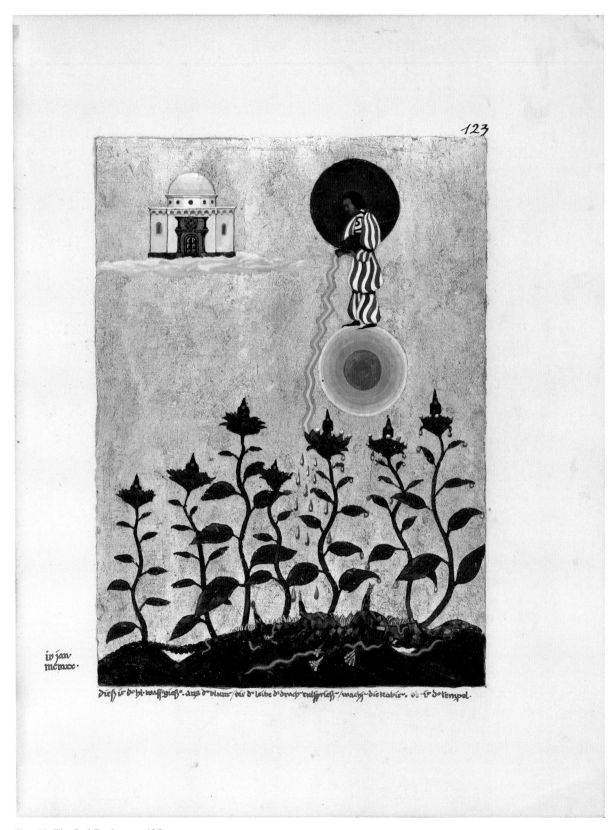

Fig. 11. *The Red Book,* page 123

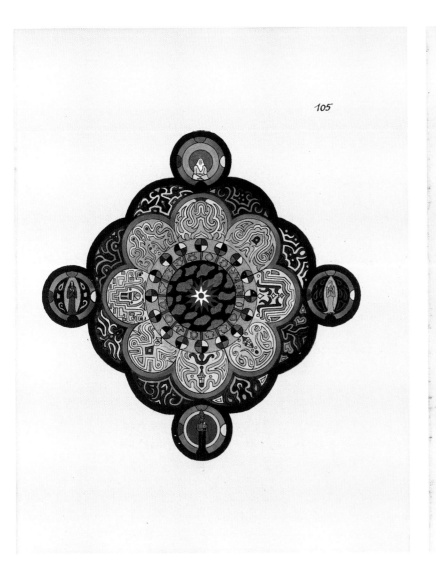

Not only Jung's early copies of a Minnesinger (cat. 8) and an Enthroned Madonna and Child (cat. 62), but also his symbolic pictures may be approached in the context of medieval art due to their colorfulness.[47] The reason for the particular color effect of medieval art, in mosaics, gold grounds, and stained-glass windows, lies in its immediate inclusion of real, physical light, according to art historian Lorenz Dittmann. The mosaics in Ravenna even appear to shimmer, as the faceted surface reflects light from various angles. The color scale has limited itself since the fourth century more and more to pure, abstract tones. In mosaics from the sixth through the ninth centuries and in Ottonian book illumination, colors did not represent anything, but rather corresponded to the Christian symbolism of color.[48]

The Red Book looks like a medieval manuscript. Some drawings seem inspired by book illuminations with gold backgrounds (fig. 11), others by stained-glass windows with black lead cames intensifying the chromaticism (fig. 12).[49] There is a clear reference to early medieval mosaics with their faceted surfaces (fig. 13). Jung visited Ravenna for the first time on a cycling tour through northern Italy with his friend Hans Schmid-Guisan in April 1914, and for a second

Fig. 12. *The Red Book*, page 105

Fig. 13. *The Red Book*, page 79

time in 1932 together with Toni Wolff. Work on *The Red Book* began in the year following the first trip to Ravenna.

> Even on the occasion of my first visit to Ravenna in 1913,[50] the tomb of Galla Placidia seemed to me significant and unusually fascinating. The second time, twenty years later, I had the same feeling. Once more I fell into a strange mood in the tomb of Galla Placidia; once more I was deeply stirred. I was there with an acquaintance, and we went directly from the tomb into the Baptistery of the Orthodox.
>
> Here what struck me first was the mild blue light that filled the room; yet I did not wonder about this at all. I did not try to account for its source, and so the wonder of this light without any visible source did not trouble me. I was somewhat amazed because, in place of the windows I remembered having seen on my first visit, there were now four great mosaic frescoes of incredible beauty which, it seemed, I had entirely forgotten.[51]

ON THE IDENTIFICATION OF COLORS IN ALCHEMY

Jung experienced modern art as a provocation, as he noted in the conversation with Hodin. Its processes of dissolution were of little interest to him. Rather, he was interested in methods that deal with the uniting of opposites: "dissolution demands synthesis."[52] From 1918 to 1926, Jung concerned himself with Gnosticism in antiquity and the Early Christian era. In studying the Chinese Taoist treatise *The Secret of the Golden Flower*, he discovered alchemy, which he hoped would renew the Gnostic tradition. By approximately 1941, Jung had acquired a collection of about 250 rare alchemical texts from the sixteenth and seventeenth centuries, and, by way of excerpts, made the hermetic language of alchemy accessible to himself.[53] In the introduction to his ETH lecture, given on October 20, 1933, Jung traced modern psychology back to alchemy and astrology:

> Psychology did not suddenly spring into existence, one could say that it is as old as civilisation itself. The ancient science of astrology, which has always appeared in the wake of culture all over the world, is a kind of psychology and alchemy is another unconscious form. In such forms, however, the psyche is seen as entirely outside man, it is projected into the stars or into matter.[54]

Alchemy teaches how precious metals and colors can be produced artificially, a practice condemned by the Church as materialistic. However, as a holistic chemistry, alchemy sees the process of individuation in the analogy of chemical and physical transformation.

In her introduction to the supplemental volume of *Mysterium coniunctionis*, Marie-Louise von Franz considers the interest of psychology in alchemical texts:

> As C.G. Jung has shown in *Psychology and Alchemy*, the early Latin texts of Western alchemy, like the earlier Greek and Arabic ones, were written in a frame of mind which caused the alchemist, seeking the divine secret of matter, to project his own unconscious into the unknown nature of chemical substances. These early texts have therefore become, for us, documents of the greatest value in regard to the formation of symbols in general and the individuation process in particular, whereas their chemical content is of significance only from the historic point of view.[55]

Jung was primarily interested in the psychological aspects of the idea of transmutation. Gradually, he discovered correspondences between the alchemist's path to knowledge and his own investigation of the soul.[56]

> This symbolism refers to a quasi-alchemical process of refining and ennobling. Darkness gives birth to light; out of the "lead of the water region" grows the noble gold; what is unconscious becomes conscious in the form of a living process of growth.[57]

Historically, alchemy has always been tied to the identifications of color. It is much the same with Jung's texts on alchemy, which speak primarily of colors and changes in color. In alchemy, the development of the inner person has four steps "characterized by the original colours mentioned in Heraclitus: *melanosis* (blackening), *leukosis* (whitening), *xanthosis* (yellowing), and *iosis* (reddening)."[58]

> In alchemy, *nigredo* is the initial state, in which death reigns, absolute *unconsciousness*. Then follows the *albedo*, that is, whitening. [. . .] In alchemy, *red* comes after white: after dawn comes sunrise, and after sunrise the full sun. [. . .] In other contexts, too, the finished body is called *rubinus* or *carbunculus* in alchemy. It is a more intense state than *albedo*. Red, as it is, is an emotional color and stands for *blood*, *passion*, and *fire*.
> The *blue* color is assigned to the following stage. Blue stands in stark contrast to red and indicates a cool and calming state. Blue [. . .] has always represented the symbol of a spiritual *vessel*. Blue is also the color of water and can thus represent the unconscious: just as we see the fish in the clear blue of the water, the spiritual contents contrast with the darkness of the unconscious. The color blue cannot be found in alchemy, but it is found in the East, where it takes the place of black and actually represents a color of the underworld.[59]

The goal of the alchemical process was to create the philosopher's stone, which united all colors within itself and to which was ascribed the power to change nonprecious metals into silver and gold. In alchemy, gold symbolized the fulfillment of personality, the *res simplex*, in which all contradictions are integrated. "Gold expresses sunlight, value, divinity even,"[60] Jung wrote in *A Study in the Process of Individuation*. In alchemy, the image of the totality of all qualities is the peacock's tail, the *cauda pavonis*. The peacock, which each year renews the feathers displayed in his colorful wheel, constitutes the symbol of the changes in nature. The appearance of all the colors is a sign that the process of change, which leads to becoming conscious of the whole, is reaching its goal, just as the rainbow points to the presence of God.

> The rainbow is a numinosum. It has a divine meaning, as it is an unusual vision. It is a bridge leading into the hereafter. It can also appear as a circle, as a halo around the sun or the moon. It contains all colors, which is a special motif. It means: all qualities. Since prehistoric times, colors, as well as numbers, have had a sacred meaning. This has even been preserved in the Church colors.[61]

"He who shall raise up his soul shall see its colors."[62] In his discussion of the treatise *Aurora consurgens*, Jung emphasized this sentence from the fourth parable and comments: "The *Aurora*

Fig. 14. Manuscript illuminations, *Aurora consurgens*, fifteenth century. Zentralbibliothek Zürich, Ms. Rh. 172

consurgens relates the colours to the soul."[63] He had recognized the psychological meaning of the 1420 text and therefore published it integrally in the supplemental volume of *Mysterium coniunctionis* translated by Marie-Louise von Franz and including her commentary. The author of *Aurora consurgens* tried "*to describe, or give shape to* [. . .] *an immediate experience of the unconscious,*"[64] von Franz wrote. One of the nine handmade copies of the treatise comes from the Kloster Rheinau and is preserved today in the Zentralbibliothek Zurich. It is decorated with unusual illustrations by an Upper Rhine master that depict the stages of the alchemical process (fig. 14). Its abstract colorfulness is of special symbolic power. To interpret the representation of a red person and a white person, reference may be made to Jung's essay "Flying Saucers: A Modern Myth of Things Seen in the Skies":

For a thousand years red was regarded as the masculine and white as the feminine colour. The alchemists spoke of the *servus rubeus* (red slave) and the *femina candida* (white woman): their copulation produced the supreme union of opposites.[65]

Jung described the alchemist as a "painter of all colours."[66] From the color quaternion of the alchemical transformation process he deducted the four basic colors and referred them to modern man's qualities of soul.

The quaternity in alchemy, incidentally, was usually expressed by the four colours of the old painters, mentioned in a fragment of Heraclitus: red, black, yellow, and white; or in diagrams as the four points of the compass. In modern times the unconscious usually chooses red, blue (instead of black), yellow or gold, and green (instead of white). The quaternity is merely another expression of the totality. These colors embrace the whole of the rainbow. The alchemists said that the appearance of the *cauda pavonis*, the peacock's tail, was a sign that the process was coming to a successful conclusion.[67]

In the work of alchemist Gerhard Dorn, Jung found the association of the alchemical colors with the temperaments: yellow with the choleric, red with the sanguine, white with the phlegmatic, and black with the melancholic.

Since the gold colour signifies intellect, the principal "informator" (formative agent) in the alchemical process, we may assume that the other three colours also denote psychological functions, just as the seven colours denote the seven astrological components of character. Consequently the synthesis of the four or seven colours would mean nothing less than the integration of the personality, the union of the four basic functions, which are customarily represented by the colour quaternio blue-red-yellow-green.[68]

Jung discusses the functions of consciousness—*thinking, feeling, intuition,* and *sensation*—in his 1921 book *Psychological Types*.[69] In the ETH lecture given on May 18, 1934, he explained how he had found parallels to his conception in Chinese culture. In this lecture, he presented a diagrammatic compass of the four functions and their four basic, related colors:

Here we have a diagram in which an attempt is made to represent the functions by colours. All sounds have colours, which we call colour illusions or coloured hearing. *Thinking* is generally, almost always, represented by blue, it is connected with the air, with the spirit, primitives use birds or feathers to represent thoughts. *Feeling* is often represented by red, because of its connection with the heart and blood. *Intuition* is the beginning of the real uncertainty, it is sometimes represented by white or yellow, like the rays of the sound. *Sensation* is often green as it is connected with the earth, and the earth's surface is green.[70]

JUNG'S MEDITATION PICTURES IN RELATION TO DADAIST MODERNISM

Flatness and a reduction to clear colors are characteristics of medieval art, which recur not just in Jung's symbolic painting but also in the concepts of abstraction in modernism. In their search for elementary forms, many avant-gardists, including Sophie Taeuber-Arp and Hans Arp, were

Fig. 15. Sophie Taeuber-Arp, *Elementary Forms: Vertical-horizontal Composition*, 1917, gouache on paper. Private collection

influenced by the Middle Ages. Taeuber-Arp's vertical-horizontal compositions look meticulous, like medieval illuminations, and like Jung's pictures. Her collages weren't made with scissors, but on a cutting machine. "Nous voulions un art anonyme et collective" (We wanted an anonymous, collective art), recalled Hans Arp in 1938 of his Dada period.[71] "In any case, he likes the Middle Ages mostly for their heraldry, which is fantastic and yet precise and exists in its entirety, right to the last really prominent contour,"[72] as Hugo Ball says of Arp. Sophie Taeuber-Arp also arranged a typology of motifs like a coat-of-arms and gained inspiration from the colorfulness of medieval art:

> In 1918, she painted again in oils, a triptych, in which she also used various gold-bronze colors. Excited by early medieval and Byzantine painting, she reclaimed the gold colors that the naturalistic development of painting had completely repressed.[73]

Using gold and silver tints, Taeuber-Arp also painted passe-partouts and frames during the Dada years, wherein the vertical-horizontal compositions radiate bright colors (fig. 15). Similarly, one finds repeated in her work the typical medieval configuration of the triptych.[74]

In the fourth Dada soirée, titled *Alte und Neue Kunst* (Old and New Art), in the Galerie Dada, Dadaists in part recited medieval texts.[75] "Art is beginning to concern itself with ascetic and priestly ideals,"[76] remarks Ball in *Flight Out of Time* and asks, "why do we have to go so far back to find reassurance? Why do we dig up thousand-year-old fetishes? Are the jolts so severe that the shock extends back to the most distant times and into the uppermost reaches of thought? Only the most cheerful and the most diminutive things can give us pleasure."[77] Like the Dadaists, Jung found confirmation of his orientation toward old art by reading Wilhelm Worringer's *Abstraction and Empathy*.[78]

> Recollection of the lifeless form of a pyramid or of the suppression of life that is manifested, for instance, in Byzantine mosaics tells us at once that here the need for empathy, which for obvious reasons always tends toward the organic, cannot possibly have determined artistic volition.[79]

Worringer's thesis, that the basic positions of abstraction and empathy do not manifest themselves as a linear development in the history of art because they are motivated by volition and not ability, might have supported the avant-gardists in their artistic positioning. "Our investigations proceed from the presupposition that the work of art, as an autonomous organism, stands beside nature on equal terms and, in its deepest and innermost essence, devoid of any connection with it, in so far as by nature is understood the visible surface of things,"[80] explains Worringer in the introduction to the work, which had been his 1907 dissertation at the University of Bern. Moreover, Worringer was convinced that the first artistic style was geometric and deduced: "A casual connection must therefore exist between primitive culture and the highest, purest regular art-form."[81] Jung underlined this place in the text. It appears to be enlightening with regard to his conception of the theory of Archetypes. In his 1913 lecture "A Contribution to the Study of Psychological Types," Jung notes: "'The urge to abstraction is the origin of all art,' says Worringer."[82] As a supplement to Worringer's historical analysis, Jung discusses the terms of abstraction and empathy in relation to the psychological types, namely the two basic attitudes of introversion and extraversion. He remarks that the extravert behaves more empathically whereas the introvert seeks abstraction. "Aesthetics by its very nature is applied psychology,"[83] Jung states in the book *Psychological Types*, which reconsiders Worringer's conception in detail.

Modern art was also discussed within a 1925 seminar on Analytical Psychology at the Psychology Club. Jung remarked that it "brought out embryonic material from the unconscious."[84] "Modern art, then, began first by dissolving the object, and then sought the basic things, the internal image back of the object—the eidolon."[85] While this process persisted for years for many artists of the avant-garde Jung seems to have found his way to abstract forms and symbols quite naturally by means of Active Imagination. In particular, in his abstract colorfulness, Jung was perhaps more modern than he wanted to believe.

NOTES

1. C.G. Jung, "Picasso," in *The Collected Works of C.G. Jung*, 21 vols., ed. Herbert Read, Michael Fordham, and Gerhard Adler; exec. ed. William McGuire; tr. R.F.C. Hull (New York: Bollingen Foundation/Pantheon Books, 1953–1967; Princeton: Princeton University Press, 1967–78), 15, § 213. Hereafter *CW.*

2. Sophie Taeuber-Arp wrote from Paris on November 11, 1932, to her sister Erika Schlegel in Zurich: "We received Jung's article and, I think, understood it well. There was a big commotion about it in Zurich, which I also understand, since Jung hardly distinguishes between Picasso and some patient and the difference is of course essential. By doing so, he gives another weapon to the opponents of new art and makes it difficult for the likes of Giedion and Dr. Friedrich." Manuscript Department, Zentralbibliothek Zurich. Erika Schlegel, as well as her husband, was a member of the Psychology Club from its founding in 1916 to the end of her life and spent twenty-three years building its library.

3. In Jung's library, there are: Leonardo da Vinci, *Traktat von der Malerei*, ed. Marie Herzfeld (Jena: Eugen Diederichs, 1909), as well as Frédéric Portal, *Des couleurs symboliques dans l'Antiquité, le Moyenage et les Temps modernes* (Paris: Niclaus, 1837).

4. Josef G. F. Rothaupt, *Farbthemen in Wittgensteins Gesamtnachlass. Philologisch-philosophische Untersuchungen im Längsschnitt und in Querschnitten* (Weinheim: Beltz Athenäum, 1996), p. 588.

5. Hans Eduard Fierz-David, *Goethes Farbenlehre als psychologisches Problem* (Zurich: Psychology Club, typescript 1940), p. 15.

6. Johann Wolfgang Goethe, *Theory of Colours*, tr. Charles Lock Eastlake (London: John Murray, 1840, reprinted 1940), p. 305.

7. Ibid., p. 304.

8. See ibid., pp. 306–16.

9. See Petra Maisak, *Johann Wolfgang Goethe. Zeichnungen* (Stuttgart: Philipp Reclam, 1996), p. 227.

10. Walter Benjamin, *Gesammelte Schriften*, vol. 3, ed. Hella Tiedemann-Bartels (Frankfurt am Main: Suhrkamp, 1980), p. 148.

11. Wassily Kandinsky, *On the Spiritual in Art*, ed. and tr. Hilla Rebay (New York: Solomon R. Guggenheim Foundation, 1946), p. 43.

12. Ibid., pp. 89–105; pp. 46–71.

13. Hugo Ball, *Kandinsky* (Bern: Swiss Literary Archives SLA, typescript 1917), p. 8.

14. Giovanni Segantini, *Schriften und Briefe*, ed. Bianca Segantini (Leipzig: Klinkhardt & Biermann, 1909); Odilon Redon, *Oeuvre graphique complet*, 2 vols. (The Hague: Artz & De Bois, 1913); *Paul Klee*, ed. Hermann von Wedderkop (Leipzig: Klinkhardt & Biermann, 1920).

15. Augusto Giacometti, *Die Farbe und ich* (Zurich: Oprecht & Helbling, 1934).

16. Sophie Henriette Arp-Taeuber and Blanche Gauchat, *Anleitung zum Unterricht im Zeichnen für textile Berufe* (Zurich: School of Arts and Crafts, Zurich, 1927), p. 8.

17. Johannes Itten, *The Elements of Color*, tr. Ernst van Hagen (Wokingham: Van Nostrand Reinhold, 1983), p. 7.

18. *CW* 14, § 333.

19. In *The Doors of Perception* (1954), Aldous Huxley recommends using mescaline to have transcendent experiences. In *Heaven and Hell* (1956), he notes that dream symbols are mostly colorless. Huxley was discussed in Jung's social circles. His books on the dehumanization of society by technical progress could have echoed Jung's critique of the Enlightenment. Jung's library contains *Grey Eminence: A Study in Religion and Politics* (1941) and *The Perennial Philosophy* (1946). The author would like to thank Thomas Fischer for this information.

20. Various letters lead to the conclusion that Jung did not have experiences with mescaline and also did not use drugs with his patients. He was,

however, interested in the results of experiments such as that performed by the psychiatrist Hans Prinzhorn around 1925, even if he questioned their therapeutic use. Mescaline exposed a layer of the unconscious, an "overflowing of colors, sounds, forms, emotions, and meanings," which could also be opened through Active Imagination. Humans, according to Jung, cannot integrate these experiences into their consciousness because they are not ready for it. See letter to Betty Grover Eisner, August 12, 1957: C.G. Jung, *Letters*, vol. 2, ed. Gerhard Adler, tr. R.F.C. Hull (Princeton: Princeton University Press, 1975), pp. 382–83; Letter to Father Victor White, April 10, 1954: ibid., pp. 172–73; Letter to A. M. Hubbard, February 15, 1955: ibid., pp. 222–24, quote p. 223.

21. C.G. Jung, Letter to Romola Nijinski, May 24, 1956, ibid., pp. 299–300. Romola Nijinski was the wife of the dancer Vaslav Nijinski. The couple first lived in Switzerland from 1919 onwards, after Vaslav Nijinski withdrew from the Ballets Russes because of his schizophrenia.

22. Joseph P. Hodin, *Modern Art and the Modern Mind* (Cleveland: Press of Case Western Reserve University, 1972), p. 88.

23. For example, note by C.G. Jung, January 21, 1899, Jung Family Archive.

24. Jung, *Memories*, p. 22.

25. Note by C.G. Jung, April 22, 1900. Jung Family Archive.

26. Note by C.G. Jung, October 29, 1900. Jung Family Archive.

27. C.G. Jung, *Psychology and Alchemy*, *CW* 12, fig. 74.

28. See Jill Mellick, "Matter and Method in *The Red Book*: Selected Findings," in this publication (pp. 217–31).

29. Ludwig Wittgenstein, *Philosophical Remarks*, ed. from posthumous writings by Rush Rhees, tr. Raymond Hargreaves and Roger White (Chicago: University of Chicago Press, 1975), p. 273.

30. Rudolf Steiner, *Colour*, tr. John Salter (London: Rudolf Steiner Press, 1971), p. 32.

31. Jung told M. Patzelt in a letter dated November 29, 1935, that he had read several books by Rudolf Steiner, but he considered anthroposophy to be speculative. In his ETH lecture in the winter semester 1933–34, Jung mentions Steiner's concepts of evolving stages of the world and stages of human bodies. His library has Steiner's early work, *Wie erlangt man Erkenntnisse der höheren Welten?* (Berlin: Philosophisch-Anthroposophischer Verlag, 1922). See C.G. Jung, *Letters* vol. I, p. 203; for the manuscript of the lecture, see ETH Zurich University Archives. I am grateful to Ulrich Hoerni for the reference to the manuscript.

32. Goethe, *Theory of Colours*, p. 350.

33. Itten, *Elements of Color*, p. 9.

34. Paul Häberlin, *Symbol in der Psychologie und Symbol in der Kunst* (Bern: Drechsel, 1916), p. 1. Jung noted in his copy "Christmas 1916."

35. Cf. Hans Rudolf Wilhelm, "Der Psychiater und Maler Franz Beda Riklin (1878–1938). Eine Spurensicherung," in *Schweizer Monatshefte* 81 (2001), pp. 19–22, here p. 22.

36. *CW* 8, § 145. See also Adolf Nadir Ammann, *Aktive Imagination. Darstellung einer Methode* (Olten/Freiburg im Breisgau: Walter, 1984).

37. *CW* 13, § 31.

38. *CW* 8, § 414.

39. Ibid.

40. Frédéric Portal, *An Essay on Symbolic Colours: In Antiquity—the Middle Ages—and Modern Times*, tr. W.S. Inman (London: John Weale, 1845), pp. 31–32.

41. Leonardo Da Vinci, *Treatise on Painting*, tr. John Francis Rigaud (London: J.B. Nichols, 1835), p. 127.

42. C.G. Jung, *Children's Dreams: Notes from the Seminar Given in 1936–1949*, ed. Lorenz Jung and Maria Meyer-Grass; tr. Ernst Falzeder (Princeton and Oxford: Princeton University Press, 2008), p. 348.

43. Jung is referring here to the 1908 fairy tale play *L'Oiseau bleu* by the Symbolist Maurice Maeterlinck.

44. Jung, *Children's Dreams*, p. 351.

45. C.G. Jung, *Dream Analysis: Notes of the Seminar Given in 1928–1930*, ed. William McGuire, Bollingen Series (Princeton: Princeton University Press, 1984), p. 268.

46. C.G. Jung, *Mysterium Coniunctionis*, CW 14, § 395.

47. A special interest in the Middle Ages is recognizable also in Jung's library, with titles such as Wilhelm Hausenstein, *Romanische Bildnerei* (Munich: Piper, 1922); August L. Mayer, *Expressionistische Miniaturen des deutschen Mittelalters* (Munich: Delphin, 1918); Wilhelm Molsdorf, *Christliche Symbolik der mittelterlichen Kunst* (Leipzig: Hiersemann, 1924); Friedrich Münter, *Sinnbilder und Kunstvorstellungen der alten Christen* (Altona: Hammerich, 1825); Wilhelm Pinder, *Der Naumburger Dom und seine Bildwerke* (Berlin: Deutscher Kunstverlag, 1925); Wilhelm Worringer, *Formprobleme der Gotik* (Munich: Piper, 1910); Wilhelm Worringer, *Die altdeutsche Buchillustration* (Munich: Piper, 1919).

48. See Lorenz Dittmann, *Farbgestaltung in der europäischen Malerei. Ein Handbuch* (Cologne: Böhlau 2010), pp. 9–10.

49. Dark outlines may also be found, however, in the Indian yantras, as Jung explained in his 1950 essay *On Symbolism in Mandalas*: "A mandala of this sort is known in ritual usage as a *yantra*, an instrument of contemplation. It is meant to aid concentration by narrowing down the psychic field of vision and restricting it to the centre. Usually the mandala contains three circles, painted in black or dark blue. They are meant to shut out the outside and hold the inside together." *CW* 9/I, § 630.

50. The date given in the *Memories* is erroneous.

51. Jung, *Memories*, p. 315.

52. Hodin, *Modern Art and the Modern Mind*, p. 89.

53. Cf. Thomas Fischer, "The Alchemical Rare Book Collection of C.G. Jung," in *International Journal of Jungian Studies* 2 (2011), pp. 169–80.

54. C.G. Jung, *Modern Psychology*, notes on lectures given at the ETH Zurich, October 1933–February 1934, compiled and edited by Elisabeth Welsh and Barbara Hannah (ETH Zurich University Archives, typescript), p. 6.

55. *Aurora Consurgens. A document attributed to Thomas Aquinas on the problem of opposites in alchemy*, ed. Marie-Louise von Franz, tr. R.F.C. Hull and A.S.B. Glover (New York: Pantheon, 1966), p. 3.

56. Cf. Gerhard Wehr, *An Illustrated Biography of C.G. Jung*, tr. Michael H. Kohn (Boston: Shambhala, 1989), pp. 74–80.

57. C.G. Jung, "Commentary on 'The Secret of the Golden Flower,'" in *CW* 13, § 35.

58. C.G. Jung, *Psychology and Alchemy*, CW 12, § 333.

59. Jung, *Children's Dreams*, p. 366.

60. C.G. Jung, "A Study in the Process of Individuation," in *CW* 9/I, § 543.

61. Jung, *Children's Dreams*, pp. 134–35.

62. *CW* 14, § 390, note 112.

63. Ibid.

64. *Aurora Consurgens*, p. 3.

65. *CW* 10, § 790.

66. *CW* 14, § 140.

67. C.G. Jung, *The Integration of Personality* (London: Kegan Paul, Trench, Trubner & Co., 1940), p. 48. Kiley Q. Laughlin drew my attention to this passage.

68. *CW* 14, § 390.

69. For Jung's definition of *Types*, see *CW* 6, § 835.

70. See C.G. Jung, *Modern Psychology*, notes on lectures given at the ETH Zurich, April 1934–July 1935, compiled and edited by Elisabeth Welsh and Barbara Hannah (ETH Zurich University Archives, typescript), p. 13. See also Kiley Q. Laughlin, "The Spectrum of Consciousness," in *Personality Type in Depth* (2015), p. 25, http://typeindepth.com/2015/10/the-spectrum-of-consciousness/ (accessed May 9, 2018).

71. Hans Arp, "Tibiis canere (Zurich, 1915–20)," in *XXe Siècle* 1 (1938), pp. 41–44, here 41.

72. Hugo Ball, *Flight Out of Time. A Dada Diary*, ed. John Elderfield, tr. Ann Raimes (Berkeley: University of California Press, 1996), p. 53.

73. Hans Arp, *Unsern täglichen Traum. . . . Erinnerungen, Dichtungen und Betrachtungen aus den Jahren 1914–1954* (Zurich: Arche, 1955), p. 14.

74. The triptych oil on canvas mentioned above (1918 catalogue raisonné 2–4); then *Petit triptyque. Rythmes verticaux-horizontaux libres, découpés et collés sur fond blanc*, distemper on paper (1919: catalogue raisonné 2); furthermore a window for a Strasbourg home including a design sketch in distemper ca. 1928; finally another work in oil on canvas (1933: catalogue raisonné 5–7) that Taeuber-Arp called *Triptychon* in the catalogue of the Constructivist exhibition in Basel in 1937.

75. Cf. Ball, *Flight Out of Time*, pp. 112–14.

76. Ibid., p. 94.

77. Ibid., p. 113.

78. There are many marks in Jung's copy of 1911.

79. Wilhelm Worringer, *Abstraction and Empathy: A Contribution to the Psychology of Style*, tr. Michael Bullock (Chicago: Ivan R. Dee, 1997), p. 14.

80. Ibid., p. 3.

81. Ibid., p. 17, marked by Jung.

82. The lecture was later published as part of Jung's book *Psychological Types*, *CW* 6, § 874.

83. Ibid., § 485.

84. C.G. Jung, *Analytical Psychology: Notes of the Seminar Given in 1925*, ed. William McGuire (London: Routledge, 1990), p. 51.

85. Ibid., p. 56.

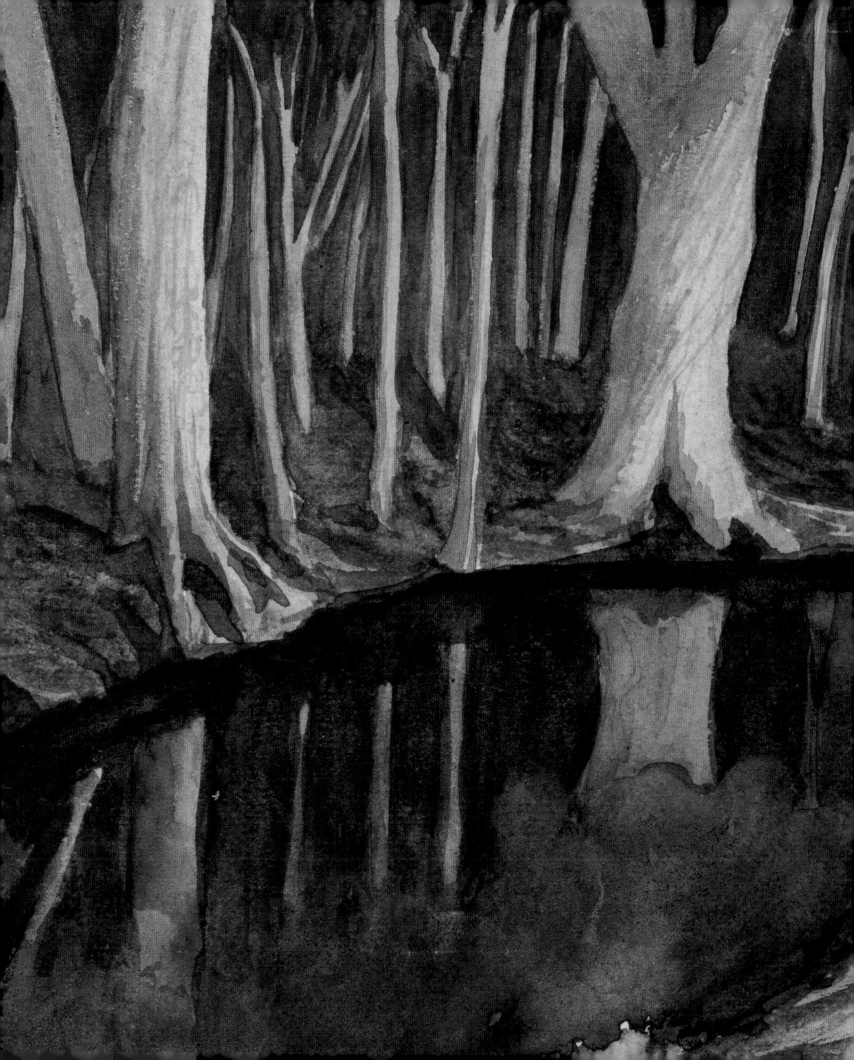

GALLERY

1. Castles, Towns, Battle Scenes

CAT. 1. *Sketchbook (Schülerzahlheft der III. und IV. Klasse von Kleinhüningen)*, ca. 1884
Graphite and ink on paper
17 × 11 cm (6$^{11}/_{16}$ × 4$^{5}/_{16}$ in.)
Jung Family Archive

LITERATURE
Jung, *Memories, Dreams, Reflections*, recorded and edited by Aniela Jaffé,
tr. Richard and Clara Winston (New York: Pantheon Books, 1963), p. 33.

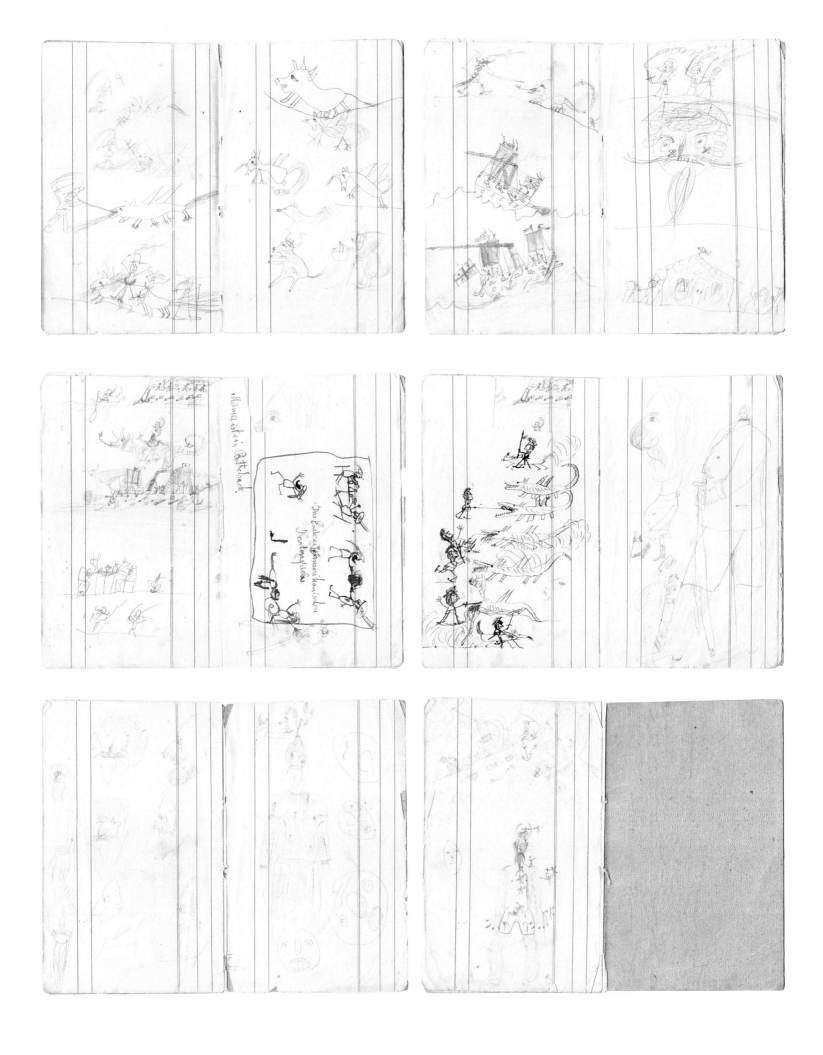

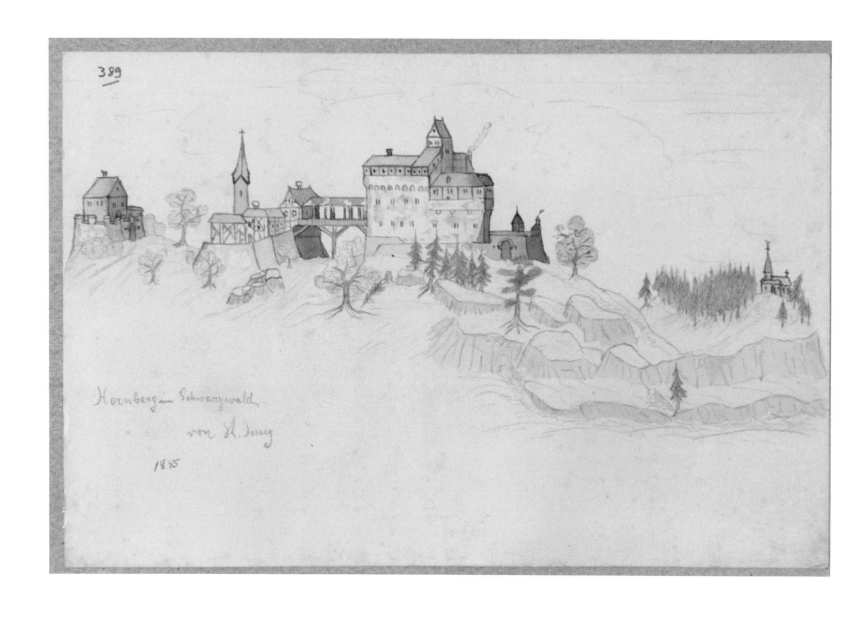

CAT. 2. *Hornberg Castle,* 1885
Graphite and colored pencil on paper
14.9 × 23 cm (5⅞ × 9¹⁄₁₆ in.)
Inscription: Hornberg im Schwarzwald von K. Jung 1885
(Hornberg in the Black Forest by K. Jung 1885)
Jung Family Archive

LITERATURE
C.G. Jung, *Memories,* p. 36.

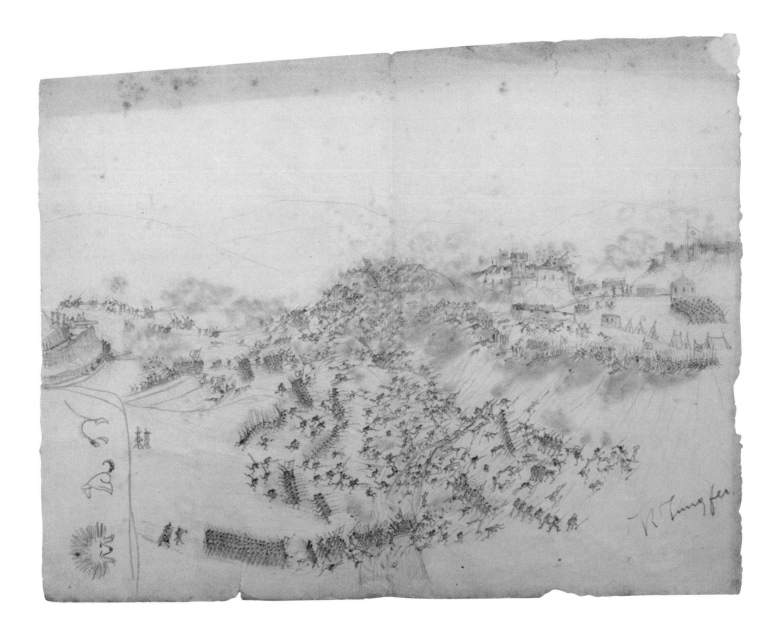

CAT. 3. *Battle Scene,* ca. 1887
Graphite on paper
16.8 × 22 cm (6⅝ × 8¹¹⁄₁₆ in.)
Inscription: K. Jung fec[it]
Jung Family Archive

LITERATURE
Jung, *Memories*, pp. 33, 43, 46.

CAT. 4. *Sketch of Imaginary Town,* ca. 1888
Sketch of Imaginary Castle and Helmets (verso)
Ink on paper
21.5 × 17.5 cm (8⁷⁄₁₆ × 6⁷⁄₈ in.)
Inscription: Jung
Jung Family Archive

LITERATURE
Jung, *Memories*, p. 46.

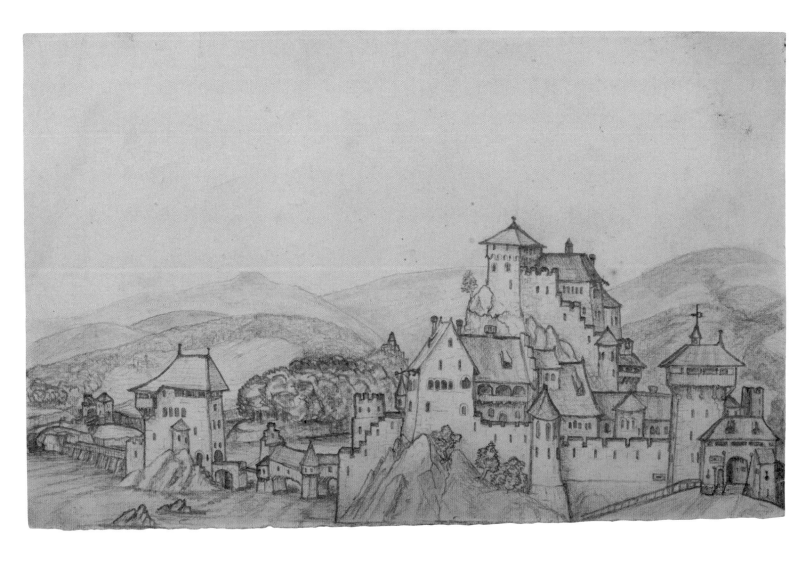

CAT. 5. *Castle and Town I,* 1898
Graphite on paper
11.1 × 17.7 cm (4⅜ × 7 in.)
Inscription verso: K.G. Jung, cand. med. 7. Mai 1898
Jung Family Archive

LITERATURE
Jung, *Memories*, p. 100.

Fig. 16. Detail from *Landscape with Castle,*
(cat. 18)

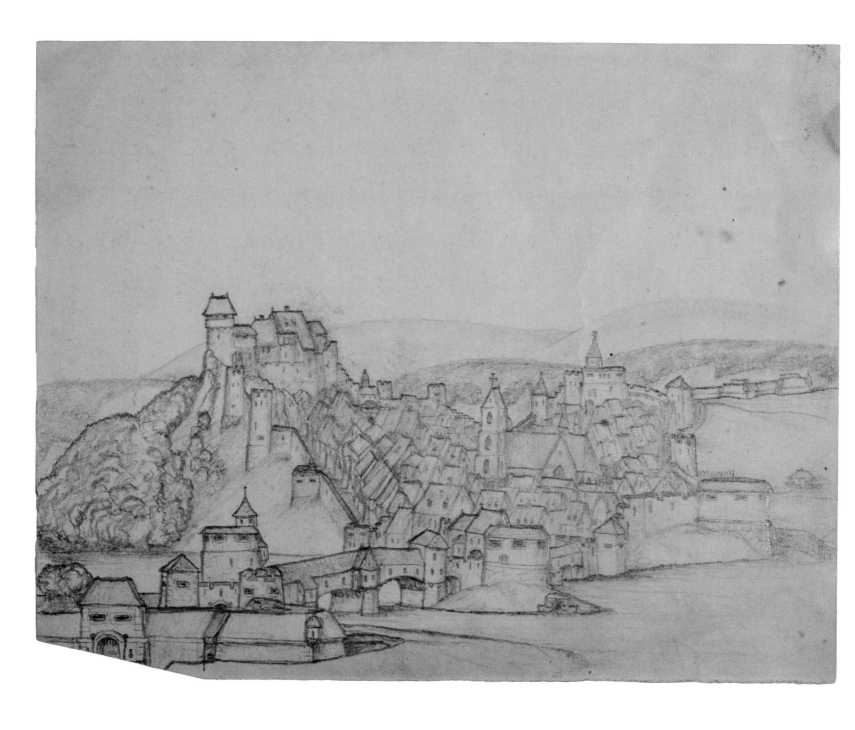

CAT. 6. *Castle and Town II,* ca. 1898
Graphite on paper
11.5 × 14.9 cm (4½ × 5⅞ in.)
Jung Family Archive

LITERATURE
Jung, *Memories,* p. 100.

Fig. 17. Jung on a walk with his Zofingia
friends, 1895. Courtesy Jung Family Archive

CAT. 7. *Jung's Song Folder of the Student Association Zofingia,* ca. 1895
Oil on cardboard
28 × 22 cm (11 × 8¹¹⁄₁₆ in.)
Jung Family Archive

LITERATURE

C.G. Jung, The Zofingia Lectures, Supplementary Volume A to the *CW*, ed. William McGuire,
tr. Jan van Heurck (Princeton: Princeton University Press, 1983); Jung, *Memories*, pp. 117–18.

Fig. 18. Detail from *Codex Manesse*, page 323 (r)
Reinmar von Zweter, 1305–1340, color on
parchment, University Library Heidelberg

CAT. 8. *Christmas Card*, 1893
Ink and gouache on parchment
7.5 × 4.5 cm (2¹⁵⁄₁₆ × 1¾ in.)
Entire document: 22 × 12.5 cm
(8¹¹⁄₁₆ × 4¹⁵⁄₁₆ in.)
Inscription lower right: K. J. fec[it].
Jung Family Archive

LITERATURE
*Die grosse Heidelberger Liederhandschrift—
Codex Manesse*, ed. Fridrich Pfaff (Heidel-
berg: Universitätsverlag C. Winter, 1984),
p. 323r.

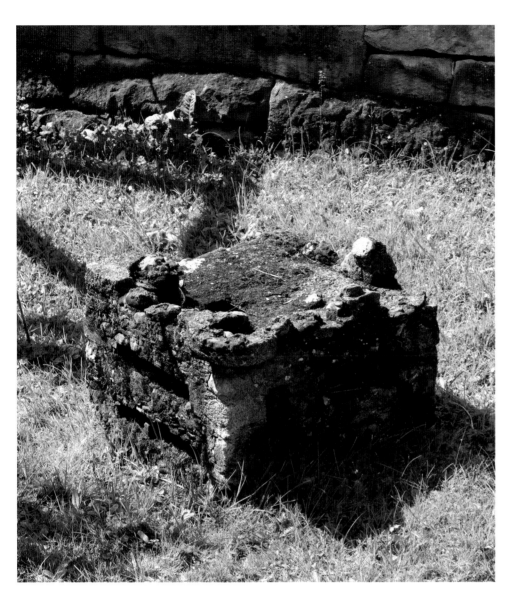

Fig. 19. *"Small Castle,"* ca. 1922. Courtesy Jung Family Archive

CAT. 9. *"Small Castle,"* ca. 1915 (partly damaged)
Natural stone, cement, formed pieces from a set of Anker
building blocks
40 × 50 × 50 cm (15¾ × 19¹¹⁄₁₆ × 19¹¹⁄₁₆ in.)
Stiftung C.G. Jung Küsnacht

LITERATURE

Jung, *Memories*, pp. 197–99; Andreas Jung et al.,
*The House of C.G. Jung: The History and Restoration of the
Residence of Emma and Carl Gustav Jung-Rauschenbach*,
ed. Stiftung C.G. Jung Küsnacht (Wilmette: Chiron
Publications, 2008), p. 23.

Fig. 20. Jung playing with grandson near the *"Small Castle"* in
the garden by the lake, ca. 1945. Courtesy Jung Family Archive

COMMENTARY

The little *Sketchbook* (Schülerzahlheft der III. und IV. Klasse von Kleinhüningen, cat. 1) from ca. 1884 contains the earliest known drawings by C.G. Jung. The fantasies of fighting knights and dragons, scary animal creatures, battleships on high seas, Wild West poker scenes and duels, as well as caricature portraits including Gulliver being tied down by the Lilliputians, illustrate Jung's rich imagination and pleasure in entertaining himself with pencil, ink, and paper at the age of about nine or ten, at a time when, according to *Memories*, he was endlessly drawing.

Hornberg Castle (cat. 2) is the earliest preserved loose sheet drawing by C.G. Jung and is dated 1885. There is no documented trip by Jung to the Hornberg Castle in the Black Forest (south-western Germany). He might have copied the castle from a book or calendar. The castle was built around 1200 and over the years destroyed and rebuilt several times. Jung was fascinated by old castles, as is witnessed by his drawings and references in text material.

In *Memories*, Jung mentions drawings of battle scenes repeatedly:

My first concrete memory of games dates from my seventh or eighth year. I was passionately fond of playing with bricks, and built towers which I then rapturously destroyed by an "earthquake." Between my eighth and eleventh year I drew endlessly—battle pictures, sieges, bombardments, naval engagements. Then I filled a whole exercise book with ink blots and amused myself giving them fantastic interpretations.[1]

School came to bore me. It took up far too much time which I would rather have spent drawing battles and playing with fire.[2]

For more than six months I stayed away from school,[3] and for me that was a picnic. I was free, could dream for hours, be anywhere I liked, in the woods or by the water, or draw. I resumed my battle pictures and furious scenes of war, of old castles that were being assaulted or burned, or drew page upon page of caricatures.[4]

This information suggests that the drawing *Battle Scene* (cat. 3) could have been made about 1887, when Jung, age twelve, went to secondary school. In support of that supposition is the Latin signature: "K. Jung fec[it]" (K. Jung made this).

The sketch of the view of a town on a hill (cat. 4) could have been made in history or Latin class at the gymnasium in Basel. Jung added drawings unrelated to the lesson to his class notes. The following words can be deciphered: "Periclean age. Pericles-'Ziebelegrind.'[5] Phidias. League of Athens with Boeotien. Tolmides (Athens) with 1000 men is defeated at Coronea. Herodotus, Thucydides, Dionysus festival, Aeschylus."

Jung continued to be fascinated by castles, but did not travel far until he finished his studies. The two later drawings *Castle and Town* (cats. 5 and 6) may therefore depict Jung's imaginary world, as in the following fantasy from his youth described in *Memories*:

we would live in another time and another world. There would be no Gymnasium, no long walk to school, and I would be grown up and able to arrange my life as I wished. There would be a hill or rock rising out of the lake, connected by a narrow isthmus to the

mainland, cut through by a broad canal with a wooden bridge over it, leading to a gate flanked by towers and opening into a little medieval city built on the surrounding slopes. On the rock stood a well-fortified castle with a tall keep, a watch-tower. This was my house. In it there were no fine halls or any signs of magnificence. The rooms were simple, panelled, and rather small. There was an uncommonly attractive library where you could find everything worth knowing. There was also a collection of weapons, and the bastions were mounted with heavy cannon. Besides that, there was a garrison of fifty men-at-arms in the castle. The little town had several hundred inhabitants and was governed by a mayor and a town council of old men. I myself was justice of the peace, arbitrator, and advisor, who appeared only now and then to hold court.[6]

The cover of the student song folder (cat. 7) also bears the silhouette of a city, actually a view of Basel Minster. During his medical studies at the University of Basel (1895–1900), Jung was an active member of the student association called Zofingia and its president from 1897. He was given the drinking association name "Walze" ("Roller"). The song folder is, however, signed "CJ!" From 1896 to 1899, Jung gave several lectures at the Zofingia.[7]

The castle motif appears again in 1915 in *The Red Book* (fig. 21, *RB*, ii [v]) as the pictorial representation of an initial letter, as in medieval book painting. In its elements, the miniature is somewhat reminiscent of the gouache with castle ruins, lake, and a line of hills (cat. 16).

That Jung was fascinated with medieval book illumination long before the creation of *The Red Book* is evident in a miniature with a gold background on parchment (cat. 8), which he made in 1893 at age eighteen. It was dedicated to his aunt and godmother Auguste Preiswerk (1828–1904): "For my dear Great-aunt, at Christmas 1893. A poet of the XII century, after the miniature of the Codex Manesse." The *Codex Manesse* is a collection of Middle High German Minnesang, named after the patrician Zurich family Manesse. The codex was created between 1300 and 1340 and contains 137 full-page miniatures. It is one of the most famous medieval secular codices in the German language. As a model for Jung's drawing, the nearest is a secondary figure on page 323, which represents the poet "Reinmar von Zweter."

Still, as an old man, Jung describes in *Memories* how, in 1913, at the beginning of his consideration of and engagement with the unconscious, he recalled childhood experiences and began building castles again:

The first thing that came to the surface was a childhood memory from perhaps my tenth or eleventh year. At that time I had had a spell of playing passionately with building bricks. I distinctly recalled how I had built little houses and castles, using bottles to form the sides of gates and vaults. Somewhat later I had used ordinary stones, with mud for mortar. [...] Yet if I wanted to re-establish contact with that period, I had no choice but to return to it and take up once more that child's life with the childish games. [...] I went on with my building game after the noon meal every day, whenever the weather permitted.[8]

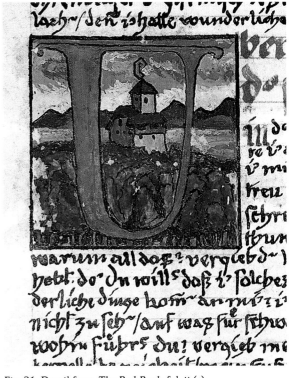

Fig. 21. Detail from *The Red Book*, fol. ii (v)

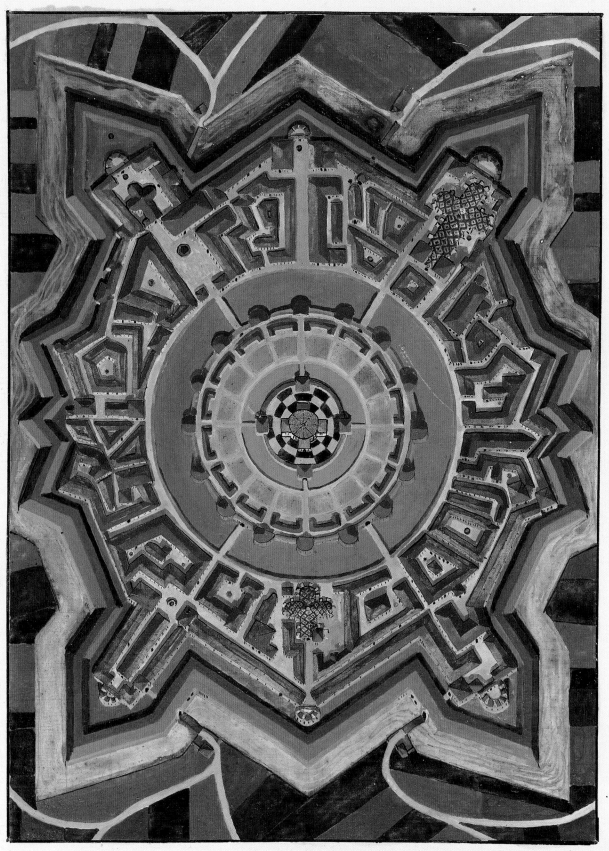

1928 . als ich dieß bild malte / welchs das goldene wohlbewehrte schloß zeigt / sandte mir Richard Wilhelm
in Frankfurt d~ chineſiſch~ / tauſend Jahr alt~ text vom geib~ schloß / d~ keim d~ unſterblich~ körpers.
ecclesia catholica et protestantes et secluſi in ſecreto . aeon finitus .

Because the method of building with clay proved vulnerable to rain and high water, in 1915 Jung decided to build the "*Small Castle*" (cat. 9) using natural stone and cement. He used parts of the Anker building-blocks set of his children, not to their great pleasure.[9]

A castle also appears in the last mandala on page 163 of *The Red Book* (fig. 22). The picture caption reads: "1928. When I painted this picture, which shows a well-fortified golden castle, Richard Wilhelm in Frankfurt sent me the 1000-year-old Chinese text of the golden castle, the embryo of the immortal body. Ecclesia catholica et protestantes et seclusi in secreto. Aeon finitus [The Catholic Church and the Protestants and those secluded in secret. The end of an eon]."

In his psychological commentary on Wilhelm's book *The Secret of the Golden Flower* in 1931, Jung explained the representation: "A *mandala* as a fortified city with wall and moat. Within, a broad moat surrounded by a wall, fortified with sixteen towers, and with another inner moat. The latter moat surrounds a central castle with golden roofs whose centre is a golden temple."[10]

Beyond these archetypal aspects, biographical reminiscences might have influenced this picture. Jung grew up in Kleinhüningen near Basel, the son of the village pastor.

Fig. 23. Bird's-eye view from the north of Huningue Fortress, designed by Sébastien Le Prestre de Vauban. Engraving after a drawing by Emanuel Büchel (1705–1775), Staatsarchiv Basel-Stadt, Image Wack. C 175

In 1679–1691, a fortification had been built in Hüningen/Huningue on the French side of the Rhine opposite Kleinhüningen, according to plans by Sébastien Le Prestre de Vauban (fig. 23); the fortification was razed in 1816. Jung knew from representations that the fortification consisted of a pentagon with five bastions as revealed in his *Memories*: "Instead of day-dreaming I began building castles and artfully fortified emplacements out of small stones, using mud as mortar—the fortress of Hüningen, which at that time was still intact,[11] serving me as a model. I studied all the available fortification plans of Vauban, and was soon familiar with all the technicalities. From Vauban I turned to modern methods of fortification, and tried with my limited means to build models of all the different types."[12] A book on "Kleinhüningen" with an engraving of the Vauban fortress after a drawing by Emanuel Büchel was in Jung's library.[13]

Fig. 22. *The Red Book*, page 163

2. Landscapes

CAT. 10. *Landscape,* 1899
Gouache on paper
21.5 × 27 cm (8⁷⁄₁₆ × 10⁵⁄₈ in.)
Inscription: Kennst du das Land? 1899 J. (Do you know the country? 1899 J.)
Jung Family Archive

CAT. 11. *Landscape with Snowy Mountains,* ca. 1899
Gouache on paper
21.5 × 27 cm (8⁷⁄₁₆ × 10⁵⁄₈ in.)
Jung Family Archive

CAT. 12. *Landscape,* ca. 1900
Pastel on paper
6.4 × 14 cm (2½ × 5½ in.)
Jung Family Archive

CAT. 13. *Landscape,* ca. 1900
Pastel on paper
10.4 × 16 cm (4¹/₁₆ × 6⁵/₁₆ in.)
Foundation of the Works of C.G. Jung

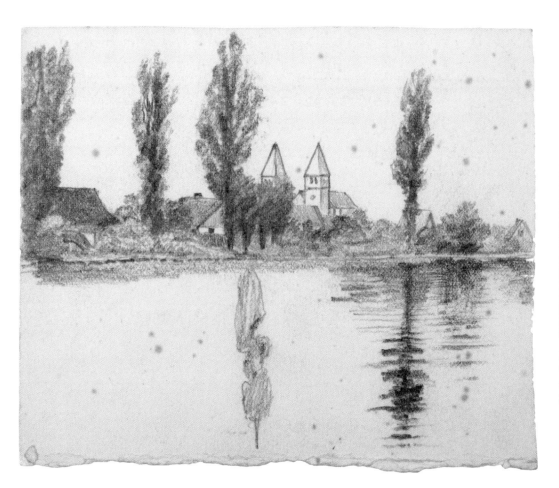

Fig. 24. Photographer unknown, Reichenau Island, the west bank with the Basilica of Sts. Peter and Paul (Reichenau-Niederzell), 1935. Courtesy ETH-Bibliothek, Zurich, Image Archive, Ans_05469–008-AL

CAT. 14. *Reichenau Island,* ca. 1900
Graphite on paper
10.7 × 13.2 cm (4³⁄₁₆ × 5³⁄₁₆ in.)
Jung Family Archive

CAT. 15. *Landscape,* ca. 1900
Pastel on cardboard
33 × 28.5 cm (13 × 11¼ in.)
Private collection

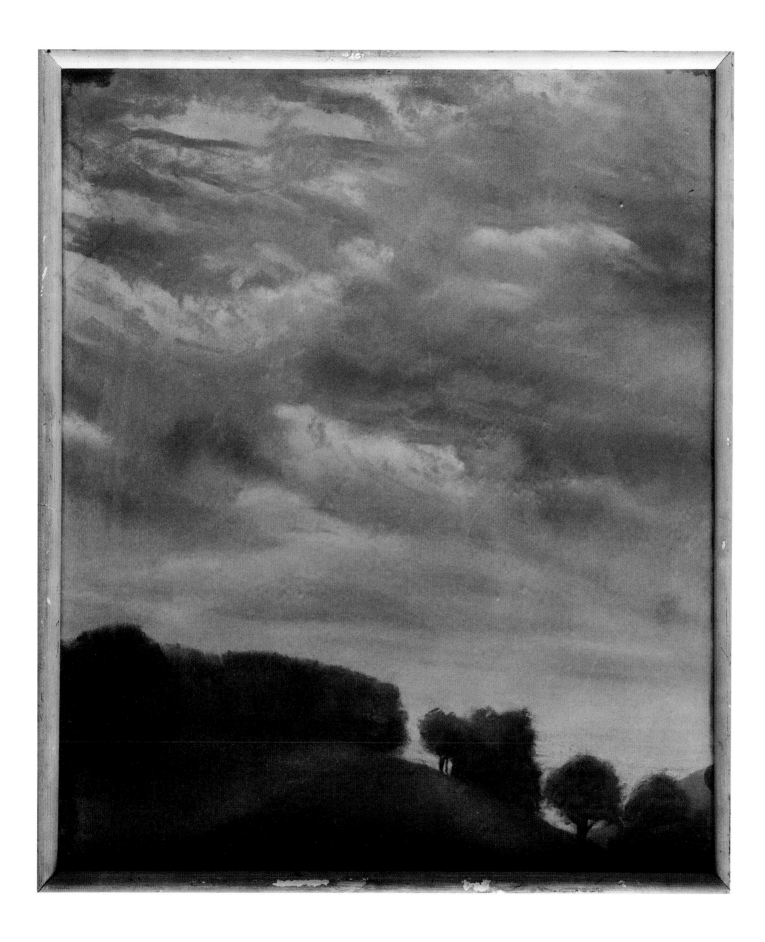

CAT. 16. *Castle Ruin,* ca. 1900
Pastel on paper
15.2 × 24.2 cm (6 × 9½ in.)
Jung Family Archive

CAT. 17. *Farmers' Houses and Clouds,* ca. 1900
Pastel on paper
25 × 40 cm (9¹³/₁₆ × 15¾ in.)
Jung Family Archive

LITERATURE
CW 11, §§ 474–87; Jung, *Memories,* pp. 95–99.

CAT. 18. *Landscape with Castle,* ca. 1900
Pastel on paper
30.5 × 36.5 cm (12 × 14⅜ in.)
Jung Family Archive

CAT. 19. *Landscape with Stream I*, 1901

Pastel on cardboard

30 × 35 cm (11^{13}/$_{16}$ × 13^{3}/$_{4}$ in.)

Inscription:

Still läuft über weisse Meere	([. . .] runs softly on the white sea
Deiner Liebe Purpur	your love's purple,
Deine letzte zögernde Seligkeit. Nietzsche[14]	Your final hesitating bliss. Nietzsche
Zur glückhaften Weihnacht 1901 von Deinem Verlobten	For a happy Christmas 1901 from your fiancé)

Center for Jungian Studies, Cape Town

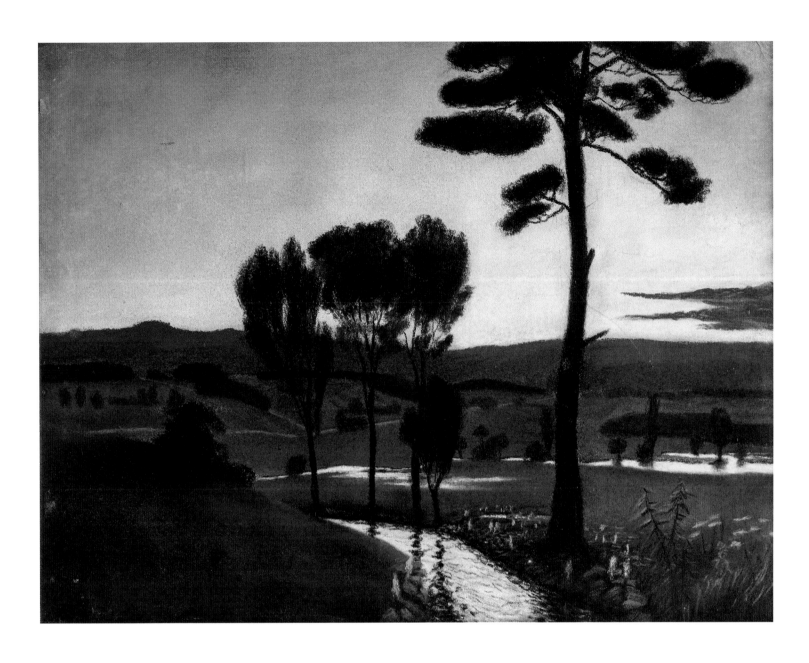

CAT. 20. *Landscape with Stream II,* 1901
Pastel on cardboard
28 × 34 cm (11 × 13⅜ in.)
Inscription verso: Meiner lieben Mutter zu Weihnachten 1901 und zum Geburtstag 1902 (To my dear Mother for
Christmas 1901 and for her birthday 1902)
Private collection

LITERATURE
Aniela Jaffé, *C.G. Jung: Word and Image* (Princeton: Princeton University Press, 1977), p. 43; *C.G. Jung: Das Rote Buch,*
exh. cat. (Zurich: Museum Rietberg, 2010), p. 4 (ill. 1); *Le livre rouge de C.G. Jung. Récits d'un voyage intérieur,* exh. cat.
(Paris: Musée Guimet, 2011), p. 2 (ill. 1).

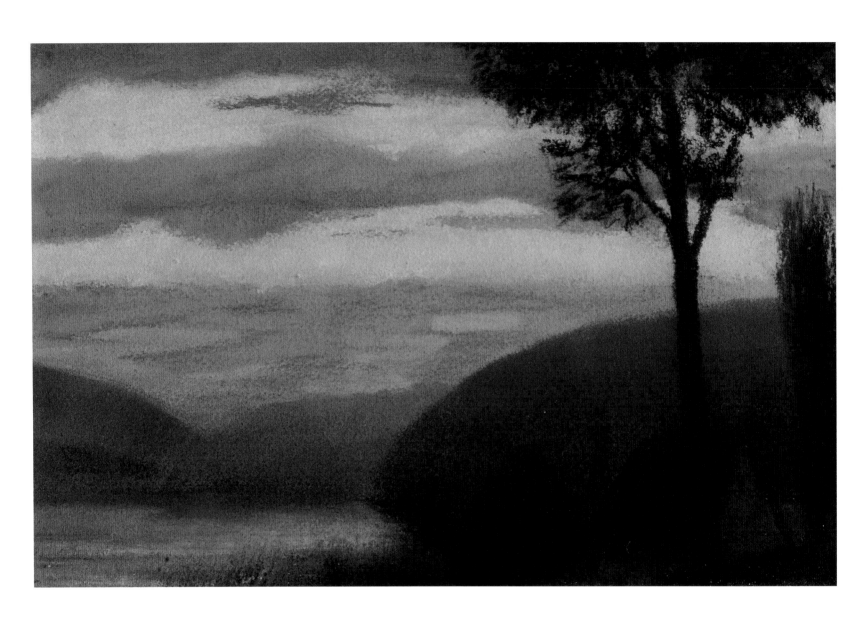

CAT. 21. *Landscape with River,* ca. 1905
Pastel on paper
16 × 23 cm (6⁵/₁₆ × 9¹/₁₆ in.)
Private collection

LITERATURE
Museum Rietberg, p. 4 (ill. 2); Musée Guimet, p. 2 (ill. 2).

CAT. 22. *Landscape,* 1904
Pastel on paper
32 × 50.6 cm (12⅝ × 19¹⁵⁄₁₆ in.)
Inscription: CGJ 1904
Klinik am Zürichberg, Zurich

LITERATURE
Katrin Luchsinger, "Ein unveröffentlichtes Bild von C.G. Jung: *Landschaft im Nebelmeer,*" in *Zeitschrift für Analytische Psychologie* 18 (1987), pp. 298–302; Ursula Baumgardt, "Betrachtung eines Bildes von C.G. Jung," in *Zeitschrift für Analytische Psychologie* 18 (1987), pp. 303–12; Gerhard Wehr, *An Illustrated Biography of C.G. Jung* (Boston: Shambhala, 1989), pp. 6–7 (ill.); Christian Gaillard, *Le Musée Imaginaire de Carl Gustav Jung* (Paris: Stock, 1998), p. 207 (ill.).

COMMENTARY

A number of landscapes by Jung from the years 1895 to 1905 are barely mentioned in *Memories*. Most of these must have been made in the gently rolling hills and at the quiet waters of northern Switzerland, but their exact locations remain unknown. They are distinguished by their emotionality more than by their motifs.[15] Humans and animals are entirely absent.

The two early landscapes in gouache, cats. 10 and 11, are notable for their luminosity. They represent a landscape reminiscent of the Black Forest or the Vosges: in the foreground light hills, in the background more distinctive ones. Cat. 10 shows a landscape like a cutout against a backlit yellow sky. The colorfulness evokes a landscape of longing, which is emphasized by the allusion to a verse from Goethe.[16] Cat. 11 depicts a spring landscape in morning or evening light. The two small yellowy pastels, cats. 12 and 13, appear to show a similar landscape. These are early experiments with pastel.

Cat. 14 shows Reichenau Island with the Romanesque Basilica of Sts. Peter and Paul. It is marked by the horizontality of the water and the verticality of the poplars and the towers. As a young man, Jung visited Reichenau Island on Lake Constance (German side) several times. He was especially impressed with the crypt of the Church of St. George.[17] The Benedictine abbey was already an important religious and cultural center in the Carolingian age. In the ninth century, it had one of the most important libraries north of the Alps. Its school of book illumination is said to have been the most influential in Central Europe in the tenth and eleventh centuries. Even fifteen years after his first visit to Reichenau Island, Jung was plainly inspired in his work in *The Red Book* by medieval book illumination, and it is hard not to assume a connection here.

Between 1900 and 1905, Jung painted a series of landscapes in pastel, some of these in rather dark tones, such as cat. 15 which shows a range of hills under a high sky streaked with clouds.

Cat. 16 presents in the foreground a ruined castle with a window opening, in the background a lake and a range of hills. The sky is again painted with dark clouds. *Farmers' Houses and Clouds* (cat. 17) shows the view from the porch of a house. One can see farmers' houses, a mountain on the left side, and a dark, cloudy sky in the background. The scene is reminiscent of Flüeli Ranft, near Sachseln (Switzerland), the birthplace and hermitage of Swiss patron saint Brother Klaus. The place and its history made a lasting impression on Jung when in adolescence he visited his father on holiday in Sachseln.[18]

Landscape with Castle (cat. 18) depicts a hilly landscape with a castle and a viaduct. The typical motif of the castle recalls the drawings cats. 2, 5, and 6. The white cloud appears to be somewhat more stylized than in Jung's sea painting (cat. 29).

Cat. 19 and the similar cats. 20 and 21 show dark hills in the foreground and mountains in the background, backlit by the sky, which is reflected in the water of a stream or river. The heavens are visualized with variegated colors drawn in fine gradations of pastel, and the reflections recall the symbolic landscapes of Arnold Böcklin, Hans Sandreuter, and Ferdinand Hodler. Jung dedicated *Landscape with Stream I* (cat. 19) to his fiancée, Emma Rauschenbach, and gave it to her for Christmas in 1901. *Landscape with Stream II* (cat. 20) is dedicated to his mother, while he gave *Landscape with River* (cat. 21) to his mother-in-law.

Landscape (cat. 22) shows forested hills in a sea of mist and a pastel-colored sky. It might depict a landscape at Untersee, the lower part of Lake Constance. The drawing is initialed by Jung and dated. It was discovered at a flea market in Zurich in 1987.

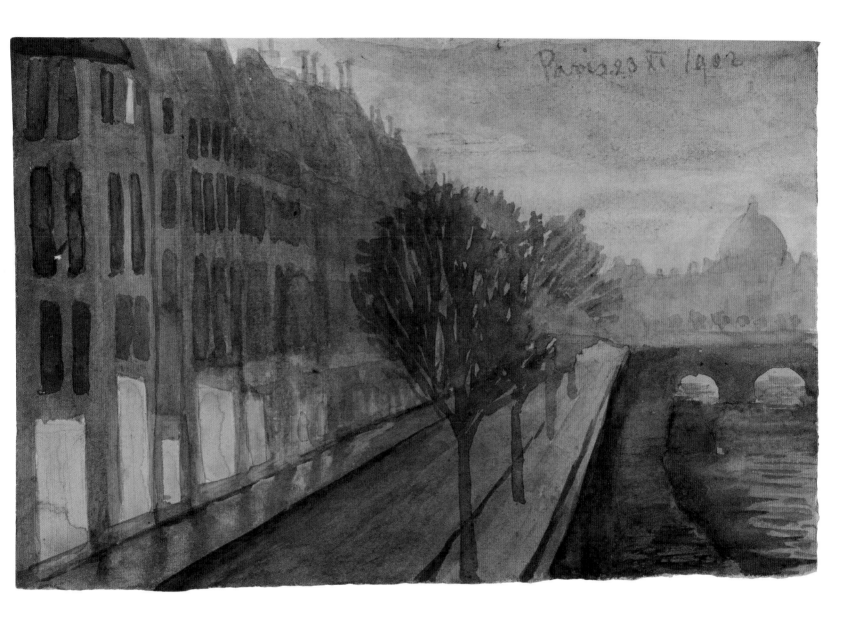

CAT. 23. *Paris, the Seine,* 1902
Watercolor on paper
13.8 × 21.3 cm (5⁷⁄₁₆ × 8³⁄₈ in.)
Inscription: Paris XI 1902
Jung Family Archive

CAT. 24. *Paris, View toward Panthéon,* ca. 1902
Sketch of Men with Hat (verso)
Watercolor and graphite on paper
21.3 × 14 cm (8⅜ × 5½ in.)
Jung Family Archive

CAT. 25. *Houses in the Countryside,* 1902
Watercolor and graphite on paper
14 × 21.3 cm (5½ × 8⅜ in.)
Inscription: 28.XI.1902
Inscription verso: Eine Reiseerinnerung für meine Liebste (Souvenir of a trip for my beloved).
Jung Family Archive

CAT. 26. *Country Road with Trees,* 1902
Watercolor on paper
14 × 21.4 cm (5½ × 8⁷⁄₁₆ in.)
Inscription verso: Paris 1.XII.1902
Jung Family Archive

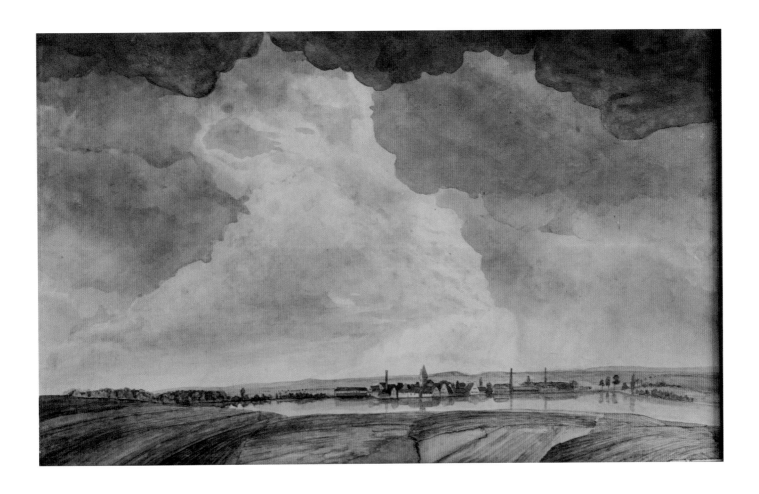

CAT. 27. *"Clouds above a Seine Landscape,"* 1902

Watercolor on cardboard

38 × 55.5 cm (14^{15}/$_{16}$ × 21^{7}/$_{8}$ in.)

Inscription verso:

Wolkenstimmung in einer Seinelandschaft	Clouds above a Seine Landscape
Meiner allerliebsten Braut zu Weihnachten 1902.	For my most beloved fiancée, Christmas 1902
Paris. Dezember 1902. Von C.G. Jung gemalt.	Paris. December 1902. Painted by C.G. Jung.

Private collection, Küsnacht

LITERATURE

C.G. Jung: Word and Image, ed. Jaffé, p. 42 (ill.); Museum Rietberg, p. 5 (ill. 3); Musée Guimet, p. 2 (ill. 3).

CAT. 28. *Forest with Small Pond,* 1902

Watercolor and graphite on paper

14 × 21 cm (5½ × 8½ in.)

Inscription verso: 2.XII.1902

Eine Reminiscenz aus dem besseren Leben. Es ist zwar wüst gesalbt, aber *ut desint vires, tamen est laudanda voluntas.*

(A reminiscence from better times. It may not be perfectly executed, but *ut desint vires, tamen est laudanda voluntas*

[though the power may be lacking, the intention is good].)

Jung Family Archive

COMMENTARY

In the winter semester of 1902/1903, Jung studied with Pierre Janet at Salpêtrière hospital in Paris. In his free time, he took long walks and visited theaters and museums—and painted watercolors as a record of his impressions of Paris and its environs. In 1958, Jung recalled his stay in Paris:

> Paris was either incredibly beautiful, tasteful, magnificent, or the abyss of misery. That was hard to endure. At that time I painted myself, landscapes of northern France, small watercolors. And once a big cloud and a few smaller sketches. Once I painted until four in the morning, a landscape from memory; this foreign landscape made a powerful impression on me; the color and mood. I wandered around alone in Paris a lot and in the surrounding area.[19]

The watercolor *Paris, the Seine* (cat. 23) shows the bank of the Seine in a gray, November twilight: the water of the river, the path along the riverbank, the illuminated windows, and in the distance a part of the city in silhouette, with a dome.

The unfinished watercolor *Paris, View towards Panthéon* (cat. 24) shows two house façades painted black; between them the Panthéon can be recognized. *"Clouds above a Seine Landscape"* (cat. 27) shows a blue sky shining through gray clouds. Jung dedicated *Houses in the Countryside* (cat. 25) and *"Clouds above a Seine Landscape"* (cat. 27) to his fiancée, Emma Rauschenbach, whom he married in Schaffhausen shortly after his return on February 14, 1903.

The watercolor *Forest with Small Pond* (cat. 28) shows a small pond in a dark forest reflecting trees and an area of sky. Presumably this is the landscape created from memory mentioned by Jung.[20]

4. Seascapes

CAT. 29. *Cliffs at the Sea,* 1903
Pastel on cardboard
23 × 30 cm (9$\frac{1}{16}$ × 11$\frac{13}{16}$ in.)
Private collection

LITERATURE
Museum Rietberg, p. 5 (ill. 4).

CAT. 30. *Sea with Sailboat,* 1903
Pastel on cardboard
30 × 54 cm (11^{13}/$_{16}$ × 21^{1}/$_{4}$ in.)
Jung Family Archive

LITERATURE
Jung, *Memories,* pp. 405–6; Wehr, *An Illustrated Biography of C.G. Jung,* p. 47.

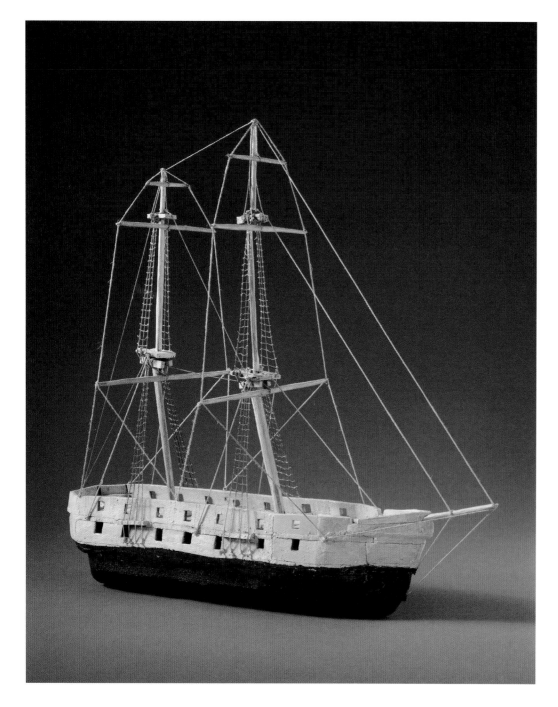

Fig. 25. Jung's sailboat; in the background, the Tower at Bollingen, 1935. Photograph by Konrad Hoerni

Fig. 26. Two-masted ship, Detail from *The Red Book*, page 125

CAT. 31. *Model Ship,* ca. 1915
Painted wood, string
59 × 26 × 59 cm (23¼ × 10¼ × 23¼ in.)
Foundation of the Works of C.G. Jung, Zurich

LITERATURE
Jung, *Memories*, pp. 100–101; Museum Rietberg, p. 41 (ill. 38); Musée Guimet, p. 16 (ill. 18).

COMMENTARY

In 1903 Jung drew two seascapes in pastel. The first, *Cliffs at the Sea* (cat. 29), shows a seascape with impressive cloud formations probably reminiscent of C.G. and Emma Jung-Rauschenbach's honeymoon, which took them to Madeira and other places in March 1903. The second pastel, *Sea with Sailboat* (cat. 30), shows a rough sea with a sailboat. Growing up in a landlocked country, Jung experienced the open sea for the first time on his honeymoon trip. His son, Franz Jung, commented in 1993 on the *Sea with Sailboat*:

> This picture must have been created during the passage from Gran Canaria to Tenerife, about March 20 or 21, 1903, as far as I recall from my father's explanations about the honeymoon trip (they started in Zurich at the end of February 1903 and travelled to Paris, London, Southampton, Madeira/Funchal, Gran Canaria, Tenerife, Gibraltar, Barcelona, Genoa and were back about April 16, 1903). I have taken these dates from letters. The background of the picture with the clouds represents [Pico de] Teide, which is over 3,000 meters high, the highest thrust of the volcanic peak (extinguished). [...] The plan was to stay in Gran Canaria for two to three days, in Tenerife about a week, which of course was delayed until the beginning of April because of the lack of ship transportation on the return toward Genoa. Barcelona was reached on April 11, Genoa on April 13/14.[21]

On this pastel an important motif for Jung appears: a sailboat with two masts. In a letter from Sousse dated March 15, 1920, to his wife, Emma, Jung mentioned the motif of the two-master:

> Then comes Sousse, with white walls and towers, the harbor below; beyond the harbor wall the deep blue sea, and in the port lies the sailing ship with two lateen sails which I once painted!!!![22]

In a fantasy from youth Jung described a similar scene:

> On the rock stood a well-fortified castle with a tall keep, a watch-tower. This was my house. In it there were no fine halls or any signs of magnificence. [...] On the landward side the town had a port in which lay my two-masted schooner, armed with several small cannons. [...] The schooner's decks were cleared, the sails rigged, and the vessel steered carefully out of the harbour before a gentle breeze, and then, as it emerged from behind the rock, tacked into a stiff nor'wester.[23]

Jung not only mentioned and painted two-masted sailboats, he also built a model of a ship with two masts. Albeit depicting different types of boats, the specification of two masts seems to have had some significance for Jung, as he later also sailed a two-masted boat himself—a very rare sight on the Lake of Zurich in his days. From the time when he built his house on the shores of Lake Zurich Jung became a passionate sailor and up to old age crisscrossed the lake many times.

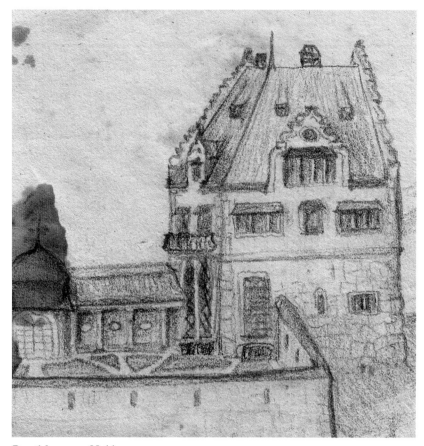

Detail from cat. 32 (v)

CAT. 32. *Southeast Façade of the House in Küsnacht,* ca. 1906
Southeast Façade with Garden, ca. 1906 (verso)
Graphite on paper
9.5 × 13.5 cm (3¾ × 5⁵⁄₁₆ in.)
Jung Family Archive

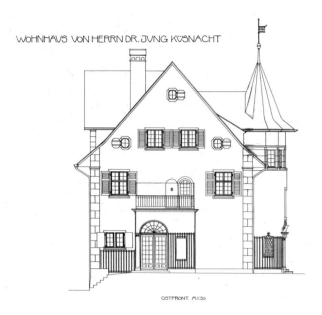

WOHNHAVS VON HERRN DR. JVNG KVSNACHT

OSTFRONT. M.1:50.

Fig. 27. Ernst Fiechter, plan, southeast façade of the house in Küsnacht, 1909, ink on paper. Courtesy Jung Family Archive

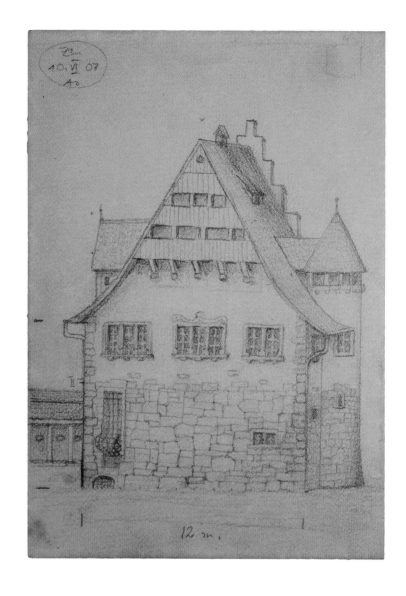

CAT. 33. *Southeast Façade,* ca. 1907
Graphite on paper
9.5 × 11 cm (3¾ × 4⁵⁄₁₆ in.)
Jung Family Archive

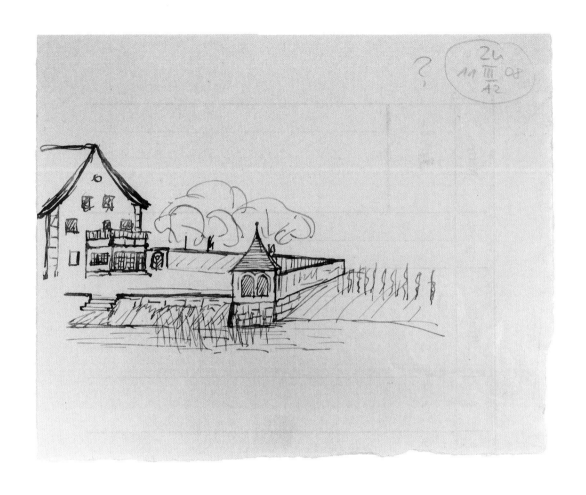

CAT. 34. *Southeast Façade with Garden,* ca. 1908
Ink on paper
9.5 × 13.5 cm (3¾ × 5⁵⁄₁₆ in.)
Jung Family Archive

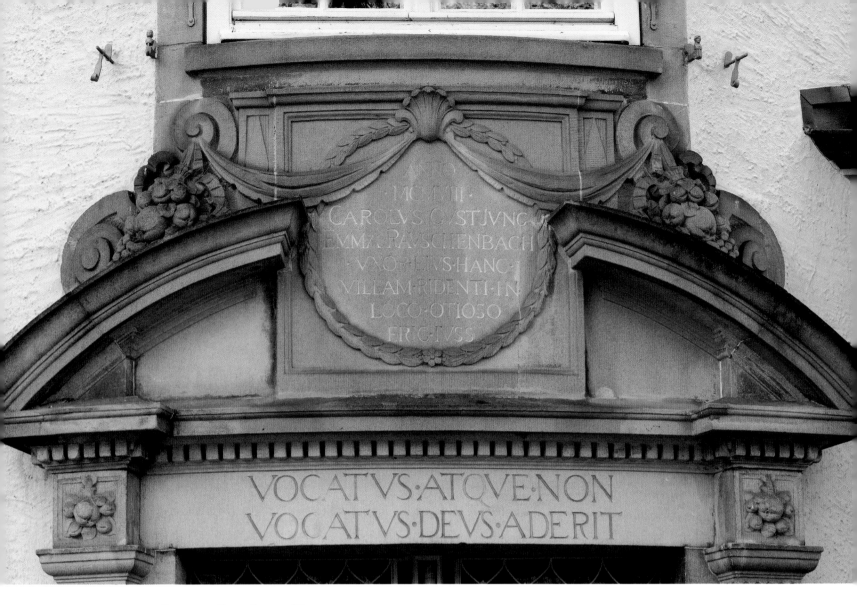

CAT. 35. *Cartouche above Entrance,* 1908
Design by C.G. Jung
Sandstone
85 × 70 × 5 cm (33⁷⁄₁₆ × 27⁹⁄₁₆ × 2 in.)
Stiftung C.G. Jung Küsnacht

The inscription in the cartouche over the entrance reads:

ANNO	In the year
MCMVIII	1908
CAROLVS GVST JVNG	Carl Gustav Jung
EMMA RAVSCHENBACH	[and] Emma Rauschenbach
VXOR EIVS HANC	his wife
VILLAM RIDENTI IN	had this house built
LOCO OTIOSO	in a happy
ERIG IVSS	peaceful place

LITERATURE

Andreas Jung et al., *The House of C.G. Jung,* ed. Stiftung C.G. Jung Küsnacht, pp. 33–59 (ills. 23, 34, 54, 39); Sonu Shamdasani, *C.G. Jung: A Biography in Books* (New York: W. W. Norton and the Martin Bodmer Foundation, 2012), pp. 6–9.

Fig. 28. Weathervane designed by
C.G. Jung on the staircase tower, House of
C.G. and Emma Jung, Küsnacht, ca. 1908.
Photograph by Alex Wydler

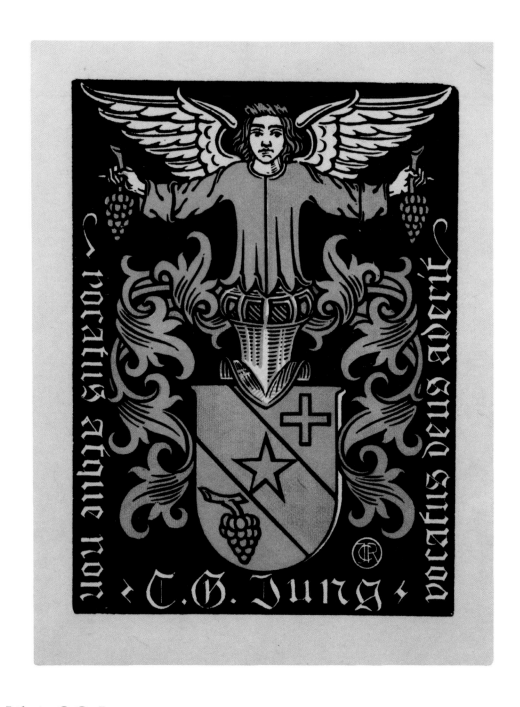

CAT. 36. *Ex Libris C.G. Jung,* 1925
Executed by Claude Jeanneret after an idea by C.G. Jung
Three-color print on paper
11.1 × 8.3 cm (4⅜ × 3¼ in.)
Foundation of the Works of C.G. Jung, Zurich

LITERATURE

Jung, *Memories,* pp. 259–60; *Protocols,* pp. 217–19; Benoît Junod, "Portrait of a Bookplate: Carl Gustav Jung,"
in *The Bookplate Journal* 1 (1987), pp. 43–46; Shamdasani, *C.G. Jung: A Biography in Books,* p. 49, note 92.

COMMENTARY

No visual works by Jung are known from the years between 1905 and 1915, presumably because of the demands of his profession. However, the construction of his new home in Küsnacht on Lake Zurich also began at this time. Küsnacht was then a small farming village, some four miles out of town, whereas today it is a wealthy garden suburb of Zurich. In 1907, the Jungs were able to acquire land on the lakefront on the outskirts of the village, where subsequently their house was built according to plans of the architect Ernst Fiechter, a relative of Jung's. In early summer 1909, the Jung family moved into their new home at Seestrasse 1003—it only later became number 228, which it still is today. Jung lived in the house on the shore of Lake Zurich until his death in 1961. In 1909, he also moved his medical practice there. Various sketches (cats. 32–34) suggest that Jung was closely involved in the process of designing the house.

Jung also designed a weathervane (fig. 28) and provided two inscriptions for the entrance. They show his connection to the place: On the architrave, one reads in Latin: VOCATVS ATQVE NON VOCATVS DEVS ADERIT (Called or not called, God is there). These words have their origins in the oracle of Delphi, when the Spartans asked the oracle if they should make war against the Athenians. The episode is passed on by Thucydides and repeated by Erasmus of Rotterdam, who was active for a long time in Basel, in his annotated collection of classical proverbs *Collectanea Adagiorum* of 1500. Jung owned *Adagiorum Epitome*, an excerpt from Erasmus's book.

Jung's ex libris (cat. 36) belongs to the same context; it can be assumed that Jung himself presented the idea for its motifs and motto. It was executed in 1925 by the Lausanne engraver Claude Jeanneret (1886–1979). Jung's coat-of-arms with a cross, star, and a bunch of grapes appears to be crowned by a winged man and flanked by Jung's motto, which is also to be found on the architrave over the entrance to his house. Jung commented on his coat-of-arms as follows:

The Jung family originally had a phoenix for its arms, the bird obviously being connected with "young," "youth," "rejuvenation." My grandfather changed the elements of the arms, probably out of a spirit of resistance towards his father. He was an ardent Freemason and Grand Master of the Swiss lodge. This had a good deal to do with the changes he made in the armorial bearings. I mention this point, in itself of no consequence, because it belongs in the historical nexus of my thinking and my life.

In keeping with this revision of my grandfather's, my coat of arms no longer contains the original phoenix. Instead there is a cross azure in chief dexter and in base sinister a blue bunch of grapes in a field d'or; separating these is an etoile d'or in a fess azure. The symbolism of these arms is Masonic, or Rosicrucian. Just as cross and rose represent the Rosicrucian problem of opposites ("per crucem ad rosam"), that is, the Christian and Dionysian elements, so cross and grapes are symbols of the heavenly and chthonic spirit. The uniting symbol is the golden star, the *aurum philosophorum*.[24]

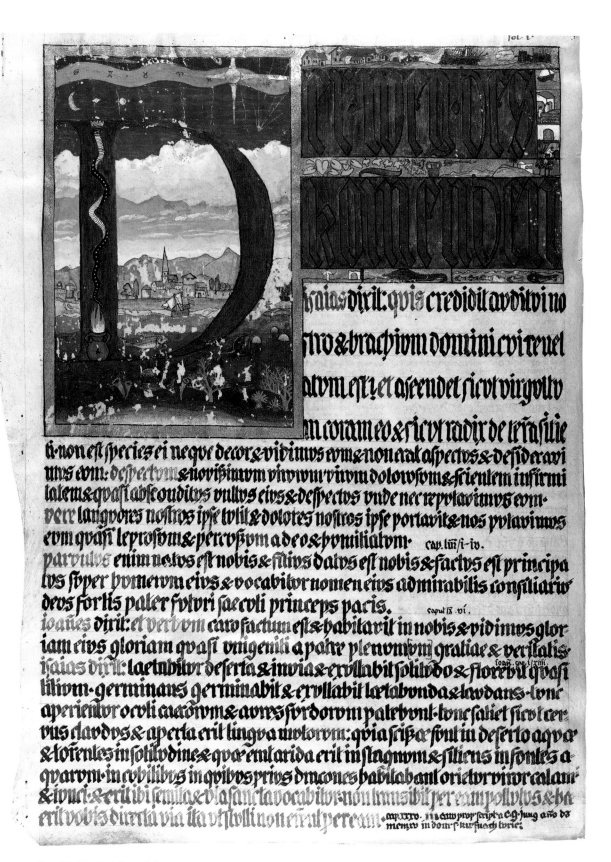

Fig. 29. *The Red Book*, fol. i

Fig. 30. *The Red Book,* fol. i (v)

COMMENTARY

The year 1913 marks a significant turning point in Jung's life. Since 1900, he had, with the exception of a brief interruption in 1902/1903, been working at the Burghölzli psychiatric university hospital in Zurich, where he became senior physician in 1905. At the same time, he was teaching on the Medical Faculty of the University of Zurich as an external lecturer. The path for a future academic career seemed laid out before him. Contact with Sigmund Freud led to several years of close collaboration between the two men. In 1909, Jung left the university clinic and opened a private practice at his newly built home in Küsnacht. Although he became president of the International Association of Psychoanalysis in 1910, Jung increasingly began formulating views that met with resistance from Freud. After the publication of Jung's *Transformations and Symbols of the Libido*[25] in 1912, a split between the two became unavoidable. What followed after, Jung later described as follows: "After the parting of the ways with Freud, a period of inner uncertainty began for me. It would be no exaggeration to call it a state of disorientation. I felt totally suspended in mid-air, for I had not yet found my own footing."[26]

At this point in his life, Jung rather abruptly ended his affiliation with Freud's psychoanalytic movement, as well as his academic teaching in Zurich, and began a self-experimentation that became known as his "confrontation with the unconscious."[27] It consisted of letting inner fantasies and images rise up and then recording them in writing. Some of them he also put down in a raw drawing, to which the mandala sketch series (cats. 81–105) in Diane Finiello Zervas's essay bear witness. He would then reflect on and rework this material in several steps before setting it out in calligraphic writing inside a thick, red leatherbound volume[28] with strongly colored images reminiscent of an illuminated medieval script. His original notes of November 1913 to April 1914 thus became the *Liber Novus*. His experiences from April 1914 to June 1916 evolved into a separate draft text, called *Scrutinies*. It was probably Jung's intention to include these texts as well, but having taken until 1930 to refine the calligraphic and visual elaboration of *Liber Novus*, he set *The Red Book* aside unfinished. In 1959, in old age, Jung tried once more to finish what he had begun some five decades earlier, but ultimately lacked the energy to complete the task.[29]

The first part of *The Red Book* is entitled "The Way of What Is to Come." Its text describes an inner journey in which Jung roams imaginary landscapes and meets fantastical characters in varying situations with whom he holds profound conversations. These dialogues contain the nucleus of his Analytical Psychology, an original psychological concept which Jung developed at the time. *The Red Book* is therefore a psychological text in poetic language. It ends with the words: "This is the way."[30] *The Red Book* has fifty-four full-size images, including a series of mandalas. In the text there are many more, smaller images, among them finely illustrated initials. Most of the images, however, do not illustrate the text but tell their own story, and their meaning is not always entirely clear. The motifs of *The Red Book* and separate visual works by Jung often show a close relationship. Images from *The Red Book* are reproduced in this publication to illustrate this relatedness, when it exists.

ELIJAH, SALOME, AND THE SNAKE/MOTHER OF GOD WITH CHILD

In his 1925 seminar on Analytical Psychology, Jung described a "fantastic vision"[31] which contained a key scene of *The Red Book*: "It was the mood of the land of the hereafter. I could see two people, an old man with a white beard and a young girl who was very beautiful. [. . .] The old man said he was Elijah and I was quite shocked, but she was even more upsetting because she was Salome. [. . .] With them was a black snake who had an affinity for me. I stuck to Elijah as being the most reasonable of the lot [. . .]."[32] This scene is represented in *The Red Book* in the chapter "Mysterium. Encounter" (fig. 31).[33]

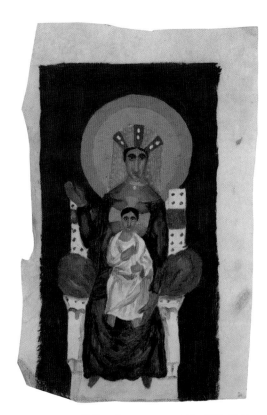

CAT. 37. *Madonna with Child,*
ca. 1905
Attributed to C.G. Jung
Gouache on parchment
17 × 11 cm (6$^{11}/_{16}$ × 4$^{15}/_{16}$ in.)
Jung Family Archive

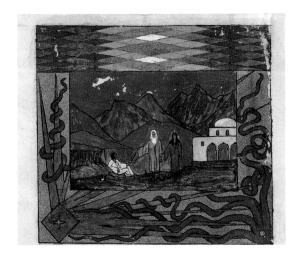

Fig. 31. Detail from *The Red Book*, fol. v (v)

In the following episode in *The Red Book*,[34] it reads further: "Wordlessly Elijah and Salome step inside the house. I follow them reluctantly. [. . .] I would like to turn back, but I cannot. I stand before the play of fire in the shining crystal. I see in splendor the mother of God with the child." The scene continues a little later: "The image of the mother of God with the child that I foresee, indicates to me the mystery of the transformation. If forethinking and pleasure unite in me, a third arises from them, the divine son, who is the supreme meaning, the symbol, the passing over into a new creation."[35] The small, undated, and unsigned work *Madonna with Child* (cat. 37), which was found in Jung's papers without any further information, is probably related to this passage in *The Red Book*. The *Madonna with Child* could be a sketch or study from the time, when Jung was experimenting with parchment in the initial stages of the calligraphic fair copy of *The Red Book*, which he made in 1915. It shows the principal motif in Christian iconography.

A third episode from the same context is represented in the partly damaged initial *L* of chapter XI ("Resolution"), in which the snake, in an almost deadly way, winds itself around Jung's body (fig. 32).[36] Jung again spoke of this vision in his 1925 seminar: "Then I saw the snake approach me. She came close and began to encircle me and press me in her coils. The coils reached up to my heart. I realized as I struggled, that I had assumed the attitude of Crucifixion. In the agony and the struggle, I sweated so profusely that the water flowed down on all sides of me. [. . .] While the snake was pressing me, I felt that my face had taken on the face of an animal of prey, a lion or a tiger."[37]

Fig. 32. Detail from *The Red Book*, fol. vi (v)

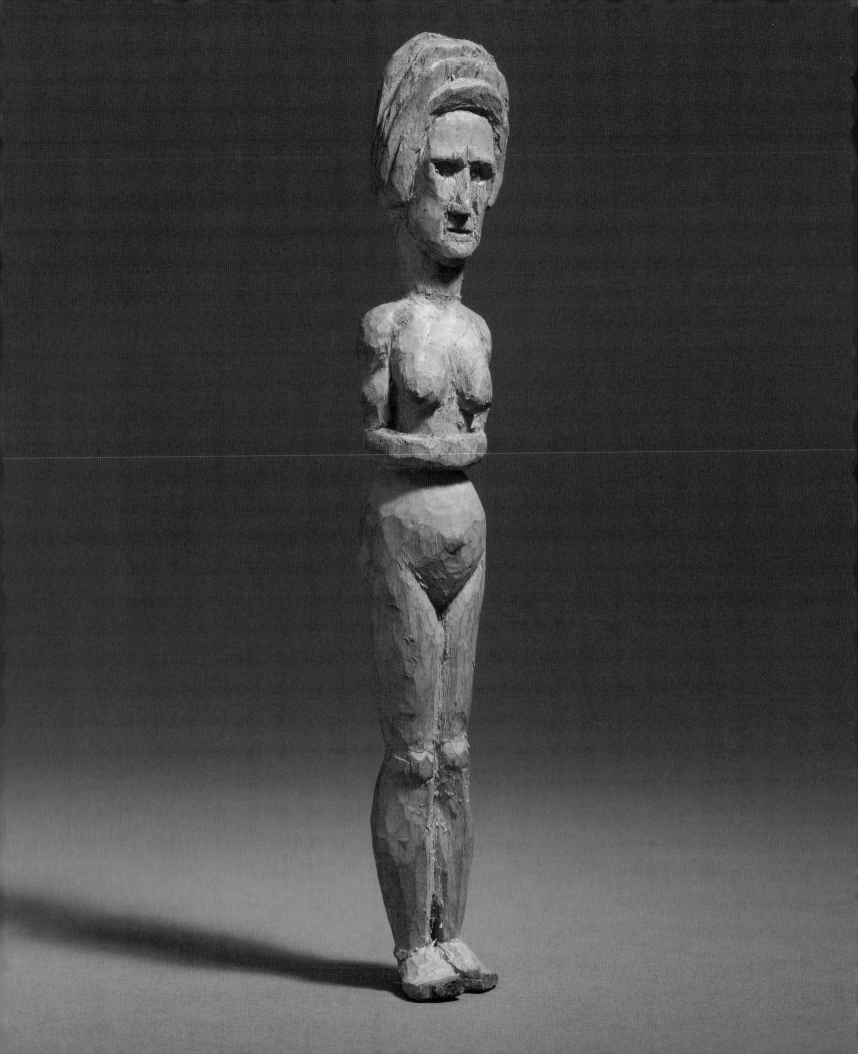

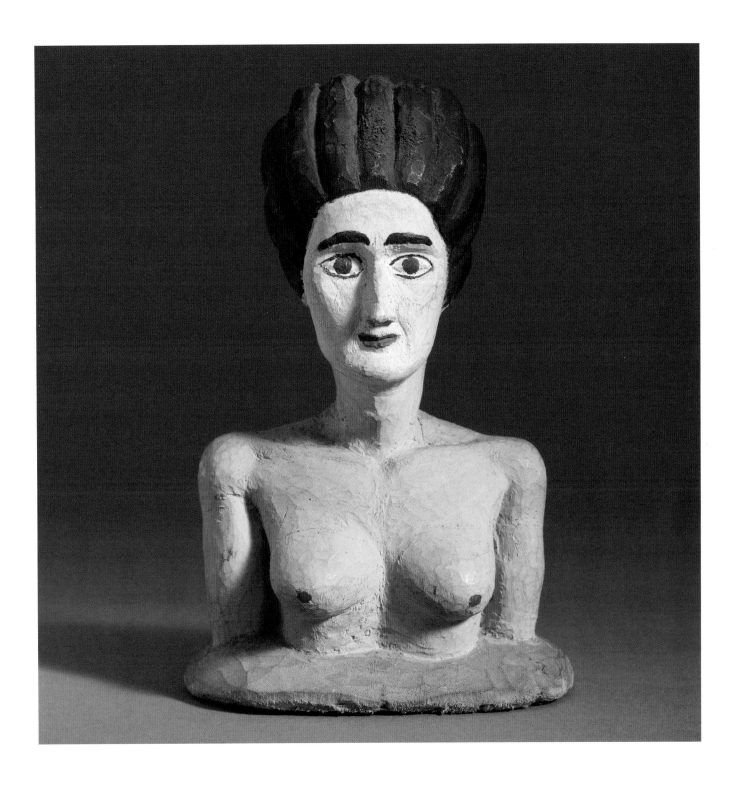

CAT. 38. *Statuette of a Woman,* ca. 1920
Carved wood
15.5 × 2.5 × 2.3 cm (6⅛ × 1 × ¹⁵⁄₁₆ in.)
Jung Family Archive

CAT. 39. *Female Half Figure,* ca. 1920
Carved wood, painted
12.8 × 7.5 × 5.5 cm (5¹⁄₁₆ × 2¹⁵⁄₁₆ × 2³⁄₁₆ in.)
Jung Family Archive

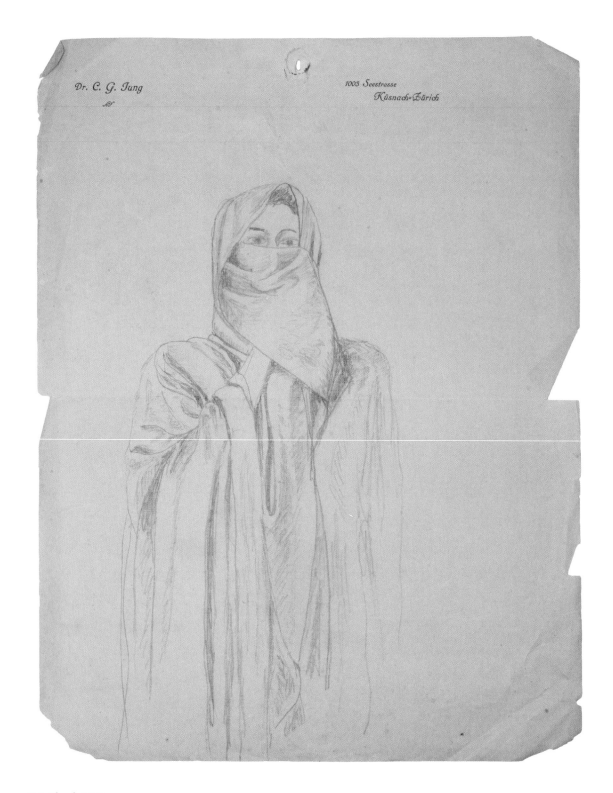

CAT. 40. *Veiled Woman,* ca. 1924
Graphite on paper
28.5 × 22.1 cm (11¼ × 8¹¹⁄₁₆ in.)
Jung Family Archive

LITERATURE
CW 9/I §§ 306–320; *RB*, p. 155; Jung, *Memories*, pp. 266–67.

COMMENTARY

As Jung worked with his unconscious at the end of 1913, he perceived an inner voice, which came from a woman. He described this in 1925: "I was much interested in the fact that a woman should interfere with me from within. My conclusion was that it must be the soul in the primitive sense, and I began to speculate on the reasons that the name 'anima' was given to the soul. Why was it thought of as feminine?"[39] Jung recognized that this inner female figure was an archetypal form in man's unconscious and called it *anima*. Many years later, in 1958, he made notes of a dream in which Toni Wolff appeared to him as a bust: "At one time—it must have been in the 1920s—I made small busts, I believe out of wood, of my anima. I painted them, and the bust of Toni reminded me of them. Only with the difference that she had black hair, but dark blue eyes."[40]

Statuette of a Woman (cat. 38) and *Female Half Figure* (cat. 39) are consequently part of the anima context. Compared to the statuette, the half figure is more finely worked. Its hair recalls figures from the period around 1920, which confirms the dating of the objects.[41]

A much more complex anima also appears in *The Red Book* on the image of p. 155 (fig. 33). Jung commented on this figure in his text "The Psychological Aspects of the Kore."[42] Kore (Greek: girls, young woman, daughter) was one name of the goddess Persephone, daughter of Zeus and Demeter. Hades kidnapped her and took her to the underworld and made her his bride. Jung describes the symbolic meaning of Demeter and Kore in the unconscious of today's humans, specifically in dreams involving women: "The 'Kore' has her psychological counterpart in those Archetypes which I have called the *self* or *supraordinate personality* on the one hand, and the *anima* on the other."[43]

Jung discussed the Kore figure observed in men, the anima, in the context of his own dreams: "Dream X shows the paradoxical double nature of the anima: banal mediocrity and Olympian divinity."[44] Moreover: "Dream XI restores the anima to the Christian church, not as an icon but

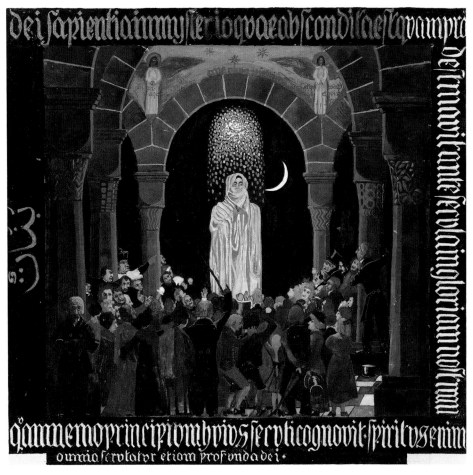

Fig. 33. *The Red Book*, page 155 (1925). Clockwise from upper left:

> Dei sapientia [sic] in mysterio quae abscondita est, quam praedestinavit ante secula in gloriam nostram quam nemo princip[i]um huius seculi cognovit. Spiritus enim omnia scrutatur etiam profunda dei (The wisdom of God in a mystery, a wisdom which is hidden, which God ordained before the world, unto our glory: Which none of the princes of this world knew. [. . .] For the Spirit searcheth all things, yea, the deep things of God) (I Corinthians 2:7–10).[38]

Left: daughters (in Arabic letters)
Above the arch: ave virgo virginum (medieval hymn)
Left and right of the arch:

> Spiritus et sponsa dicunt veni. et qui audit / dicat: veni. et qui sitit, veniat. et qui vult / accipiat aquam vitae gratis

(But the Spirit and the bride say, Come! To let him that heareth / say, Come! And let him that is athirst come. And whoever will, / let him take the water of life freely) (Revelation 22:17)

Fig. 34. Detail from *The Red Book*, page 105

as the altar itself. The altar is the place of sacrifice and also the receptacle for consecrated relics."[45]

The drawing *Veiled Woman* (cat. 40) is probably the sketch for the central figure on page 155 of *The Red Book*. Its origin and date are unclear. Conceivably, it is a reminiscence of North Africa, which Jung visited in 1920: "It was clear that men spoke to men and women to women here. Only a few of the latter were to be seen, nunlike, heavily veiled figures. I saw a few without veils."[46]

The above-mentioned double nature of the anima also appears in the mandala painting on page 105 of *The Red Book* as a light and a dark female figure in the cardinal points to the right and left representing "the two aspects of the anima"[47] (figs. 34 and 35).

Fig. 35. Detail from *The Red Book*, page 105

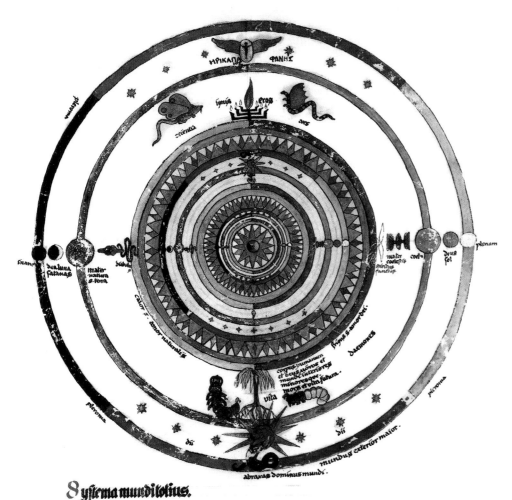

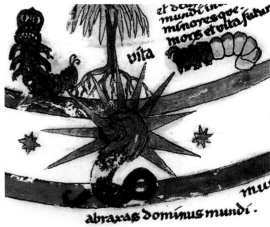

Fig. 36. Detail from *Systema Mundi Totius*

CAT. 41. *Systema Mundi Totius,* 1916

Gouache on parchment

30 × 40 cm (11¹³⁄₁₆ × 15¾ in.)

Inscription verso: This is the first mandala I constructed in 1916, wholly unconscious of what it meant. C.G. Jung.

Dr. Robert Hinshaw, Einsiedeln

LITERATURE

CW 9/I, frontispiece; *RB*, p. 364; C.G. Jung, "Mandala eines modernen Menschen," in *Du: Schweizerische Monatsschrift* 4 (1955), p. 18; *C.G. Jung: Word and Image*, ed. Jaffé, p. 76; Wehr, *An Illustrated Biography of C.G. Jung*, p. 50 (ill.); Gaillard, *Le Musée Imaginaire*, p. 215; Barry Jeromson, "Systema Munditotius and Seven Sermons: Symbolic Collaborators in Jung's Confrontation with the Dead," in *Jung History* 1, 2 (2005/06), pp. 6–10; "The Sources of Systema Munditotius: Mandalas, Myths and Misinterpretation," in *Jung History* 2 (2007), pp. 20–22; Museum Rietberg, pp. 20–21 (ill. 14); Musée Guimet, p. 8 (ill. 8); Shamdasani, *C.G. Jung: A Biography in Books*, p. 125 (ill.).

CAT. 42. *Cosmological Schema in Black Book V,* page 169 (1916)
Ink and colored pencil on paper
22.9 × 17.8 cm (9 × 7 in.)
Foundation of the Works of C.G. Jung, Zurich

LITERATURE

RB, pp. 363, 370–71; Museum Rietberg, p. 11 (ill. 9); Musée Guimet, p. 5 (ill. 5);
Shamdasani, *C.G. Jung: A Biography in Books*, p. 124 (ill.).

CAT. 43. *Sketch for Systema Mundi Totius,* 1916
Graphite on paper
31 × 13 cm (12¹³⁄₁₆ × 5⅛ in.)
Jung Family Archive

LITERATURE
Jung, *Memories,* pp. 389–98 (the *Sermones* were reproduced only in
early English editions of *Memories,* the last being 1989).

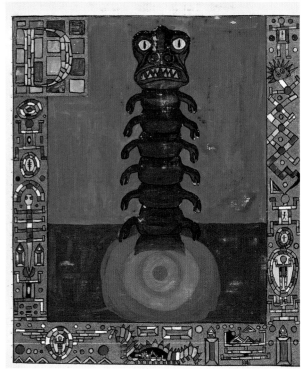

Fig. 37. Detail from *The Red Book*, page 29

Fig. 38. Detail from *The Red Book*, page 61

CAT. 44. *Stele,* ca. 1916
Carved wood, painted
51 × 11 × 3 cm (20¹/₁₆ × 4¹⁵/₁₆ × 1³/₁₆ in.)
Jung Family Archive

LITERATURE
C.G. Jung, "Mandala eines modernen
Menschen," pp. 16–17, 21; Museum Rietberg,
p. 36 (ill. 23); Musée Guimet, p. 14 (ill. 14).

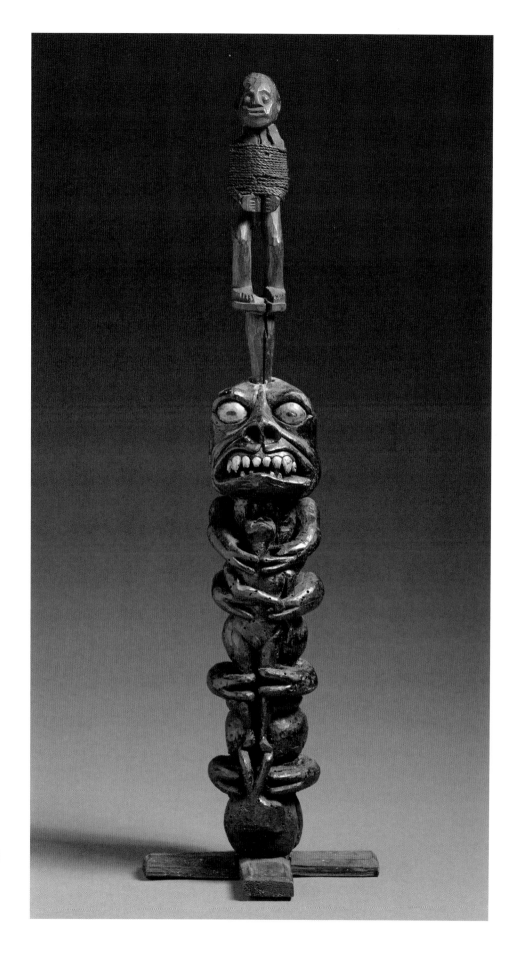

CAT. 45. *Devilish Monster,* ca. 1925
Carved wood, painted
33 × 8 × 8 cm (13 × 3⅛ × 3⅛ in.)
Private collection

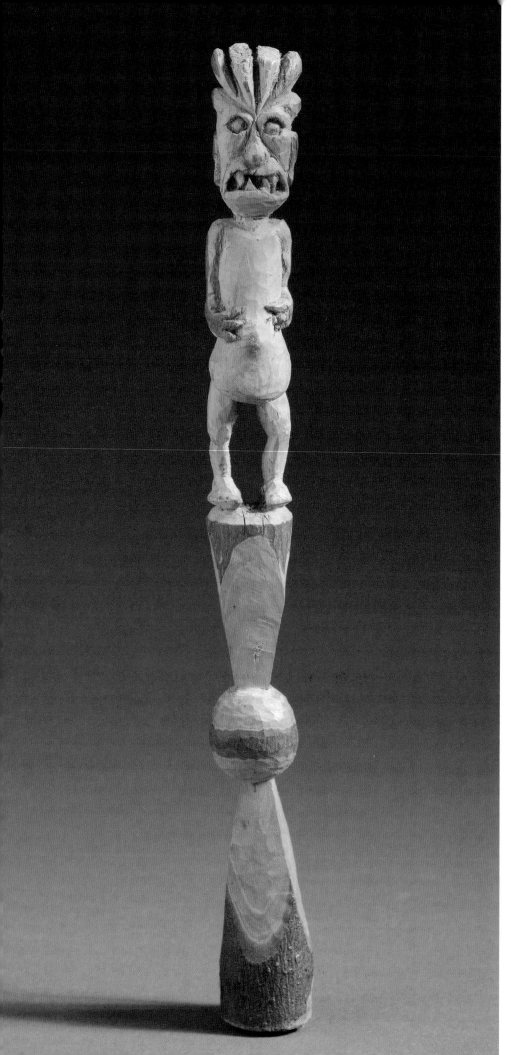

CAT. 46. *Gnome,* ca. 1920
Carved wood
27 × 3 × 3 cm (10⅝ × 1³⁄₁₆ × 1³⁄₁₆ in.)
Jung Family Archive

LITERATURE
Museum Rietberg, p. 38 (ill. 25); Musée Guimet,
p. 14 (ill.).

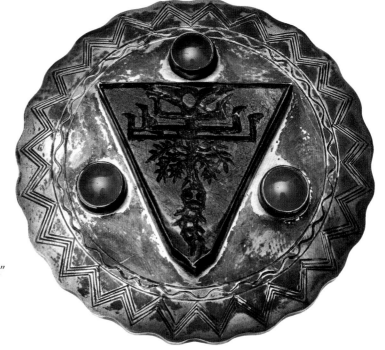

CAT. 47. *Brooch,* ca. 1917
Silver, moss agate, carnelian
6 cm (2⅜ in.) dia.
Jung Family Archive

LITERATURE
C.G. Jung, "Mandala eines modernen Menschen,"
pp. 16–17, 21.

 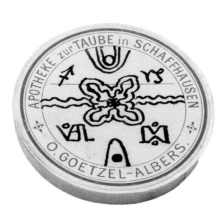

CAT. 48. *Talisman in Pillbox,* ca. 1917
Soapstone, cardboard, paper
Stone: 3.5 × 1.7 cm (1⅜ × ¹¹⁄₁₆ in.), Case: 5.2 cm (2¹⁄₁₆ in.) dia.
Jung Family Archive

LITERATURE
C.G. Jung, "Mandala eines modernen Menschen," pp. 16–17, 21.

COMMENTARY

The *Systema Mundi Totius* (cat. 41) was created in connection with the text of February 1916 in the *Black Books*, wherein Jung designed a kind of cosmology,[48] which was shortly thereafter printed privately and distributed under the title *Septem Sermones ad Mortuos*. The *Systema Mundi Totius*—the Greek/Latin title can be translated as "structure of the whole world"[49]—illustrates a world order, containing the same figures and concepts in image details and captions. Jung noted on the verso: "This is the first mandala I constructed in 1916, wholly unconscious of what it meant. C.G. Jung." Jung's handwritten copy of the *Sermones* contains a photograph of the *Systema*.[50] Much later, in 1955, Jung elaborated on the meaning of the *Systema* in the Swiss periodical *Du*:

> It represents the oppositions of the microcosmos within the macrocosmic world and its oppositions. At the top, the figure of a boy in a winged egg, named Erikapaios or Phanes, thus recalling orphic gods. His dark opponent in the depths is called here Abraxas. He represents the "dominus mundi," the lord of the physical world, and is a creator of the world with a dual oppositional nature.
>
> The tree of life with the inscription "vita" (life) grows out of him, correspondingly above a tree of light in the form of a candelabra with seven flames and the inscription "ignis" (fire) and "eros" (love) can be seen. Its light is directed toward the spiritual world of the divine child. Art and knowledge belong to this spiritual world; the former represented as a winged snake, and the latter as a winged mouse (as the activity of digging holes).
>
> The candelabra refers to the principle of the holy number three (two times three flames, with the one large flame in the middle, while the underworld of "Abraxas" is characterized by the number of the human being, five (two times five corners of his star). The accompanying animals of the nature-like world are a devilish monster and a grub. This refers to death and rebirth.
>
> Another part of the mandala is oriented horizontally. A snake climbs out of an inside circle, representing either the body or blood, and winds itself around the phallus, as a procreative principle. It is light and dark, pointing toward the dark world of the earth, the moon, and the void (therefore named Satanas).
>
> The lighted realm of abundance is on the right, where the dove of the Holy Ghost rises from the glowing circle "frigus sive amor dei" [cold or the love of God], and wisdom pours from a double-pitcher to the right and to the left.—This female sphere is that of heaven. The larger circle, indicated by the prongs or beams, represents an inner sun; inside this circle, the macrocosmos is repeated, though upside-down, as a reverse mirror-image. These repetitions are to be thought of as infinite, becoming ever smaller, until the center, which reaches the actual microcosmos.[51]

In 1940, Jung made the following observations about the *Systema* in his preparatory notes for a lecture on the comparative history of symbols to be delivered at the Davos Kunstgesellschaft: "4 pr.[imary] color[s] blue red yellow green. Cross/star in cent[er]/4 horizontal points. charact[er]ize] 4 elements./macro- a. microcosmos."[52]

The central figure of Abraxas was explained in 1932–33 in the seminar Visions:

it is the Gnostic symbol Abraxas, a made-up name meaning "365"; the number value of the letters amounts to the sum of 365, the number of days in a year, and the Gnostics used it as the name of their supreme deity. He was a time god. [. . .] (Proclus, the Neoplatonist, said:) "Where there is time, there is creation. Time and creation is the same."[53]

[. . .] that figure of Abraxas means the beginning and the end, it is life and death, therefore it is represented by a monstruous figure. It is a monster because it is the life of vegetation in the course of one year, the spring, and the autumn, the summer and the winter, the yea and nay of nature. So Abraxas is really identical with the Demiurgos, the world creator. [. . .] The philosophic school of Alexandria is probably the cradle of the Abraxas idea.[54]

Abraxas is usually represented with the head of a fowl, the body of a man, and the tail of a serpent, but there is also the lion-headed symbol with a dragon's body, the head crowned with twelve rays, alluding to the number of months.[55]

Two preparatory studies for the *Systema Mundi Totius* exist. First, in January 1916 Jung sketched the concept of the cosmological schema in his *Black Book V*.[56] It shows the basic structure, the circle with the vertical and horizontal axes, as well as symbolic motifs.

After the *Black Book* concept, Jung elaborated upon certain symbols of the *Systema* separately. In October of the same year, he sketched a vertical series of symbolic motifs in his calendar (cat. 43). Starting from the bottom, the following can be recognized: a caterpillar-like creature with a hideous, frightening face; a palm tree with its roots; a candelabra with seven arms; and a winged egg, which encloses a humanlike figure, the god Phanes. The same series of symbols is found on the colorfully painted wooden relief stele (cat. 44), in which the caterpillar is depicted like a snake.

Jung subsequently created different figures from this series of symbolic motifs in separate works. In particular, the motif of the devilish caterpillar-like monster seems to have fascinated him. The earliest representation of it is found on page 29 of *The Red Book* as a miniature with the initial letter *D*. This precedes the *Systema Mundi Totius* by a year. The monster with twelve feet and the frightening face appears to climb out of the red, glowing insides of the earth. The illumination is framed on three sides by gold, in which precious stones and human and animal figures are inlaid.

The caterpillar creature on page 61 in *The Red Book* was made at about the same time as the *Systema Mundi Totius*. It stands over a vessel, which is carrying an egg. The representation is part of a series of images that show the rebirth of god in the soul. The metamorphic caterpillar may symbolize this transformation. While the masklike face is frontal, the body appears in profile and is covered in ornamentation.[57]

Jung also carved *Devilish Monster*, a caterpillar creature, in wood (cat. 45). This sculpture has one peculiarity: its eight claws are wrapped around a female figure. Moreover, emerging from its head is a chained male figure of African origin, from the area of Mali or the northern Côte d'Ivoire.[58] It is unclear if Jung brought this sculpture back from his trip to Africa in 1925/26, when he went to Kenya, Uganda, Sudan, and Egypt, but not to West Africa.

The physiognomy of a carved wooden gnome or troll (cat. 46) again shows similarities with the various versions of *Devilish Monster* (cf. cat. 45). The rich detail of the fine wood carving suggests the period around 1920.

The devilish monster finally also adorns two small works of special character: a round silver brooch (cat. 47) with triangular blackish-gray moss agate and three round, polished carnelians shows the same motifs as the calendar sketch (cat. 43); and the painted wooden stele (cat. 44). Jung may have carved these himself on the piece, whereas a silversmith made the casing. The brooch was a gift to his wife.

The talisman (cat. 48) was also a gift to his wife. It consists of a small soapstone with a carved caterpillar. It was kept in a pillbox from the Schaffhausen pharmacy *Zur Taube*. On the cover there is a mandala that is related to the mandala series on pages 80–97 of *The Red Book*.[59] The following rhyme is written on the enclosed note:

> A mean ghost of sickness,
> Who's called rheumatism,
> Against him no one can help
> Like this talisman.

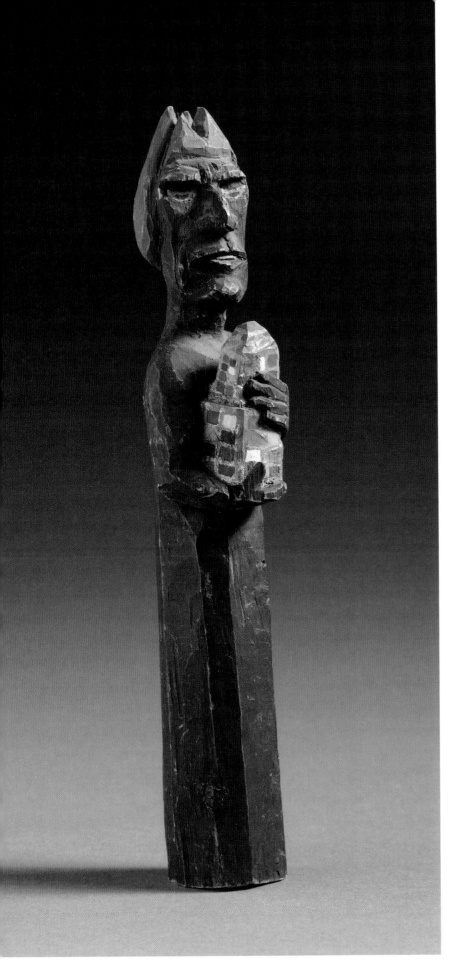

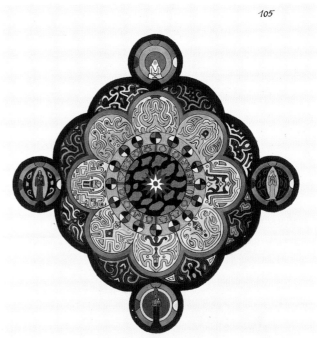

Fig. 39. Mandala, *The Red Book*, page 105

Fig. 40. Mandala, Detail from *The Red Book*, page 105

CAT. 49. *Loki / Hephaestus,* ca. 1920
Carved wood, painted
21 × 4 × 4 cm (8¼ × 1⁹⁄₁₆ × 1⁹⁄₁₆ in.)
Jung Family Archive

LITERATURE
CW 9/I, § 682; *RB*, p. 5; Museum Rietberg, p. 36 (ill. 24);
Musée Guimet, p. 15 (ill. 15).

COMMENTARY

The mandala motif is the most depicted figure in *The Red Book*, yet it is not mentioned anywhere in the text. However, Jung spoke about the mandala motif in detail elsewhere, for example in *Concerning Mandala Symbolism*, which first appeared in the German volume *Gestaltungen des Unbewussten* (*Forms of the Unconscious*) in 1950:[60]

> As I have said, mandala means "circle." There are innumerable variants of the motif here, but they are all based on the squaring of a circle. Their basic motif is the premonition of a centre of personality, a kind of central point within the psyche, to which everything is related, by which everything is arranged, and which is itself a source of energy. The energy of the central point is manifested in the almost irresistible compulsion and urge *to become what one is*, just as every organism is driven to assume the form that is characteristic of its nature [. . .]. This centre is not felt or thought of as the ego but [. . .] as the self. Although the centre is represented by an innermost point, it is surrounded by a periphery containing everything that belongs to the self—the paired opposites that make up the total personality. This totality comprises consciousness first of all, the personal unconscious, and finally an indefinitely large segment of the Collective Unconscious whose Archetypes are common to all mankind.[61]

Only the image from page 105 (fig. 39) of *The Red Book* is reproduced in this Gallery as an outstanding example of mandalas. It is one of the three images that Jung published anonymously in *The Secret of the Golden Flower* in 1929, where he wrote about it:

> In the centre, the white light, shining in the firmament; in the first circle, protoplasmic life seeds; in the second, rotating cosmic principles which contain the four primary colours; in the third and fourth creative forces working inward and outward. At the cardinal points: the masculine and feminine souls, both again divided into light and dark.[62]

In the essay "Concerning Mandala Symbolism," he later specified:

> In the centre is a star. The blue sky contains golden clouds. At the four cardinal points we see human figures: at the top, an old man in the attitude of contemplation; at the bottom, Loki or Hephaestus with red, flaming hair holding in his hand a temple. To the right and left are a light and a dark female figure. Together they indicate four aspects of the personality, or four archetypal figures belonging, as it were, to the periphery of the self. The two female figures can be recognized without difficulty as the two aspects of the anima. The old man corresponds to the Archetype of meaning, or of the spirit and the dark chtonic figure to the opposite of the Wise Old Man, namely the magical (and sometimes destructive) Luciferian element. [. . .] The circle enclosing the sky contains structures or organisms that look like protozoa. The sixteen globes painted in four colours just outside this circle derived originally from an eye motif and therefore stand for the observing and discriminating consciousness. Similarly, the ornaments in the next circle, all opening inwards, rather like vessels pouring out their content toward the centre. On the other hand the ornaments along the rim open outwards, as if to receive something from outside.

That is, in the individuation process what were originally projections stream back "inside" and are integrated into the personality again.[63]

The painted wooden sculpture (cat. 49) corresponds to "Loki or Hephaestus with red, flaming hair holding in his hand a temple" that is recognizable in the circle in the lower part of the mandala. In Germanic mythology, Loki is the demon of fire and decay; Hephaestus in Greek mythology is the god of fire and blacksmithing.

10. Phanes

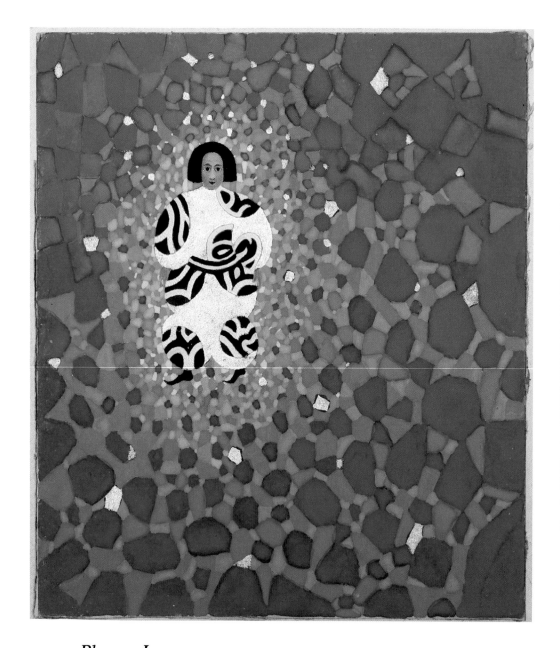

Fig. 41. Detail from *The Red Book*, page 113

CAT. 50. *Phanes I,* 1917
Gouache and gold bronze on cardboard
19 × 18.4 cm (7½ × 7¼ in.)
Private collection

LITERATURE
CW 5, § 198; *RB*, p. 70; Wehr, *An Illustrated Biography of C.G. Jung,* p. 140 (ill.); Karl Kerényi,
The Gods of the Greeks (London: Thames and Hudson, 1951), p. 147; Museum Rietberg, p. 33 (ill. 19);
Musée Guimet, p. 13 (ill. 12).

Fig. 42. Phanes in the egg with the twelve signs of the zodiac, reproduced in *Revue archéologique XL*, 1902. © Ministerio dei Beni e delle Atività Culturali e del Turismo—Archivio fotografico delle Gallerie Estensi, Foto Paolo Terzi

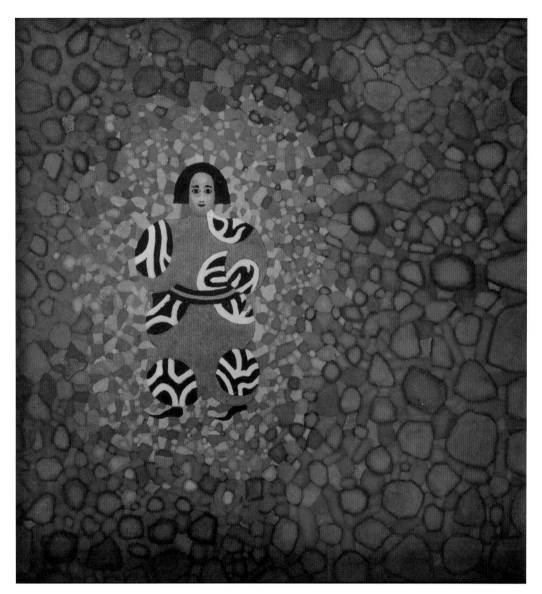

CAT. 51. *Phanes II*, 1917

Gouache and gold bronze on cardboard

20 × 19 cm (7⅞ × 7½ in.)

Inscription verso: nicht später als 1917 (CGJ 1953) [not later than 1917 (CGJ 1953)]

Private collection

LITERATURE

CW 5, § 198; Carl Gustav Jung, *Jung's Seminar on Nietzsche's Zarathustra*, vol. 2, ed. James L. Jarrett (Princeton: Princeton University Press, 1988), p. 796; *RB*, p. 70; Kerényi, *The Gods of the Greeks*, p. 147; Wehr, *An Illustrated Biography of C.G. Jung*, p. 140.

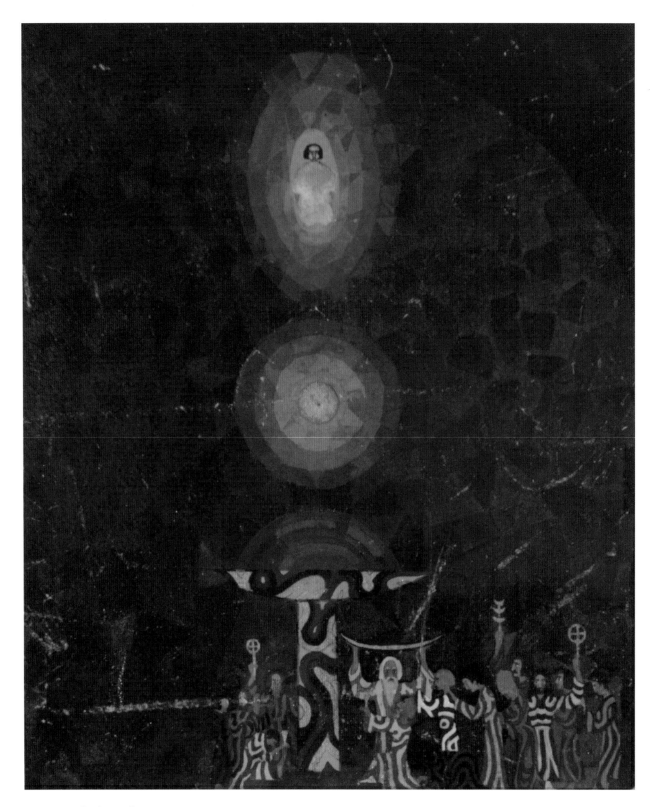

CAT. 52. *Cultic Scene I,* ca. 1917
Gouache on cardboard
26 × 21 cm (10¼ × 8¼ in.)
Jung Family Archive

LITERATURE
Museum Rietberg, p. 39 (ill. 27); Musée Guimet, p. 17 (ill.).

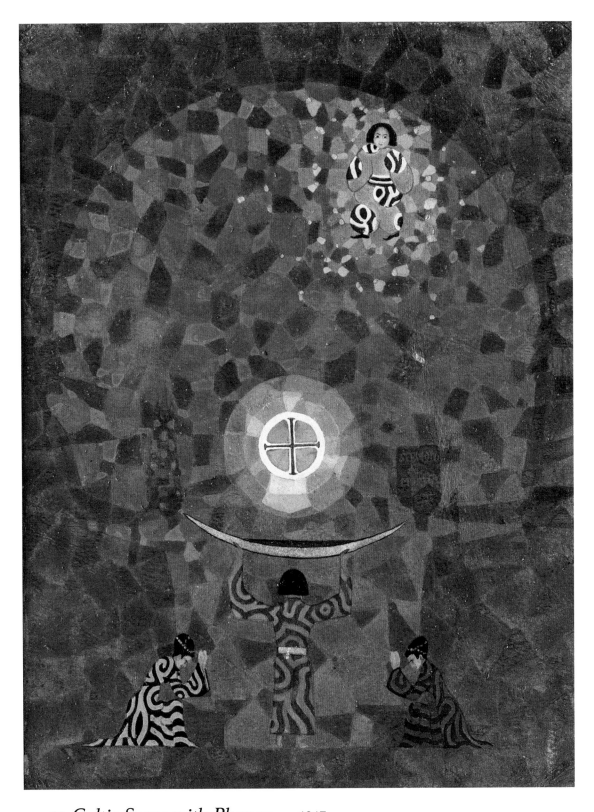

CAT. 53. *Cultic Scene with Phanes,* ca. 1917
Gouache and gold bronze on paper
28.5 × 20.5 cm (11¼ × 8¹/₁₆ in.)
Private collection

LITERATURE
Diana Jansen Baynes, *Jung's Apprentice* (Einsiedeln: Daimon, 2004), p. 278 (ill.); Sotheby's London, *Sale Music, Continental and Russian Books and Manuscripts,* sales cat., May 28, 2015, Lot 45.

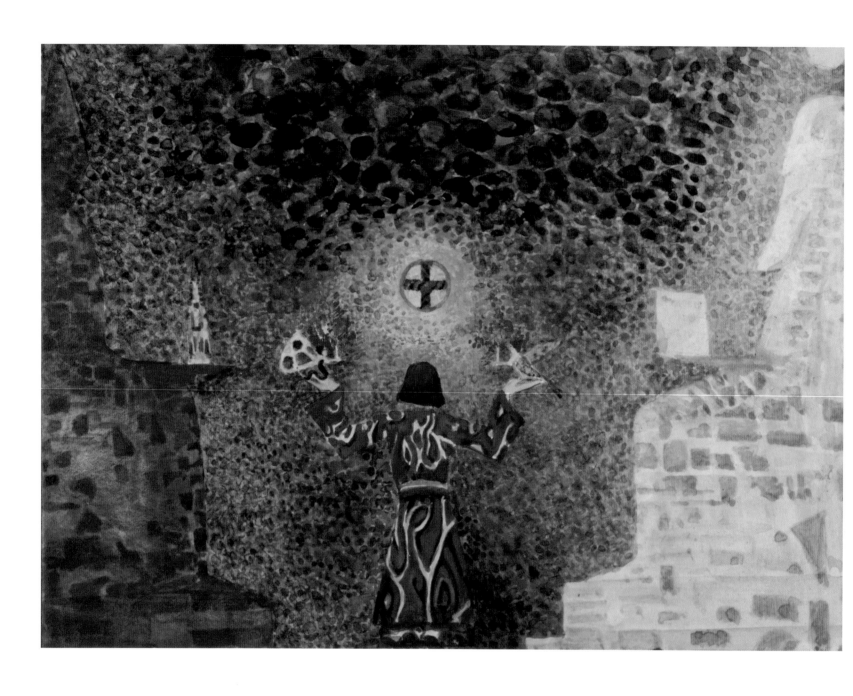

CAT. 54. *Cultic Scene II,* ca. 1919
Gouache on paper
11 × 14 cm (4⁵⁄₁₆ × 5½ in.)
Jung Family Archive

LITERATURE
Museum Rietberg, p. 41 (ill. 34); Musée Guimet, p. 17 (ill.).

CAT. 55. *Imagination of Spring,* ca. 1920
Pastel on cardboard
18 × 22 cm (7¹⁄₁₆ × 8¹¹⁄₁₆ in.)
Inscription verso: Ein Frühlingsanblick ohne Schnee in einer besseren Zukunft oder Vergangenheit. Zu Deinem
Geburtstag künstlich dargestellet und mit Farben gezieret. [A spring view without snow into a better future or past.
Artistically created for your birthday and decorated with colors.]
Jung Family Archive

COMMENTARY

In 1912, Jung noted in *Wandlungen und Symbole der Libido*: "Numerous mythological and philosophical attempts have been made to formulate and visualize the creative force which man knows only by subjective experience. To give but a few examples, I would remind the reader of the cosmogonic significance of Eros in Hesiod, and also of the Orphic figure of Phanes, The Shining One, the First-Created, the 'Father of Eros.'"[64] In 1951, the classicist and religious scholar Karl Kerényi described the Orphic creation myth as follows:

> Ancient Night conceived of the Wind and laid her silver Egg in the gigantic lap of Darkness. From the Egg sprang the son of the rushing Wind, a god with golden wings. He is called Eros, the god of love; but this is only *one* name, the loveliest of all the names this god bore. [. . .] His name of Phanes exactly explains what he did when he was hatched from the Egg: he revealed and brought into the light everything that had previously lain hidden in the silver Egg—in other words, the whole world.[65]

In 1917 in the *Black Books*, Jung let his fantasy figure Philemon proclaim a long hymn of praise to Phanes:

> Phanes is the god who rises glowing from the waters.
> Phanes is the smile of the reddening morning.
> Phanes is the beaming day.
> He is the eternally immortal today.
> He is the bubbling of the streams.
> He is the rustling of the wind.
> He is hunger and satisfaction.
> He is love and desire.
> He is sadness and consolation.
> He is the promise and fulfillment.
> He is the light that illuminates all darknesses.
> He is the eternal day.
> He is the silver light of the moon.
> He is the flickering of the stars.
> He is the falling star that lights up and travels away and is extinguished.
> He is the stream of falling stars that returns each year.
> He is the sun and moon, which return.
> He is the comet which brings war and noble wine.
> He is the good and the fullness of the year.
> He completes the hours with life-filled joy.
> He is the embrace and whispering of love.
> He is the warmth of friendship.
> He is the hope which enlivens the void.
> He is the magnificence of all the renewed suns.
> He is the joy at every birth.
> He is the glowing of the flowers.

He is the silk in the wing of a butterfly.

He is the scent of blooming gardens that fills the nights.

He is the song of joy.

He is the tree of light.

He is the perfection, to make each thing better.

He is all that sounds good.

He is harmony.

He is the holy number.

He is the promise of life.

He is the contract and the holy vow.

He is the plenitude of sounds and colors.

He is the observance of the morning, the noontime, and the evening.

He is kindness and gentleness.

He is the salvation.

After this hymn of praise, Philemon sat on the shining throne and closed his eyes and saw the eternal present. And after some time, he rose and spoke:

Truly, Phanes is the joyous day.

And he sat down again and hardened his gaze. And after some time had passed, he rose for a third time and spoke:

Truly, Phanes is the work and its completion and its compensation.

He is the difficult task and the peace of the evening.

He is the step on the middle way, he is its beginning,

its middle and its end

He is foresight.

He is the end of fear.

He is the sprouting seed, the bud that opens.

He is the gate of reception, the taking up and the putting down.

He is the spring and the desert.

He is the safe haven and the night of the storm.

He is the certainty in doubt.

He is the stable in dissolution.

He is being freed from captivity.

He is counsel and power in marching ahead.

He is the human's friend, the light that radiates from him, the bright light that the human sees on his way.

He is the greatness of the human, his worth and his power.[66]

In the *Systema Mundi Totius*, Jung still represented Phanes according to mythological traditions, as a boy in a winged egg. Later he illustrated him in more personal variations as a childlike figure whose roundness is reminiscent of the egg.[67]

Around 1917, Jung painted the two very similar images, *Phanes I* (cat. 50) and *Phanes II* (cat. 51). He gave *Phanes I* to his wife, Emma Jung-Rauschenbach, and *Phanes II* to his close confidante, Toni Wolff—which he probably signed after she passed away in 1953.

In 1919, he painted the figure of Phanes on page 113 of *The Red Book* (fig. 41), though he does not mention him in the text. Phanes appears here not in front of a blue background but rather in the middle of an organic marmoreal ornament of turquoise and yellow, which repeats in the robe the polar opposites white and black, as well as gold. In this parallel, Kerényi's characterization of Phanes as the "appearing" and the "showing" manifests itself as one.[68] The picture caption reads: "This is the image of the divine child. It means the completion of a long path. [. . .] I called him Phanes, because he is the newly appearing God."[69]

Cultic Scene I (cat. 52) shows a ceremony where the incantation brings on a double vision consisting of a sphere of light and a humanlike creature reminiscent of Phanes. It is possible that this picture preceded the concentration on representations of Phanes, but the dating of this work is uncertain.

Cultic Scene with Phanes (cat. 53) shows the same configuration in a more abstract form: in front of a deep-blue background, three praying figures evoke the vision of the "appearing god" Phanes. As in *Cultic Scene I*, there are the sphere symbol and the humanlike creature, who looks like Phanes.[70] The gestures of the central figure recall the vessel-like form on one of the pages in the series of *Incantations* on page 53 in *The Red Book*. Instead of the side figures of the *Cultic Scene I*, outsized sitting forms are outlined here right and left in front of the shimmering ground. The one on the right holds in his hands a bowl with the inscription . . . SERMON . . . AD . . . MORTU . . . (i.e., *Septem Sermones ad Mortuos*), the one on the left has a device mounted with precious stones. The picture was a gift from Jung to his early colleague and traveling companion Helton Godwin Baynes.

In *Cultic Scene II* (cat. 54), the two kneeling figures in *Cultic Scene with Phanes* are gone, while the sitting figures on the side have a more sculptural appearance. Above this scene of invocation, the sphere appears as a symbol of completeness and the self, as it is the case in many of Jung's other pictures of 1919.

There is another painting that shows some similarities to *Cultic Scenes*, though it does not take up the Phanes motif. In this miniature *Imagination of Spring* (cat. 55), an exotic island landscape is imagined. A pagodalike building, surrounded with many stelae, can be seen in front of islands covered in bushes. A wooden bridge crosses to a small island, on which people are gathered around a smoldering fire. The celebratory scene may illustrate a ritual act. The building would then be a temple, the stele would be a cult object, the figures that stand apart from the group would be the priests. Of central importance is the light, shown in the sky in fine color gradings and reflected in the water, which seems to unite earth and sky. There is a sickle of a moon, but the sun remains invisible, which suggests a morning or evening sky. On the back of the picture, there is a dedication to Emma Jung-Rauschenbach attached, whose birthday on March 30 coincided with the beginning of spring.[71]

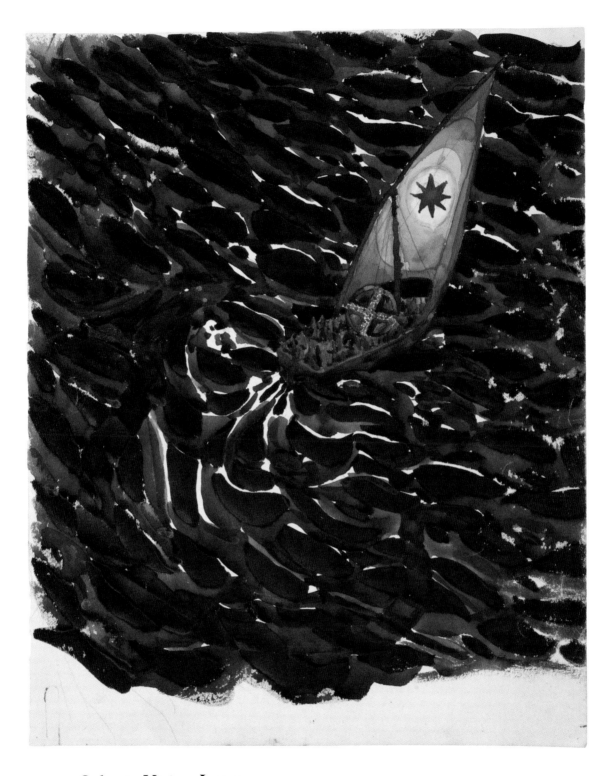

CAT. 56. *Spheric Vision I,* 1919
Gouache on paper
30 × 26 cm (11¹³⁄₁₆ × 10¼ in.)
Jung Family Archive

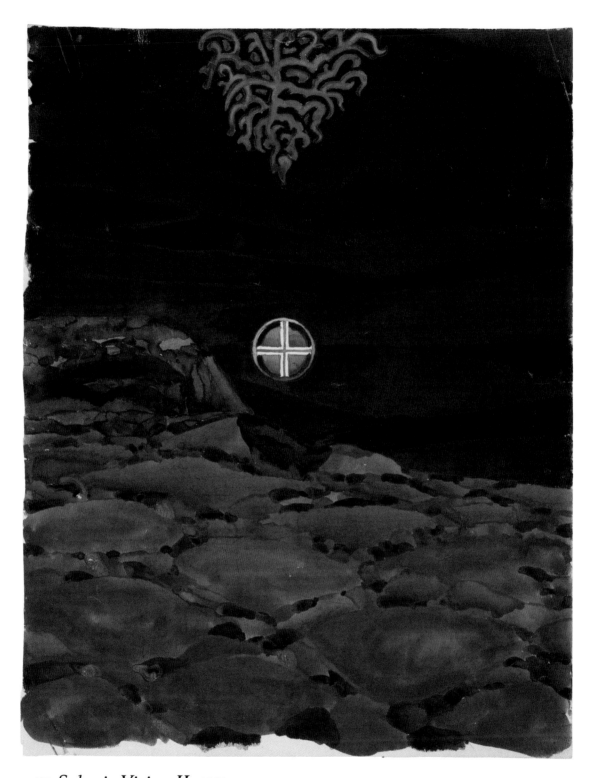

CAT. 57. *Spheric Vision II,* 1919
Gouache on paper
30 × 26 cm (11¹³⁄₁₆ × 10¼ in.)
Jung Family Archive

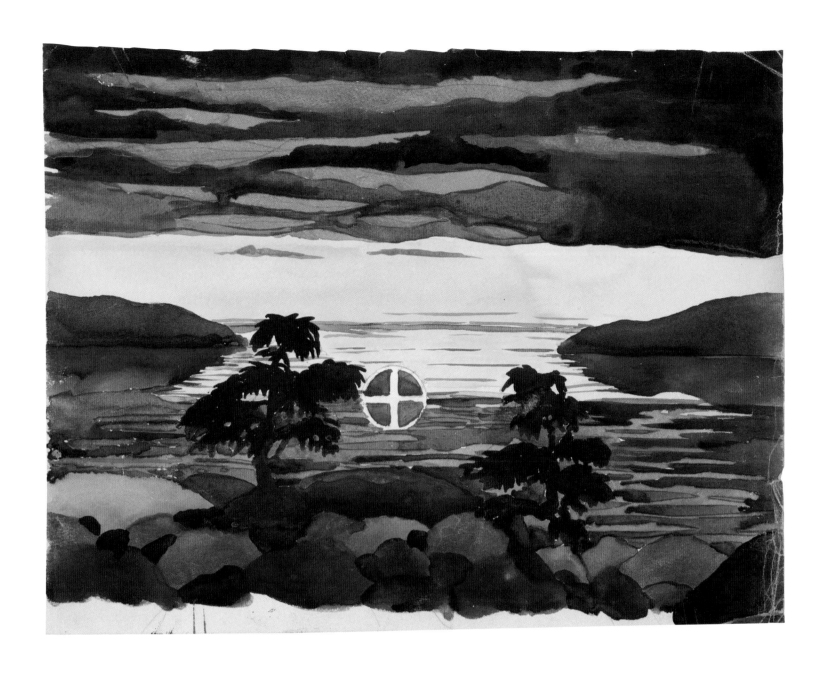

CAT. 58. *Spheric Vision III,* 1919
Gouache on paper
26 × 30 cm (10¼ × 11¹³⁄₁₆ in.)
Jung Family Archive

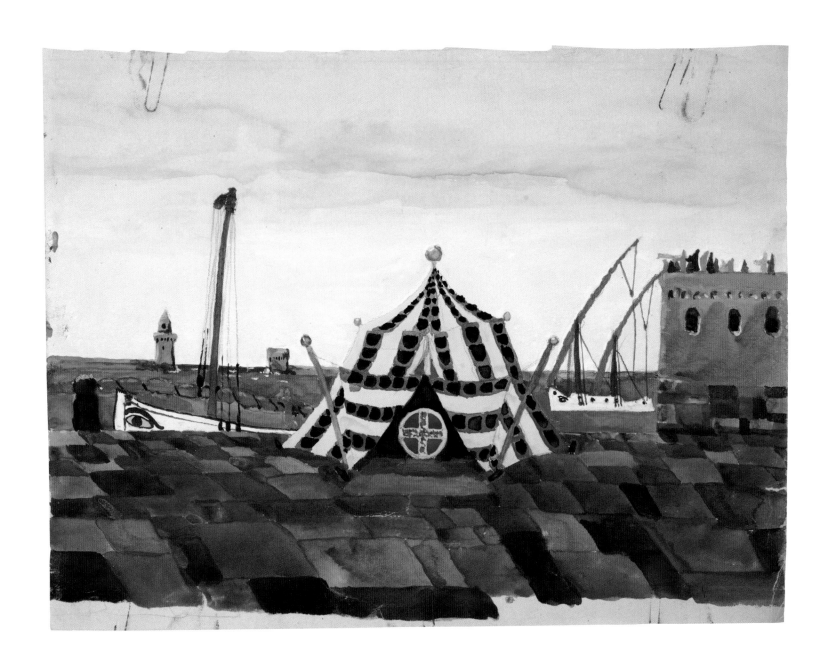

CAT. 59. *Spheric Vision IV,* 1919
Gouache on paper
26 × 30 cm (10¼ × 11¹³⁄₁₆ in.)
Jung Family Archive

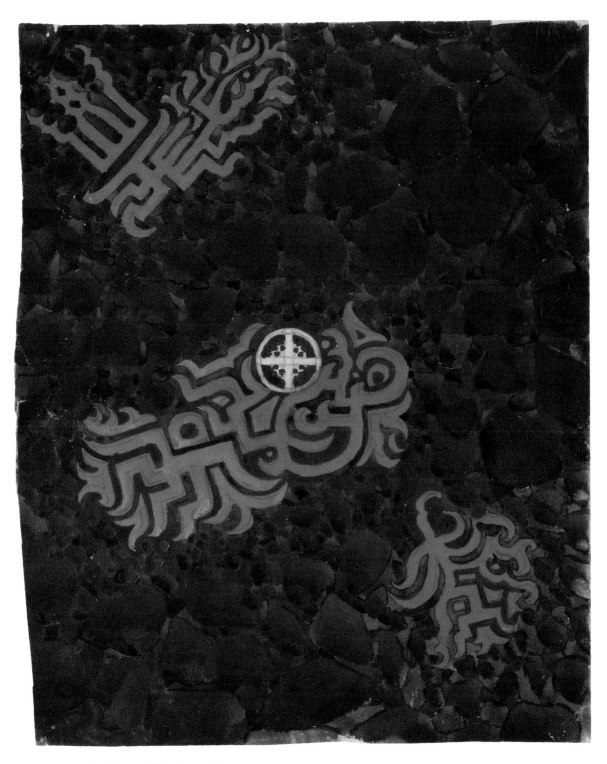

CAT. 60. *Spheric Vision V,* 1919
Gouache on paper
30 × 26 cm (11¹³⁄₁₆ × 10¼ in.)
Jung Family Archive

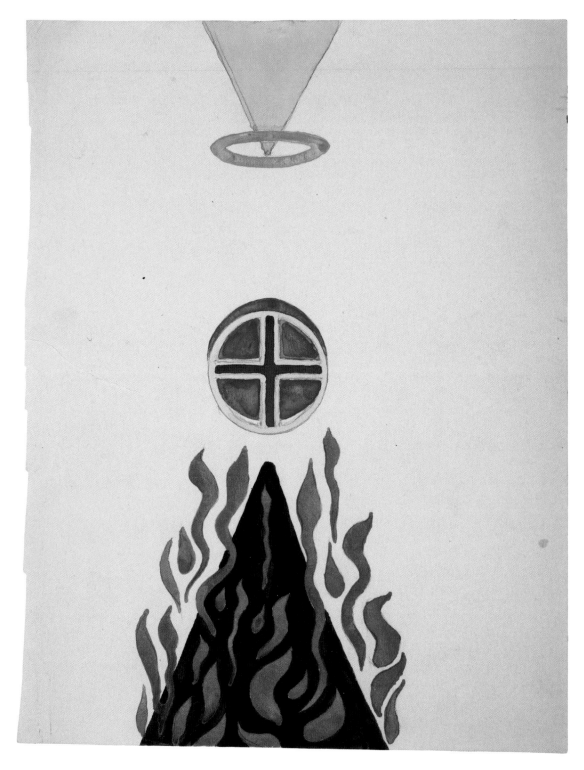

CAT. 61. *Spheric Vision VI*, 1919
Gouache on paper
30 × 26 cm (11¹³⁄₁₆ × 10¼ in.)
Jung Family Archive

LITERATURE
Jung, *Memories*, pp. 405–6; Museum Rietberg, pp. 39–40 (ills. 28–33); Musée Guimet, p. 16 (ill. 17a-e).

COMMENTARY

In conversation with Aniela Jaffé on February 6, 1959, Jung spoke of a series of spheric visions:

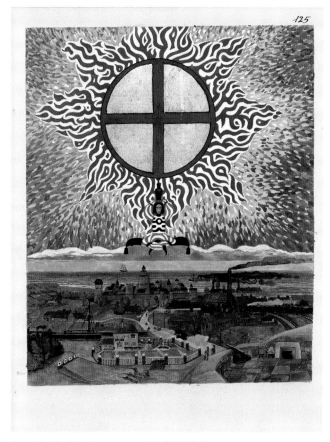

Fig. 43. *The Red Book*, page 125 (1919/20)

> In 1919 I had a bad flu and a forty-degree temperature. It was the "Spanish Flu." I felt I was losing my hold on life. Then I had a dream. Of course, I can't say for sure that it was a dream, or a vision: I found myself in a small sailboat on a wildly disturbed sea. In the boat I found a sphere. It was in the inside of the boat, and I had to bring it to safety. Behind me a monstrous wave arose, which threatened to swamp me and the boat [cat. 56]. Then, I landed on an island. It was a volcanic island, barren, like a lunar landscape or a dead country. Nothing grew there. I can't remember: was the sphere lying on the ground on the island, or did it hover over it? [cat. 57]. Later, another beautiful picture came. That must have been when I was recovering, or the dream picture denoted the beginning of the healing process: a wonderful evening sky vaulted over the island. Between the two trees, a sphere floated or had settled there [cat. 58]. And a last dream picture: it was in the harbor of Sousse in Tunis. There a precious tent was set up, and in the tent the sphere dwelled or was kept. In the harbor, the characteristic African sailboats were docked. The impression of the harbor was very clear and lucid. When I landed in Sousse a few weeks later, it was exactly as I had seen it in my dream [cat. 59]. At that time I didn't know that I would go to Africa. That was only two or three months later. When I arrived in Sousse, I saw right away: That is my dream! There are the boats just like in the dream![72]

The sphere or circle motif, symbol for *completeness* and *self*, appears in many of Jung's pictures.[73] In the four vertical and the two horizontal gouaches, the sphere is painted in various colors. However, just four of the six works are directly related to Jung's vision. They can be compared stylistically: three are done in a reductive realism and three with a symbolic language of forms. In the first gouache (cat. 56), Cabiri (dwarf gods in Greek mythology) are drawn in as the crew, recognizable by their peaked hats. The Cabiri can also be seen on the citadel in *Vision IV* (cat. 59). Certain elements of the gouaches (cats. 60, 61) are found again on pages 72 and 125 of *The Red Book*.

In particular the image on page 125 of *The Red Book* (fig. 43) belongs to the context of the spheric visions. Jung writes about it in *Flying Saucers: A Modern Myth of Things Seen in the Skies*:

> I also remember a picture that was shown to me in 1919, of a town stretching along the edge of the sea, an ordinary modern port with smoking factory chimneys, fortifications, soldiers, etc. Above it there lay a thick bank of cloud, and above this there rolled an "austere image," a shining disk divided into quadrants by a cross. Here again we have two worlds separated by a bank of cloud and not touching.[74]

12. Stars

CAT. 62. *Star,* ca. 1921
Gouache on paper
23 × 18 cm (9¹/₁₆ × 7¹/₁₆ in.)
Collection Emmanuel Kennedy

LITERATURE
Wehr, *An Illustrated Biography of C.G. Jung,* p. 141; Museum Rietberg, p. 34 (ill. 20); Musée Guimet, p. 13 (ill. 13).

COMMENTARY

Jung saw the star as a variation of the mandala figure. In 1950, he published the painting *Star* (cat. 62) in "Concerning Mandala Symbolism," immediately after the image of page 105 (fig. 39) in *The Red Book*, and added the following commentary:

> Once again the centre is symbolized by a star. This very common image is consistent with the previous pictures, where the sun represents the centre. The sun, too, is a star, a radiant cell in the ocean of the sky. The picture shows the self appearing as a star out of chaos. The four-rayed structure is emphasized by the use of four colours. The picture is significant in that it sets the structures of the self as a principle of order against chaos.[75]

The picture shows significant similarities to the image on page 129 of *The Red Book* (fig. 44). Jung's commentary, therefore, is probably valid for both of these images. The star image shows the structure of the self when faced by chaos.[76] The representation in *The Red Book*, however, is more complex. A dragon penetrates the star; below left one can see the light outlines and roofs of houses and an illuminated window; below right a human figure with raised arms is recognizable. The self belongs to the spiritual world. The dragon, in Jung's view, is the mythological form of the snake[77] and embodies similar traits. The motif could again refer to uniting the above with the below, the mental with the earthy aspects of the soul.

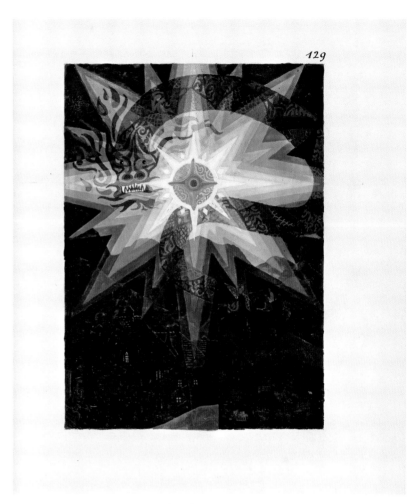

Fig. 44. *The Red Book*, page 129 (1921)

The star motif appears again in the image on page 159 of *The Red Book* (fig. 45). Jung published this work anonymously along with two other mandalas[78] in *The Secret of the Golden Flower* in 1929. He wrote about it: "A luminous flower in the centre, with stars rotating about it. Around the flower, walls with eight gates. The whole conceived as a transparent window."[79] In 1950, Jung wrote a new comment:

> The rose in the centre is depicted as a ruby, its outer ring being conceived as a wheel or a wall with gates [...]. The mandala [...] based on a dream: The dreamer found himself with three younger travelling companions in Liverpool. It was night, and raining. The air was full of smoke and soot. They climbed up from the harbor to the "upper city." The dreamer said: "It was terribly dark and disagreeable, and we could not understand how anyone could stick it here. We talked about this, and one of my companions said that, remarkably enough, a friend of his had settled here, which astonished everybody. During

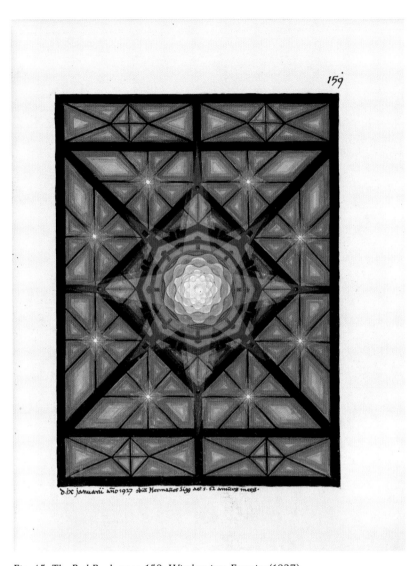

159

Fig. 45. *The Red Book*, page 159, *Window into Eternity* (1927)

this conversation we reached a sort of public garden in the middle of the city. The park was square, and in the centre was a lake or large pool. On it there was a single tree, a red-flowering magnolia, which miraculously stood in everlasting sunshine. I noticed that my companions had not seen this miracle, whereas I was beginning to understand why the man had settled here." The dreamer went on: "I tried to paint this dream. But as so often happens, it came out rather different. The magnolia turned into a sort of rose made of ruby-coloured glass. It shone like a four-rayed star. The square represents the wall of the park and at the same time a street leading round the park in a square. From it there radiate eight main streets, and from each of these eight side-streets, which meet in a shining red central point, rather like the Étoile in Paris. The acquaintance mentioned in the dream lived in a house at the corner of one of these stars." The mandala thus combines the classic motifs of flower, star, circle, precinct (*temenos*), and plan of [a] city divided into quarters with citadel. "The whole thing seemed like a window opening onto eternity."[80]

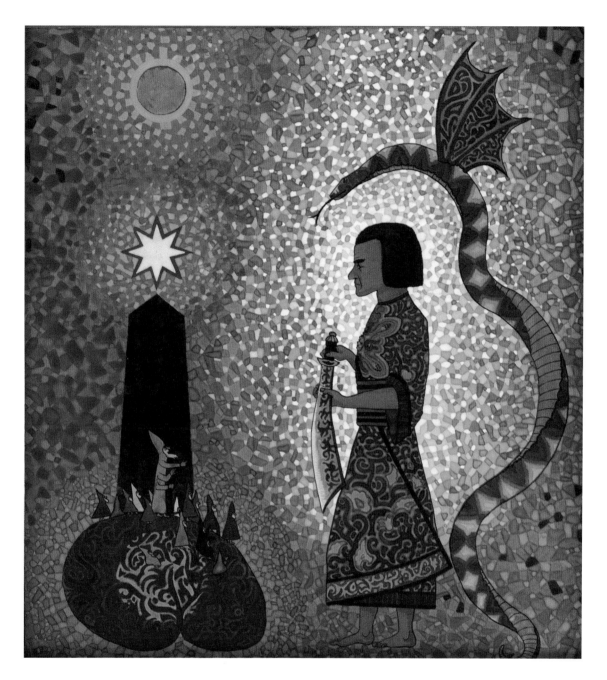

CAT. 63. *"The Artfully Tied Knot,"* 1917
Gouache and gold bronze on cardboard
37 × 31.5 cm (14⁹⁄₁₆ × 12³⁄₈ in.)
Inscription: Jung Dec. 1917
Dr. Felix Naeff-Meier, descendant of Wolff-Sutz

LITERATURE
CW 5, §§ 180–184; *CW* 12, §§ 203–205; Karl Kéreny, "The Mysteries of the Kabeiroi," in
The Mysteries: Papers from the Eranos Yearbooks, ed. Joseph Campell (Princeton: Princeton
University Press, 1979); Wehr, *An Illustrated Biography of C.G. Jung*, p. 141 (ill.); Museum Rietberg,
p. 31 (ill. 18); Musée Guimet, p. 12 (ill. 11).

Fig. 46. Detail from *Systema Mundi Totius*, cat. 41

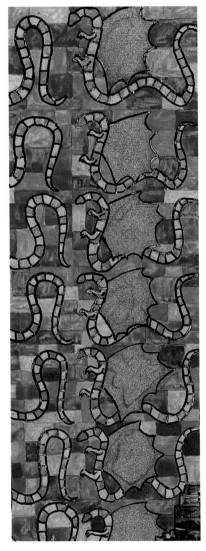

Fig. 47. Detail of the winged snake from *The Red Book*, page 36 (1915)

COMMENTARY

"The Artfully Tied Knot" (cat. 63) represents a special category of imagery. It illustrates a scene from *The Red Book* without having been included in the book itself. Jung did not give an explanation of it. However, the relevant passage in *The Red Book* text can be identified, which also refers to the title *"The Artfully Tied Knot,"* taken from an inscription on a piece of paper on the back of the painting. The verso inscription is a partial transcription from pages 165–68 of *The Red Book*:

> The Cabiri: We hauled things up / we built. / We placed stone upon stone. Now you stand on solid ground. We forged a flashing / sword for you / with which you can cut / the knot that entangles you. we also place before you the devilishly, skillfully twined knot / that locks and seals you. Strike / only sharpness will cut through it. do not hesitate. we need destruction since we ourselves are the entanglement. he who wishes to conquer new land/brings down the bridges behind him/let us not exist anymore. we are the thousands canals, in which everything also flows back again into its origin. 24 Dec. 1917[81]

From the text in *The Red Book* it also becomes clear that the male figure with the sword is Jung himself, while the knot represents his brain. Two more remarkable figures that also appear in other works by Jung are to be found in this image: the Cabiri and the winged snake.

In Greek mythology, the Cabiri were invisible, artistic, powerful dwarf gods from Asia Minor. On Samothrace, a shrine was dedicated to them.[82] They awakened Jung's scholarly interest as well as his fantasy. They also appear in the *Spheric Visions I* and *IV* (cats. 56, 59). Jung also referred to Atmavictu (cat. 67) and the central figure on the Bollingen Stone as Cabiri. The winged snake standing tall behind the person with the sword is also to be found in the *Systema Mundi Totius* (fig. 46), where it represents art as part of the spiritual world.[83] It may thus be a statement on Jung's understanding of art. The detail of the winged snake is again found in ornamental form in the image on page 36 of *The Red Book* (fig. 47).

CAT. 64. *Sketch Flying Philemon,* 1919
Graphite on paper
18 × 12 cm (7¹/₁₆ × 4¾ in.)
Jung Family Archive

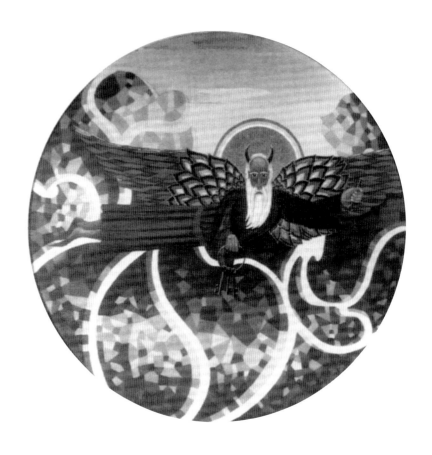

CAT. 65. *Philemon in Flight,* ca. 1920
Material and format unknown
Present whereabouts unknown

LITERATURE
Jung, *Memories*, pp. 205–9; Wehr, *An Illustrated Biography of C.G. Jung*, p. 72 (ill.).

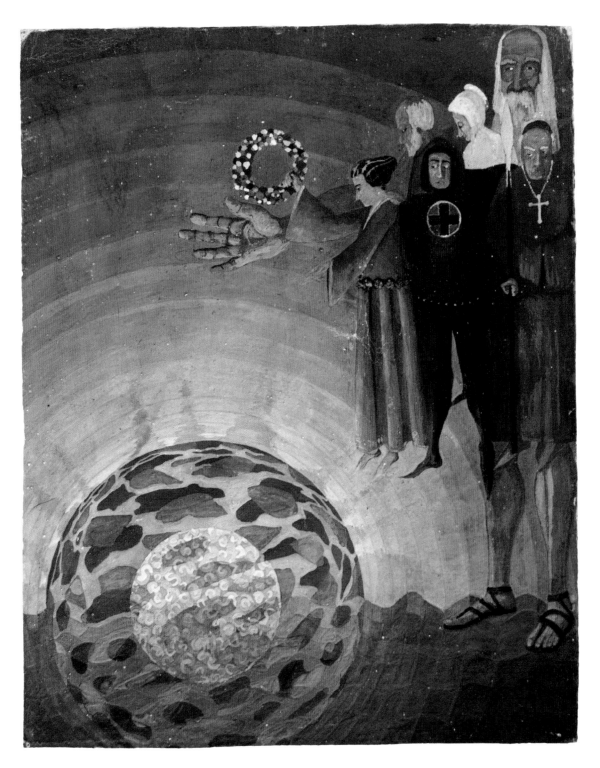

CAT. 66. *"We Fear and We Hope,"* 1923
Gouache on cardboard
30 × 23 cm (11^{13}/$_{16}$ × 9^{1}/$_{16}$ in.)
Inscriptions verso: AD 1923 Jung.sig. 1953
Private collection, Dornach

LITERATURE
Wehr, *An Illustrated Biography of C.G. Jung*, p. 46 (ill.); Museum Rietberg, p. 30 (ill. 17);
Musée Guimet, p. 12 (ill. 10).

COMMENTARY

In *The Red Book*, Jung conducts dialogues with imaginary figures, first with Elija and Salome, then more frequently with Philemon. The Philemon fantasies in *Black Book* IV begin in 1914. In *Memories* Jung explained:

> Soon after this fantasy another figure rose out of the unconscious. He developed out of the Elijah figure. I called him Philemon. Philemon was a pagan and brought with him an Egypto-Hellenic atmosphere with a Gnostic colouration. His figure appeared to me in the following dream.

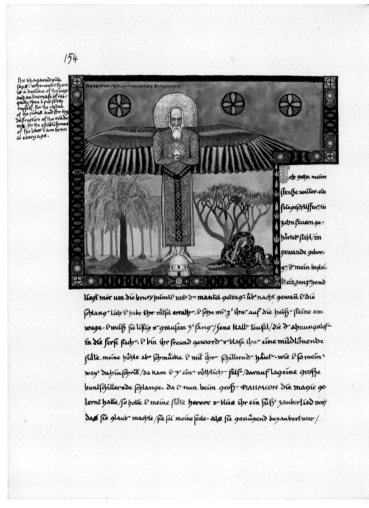

Fig. 48. *The Red Book*, page 154 (1925)

There was a blue sky, like the sea, covered not by clouds but by flat brown clods of earth. It looked as if the clods were breaking apart and the blue water of the sea were becoming visible between them. But the water was the blue sky. Suddenly there appeared from the right a winged being sailing across the sky. I saw that it was an old man with the horns of a bull. He held a bunch of four keys, one of which he clutched as if he were about to open a lock. He had the wings of the kingfisher with its characteristic colours.

Since I did not understand this dream-image, I painted it in order to impress it upon my memory. During the days when I was occupied with the painting, I found in my garden by the lake shore, a dead kingfisher! I was thunderstruck, for kingfishers are quite rare in the vicinity of Zurich and I have never since found a dead one. The body was recently dead—at the most, two or three days—and showed no external injuries.

Philemon and other figures of my fantasies brought home to me the crucial insight that there are things in the psyche which I do not produce, but which produce themselves and have their own life. [. . .] In my fantasies I held conversations with him, and he said things which I had not consciously thought. For I observed clearly that it was he who spoke, not I. He said I treated thoughts as if I generated them myself, but in his view thoughts were like animals in the forest, or people in a room, or birds in the air [. . .]. Through him the distinction was clarified between myself and the object of my thought. He confronted me in an objective manner, and I understood that there is something in me which can say things that I do not know and do not intend, things which may even be directed against me.[84]

Philemon is one of the most important figures in *The Red Book*. His character and appearance underwent certain changes. The first representations (cats. 64, 65) show his figure as Jung initially described it. Their more detailed execution in *The Red Book* can be dated to the end of 1923. The picture of Philemon on page 154 of *The Red Book* (fig. 48) was painted by Jung in 1924/25. There, Philemon is represented as a venerable old man, with wings surrounded by an aura. At his feet sits a small white Asian building with a dome, probably Philemon's temple. From the right, a snake unwinds itself and crawls toward the temple, which, in *The Red Book*, stands for the earthly aspect of the soul. At the upper edge of the picture is written in Greek letters ΠΡΟΦΗΤΩΝ ΠΑΤΗΡ ΠΟΛΥΦΙΛΟΣ ΦΙΛΗΜΩΝ [Father of the prophets, loving Philemon]. Exotic trees form the background. To the left of the picture, the following text is found: "The bhagavadgita says: whenever there is a decline of the law and an increase of iniquity, then I put forth myself. For the rescue of the pious and for the destruction of the evildoers, for the establishment of the law I am born in every age."[85]

The pencil drawing (cat. 64) is the first known representation of Philemon and is found on the page of Jung's calendar dated January 3, 1919. It is probably a study for a picture that has now been lost (cat. 65), which once hung in Emma Jung's room. Philemon is depicted as a man with bullhorns, carrying a bundle of keys. He appears out of an abstract organic ornamentation, which recalls *Spheric Vision V* (cat. 60).

The somewhat enigmatic picture "*We Fear and We Hope*" (cat. 66) may also belong to the Philemon context. Its title is taken from an inscription on the verso: "We fear and we hope: will you sacrifice the laurel of eternity to the bridal expectant earth? our feet stand in the void and are granted no beauty and fulfillment. will the promise be broken? will the eternal marry the temporal?" A literary source for this text has to date not been identified. In the lower left half of the picture, there is a variously colored, shimmering sphere half resting on the ground, perhaps a celestial body, which is surrounded by spheres of decreasing brightness. On the right side of the picture, there are two female and three male figures swaying in the void, along with a much larger bearded old man wearing sandals who stands on solid ground. His face recalls that of Philemon.[86] It appears that the people are illuminated by the sphere and are warmed by it. The picture was a gift for Toni Wolff. The signature of 1953 was probably added by Jung after her death.

15. Atmavictu and Other Figures

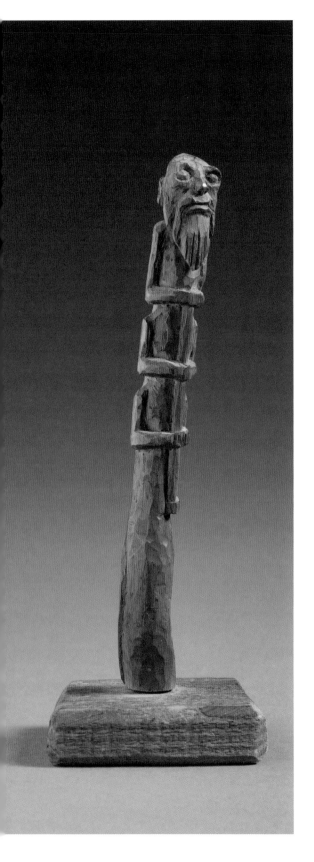

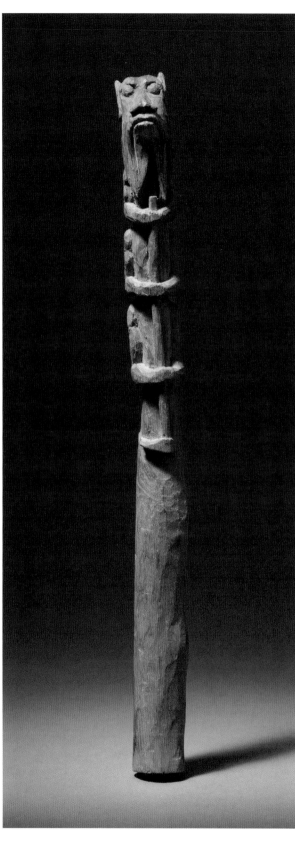

CAT. 67. *Atmavictu*, 1919
Carved wood
18 × 1.7 × 1.9 cm
(7¹/₁₆ × ¹¹/₁₆ × ³/₄ in.)
Jung Family Archive

LITERATURE
Jung, *Memories*, pp. 36–39;
*Carl Gustav Jung, Ausstellung
aus Anlass des 100. Geburts-
tages*, exh. cat. (Zurich: Helm-
haus, 1975), p. 13 (ill.); Wehr,
*An Illustrated Biography of
C.G. Jung*, p. 126 (ill.); Museum
Rietberg, p. 45 (ill. 37).

CAT. 68. *Bearded Figure
(Atmavictu?)*, 1919
Carved wood
28.5 × 2.3 × 3.2 cm
(11¹/₄ × ¹⁵/₁₆ × 1¹/₄ in.)
Private collection

LITERATURE
Jung, *Memories*, p. 126;
C.G. Jung: Word and Image, ed.
Jaffé, pp. 139–40; Museum
Rietberg, p. 44 (ill. 36).

Fig. 49. Sketch of the Cranwell Farm near Waddesdon Manor, UK, letter from Jung to Emma Jung, 1919. Courtesy Jung Family Archive

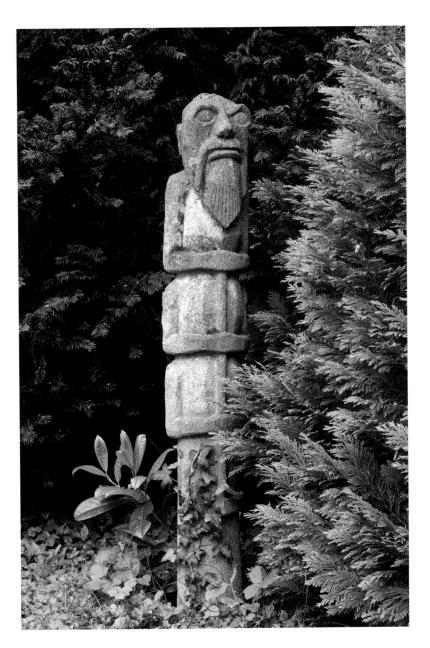

Fig. 50. Jung's daughters Helene (left) and Marianne (right) next to Atmavictu, ca. 1920

CAT. 69. *Atmavictu,* ca. 1920
Shell-limestone
112 × 15.5 × 16.5 cm (44¹/₁₆ × 6⅛ × 6½ in.)
Stiftung C.G. Jung Küsnacht

LITERATURE
Jung, *Memories*, pp. 36–39; *C.G. Jung: Word and Image*, ed. Jaffé, p. 141 (ill.); Gaillard, *Le Musée Imaginaire*, p. 217 (ill.); Andreas Jung et al., *The House of C.G. Jung*, ed. Stiftung C.G. Jung Küsnacht, p. 27 (ill.); Museum Rietberg, p. 44 (ill. 35); Musée Guimet, p. 17 (ill).

Fig. 51. *The Red Book*, page 117 (1919)

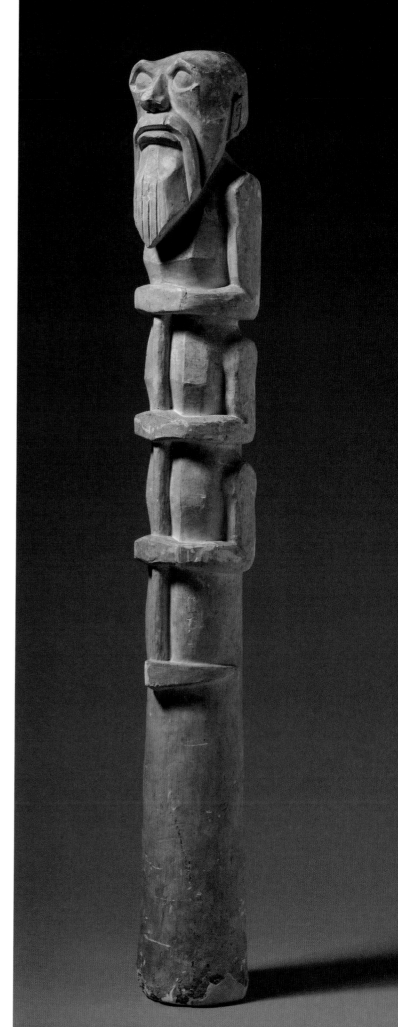

CAT. 70. *Atmavictu,* ca. 1920
Plaster
121 × 16 × 16 cm (47⅝ × 6⁵/₁₆ × 6⁵/₁₆ in.)
Jung Family Archive

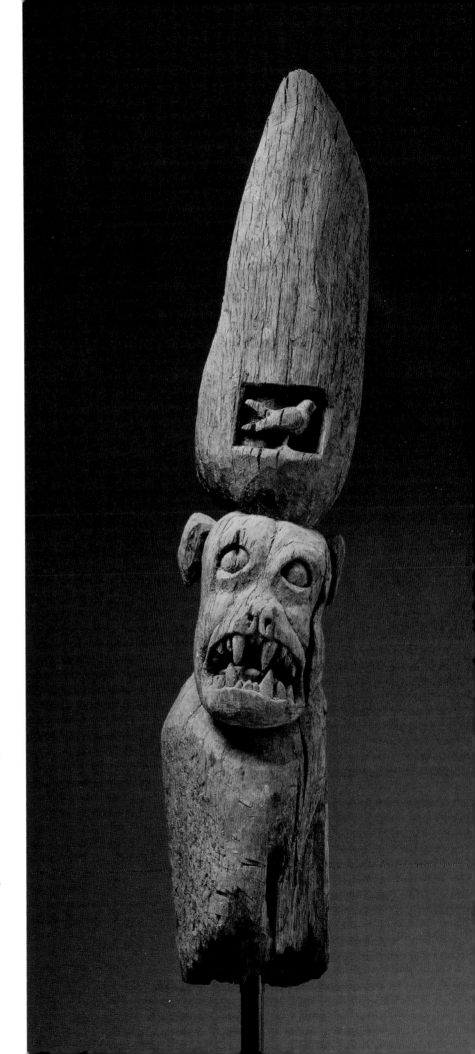

CAT. 71. *Grave Figure for a Dog,* ca. 1920
Carved oak
100 × 20 × 20 cm (39⅜ × 7⅞ × 7⅞ in.)
Jung Family Archive

LITERATURE
C.G. Jung, *Letters*, vol. 1, ed. Gerhard Adler,
tr. R.F.C. Hull (Princeton: Princeton University Press,
1973), p. 80; Museum Rietberg, p. 38 (ill. 26);
Musée Guimet, p. 15 (ill.).

COMMENTARY

In 1958, Jung described an event from when he was ten years old (1885):

> I had in those days a yellow, varnished pencil-case of the kind commonly used by
> primary-school pupils with a little lock and the customary ruler. At the end of this ruler
> I now carved a little manikin, about two inches long, with frock coat, top hat, and shiny
> black boots. I coloured him black with ink, sawed him off the ruler, and put him in the
> pencil-case, where I made him a little bed. I even made a coat for him out of a bit of
> wool. In the case I also placed a smooth, oblong blackish stone from the Rhine, which I
> had painted with watercolours to look as though it were divided into an upper and lower
> half, and had long carried around in my trouser pocket. This was *his* stone. All this was a
> great secret.[87]

And further:

> The episode with the carved manikin formed the climax and the conclusion of my child-
> hood. It lasted about a year. Thereafter I completely forgot the whole affair until I was
> thirty-five. [. . .] When I was in England in 1920, I carved out of wood two similar fig-
> ures without having the slightest recollection of the childhood experience. One of them
> I had reproduced on a larger scale in stone, and this figure now stands in my garden in
> Küsnacht. Only while I was doing this work did the unconscious supply me with a name.
> It called the figure "Atmavictu"—"breath of life."[88]

In the *Protocols* of 1957, Jung went still further: "The Atmavictu (in the Garden) is shown with a
hoe: this stands for farming. But as a whole it is a Kabir, shrouded in a small cloak, shrouded in
the 'kista' and provisioned with supplies of the life force."[89]

A year later, in 1958, he made another statement about the Atmavictu fantasy in the
Protocols:

> I was in England in 1920. There, I remember, I carved two similar figures in wood, like
> the little man made from the ruler. Or possibly I only carved the first figure there and
> the other when I got home. I then had them carved, enlarged, in stone, and this figure
> stands in my garden in Küsnacht. I know that at the time I was quite preoccupied with
> this fantasy, with this strange creature of the earth, who grew out of the ground. Atma-
> victu is a further development of this quasi sexual object, where it turns out that basically
> the breath of life that manifests itself in this way is a creative impulse. The segmentation
> recalls insects or plants, for example, equisetum, horsetail, a quite archaic plant. Both
> insects and plants have this segmentation, as well as the human spinal column.[90]

On the basis of letters to Emma, it can be accurately stated that Jung was in fact in England in
1919, a year earlier than the date given in the above recollections. From the beginning of June
until the beginning of July 1919, he visited Dr. Maurice Nicoll in London. On weekends, they
rented a country cottage at Cranwell Farm in Buckinghamshire, northwest of London, close to
Waddesdon Manor. According to Jung, the place was supposed to be haunted.[91] In a letter to

Emma, Jung drew Cranwell Farm (fig. 49).[92] Of the two Atmavictu figures carved in the summer of 1919 in England, cat. 67 is the model for the stone version. When he returned to Switzerland, Jung commissioned a sculptor to prepare first a model in plaster (cat. 70) and then to make the sculpture out of stone (cat. 69). Jung had the stone Atmavictu installed next to the shore at his house in Küsnacht (fig. 50).

Like Philemon or Phanes, Atmavictu in Jung's fantasy took form in different variations. He appeared to him for the first time in a fantasy on April 25, 1917.[93] A snake explains that Atmavictu was once an old man, who after his death changed himself into a bear and, in further metamorphoses, into an otter, a newt, and a snake. Finally, the snake transformed itself into Philemon. In 1919, on page 117 of *The Red Book*, Jung painted Atmavictu as a many-armed dragon. A similar dragon can be found in the images on pages 119 and 123; at the same time, Atmavictu on page 122 also appears as a petrified old man.

Unlike other pages, page 117 of *The Red Book* (fig. 51) has a block for writing and underneath it—similar to a pictorial encyclopedia—a row of figures with the corresponding inscription: a reptile with thirty-four feet under the disc of the sun: *Atmavictu*; a colorfully dressed human figure: *iuvenis adiutor* [a young aid]; a smaller colorfully dressed human figure: *Telesphoros*; a tiger: *spiritus malus in hominibus quibusdam* [the evil spirit in some people]. The caption reads: "The dragon wants to eat the sun, the youth beseeches him not to. But he eats it nevertheless." In ancient Chinese culture, the dragon that devours the sun was as an embodiment of the solar eclipse.

Around 1920, Jung carved a series of wooden figures that do not represent Atmavictu but that might have been inspired by him. Examples include the carved wooden gnome (cat. 46) and the stele for his dead dog, Pascha (cat. 71). There are indications that Jung made other figures of this type in the 1920s.[94] In the stele for his dead dog he worked the sculpture out of a piece of a tree trunk and placed it on the grave of his dog in the garden. The section planted in the earth decayed after thirty-five years, the intact part was later preserved in the house. At the top, the stele ends in a point, so that it looks as if the dog is wearing a bishop's miter. In the top section, a small niche is noticeable, in which a tiny bird is to be seen. Jung explains in the *Protocols*:

There are very strange forms in which the dead may show themselves. Even dead animals! [. . .] For example, I had a boxer called "Pascha," and whenever I was digging in the garden he would sit next to me and eagerly ate the larvae of the leaf thorn beetle which came to light while digging. Then he died, and I was very saddened by his death. Then I was digging again, and a small robin flew in and sat near me and began to eat the larvae, just like "Pascha" used to do. Finally, it sat on the shovel and waited to see if more larvae would be brought out. I was very touched and thought: that is my "Pascha," coming as a bird soul and eating the larvae. But then I was angry and thought: you're finally hallucinating! I called to my wife to come and verify what I saw. "Please come and look at this!" She came too, but when she was about fifteen meters away, the robin flew away; but she still saw it.[95]

16. Snakes

CAT. 72. *Sphere and Snake,* 1920
Gouache on paper
ca. 17 × 22 cm (6¹¹⁄₁₆ × 8¹¹⁄₁₆ in.)
Jung Foundation for Analytical Psychology, New York

LITERATURE
Museum Rietberg, p. 35 (ill. 22); Musée Guimet, p. 13 (ill).

CAT. 73. *Snake,* ca. 1920
Carved wood, painted
25 × 2 × 2 cm (9¹³⁄₁₆ × ¹³⁄₁₆ × ¹³⁄₁₆ in.)
Jung Family Archive

COMMENTARY

The snake symbol plays a prominent role in Jung's work. In *The Red Book*, the snake is one of the most important single motifs.[96] In his 1925 seminar Analytical Psychology, Jung explained the meaning of the snake as follows:

> The serpent is the animal, but the magical animal. There is hardly anyone whose relation to a snake is neutral. When you think of a snake, you are always in touch with racial instinct. Horses and monkeys have snake phobia, as man has. In primitive countries, you can easily see why man has acquired this instinct. The Bedouins are afraid of scorpions and carry amulets to protect themselves, especially stones from certain Roman ruins. So whenever a snake appears, you must think of a primordial feeling of fear. The black color goes with this feeling, and also with the subterranean character of the snake. It is hidden and therefore dangerous. As animal it symbolizes something unconscious; it is the instinctive movement or tendency; it shows the way to the hidden treasure, or it guards the treasure. The snake has a fascinating appeal, a peculiar attraction through fear. [. . .] The serpent shows the way to hidden things and expresses the introverting libido, which leads man to go beyond the point of safety, and beyond the limits of consciousness, as expressed by the deep crater. [. . .] The serpent leads the psychological movement apparently astray into the kingdom of shadows, dead and wrong images, but also in the earth, into concretization. [. . .] Inasmuch as the serpent leads into the shadows, it has the function of the anima; it leads you into the depths, it connects the above and the below. [. . .] Therefore the serpent is also the symbol of wisdom, speaks the wise word of the depths.[97]

The green snake (cat. 73) may be one of Jung's early works in wood. The use of a crooked branch is characteristic.

In the text of *The Red Book*, the soul appears with an earthly aspect as a snake, and with a heavenly aspect as a bird. In some scenes, it changes itself from a bird into a snake, then back again into a bird. *The Red Book* contains four full-page snake images (pages 54, 71, 109, and 111). The image on page 54 (fig. 52) is part of the "Incantations" series, and as such could refer to Jung's explanation of the snake as a symbol connecting the spiritual above and the earthly below. In the caption to the snake motif on page 109 of *The Red Book* (fig. 53), Jung wrote: "This man of matter rises up too far in the world of the spirit, but there the spirit bores him the heart with a golden ray. He falls with joy and disintegrates. The serpent, who represents evil, could not remain in the world of the spirit."[98]

About the snake in the picture on page 111 of *The Red Book* (fig. 54), Jung noted: "The serpent fell dead unto the earth." This event could be the continuation of page 109.

In its content and style, the drawing *Sphere and Snake* (cat. 72) is related to the snake pictures in *The Red Book* (figs. 52–54).[99] Jung painted it during a seminar at Sennen Cove in Cornwall, as can be deduced from the writing on the back: "painted by Jung during conference at Sennen Cove—Cornwall autumn 1920 and given to Dr. Beatrice M. Hinkle given to E. Bertine at her death march 1953."[100]

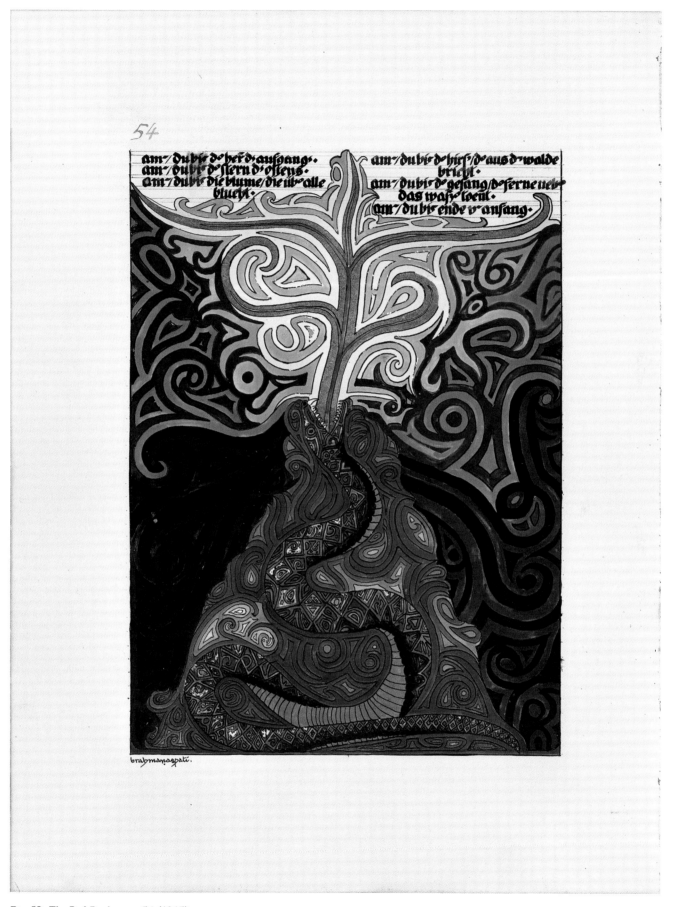

Fig. 52. *The Red Book*, page 54 (1915)

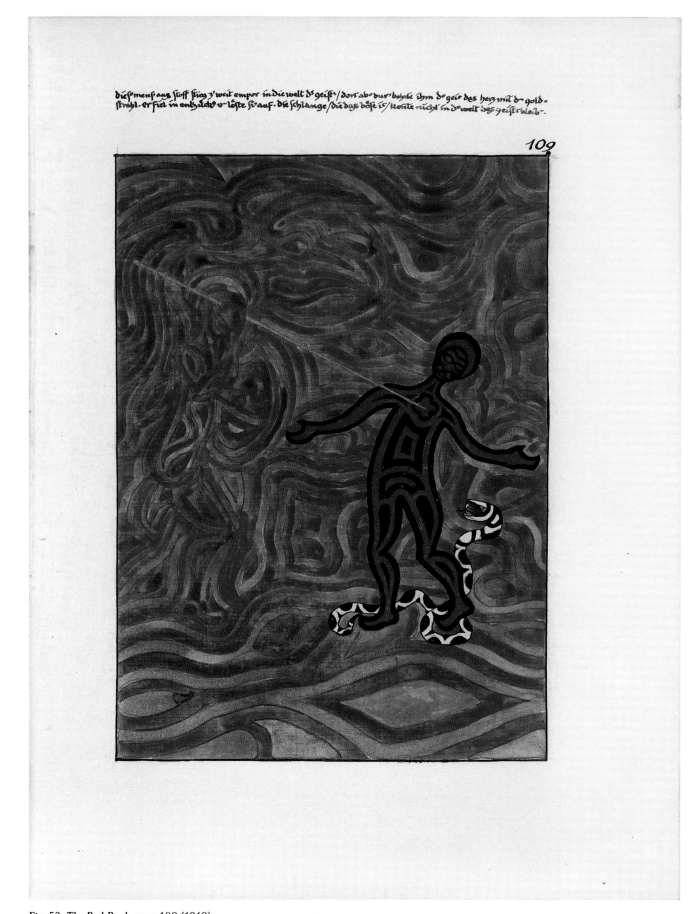

Fig. 53. *The Red Book,* page 109 (1919)

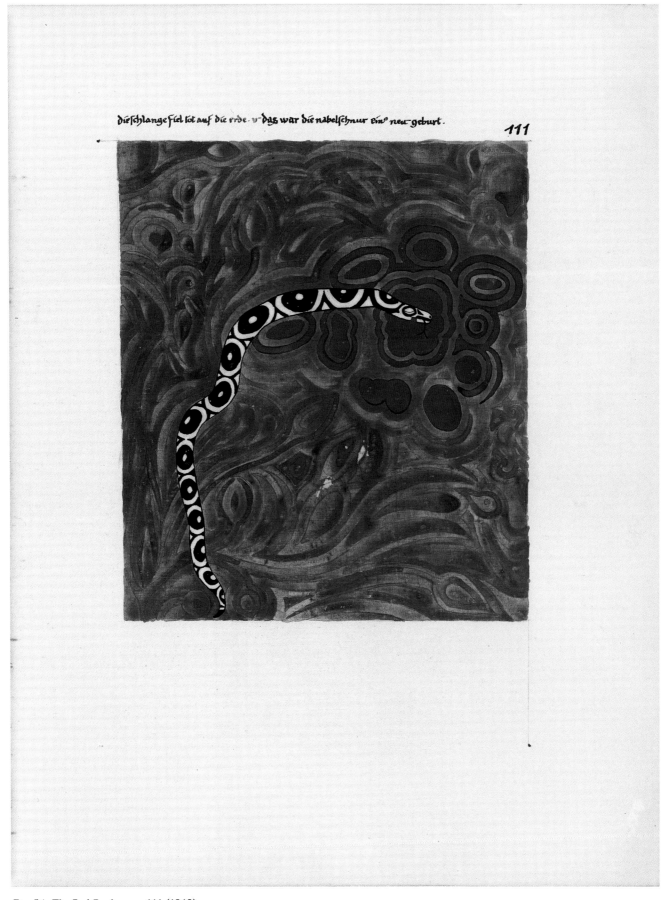

Fig. 54. *The Red Book,* page 111 (1919)

17. The Stone at Bollingen

CAT. 74. *Stone at Bollingen*, 1950
Sandstone, carved
Each 55 × 55 × 55 cm without the base
(each 21⅝ × 21⅝ × 21⅝ in.)
C.G. Jung-Stiftung Bollingen-Jona

LITERATURE
Jung, *Memories*, pp. 253–55; Homer,
Odyssey; Hermann Diels, *Die Fragmente
der Vorsokratiker* (Berlin: Weidmann,
1903); Albrecht Dieterich, *Eine Mithras-
liturgie* (Leipzig and Berlin: Teubner,
1923); *C.G. Jung: Word and Image*, ed.
Jaffé, pp. 196–205, 204–5 (ill.); Wehr,
An Illustrated Biography of C.G. Jung,
pp. 70–71 (ill.); Christian Gaillard,
Le Musée Imaginaire, p. 229 (ill.); Maud
Oakes, *The Stone Speaks: The Memoir
of a Personal Transformation* (Wilmette:
Chiron Publications, 1987); Museum
Rietberg, p. 52 (ill. 39); Musée Guimet,
p. 18 (ill.).

Inscription (facing north):

HIC LAPIS EXILIS EXTAT.
PRETIO QUOQUE VILIS.
ASPERNITUR A STULTIS,
AMATUR PLUS AB EDOCTIS.
IN MEMORIAM NATURAE SUAE DIEI
LXXV CGJUNG EX GRATIA
FECIT ET POSUIT ANNO MCML

Stone facing east

Stone facing south

Inscription (facing east):
Ο ΑΙΩΝ ΠΑΙΣ ΕΧΤΙ
ΠΑΙΖΩΝ ΠΕΤΤΕΥΩΝ
ΠΑΙΔΟΣ Η ΒΑΣΙΛΗΙΗ
ΤΕΛΕΣΦΟΡΟΣ
ΔΙΕΛΑΥΝΩΝ ΤΟΥΣ ΣΚΟΤΕΙΝΟΥΧ
ΤΟΥ ΚΟΣΜΟΥ ΤΟΠΟΥΣ
ΚΑΙ ΩΣ ΑΣΤΗΡ
ΑΝΑΛΑΜΠΩΝ ΕΚ ΤΟΥ ΒΑΘΟΥΣ.
ΟΔΗΓΕΙ ΠΑΡ ΗΛΙΟΙΟ ΠΥΛΑΣ
ΚΑΙ ΔΗΜΟΝ ΟΝΕΙΡΩΝ.

Inscription (facing south):
ORPHANUS SUM, SOLUS;
TAMEN UBIQUE REPERIOR. UNUS SUM,
SED MIHI CONTRARIUS.
IUVENIS ET SENEX SIMUL.
NEC PATREM NEC MATREM
NOVI, QUIA LEVANDUS SUM
PROFUNDO AD INSTAR PICIS
SEU DELABOR A COELO
QUASI CALCULUS ALBUS. NEMORIBUS
MONTIBUSQUE INERRO, IN PENITISSIMO
AUTEM HOMINE DELITESCO.
MORTALIS IN UNUM QUODQUE CAPUT,
NON TAMEN TANGEOR TEMPORUM MUTATIONE

COMMENTARY

On the origin of the stone (cat. 74) Jung related the following in *Memories*:

In 1950 I made a kind of monument out of stone to express what the Tower means to me. The story of how this stone came to me is a curious one. I needed stones for building the enclosing wall for the so-called garden, and ordered them from the quarry near Bollingen.[101] I was standing by when the mason gave all the measurements to the owner of the quarry, who wrote them down in his notebook. When the stones arrived by ship and were unloaded, it turned out that the cornerstone had altogether the wrong measurements; instead of a triangular stone, a square block had been sent: a perfect cube of much larger dimensions than had been ordered, about twenty inches thick. The mason was furious and told the barge men to take it right back with them.

But when I saw the stone, I said: "No, that is my stone. I must have it!" For I had seen at once that it suited me perfectly and that I wanted to do something with it. Only I did not yet know what. The first thing that occurred to me was a Latin verse by the alchemist Arnaldus de Villanova (died 1313). I chiseled this into the stone;[102] in translation it goes:

Here stands the mean uncomely stone
'Tis very cheap in price!
The more it is despised by fools,
The more loved by the wise.
This verse refers to the alchemist's stone, the *lapis*, which is despised and rejected.[103]

Soon something else emerged. I began to see on the front face, in the natural structure of the stone, a small circle, a sort of eye, which looked at me. I chiseled it into the stone, and in the centre made a tiny homunculus. This corresponds to the "little doll" (*pupilla*)—yourself—which you see in the pupil of another's eye; a kind of Kabir, or the Telesphoros of Asklepios. Ancient statues show him wearing a hooded cloak and carrying a lantern [figs. 55–57]. At the same time he is a pointer of the way. I dedicated a few words to him which came into my mind while I was working. The inscription is in Greek; the translation goes:

Time is a child,
playing like a child, playing a board game,
the kingdom of the child.[104]
This is Telesphoros,[105]
who roams through the dark
regions of this cosmos
and glows like a star
out of the depths.[106]
He points the way to the gates of the sun
and to the land of dreams.[107]

These words came to me—one after the other—while I worked on the stone.
On the third face, the one facing the lake, I let the stone itself speak, as it were, in a

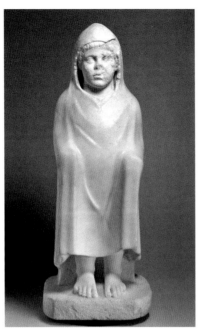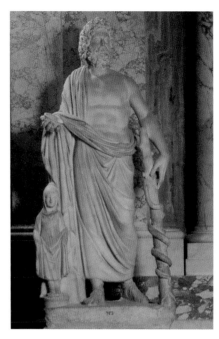

Fig. 55. A sleeping child holding a lamp and wearing a *cucullus* (hood), 1st–2nd century AD, found in Rome near the Palatine Bridge. National Museum of Rome, Baths of Diocletian

Fig. 56. Telesphoros in his usual form, 2nd century AD. Formerly in the Glyptothek, Munich. Gift of Paul Arndt and Walther Amelung

Fig. 57. Asclepius and Telesphoros, early 2nd century AD. Galleria Borghese, Rome

Latin inscription. These sayings are more or less quotations from alchemy.[108] This is the translation:

> I am an orphan, alone;
> nevertheless I am found everywhere. I am one,
> but opposed to myself.
> I am youth and old man at one and the same time.
> I have known neither father nor mother,
> because I have had to be fetched out of
> the deep like a fish, or fell
> like a white stone from heaven. In woods
> and mountains I roam, but
> I am hidden in the innermost soul of man.
> I am mortal for everyone, yet
> I am not touched by the cycle of aeons.[109]

In 1919, Jung painted a motif on page 121 of *The Red Book* (fig. 58) that he referred to as the philosopher's stone and explained in the caption: "XI. MCMXIX. This stone, set so beautifully, is certainly the Lapis Philosophorum. It is harder than diamond. But it expands into space

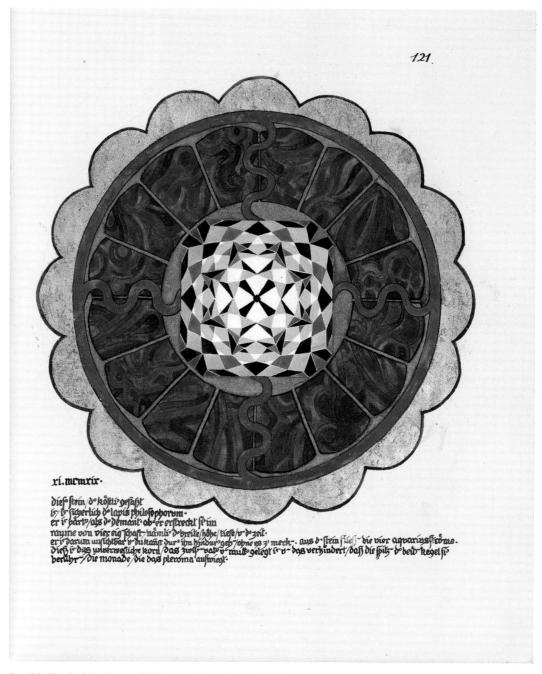

Fig. 58. *The Red Book*, page 121, *Lapis philosophorum* (1919)

through four distinct qualities, namely breath, height, depth, and time. It is hence invisible and you can pass through it without noticing it. The four streams of Aquarius flow from the stone. This is the incorruptible sea that lies between the father and the mother and prevents the heads of both cones from touching: it is the monad which countervails the Pleroma."[110] It is noteworthy that he painted this important alchemical symbol before he started studying alchemy in greater depth.

One can also argue that the Bollingen Stone incorporates the idea of a four-dimensional space through the configuration of its three chiseled faces and with the first word on the front face referring to "Time." The reference to space with four characteristics, specifically the "breadth [width], height, depth, and time" appears to be to Albert Einstein's discovery of four-dimensional space.[111] It was not the first time Jung referred to this concept. In *Septem Sermones ad Mortuos* (1916), it says: "four is the number of the measurements of the world."[112] In a certain sense, the *Lapis philosophorum* appears to be the dominant motif of the *Stone* (cat. 74).

The figure of Telesphoros, which Jung chiseled in the center of the front face, was the companion of the god of healing, Asklepios. As such, Telesphoros represented a physician's professional instincts. Jung comments on the figure of Telesphoros in several of his works.[113] However, Telesphoros does not look like any of the precedents from antiquity,[114] but rather Jung's imagining of Phanes in the pictures (see cats. 50–53; *RB*; p. 113).

18. Memorials

Fig. 59. The memorial for Toni Wolff in its garden setting next to the young gingko. Courtesy Walther Niehus

CAT. 75. *Memorial for Toni Wolff,* 1956
Sandstone
47 × 46.5 × 3 cm (18½ × 18⁵⁄₁₆ × 1³⁄₁₆ in.)
Jung Family Archive

LITERATURE
Nan Savage Healy, *Toni Wolff and C.G. Jung: A Collaboration* (Los Angeles: Tiberius Press, 2017), p. 302–6.

TONI ANNA WOLFF (SEPTEMBER 18, 1888–MARCH 21, 1953) Born in Zurich as the first of three daughters of the merchant Anton Wolff and Anna Elisabeth Sutz. She came to C.G. Jung as a patient for the first time in 1910. She became Jung's private assistant and close confidante at the time of the creation of *The Red Book*. She was also a founding member of the Psychology Club Zurich (president starting in 1928) and worked as an analyst with contributions regarding the female psyche. She died in Zurich in 1953.

ΤΟΥΤΟ ΤΟ ΜΝΗΜΕΙΟΝ ΤΗΣ ΑΓΑΘΗΣ ΚΑΙ ΛΙ
ΤΗΣ ΑΔΕΛΦΑΣ ΕΝ ΤΕΧΝΗΙ ΒΑΣΙΛΙΚΗΣ
ΑΝΤΩΝΙΑΣ ΤΗΣ ΠΕΡΙΣΤΕΡΑΣ ΤΟΥ ΕΡΜΟΥ
Κ. Γ. ΙΟΥΝΓ ΕΠΟΙΗΣΕΝ ·

CAT. 76. *Sketches for the Memorial for Toni Wolff,* 1955/1956
Graphite on ruled paper
18 × 23.5 cm (7¹⁄₁₆ × 9¼ in.)
Jung Family Archive

CAT. 77. *Book Dedication for Emma Jung-Rauschenbach in Swiss Chronicle by Johannes Stumpf,* 1921

Gouache on paper

Inscription: dieses Buch gehört Emma Jung-Rauschenbach geschenkt von ihr~ gatt~ zu weihnacht~ a.d. 1921 [this book belongs to Emma Jung-Rauschenbach, given by her husband on Christmas 1921]

12.7 × 18.9 cm (5 × 7⁷/₁₆ in.)

Foundation of the Works of C.G. Jung, Zurich

LITERATURE

RB, i (v); Jung, *Memories*, pp. 259–60; *Historisch-biographisches Lexikon der Schweiz*, vol. 6 (Neuchatel: Administration HBLS, 1931), p. 591; Wehr, *An Illustrated Biography of C.G. Jung*, p. 5.

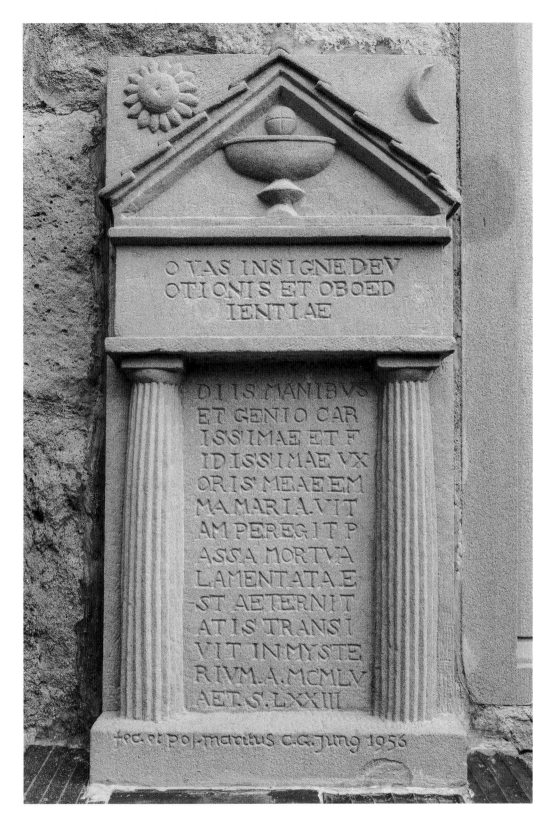

Inscription:
O VAS INSIGNE
DEVOTIONIS ET
OBOEDIENTIAE
DIIS MANIBUS
ET GENIO
CARISSIMAE ET
FIDISSIMAE
UXORIS MEAE
EMMA MARIA.
VITAM PEREGIT
PASSA MORTUA
LAMENTATA EST.
AETERNITATIS
TRANSIVIT
IN MYSTERIUM.
ANNO MCMLV
AETAS SUA LXXIII
fecit et posuit maritus
C.G. Jung 1956

EMMA JUNG-RAUSCHENBACH
(MARCH 30, 1882–NOVEMBER 27, 1955)
She was born in Schaffhausen,
Switzerland, first daughter of the
industrialist Jean Rauschenbach and
Bertha Schenk. After attending a
school for girls, she spent a year in
Paris. In 1899, she met Jung and they
married in 1903. Together they had
five children. She became the first
president of the Psychology Club
Zurich, founded in 1916. She worked
as a psychotherapist and made
extensive studies on the legend of
the Holy Grail. In 1950, she became
vice-president of the C.G. Jung
Institute Zurich. She died in 1955 at
her home in Küsnacht.

CAT. 78. *Memorial for Emma Jung-Rauschenbach,* 1956
Sandstone
91 × 47 × 13 cm (35¹³⁄₁₆ × 18½ × 5⅛ in.)
C.G. Jung-Stiftung Bollingen-Jona

CAT. 79. *Sketches for the Memorial for Emma Jung-Rauschenbach,* 1955/56
Graphite on ruled paper
18 × 11.7 cm (7 1/16 × 4 5/8 in.)
Jung Family Archive

Fig. 60. Franz Jung-Merker, plan for the execution of the memorial, 1957, ink on transparent paper, Jung Family Archive

CAT. 80. *Jung Family Grave*, 1961
Concept C.G. Jung
Shell–limestone, treated
130 × 82 × 15 cm (51³⁄₁₆ × 32¼ × 5¹⁵⁄₁₆ in.)
Friedhof Küsnacht Dorf, Obere Wiltisgasse Küsnacht

LITERATURE
C.G. Jung, *Letters*, vol. 2, ed. Gerhard Adler, tr. R.F.C. Hull (Princeton: Princeton University Press, 1975), pp. 610–11; Wehr, *An Illustrated Biography of C.G. Jung*, p. 109 (ill.).

COMMENTARY

In 1955, Jung was given a young gingko tree for his eightieth birthday. He planted it in the garden of his home in Küsnacht. In 1956, he placed a flagstone that he had carved (cat. 75) under the gingko tree. It shows Chinese characters and a gingko branch. According to one possible interpretation, Jung created a sort of riddle out of Chinese characters and phonetic symbols:

朵	To
靾	Ni
犭	Wolf
尼	Ni = Buddhist nun
賾	Cho = secret, occult

The meaning can be read: "Toni Wolff *soror mystica.*" The companion of an alchemist who contributed to his work was called *soror mystica.* Toni Wolff (1888–1953), confidante and colleague of Jung, was sometimes called *soror mystica* in jest.

The Latin inscription on the reverse side of the stone reads:

D M	(Dedicated to the spirits of the
SACRO ARBORIS	ancestors [and] the holy divine
HUIUS NUMINI	being of this tree, C.G. J[ung]
FEC ET POS C.G.J	created and placed [this stone]
ANNO MCMLVI	in the year 1956)

A notebook contains sketches of the memorial (cat. 76). It shows a sketch of an old man depicted on the slab, and there is a gingko leaf glued on. One page shows phonetic signs for *To* and *Ni* and the pictogram for *lupus* (Wolf), Buddhist nun and secret or occult.

Emma Jung-Rauschenbach died in the autumn of 1955. One year later, Jung erected her memorial stone, inspired by ancient Roman models, on the grounds of the Tower at Bollingen (cat. 78). As with the hand-painted vignette for Emma in the book (cat. 77), the motifs of temples and signs for sun and moon in coats-of-arms appear here again. The Latin inscription reads:

O incomparable vessel of dedication and obedience! To the spirit of the ancestors and the soul of my so very much beloved and faithful wife Emma Maria. She completed her life. After her suffering and death, she was consoled. She passed over into the

secret of eternity in the year 1955. Her age [was] seventy-three. Her husband C.G. Jung had made and placed [this stone] here in 1956.

Jung also designed this stone in his notebook (cat. 79). In 1957, he recalled how important carving stone was for him: "Everything that I have written this year and last year [. . .] has grown out of the stone sculptures I did after my wife's death. The close of life, the end, and what it made me realise, wrenched me violently out of myself. It costs me a great deal to regain my footing, and contact with stone helped me."[115]

The memorial stone for Emma is reminiscent of a small work by Jung dating from 1921, an illustrated book dedication. Jung painted the dedication to his wife, Emma Jung-Rauschenbach, in Johannes Stumpf's *Swiss Chronicle* (cat. 77).[116] The miniature, which is framed by columns and a simple crossbeam, shows the coats-of-arms of the Jung[117] and Rauschenbach[118] families in the crown of a tree. The abbreviations in the inscription follow the system applied by Jung in the text of *The Red Book*.

The family grave of 1961 (cat. 80) consists of one big rectilinear slab of stone. Above sits the coat-of-arms of the Jung family surrounded by inscriptions. The texts read, from bottom to top: "Vocatus atque non vocatus deus aderit" [Called or not called, God is there], Jung's motto;[119] and to the side: "Primus homo de terra terrenus secundus homo de caelo caelestis" [The first human comes from the earth and is earthly. The second human comes from the sky and is heavenly] (1 Corinthians 15: 47). In the corner, however, is the symbol of completeness: ⊕. Deceased members of the Jung family are memorialized:

Johannes Paul Jung 1842–1896 Emilie Jung-Preiswerk 1848–1923
Gertrud Jung 1884–1935
Emma Jung-Rauschenbach 1882–1955 Carl Gustav Jung 1875–1961[120]

Jung's son, Franz Jung-Merker, an architect by profession, explained: "The family grave of today was first built after the death of CGJ in 1961. The gravestone was designed during my father's life and discussed with him, and he chose the surrounding inscription, which I then drew out as described (fig. 60). I would find it appropriate for the gravestone to be classed among the works of CGJ and documented accordingly, because CGJ was involved substantively and decisively in the design. I was, so to speak, the one carrying it out, the drawing hand of his intuition."[121]

Jung began to concern himself with the subject of death long before he actually passed away, at an advanced age. His personal engagement with the questions concerning the end of life was also in the background of his attempt to finish the last full-size image on page 169 of *The Red Book* (fig. 61), as Aniela Jaffé recalled in 1961:

In the autumn of the year 1959, Jung took out *The Red Book*, after a long period of feeling of indisposition in order to finish the last remaining incomplete picture. He couldn't or wouldn't finish it. It had to do with death, he said. Instead he wrote a new longer fantasy dialogue,[122] which connects to one of the earliest dialogues in the book. The speakers

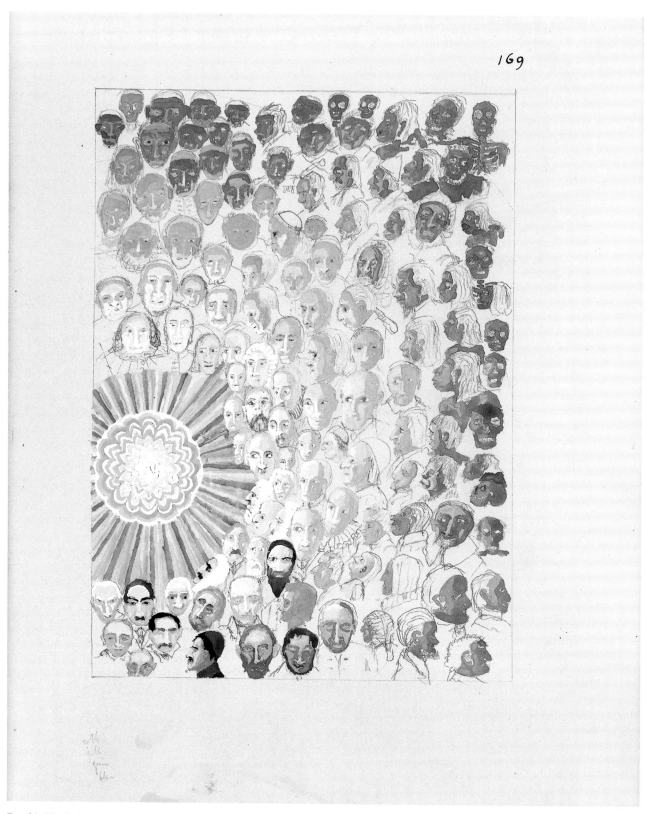

Fig. 61. *The Red Book*, page 169 (1928)

are again Elijah, Salome, and the snake. This time, he also wrote carefully in black ink in abbreviated gothic letters. [. . .] Sometimes the initial letters were decorated with paintings. At the end, there is a later entry, which is the only page in book that he wrote in his ordinary handwriting; it breaks off in the middle of a sentence. It says:

> 1959. I worked on this book for sixteen years. The acquaintance with alchemy in 1930 took me away from it. The beginning of the end came in 1928, when [Richard] Wilhelm sent me the text of *The Golden Flower*, this alchemical treatise. The content of the book found its way to reality. I could no longer work on it. To the superficial observer, it will seem like insanity. It would have become that, if I had not been able to capture the overwhelming power of the original experiences. I always knew that those experiences held something precious, and therefore I could not think of anything better to do than to write them down in a "precious," that is to say, expensive book, and to paint the pictures that rise up in re-experiencing them—as best as I could. I know how terribly inadequate this project was, but despite the heavy work and distraction, I stayed true to the task, even if another possibility never . . .[123]

Jung started the last picture in *The Red Book* around 1928, presumably grieving the loss of his good friend Hermann Sigg, who died the previous year.[124] In 1959, Jung was eighty-four years old. In the meantime, many people close to him had died; in 1953 Toni Wolff and in 1955 his wife, Emma Jung-Rauschenbach. He himself had had a near-death experience in 1944.[125] Jung died in 1961.

1. C.G. Jung, *Memories, Dreams, Reflections*, recorded and edited by Aniela Jaffé, tr. Richard and Clara Winston (New York: Pantheon Books, 1963), p. 33.

2. Ibid., p. 43.

3. Six months in the summer/fall 1887.

4. Jung, *Memories*, p. 46.

5. "Onion head" in the Basel dialect of Swiss German.

6. Jung, *Memories*, p. 100.

7. C.G. Jung, *The Zofingia Lectures*, Supplementary Volume A to *The Collected Works of C.G. Jung*, 21 vols., ed. William McGuire, tr. Jan van Heurck (Princeton: Princeton University Press, 1983).

8. Ibid., pp. 197–98.

9. Information provided by Agathe Niehus-Jung (1904–1998) and Franz Jung-Merker (1908–1996) in conversation with Ulrich Hoerni.

10. *The Secret of the Golden Flower: A Chinese Book of Life*, tr. Richard Wilhelm, Commentary by C.G. Jung, tr. into English Cary F. Baynes (London: Kegan Paul, Trench, Trubner & Co., 1931), ill. 10. Jung also discusses the picture in his essay "Concerning Mandala Symbolism" of 1950 (*CW* 9/I, § 691, ill. 36).

11. Here Jung is mistaken in his recollection. The fortress in Huningue had already been razed to the ground in 1816, about sixty years before Jung was born. It is possible that Jung knew the fortification in detail from engravings and plans, such that it could easily have been a model for his building plans. According to *Protocols*, he had visited another similar fortress, in Belfort, France, in his youth. See entry for May 4, 1959, Protocols of Aniela Jaffé's interviews with Jung for *Memories, Dreams, Reflections*, 1956–1958, Library of Congress, Washington, DC, p. 77. Hereafter *Protocols*.

12. Jung, *Memories*, p. 102.

13. Justin Gehrig, *Aus Kleinhüningens vergangenen Tagen, 1640/41–1940/41—Erinnerungsschrift an die 300jährige Zugehörigkeit des Ortes zur Schweiz* (Basel: Hans Boehm, 1941).

14. Friedrich Nietzsche, *Dionysos-Dithyramben*, Kritische Studienausgabe, vol. 6, ed. M. Montinari and G. Colli (Berlin: Walter de Gruyter, 1980), p. 396; *Dithyrambs of Dionysus*, tr. R. J. Hollingdale (London: Anvil Press, 1984), p. 51.

15. That the land had a strongly emotional significance for Jung becomes evident in different published letters: C.G. Jung, *Letters*, vol. 1, Letter to Meinrad Inglin, August 2, 1928: "with your book I knew what you were talking about – you talk about the great mystery of the Swiss lakes and mountains in which from time to time I blissfully immerse myself"; ibid., Letter to Emil Egli, September 15, 1943: "I am deeply convinced of the – unfortunately – still very mysterious relation between man and landscape, but hesitate to say anything about it because I could not substantiate it rationally."

16. In Goethe's novel *Wilhelm Meisters Lehrjahre* (Wilhelm Meister's Apprenticeship) of 1795/96, Mignon recites a poem, which starts with the verse, "Do you know the country, where the lemons bloom?" For Goethe, it has to do with the longing for Italy.

17. See entry for April 30, 1958, Jung, *Protocols*, p. 364.

18. Jung, *Memories*, pp. 97–99. *CW* 11, §§ 474–87.

19. Entry for October 4, 1957, Jung, *Protocols*, p. 165.

20. See ibid.

21. Franz Jung-Merker, Letter to Ulrich Hoerni, November 29, 1993.

22. Jung, *Memories*, p. 406.

23. Ibid., pp. 100–101.

24. Ibid., pp. 259–60.

25. First published in English in 1916 under the title *Psychology of the Unconscious: A Study of the Transformations and Symbolisms of the Libido* (New York: Moffat, Yard & Co.)

26. Jung, *Memories*, p. 194.

27. Ibid.

28. Dimensions 39 × 39 cm (15⅜ × 15⅜ in.), weight ca. 11 kg (24¼ lbs.). Jung first experimented with parchment (see *The Red Book/Liber Primus*, fols. i–viii), but, probably recognizing the limits of his skills in working on that medium (problems of color adhesion, script and color appearing on the verso), switched to vellum in *Liber Secundus*, which proved more sustainable for his painting techniques. *The Red Book/Liber Novus* material was published in a large-size facsimile edition by W. W. Norton in 2009, with an extensive explanatory commentary by Sonu Shamdasani.

29. Aniela Jaffé, "Nachtrag zum 'Roten Buch,'" in C.G. Jung, *Erinnerungen, Träume, Gedanken von C.G. Jung*, recorded and edited by Aniela Jaffé (Zurich and Düsseldorf: Walter, 1962), p. 387 (not included in the English editions of *Memories*).

30. C.G. Jung, *The Red Book: Liber Novus*, edited and introduced by Sonu Shamdasani, tr. Mark Kyburz, John Peck, and Sonu Shamdasani (New York: W. W. Norton, 2009), p. 330. Hereafter *RB*.

31. C.G. Jung, *Introduction to Jungian Psychology: Notes of the Seminar on Analytical Psychology Given in 1925*, ed. William McGuire; rev. ed. Sonu Shamdasani (Princeton: Princeton University Press, 2012), p. 68.

32. Ibid., p. 69.

33. *RB*, image detail, fol. v (v), translation, p. 245.

34. Ibid., fol. vi (r), translation, pp. 248f.

35. Ibid., translation, p. 250.

36. Ibid., image detail fol. vi (v), translation, p. 252.

37. C.G. Jung, *Introduction to Jungian Psychology*, p. 104.

38. *RB*, p. 155, translation, p. 317, note 283.

39. Jung, *Introduction to Jungian Psychology*, p. 48.

40. C.G. Jung, *Black Book* VIII, p. 6, forthcoming from the Philemon Foundation.

41. See Cultic Scene with Phanes, ca. 1917 (cat. 53).

42. *CW* 9/I, §§ 306–83.

43. Ibid., § 306.

44. Ibid., § 379.

45. Ibid., § 380.

46. Jung, *Memories*, p. 267.

47. *CW* 9/I, § 682.

48. Jung, *Black Book* V, entry of January 16, 1916, p. 63.

49. See note 7 in the Introduction.

50. Jung Family Archive.

51. The Swiss periodical *Du* dedicated an issue to Jung in 1955, in which, in the essay "Mandala eines modernen Menschen" (Mandala of a modern man), the *Systema Mundi Totius* was first reproduced and publicly commented by Jung. See Jung, "Mandalas," in *Du: Schweizerische Monatsschrift* 4 (1955), p. 16.

52. C.G. Jung, "Einführung in die vergleichende Symbolik. Grundideen der Menschheit. Ein Bild durch versch. Culturen und bei Individuen," lecture of December 4, 1940, on the comparative history of symbols at the Davos Kunstgesellschaft, ETH Zurich University Archives, Hs 1055: 245.

53. C.G. Jung, *Visions: Notes of the Seminar Given in 1930–1934*, vol. 2, ed. Claire Douglas (Princeton: Princeton University Press, 1997), p. 806.

54. Ibid., p. 807.

55. Ibid., p. 1041.

56. Jung, *Black Book* V, p. 169.

57. See Jay Sherry, "A Pictorial Guide to *The Red Book*," https://aras.org/sites/default/files/docs/00033Sherry.pdf, pp. 16–17 (accessed October 14, 2017).

58. We thank Lorenz Homberger for this information. In a communication of February 10, 2016, he recalls: "In my opinion, the small figure with the demon stuck in his head comes from a West African carving studio. The seers of the Bamana and Senufo (and also the neighboring people in

Burkina Faso) use these figures in their divining rites. Also the fact that the torso of the small figure is wound about with thread speaks to its use as device for divining."

59. Besides the central mandala, the hieroglyphics and the zodiac symbols for Sagittarius and Capricorn are to be found both in the mandala series in *The Red Book* and on the cover of the pillbox.

60. *CW* 9/I, §§ 627–712.

61. Ibid., §§ 629, 634.

62. *The Secret of the Golden Flower*, in *CW* 13, ill. A6.

63. *CW* 9/I, § 682.

64. *CW* 5, § 198.

65. Karl Kerényi, *The Gods of the Greeks* (London: Thames and Hudson, 1951), pp. 16–17.

66. Jung, *Black Book* VII, pp. 16–19.

67. The representation of Telesphoros in *RB*, p. 117, shows similarities with this Phanes type.

68. Kerényi, *The Gods of the Greeks*, p. 147.

69. *RB*, p. 113, translation, p. 301.

70. See *RB*, p. 113; cats. 50 and 51.

71. See inscription on *Imagination of Spring* (cat. 82 verso).

72. Aniela Jaffé, *Erlebtes und Gedachtes bei Jung*, p. 53, unpublished manuscript, ETH Zurich University Archives, Hs 1090: 97.

73. See, for example, *Systema Mundi Totius* (cat. 41), *Cultic Scene II* (cat. 54), *Star* (cat. 62), and *Cosmological Schema in Black Book V* (cat. 42); and in *RB*, pp. 45, 107, 121, 125, 127, 129, 131, 136. The red ornamentation corresponds to the type known on *RB*, pp. 53–55, 59, 60, 69, 70, 105, and 125.

74. *CW* 10, § 730.

75. *CW* 9/I, § 683.

76. See ibid.

77. Jung, *Introduction to Jungian Psychology*, pp. 99–108.

78. *RB*, pp. 163, 105.

79. *The Secret of the Golden Flower*, ill. A3.

80. *CW* 9/I, §§ 654–55.

81. Cf. *RB*, pp. 165–168, translation p. 321.

82. *CW* 5, §§ 180–184; *CW* 12, §§ 203–205.

83. See *Systema Mundi Totius* (cat. 41).

84. Jung, *Memories*, pp. 207–8.

85. Bhagavad Gita, IV, 7–8. Krishna teaches Arjuna about the essence of truth.

86. *RB*, p. 154.

87. Jung, *Memories*, p. 36.

88. Ibid., pp. 36–39. The little man from Jung's childhood cannot be located.

89. *Protocols*, entry for January 19, 1957, p. 11.

90. Ibid., entry for March 7, 1957, p. 325.

91. *CW* 18/I, §§ 764–777.

92. Jung Family Archive.

93. Jung, *Black Book* VI, pp. 178–86.

94. "Father was always carving on a branch," recalled Franz Jung-Merker ca. 1993 to Ulrich Hoerni.

95. *Protocols*, entry for December 6, 1957, p. 253.

96. Variations of the snake motif in *The Red Book* can be found on: fol. I (r), fol. ii (r), fol. iii (r), fol. v (v), fol. vi (v), pp. 22, 37, 40, 45, 51, 54, 71, 109, 111, and 154.

97. Jung, *Introduction to Jungian Psychology*, pp. 102–3.

98. The English translation in facsimile edition of *The Red Book* differs from the original. Cf. *RB*, p. 298, note 193.

99. See *"The Artfully Tied Knot"* (cat. 63) and *Sphere and Snake* (cat. 72); *RB*, pp. 54, 109, 111.

100. C.G. Jung, "Human Relationships in Relation to the Process of Individuation," unpublished lecture at Sennen Cove near Polzeath, Cornwall, July 1923. Only unauthorized longhand notes taken by M. Esther Harding and Kristine Mann for their own use survived. Cf. William McGuire, Introduction, C.G. Jung, *Dream Analysis: Notes of the Seminar Given in 1928–30*, ed. William McGuire (Princeton: Princeton University Press, 1884), p. ix.

101. In the Bollingen area, on the banks of Lake Zurich, there are quarries, the stones from which were used to build the old city of Zurich, among other things.

102. Arnaldus de Villanova (1235–ca. 1311) was an important Spanish doctor and pharmacologist. He translated significant medical works from Arabic into Latin. In addition, he studied theology, philosophy, and mysticism. He is supposed to have written some alchemical treatises.

103. Jung, *Memories*, p. 253.

104. Fragment 52B of the philosopher Heraclitus of Ephesus (ca. 520–460 BC).

105. Karl Kerényi, *Der göttliche Arzt* (Basel: Ciba, 1948), pp. 97, 100; see also *RB*, p. 117, translation, p. 303, note 222.

106. Albrecht Dieterich, *Eine Mithrasliturgie* (Leipzig und Berlin: Teubner, 1923), p. 9. Mithras is an Asian god in whom Jung was especially interested (see *CW* 5, p. 141, ill. 20). See also Sonu Shamdasani, *C.G. Jung: A Biography in Books* (New York: W. W. Norton and the Martin Bodmer Foundation, 2012), pp. 51–52.

107. Homer, *Odyssey*, Book 24, Verse 12.

108. The original sources of these sentences have not been found to date. It is possible that Jung recalled them from memory.

109. Jung, *Memories*, pp. 253–54; see *CW* 9/II, pp. 12, 13, 14.

110. *RB*, p. 121, translation, p. 305, note 229.

111. Albert Einstein published his Special Theory of Relativity in 1905.

112. Jung, *Erinnerungen*, p. 394 (the *Septem Sermones* are no longer included in the current English editions of *Memories*).

113. *CW* 12, §§ 203–4; *CW* 14/I, § 298, *CW* 17, § 300.

114. Kerényi, *Der göttliche Arzt*, pp. 97, 100; tr. Ralph Manheim, *Asklepios: Archetypal Image of the Physician's Existence* (Princeton: Princeton University Press, 1959); Carl Alfred Meier, *Antike Inkubation und moderne Psychotherapie* (Zurich: Rascher, 1949), p. 6.

115. Jung, *Memories*, p. 199.

116. Johannes Stumpf, *Schweizer Chronik*, published in 1554 by the Zurich printer Christoffel Froschauer.

117. Regarding Jung's coat-of-arms, see Jung, *Memories*, pp. 259–60.

118. The Rauschenbachs are citizens of the city of Schaffhausen. Johannes Rauschenbach (1813–1881) founded a machine factory that became known for its farming machines. His son Johannes Rauschenbach (1856–1905), father of Emma Rauschenbach, was also a machine manufacturer.

119. C.G. Jung, *Word and Image*, ed. Aniela Jaffé (Princeton: Princeton University Press, 1979), pp. 136–37; C.G. Jung, *Letters* II, pp. 610–11.

120. Later the following family members were added: Lilli Jung-Merker 1915–1983, Franz Jung-Merker 1908–1996.

121. Franz Jung-Merker, Letter to Ulrich Hoerni, November 29, 1993.

122. According to present knowledge, it was the calligraphic fair copy of the old text draft.

123. Aniela Jaffé, "Nachtrag zum 'Roten Buch,'" in Jung, *Erinnerungen*, p. 387 (not included in the English editions of *Memories*); cf. *RB*, Epilogue, p. 360.

124. Jung's mother died in 1923; Hermann Sigg was probably the person closest to Jung to pass away. Two years later, in March 1930, Richard Wilhelm, the colleague with whom Jung had closely collaborated on *The Secret of the Golden Flower*, died.

125. Jung, *Memories*, p. 293.

Die Toten, die uns bedrängen, sind Seelen, die das
mysterium in vita... ...ationis nicht erfüllt haben,
sonst wären sie zu ... geworden.
Insofern wir ... nicht erfüllen, haben die
Toten ein ... an uns und bedrängen
uns und wir entgehen ihnen nicht.

Diagram labels:

PLEROMA

DII ASTRA

DAEMONES
sol ...

SINISTER — DEXTER

SPATIVM ☿
LVNA ☿
SATANAS

HOMO

MATER COELESTIS — DEVS SOL — VIS

PLENVM

INANE

ΑΠΠΗ

ABRAXAS ASTRA

Legend (right margin):

A = ?Ἄνθρωπος Mensch
A = Menschenseele.
⚡ = Schlange = Erdseele
⚡ = Vogel = Himmelseele
♇ = Himmelsmutter
☐ = Phallus (Teufel)!
Engel.
↑ = Teufel.
⊗ = Himmelswelt.
☿ = Erde.. Mutter des Teufels.
☉ = Sonne Auge des Pleroma.
☾ = Mond, Aug des Pleroma.
[Mond scheint, Sonne verschwunden]
Mond = Satan. Sonne = Gott.
• = ☉ + ☾ = Gott der Frösche = Abraxas.
○ das Volle
● das Leere.
☉ = Flamme, Feuer, Liebe = Eros, ein Daemon.

☿ ♃ ♂ ♃ ♂ ♄ ⚡ ♅ ☉ = Götter, Sterne ohne Zahl.

Der Gott der Frösche oder Kröten, der Hirnlose, ist
die Vereinigung des christlichen Gottes mit Satan. Seine Natur
ist ähnlich der Flamme, er ist Eros ähnlich, jedoch ein Gott, Eros

INTIMATIONS OF THE SELF
JUNG'S MANDALA SKETCHES FOR *THE RED BOOK*

DIANE FINIELLO ZERVAS

JUNG AND THE MANDALA: AN INTRODUCTION

During an interview in August 1957, when Jung was eighty-two, Richard Evans asked him about the term *mandala*, a "very fundamental part of your writing." His response provides a useful introduction to this essay, which explores the genesis and development of the mandala in Jung's imagery and thought during the years he was creating *The Red Book*, and in particular his mandala sketches, made during the summer of 1917.

Jung replied that the mandala is a typical archetypal form, the *quadratura circuli*: the square in the circle or circle in the square. One of man's most ancient symbols, the mandala expresses either the deity or the self. As an Archetype of inner order, it is used to arrange the multifaceted aspects of the universe into a world scheme or to make a scheme of the individual psyche. It has a center and a periphery and attempts to embrace the whole. In analysis, during periods of psychic turbulence and chaos, the mandala symbol often appears spontaneously as a compensatory Archetype, bringing order, showing the possibility of order. As such, it signifies the center of the whole personality, which is not that of the ego, but of the self. Jung noted its important role in the East and also in the Western Middle Ages. In conclusion, he stated that the mandala "is a highly important and highly autonomous symbol. [. . .] We could easily say that it is the main Archetype."[1] Jung was referring to his patients' experience with the mandala, but also to his own.

Although Jung began to make mandala-like forms in 1915, while working on *The Red Book*, he only began to write about the mandala in 1929, when he composed a commentary to *The Secret of the Golden Flower*, a Taoist alchemical manuscript that Richard Wilhelm had sent him the previous year. This text provided the missing link between the ancient sources and contemporary Western mandalas that Jung had been collecting and studying for fourteen years. In his commentary, Jung described the mandala—in its simplest state—as a circle, especially a "magic circle," typical forms of which include the "flower, cross, or wheel, and show a distinct tendency towards a quaternary structure."[2] The egg, eye, tree, sun, star, light, fire, flower, and precious stone are symbols of the mandala. In the seminar Dream Analysis (1928–1930), Jung explained that mandalas could be drawn, built, danced, or performed through life—"the accomplishment of the mandala in time."[3]

Jung was particularly struck by the *Golden Flower*, a mandala symbol he had frequently encountered:

Black Book V (cat. 42)

179

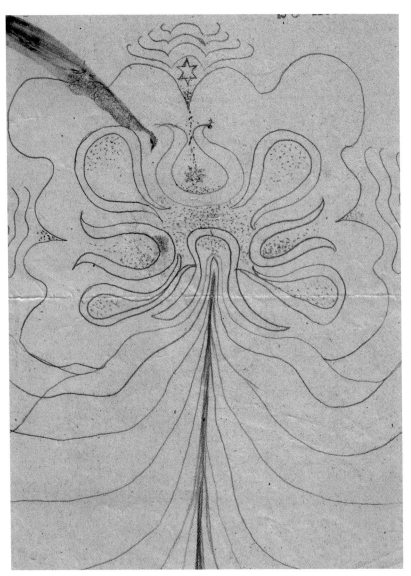

Fig. 62. Detail, cat. 87

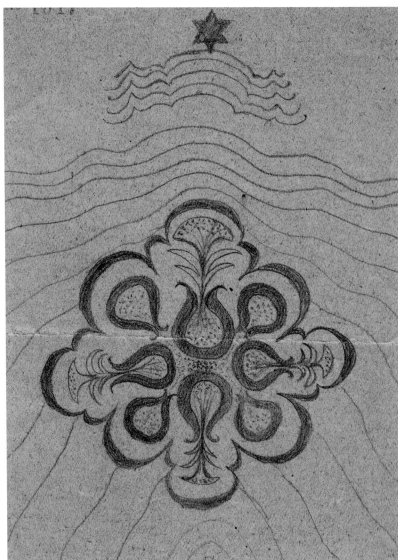

Fig. 63. Detail, cat. 89

It is drawn either seen from above as a regular geometric pattern, or in profile as a blossom growing from a plant. The plant is frequently a structure in brilliant fiery colours growing out of a bed of darkness, and carrying the blossom of light at the top, a symbol recalling the Christmas tree.[4]

The origin of such a drawing is the "germinal vesicle," the "seed place" with many names. Jung explained the preexistent state from which the golden flower comes into being:

The beginning, where everything is still one, and which therefore appears as the highest goal, lies at the floor of the sea, in the darkness of the unconscious. In the germinal vesicle, consciousness and life [. . .] are still a "unity, inseparably mixed like the sparks in the refining furnace." "Within the germinal vesicle is the fire of the ruler."[5]

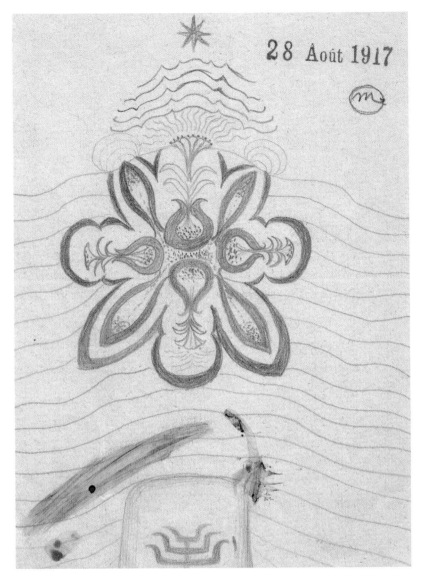

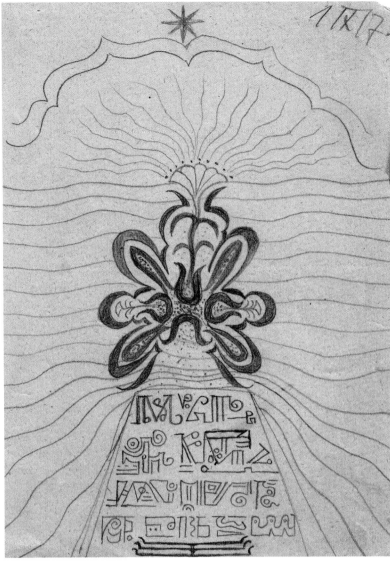

Fig. 64. Detail, cat. 90

Fig. 65. Detail, cat. 91

He related this to "a series of European mandala drawings in which something like a plant seed surrounded with membranes is shown floating in the water. Then, from the depths below, fire penetrates the seed and makes it grow, causing a great golden flower to unfold from the germinal vesicle."[6] However, Jung did not disclose that these drawings were in fact some of his mandala sketches from the summer of 1917 (figs. 62–65); nor did he include them or their painted versions in *The Red Book* among the anonymous Western mandalas accompanying his commentary.[7]

Such symbolism referred to a type of "quasi-alchemical process of refining and ennobling. Darkness gives birth to light; out of the 'lead of the water region' grows the noble gold; what is unconscious becomes conscious in the form of a living process of growth." Jung observed that the mandalas produced by his patients arose spontaneously from two sources: the unconscious, "which spontaneously produces fantasies of this kind," and life, "which, if lived with utter devotion, brings an intuition of the self, of one's own individual being."[8] This was also his personal experience.

THE ORIGINS OF JUNG'S MANDALA SYMBOLISM: 1913–1921

For Jung, the years between 1913 and 1921 were marked by psychological turmoil and intense creativity. The constant stream of fantasies and visions he experienced were recorded in his *Black Books* (1913–1916). He began to edit this *prima materia* and to add commentaries with mantic pronouncements, which then became the text of *Liber Novus* (1914–1918). Sometime in 1915 he started to transcribe *Liber Novus* onto the parchment sheets and folio pages that comprise *The Red Book*, employing medieval script, and embellishing the text with symbolic motifs and paintings. In addition to his ongoing analytic work with patients, Jung continued to research and develop his ideas about typology arising from his break with Freud in 1913, culminating in the publication of *Psychological Types* (1913–1921). From 1914 he lectured and published articles developing the psychological concepts that emerged from his experiences with the unconscious, including the self, the new god-image, and the process of individuation. The mandala sketches and related paintings in *The Red Book* were done toward the end of this period, between August 1917 and January 1919.[9]

Jung's Knowledge of Mandalas and Proto-mandalas before 1915

Jung was familiar with the core concepts underlying mandala symbolism from his research for *The Psychology of the Unconscious* (1912).[10] Of particular relevance for his theory of libido as creative impulse and psychic force were the Eastern cosmogonic myths in which, through introversion, the unformed creator god procreates himself and the universe of opposites, holds all in balance, and eventually withdraws back into nonbeing: a pattern both temporal and eternal.[11] Prajapati, the unknown creator of all things in Rig Veda X, 121, and Hiranyagarbha (golden seed), "the egg produced from himself, the world egg," is an important example. Jung also cites the Orphic god Phanes, the "shining one," as a cosmogenic principle.[12]

Fig. 66. Detail from *The Red Book*, fol. iv (v)[2]

In *The Red Book*, Jung began to use cosmogonic symbolism in the text of *Liber Secundus. The Incantations*, mandalic hymns invoking Izdubar's rebirth from the incubating egg,[13] declare that "God is in the egg"; "I am the egg that surrounds and nurtures the seed of the God in me"; God "is the eternal emptiness and the eternal fullness. [. . .] Simple in the manifold"; "Oh light of the middle way, enclosed in the egg."[14]

Similar concepts are visually expressed in Jung's first "proto-mandala" in *Liber Primus* of *The Red Book*. Significantly, this flower mandala forms the background for the historiated initial *G* ("Gottes Empfängnis," "Conception of the God" done during 1915, fig. 66: *RB*, fol. iv [v][2]). Set within a square, its forms are created around the small golden circle in the center, whose circumference is outlined in black, delineating an inner "magic circle." From the invisible center-point of this circle, the abode of the unformed god, eight golden rays radiate outward, extroverting to form an eight-rayed star—the first in *The Red Book*—a symbol Jung associated with individuation.[15] The rays become spokes of the second white circle. On the horizontal and vertical axes they divide the square into four sections. The diagonal rays form the axes of four "petal" vessels that contain and direct the energies of the diagonal golden rays back to the invisible point from which they emerged.

Systema Mundi Totius, 1916: From Sketch to Painting

> I did as my soul advised, and formed in matter the thoughts that she gave me. She spoke often and at length to me about the wisdom that lies behind us.[16]

In *Memories, Dreams and Reflections*, Jung claimed that he made his first mandala, *Systema Mundi Totius*, in 1916, after he had written the *Septem Sermones ad Mortuos*. The process leading to its creation was initiated by a dialogue between Jung's "I" and his soul about Gnostic cosmology and the *principium individuationis* (principle of individuation) on January 16, 1916, followed by an annotated sketch summarizing the dialogue's main points in visual form in *Black Book* V (cat. 42). Two weeks later the *Sermones* began to erupt into Jung's consciousness.[17] Thus the *Systema* sketch was not a direct product of the unconscious, but Jung's attempt to "form in matter" his soul's thoughts, a visual prologue to the ideas expounded in *Sermones* and *Systema Mundi Totius*.[18]

A cosmological scheme, the sketch is formed from seven concentric circles representing areas of the cosmos, moving inward from the infinity of the Pleroma.[19] The innermost circle represents Anthropos (Greek for *man*), the center from which the opposites arise and which unites them.[20] The large A (Anthropos) rests on the vertical and horizontal axes, together with his earthly (snake), human (A), and heavenly (bird) souls. The circles' invisible center-point symbolizes the concentration of the Pleroma that occurs by man's "becoming" through the *principium individuationis*. It is "the point that contains the greatest tension and is itself a shining star, immeasurably small, just as the Pleroma is immeasurably great." From it radiates a ten-rayed blue star. Surrounded by gold clouds, this is the star of the individual, which wanders with him, a microcosmic "God and the grandfather of souls," just as the Sun is the macrocosmic one.

The horizontal axis displays the celestial/feminine and earthly/masculine realms with their respective symbols and colors. The vertical axis depicts the chthonic (Greek, in or beneath the earth's surface) and spiritual dynamic of Abraxas, Jung's new God, formed from the union of the Christian God with Satan. A Gnostic time god of the cosmos who rules over the human world, Abraxas symbolizes the creative drive and universal death.[21] At the bottom of his sketch, Jung wrote that its "middle point is again the Pleroma. The God in it is Abraxas, a world of daimons surrounds it, and again in a middle point is humanity, ending and beginning." Thus, the ten-rayed star is both Anthropos and Abraxas,[22] and, the invisible center contains all the undifferentiated opposites of the inner and outer cosmos.

These images were amplified during two dialogues between Jung's "I" and his soul in late September 1916. In the first, Jung's soul educates his "I" about "the tree of light" with six lights and one blossom (the seven-branched candelabra). Its six lower lights signify the celestial and earthly realms. The seventh light, the star, which encloses the remaining elements of the cosmos

> is the highest, the floating, which rises with flapping wings, released [. . .] from the one blossom, in which the God of the star lay slumbering. The six lights are single and form a multiplicity; the one light is one and forms a unity; it is the blossoming crown of the tree, the holy egg, the seed of the world endowed with wings so it can reach its place. The one gives rise to the many over and again, and the many entails the one.[23]

Thus the tree of light contains all the elements depicted on the horizontal axis of the *Systema* sketch.[24]

In the second dialogue, Jung's "I" is further instructed about the images symbolizing psychological growth of the individual, and its relation to the self and the new God (the vertical axis on the *Systema* sketch). Some are linked to images Jung had already scattered through *The Red Book* before 1916, but were now brought together, including the plant (tree of life),[25] the tree of light, and Phanes, the golden bird.[26] Abraxas grows out of the Pleroma. A plant without flowers and fruits, called an individual, grows (as a thought) out of Abraxas's head. The individual/plant is a passageway and precursor to the tree of light. The lucent (seventh flame)—"Phanes himself, Agni, a new fire, a golden bird"—blossoms from the individual "after it has been reunited with the world; the world blossoms from it." The golden bird flies ahead, toward the star, but it is also a part of Jung, "and it is at once its own egg," containing Jung; it is his entire nature.[27] Thus Phanes—Jung's new God—replaces Abraxas and the gods who had crowned the vertical axis in the *Systema* drawing and is now the spiritual counterpart to chthonic Abraxas. Jung made a summary sketch of this dialogue, depicting Abraxas as a beetle, a symbol of instinctual life and death, in his 1916 agenda, on the page for October 15 (cat. 43), and subsequently carved it twice, once as a talisman brooch, and again in wood (cats. 47 and 44).[28] This imaginal sequence is elaborated in the *Systema Mundi Totius*, suggesting that Jung painted it close to or after mid-October.

For the painted version of *Systema Mundi Totius*, Jung multiplied the cosmological elements to emphasize the endless repetitions of macro-/microcosm and enriched the symbolic color scheme.[29] He also added several new images along its vertical axis. Below, the beetle and a larva, animals of the natural world symbolizing death and rebirth, flank the tree of life.[30] Above, a winged mouse (Science) and a gold-winged serpent (Art), creatures of the spiritual world, flank the light-tree.[31] Erikapaios/Phanes, the young boy in the winged egg, described as the "all-shining flower" in his Orphic Hymn, crowns the vertical axis.

The Reconciling Symbol

Jung intensified his study of Gnosticism, Christian mysticism, and Eastern and Asian sources during his research for *Psychological Types*, which was nearly completed by the end of August 1917.[32] In *The Type-Problem in Poetry*, Jung noted that "the religions of India and China, and particularly Buddhism, which combines the spheres of both, possess the idea of a redemptive middle way of magical efficacy which is attainable by means of a conscious attitude."[33] He cited Buddhist, Brahmanic, and Taoist texts in which the problem of opposites is resolved by the reconciling symbol, later stating that it puts an end to the division, forcing the energy of the opposites into a common channel, thereby producing expanded energy and goals.[34] Jung later confirmed that the mandala has the dignity of a "reconciling symbol."[35] He called the process by which this occurs the transcendent function.[36]

That Jung experimented with expressing such symbols visually is strikingly clear from images he painted in *Liber Secundus* of *The Red Book*, especially as they become progressively detached from its narrative. Proto-mandalas, circles, trees, golden flowers, mandala roses, and other related forms attest to his increasing fascination with the mandala between January 1916 and June 1917.[37]

Significantly, the two historiated initials that Jung made immediately after December 25, 1915, for chapter 8, "The First Day" (when Jung's "I" first encounters Izdubar) are mandalas

based on the cosmogonic image of the snake (Shakti) coiled around the creative point (Shiva-bindu) (figs. 67 and 68). Jung explained Shiva—Shakti as "the eternal cohabitation of the god with its female form, its offspring, its emanation, its matter." Shiva is "the lightening, the hidden power of creation." His spouse, Shakti, is "the emanation of power, the active creative power." In images of worship the invisible Shiva-bindu is encompassed by Shakti in the form of a wheel; this is "the primal form of the mandala."[38] In 1931, Jung drew and amplified this image, relating it to Gnostic forms:

> the egg is the eternal example of the perfect germ in a dormant potential condition. It is often represented on antique Gnostic gems encircled by a snake. That is important symbolism which occurs also in Tantric philosophy, where the snake coils around the creative point called the *bindu*. This is represented by a small golden or fiery point, which in the Upanishads has the name *Hiranyagharbha*, meaning the golden germ, or Shiva *bindu*, the Shiva point, or the creative egg, the germ of things.[39]

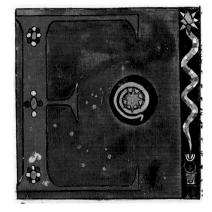

Jung was also grappling with the nature of the imagery being created in *Liber Novus* and *The Red Book*. In October 1957, he recounted that, as his confrontation with the unconscious continued to plunge him deeper into the labyrinth, he was struggling to defend his fantasies, visions, and related paintings as works of "Nature," whereas a former Dutch patient and colleague, Maria Moltzer, kept trying to convince him that they were "Art," which would have relieved him from the ethical obligation to integrate them into life, a moral responsibility of the analyzed individual.[40] Moreover, his relationship with Toni Wolff had begun and with it he had entered into a chaos.[41]

THE MANDALA SKETCHES: FORMATION, TRANSFORMATION

In this multifaceted state of "indescribable chaos," Jung left Küsnacht in June 1917 to serve as commander of the British military internees at Château-d'Oex for four months. While there he sketched a series of small mandalas, all carefully dated, in his perforated military notepad and on other sheets of paper between August 2 and September 26. The visual counterparts to his *Black Books*, which he did not have with him during the summer, the mandala sketches thus formed a crucial part of the primal stream of lava that reshaped Jung's life and theories.

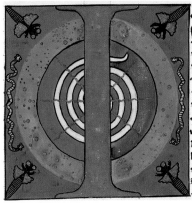

Fig. 67. Detail from *The Red Book*, page 37

Fig. 68. Detail from *The Red Book*, page 40

From Personal to Monad: Sketches 1–4 (August 2–7, 1917)

Jung's first four drawings comprise an initial group. Some of their forms and motifs refer back to the visual vocabulary that Jung had begun to articulate in *The Red Book*, but would subsequently be developed in the series of sketches. Thus they provide an introduction and a précis of the process that would unfold over the next two months.

The first one, entitled ΦΑΝΗΣ (Phanes), is an eight-lobed mandala (cat. 81).[42] A seedpod, or germinal vesicle, occupies the central space. From an invisible center-point within it, some seeds have fused to form an eight-rayed star that radiates outward, creating the mandala's axes. The vesicle's diagonal protuberances point toward the necks of four womb-like vessels positioned on the diagonal axes, inseminating the protoplasmic life seeds within. Anonymously describing one of his own mandalas in *The Secret of the Golden Flower*, Jung stated that such elements represent the creative force working inward.[43] They are images of centripetal introversion and systolic concentration.[44]

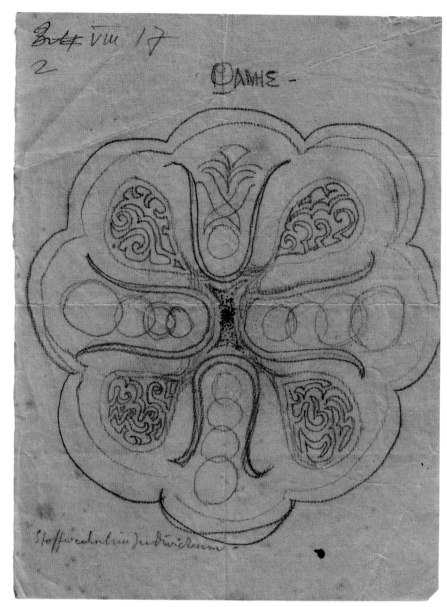

Cat. 81. Mandala sketch 1, August 2, 1917. Two types of graphite on paper,
19.4 × 13.3 cm (7⅝ × 5¼ in.), Jung Family Archive

By contrast, four U-shaped vessels surround the germinal vesicle on the main axes. At the base of each is a small circle or "drop."[45] However, the sketch is not a totally symmetrical mandala; change has already begun. For in its upper vertical vessel, two crossed pairs of flame/wing-like lines rise above the base circle, crowned by a hieroglyph of a lotus-like flower. These are symbols of Phanes, the all-shining golden flower, which had already appeared in *The Red Book*.[46] In the other vessels three expanding circles are linked to the base circles. They represent the creative force working outward: a centrifugal image of diastolic expansion.[47] At the bottom of the sketch, Jung wrote *"Stoffwechsel im Individuum"* (Metabolism in the individual), to emphasize that the mandala is an energic image of the metabolism required for the birth of the new God in the individual.

On the back of the sheet, Jung drew a smaller mandala (cat. 81 [v]). Significantly, its basic structure is related to *The Red Book*, page 75 (fig. 69), done earlier that year. The painting's

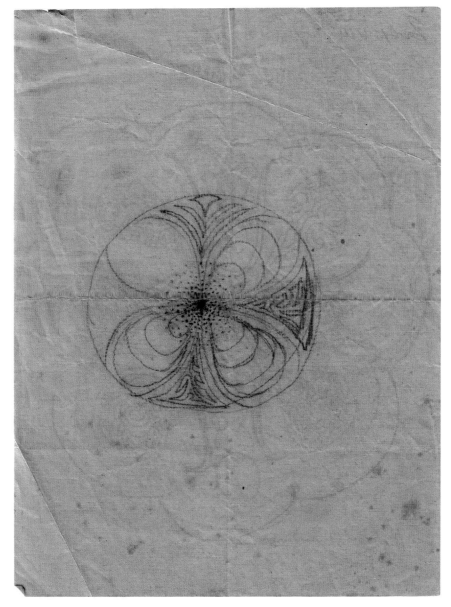

Cat. 81 (v). Mandala sketch 2, August 2, 1917. Two types of graphite on paper,
19.4 × 13.3 cm (7⅝ × 5¼ in.), Jung Family Archive

vertical axis depicts a process of transformation. A mass of primitive life-forms, changing
from dark to bright red, writhe upward in the black wedge-shaped cone between two tangent
half-circles. In the upper white cone, they begin to separate around the red seed ball (the
chthonic sun); then, above the gold seed ball (the spiritual sun) in the upper white cone they
change color and rise to form the wing-like leaves and golden flame/flower/bird of Phanes.[48]

In the sketch, upper and lower half-circles intersect with those on the vertical axis to form
the petal-like introverting vessels on the diagonal axes, and, as in *The Red Book*, page 75
(fig. 69), the wedge-shaped cones between them form the outward-directing vessels. Some inner
elements have rotated vessels, thereby reversing their direction from introverted to extroverted
and vice versa. The lotus flower has grown, its blossom tangent to the mandala's enclosing circle,
but two other axial vessels (right and bottom) now contain protoplasmic life-forms of phallic
shapes: extroverted energies penetrating inward. Conversely, the linked rings of the first sketch

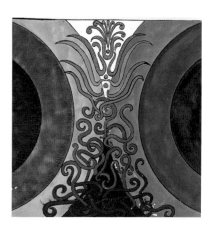

Fig. 69. Detail from *The Red Book*,
page 75

Cat. 82. Mandala sketch 3, August 4 and 7, 1917. Two types of graphite on paper,
14.9 × 12.4 cm (5⅞ × 4⅞ in.), Jung Family Archive

have become overlapping circular segments of the diagonal vessels, waves of creative force radiating inward.[49] The vesicle has become a dark circle, whose seeds scatter outward, some coalescing into a six-rayed star.[50] As in *The Red Book*, page 75 (fig. 69), the cone-shaped vessels on the vertical axis depict chthonic Abraxas energy transforming into the lotus blossom/Phanes.[51] Thus these first two mandala sketches reveal the continuing influence of Abraxas–Phanes imagery as a living symbol of Jung's individuating psyche.

The next two sketches were decisive for Jung's subsequent understanding of the mandala. Sketch 3 (cat. 82) is dated August 4 and 7, and sketch 4 (cat. 83) is dated August 6; thus, Jung reworked sketch 3 after completing sketch 4. The original design of sketch 3, drawn with a fine-leaded pencil, comprised only the elements within the mandala's circular frame. Its petal vessels have doubled from those in sketches 1 and 2, forming a flower mandala, which, as a sun wheel, begins to run a circular course, a *circumambulatio*.[52] Seeds radiate out from the

Cat. 83. Mandala sketch 4, August 6, 1917. Graphite on paper, 20.3 × 14.9 cm (8 × 5⅞ in.), Jung Family Archive

spherical vesicle into the petals on the main and diagonal axes. The spaces between them are divided into curved segments that propel the upper seeded ones toward the mandala's circumference.

In sketch 4, perfection has been shattered. The top petal and surrounding vessels have disintegrated, scattering seed into space. Seed is also released from the tips of the remaining seven petals. Curved lobes have been added to the mandala's circular frame, extensions of the extroverting segments.[53]

Jung recounts that he drew this sketch the day after he received a letter from Maria Moltzer, again arguing that his fantasies "had artistic value and should be considered art"; its symmetry had been destroyed by his disturbed emotional state.[54] This revelation enabled him to understand what the mandala represented: "Formation, transformation, the eternal mind's eternal re-creation." "My mandalas were cryptograms concerning the state of the self which were

presented to me anew each day." He then began to grasp that the living idea of the self "was like the monad which I am, and which is my world. The mandala represents this monad, and corresponds to the microcosmic nature of the psyche."[55]

Significantly, the disintegration in sketch 4 releases the potential for new growth, symbolized by seeds scattered into unknown space. Jung returned to sketch 3 the following day. With a thicker graphite pencil, he strengthened the mandala, as if to repair the magic circle. He reinforced its vesicle and circular frame and added external lobes and groups of scattering seeds between the top four lobes, reestablishing psychic order.

Creation of the Golden Flower: Sketches 5, 9–18 (August 20–September 5)
Chthonic Penetration: Sketches 5, 9–11

No sketches survive for the next twelve days, when Jung appears to have been exceptionally busy with his military duties.[56] He subsequently drew one daily between August 20 and 23. Significantly, in order to reengage with the earlier images, on the back of sketch 5 (cat. 84) Jung made three thumbnail versions of sketches 1, 3, and 4 (sketches 6, 7, and 8 [cat. 84 (v)]), adding various letters and astrological signs to sketches 7 and 8.[57] The next four sketches reveal a new stage in the process. Whereas the earlier ones portray only the mandala, in subsequent drawings it exists within a context; the mandala is acted upon, and interacts with, external forces.

Following the fragmentation of sketch 4, a new element appears in the next four sketches. A dark phallic force erupts from the unconscious depths. Thrusting upward from its cave, it eventually distorts, penetrates, and fertilizes the mandala. In 1933, Jung referred to a painting from his collection, executed by a man, in which a black phallic object rises from below to enter a floating mandala, clearly one in *The Red Book*, based on sketches 5, 9–11 (*RB*, pp. 83–86). Jung explained the meaning of this act: "the unconscious wishes to force evil upon us [. . .] to show us that we know nothing." This is done in order to release man from a moral responsibility that he is unable to carry, freeing him to "accept the earth," and to acknowledge that "there are overpowering forces from which one cannot escape. We cannot live without being approached by evil"; "evil, the serpent, is a necessary part of the process of growth. The dark part must be brought completely above the horizon, so that life can go on."[58] This is a psychological necessity, because "if we prefer not to liberate the spirit buried in the earth, dormant in the stone, we get stuck in the earth, caught in an unconscious fascination by material conditions."[59]

The inner elements of mandala sketch 1 reappear in sketch 5, but the diagonal womblike vessels have moved outward, shaping the four-lobed perimeter. All the extroverting vessels on the main axes contain embryonic "seed" versions of the lotus flower at the top of sketch 1. An outer twelve-lobe frame protects the mandala's inner core. Seeds nestle in the external cavities of its main axes and converge around the outer points of the diagonal ogive lobes.

Below, a black phallic shape rises in its chthonic cave; it is a reversed image of the lotus flower in sketches 1 and 2. The eruption sends expanding waves of energy toward the mandala. The impending penetration is guided by Scorpio on the left and its planetary ruler, Mars, to the right—zodiacal symbols of passionate sexuality.[60] In the narrowing space between the uppermost phallic wave and seeds below the mandala, Jung placed conjoined concave and convex curves, possibly the astrological sign of Pisces.

Cat. 84. Mandala sketch 5, August 20, 1917. Graphite and ink on paper, 20.3 × 14.9 cm
(8 × 5⅞ in.), Jung Family Archive

A second phallus-driven force approaches the mandala from the right, emphasizing the urgency with which the chthonic energies need to be made conscious and integrated. The six-rayed star between them—previously an embryo in the vesicle of sketch 2—suggests a deeper meaning: the approaching birth of the divine child, the reconciling symbol of the renewed attitude to life. In *Psychology of the Unconscious*, Jung noted that the star is a symbol of libido at a birth scene and cited Buddha's miraculous conception, when his mother, Maya, dreamed that a "star from heaven—splendid, six-rayed," whose token was a six-tusked elephant, "shot through the void; and shining into her, entered her womb upon the right."[61] The six-rayed star symbolizes fertilization through the breath of spirit, and the tusk-like dark phallus fertilization by the animal, symbol of the chthonic spirit.[62] To the left of the mandala, Jung composed six runes, including "upper" and "lower" cones, vessels of the upper and lower suns described in *The Red Book* and subsequent *Black Book* entries.[63]

Cat. 84 (v). Mandala sketches 6, 7, and 8 before August 5, 1917. Graphite and ink on paper, 20.3 × 14.9 cm (8 × 5⅞ in.), Jung Family Archive

Fig. 70. Closeup of sketches 6, 7, and 8

In sketch 9 (cat. 85), made the following day, the chthonic force has reached the mandala, forcing open its receiving vessel. The thrust has scattered seed from the hollow of the top vertical axis. A hexagram star presides over the cosmic union unfolding below, its opposing triangles symbolizing the union of fire and water, male and female.[64] On both sides of the mandala, Jung drew curving compound lines, possibly the astrological signs for Leo and Scorpio.[65]

By sketch 10 (cat. 86), the phallic forces have destroyed the perimeter of the inner mandala and penetrated its lower vertical vessel, causing further distortion. The upper vertical vessel is protected in a womblike circular lobe, but the violent impact has scattered seeds into the expanding space of the outer mandala frame.

Following the chthonic *coniunctio* in sketch 10, the phallic force begins to withdraw in sketch 11 (cat. 87), permitting the mandala's inner elements to resume their former positions

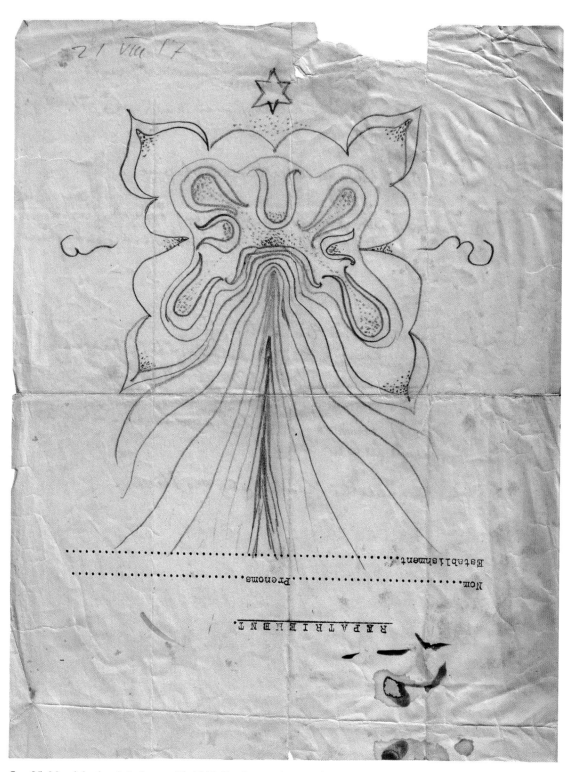

Cat. 85. Mandala sketch 9, August 21, 1917. Graphite and watercolor on paper, 20.3 × 14.9 cm (8 × 5⅞ in.), Jung Family Archive

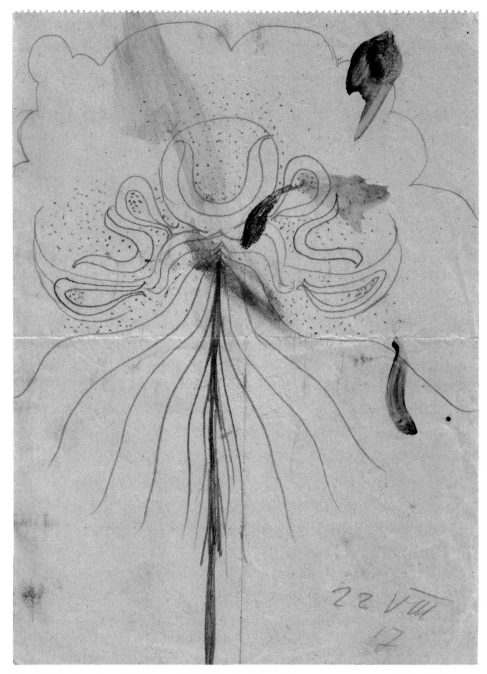

Cat. 86. Mandala sketch 10, August 22, 1917. Graphite and watercolor on paper, 20.3 × 14.9 cm (8 × 5⅞ in.), Jung Family Archive

and shapes. The chthonic lines of force begin to curve upward and more curvy lines surround the mandala on both sides. An eight-rayed seed star—symbol of totality—nestles within the upper vessel. The hexagram star, sheltered by an ethereal canopy, closely guards the embryonic form. In keeping with this delicate transition, Jung changed his graphite pencil to violet, a royal color. He also altered his drawing style, replacing the forceful strokes of the earlier sketches with finely rendered lines, sometimes reinforced with the same pencil.

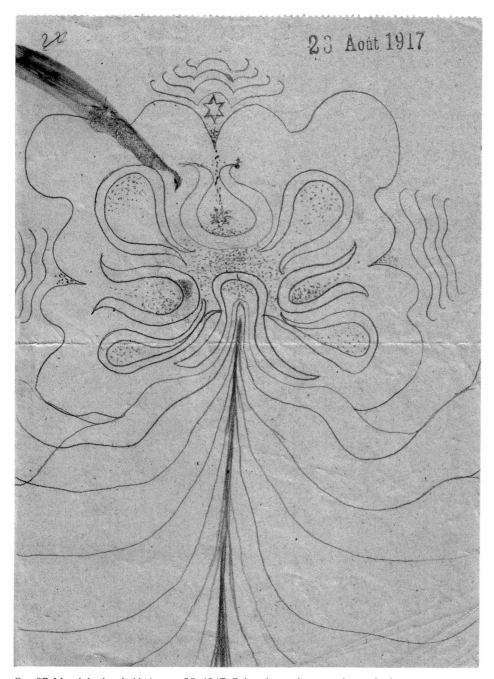

Cat. 87. Mandala sketch 11, August 23, 1917. Colored pencil, watercolor, and ink on paper, 20.3 × 14.9 cm (8 × 5⅞ in.), Jung Family Archive

Floating Gestation: Sketches 12–13 (August 25, 27)

The next two sketches are images of gestation, charting growth within the fertilized mandala. After a two-day pause, Jung made the exquisitely detailed sketch 12 (cat. 88). The phallic force has disappeared into its conical cave in the unconscious matrix, and the chthonic lines of force are changing into watery waves as they move upward. The mandala, floating in the midst of the depths, has reverted to its original eight-lobed form in sketch 1. Within it, four lotus flowers are emerging from the extroverting axial vessels. The hexagram star has risen higher, surrounded by ethereal waves.

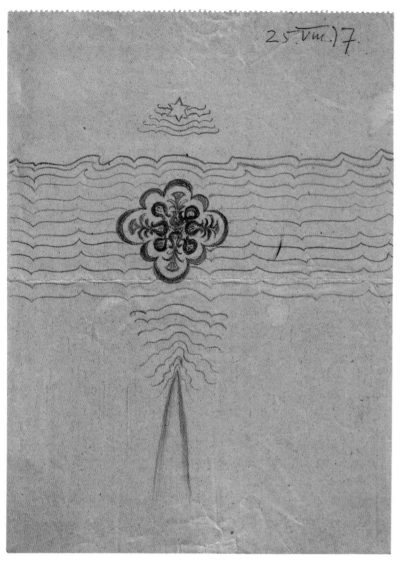

Cat. 88. Mandala sketch 12, August 25, 1917. Colored pencil and graphite on paper, 20.3 × 14.9 cm (8 × 5⅞ in.), Jung Family Archive

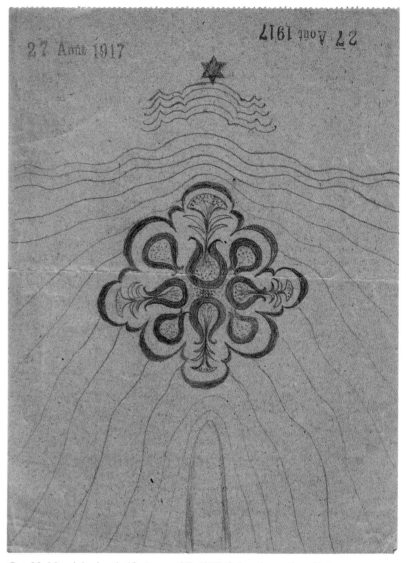

Cat. 89. Mandala sketch 13, August 27, 1917. Colored pencil and ink on paper, 20.3 × 14.9 cm (8 × 5⅞ in.), Jung Family Archive

In sketch 13 (cat. 89), done two days later, waves of energy from the chthonic cave propel the mandala through the water. Tripartite lobes are now necessary to contain the mandala's growing lotus flowers. As in sketch 1, the upper lotus flower is the most developed. The hexagram star has changed position, hovering above an ethereal canopy that shelters the mandala.

Blossoming of the Golden Flower: Sketches 14–18 (August 28–September 5)
In the next five sketches, the mandala's golden flower gradually comes into blossom as it reaches the air. A new symbol appears to succor this process in sketch 14 (cat. 90). Within a lower chamber, the light-tree replaces the chthonic phallus and its cave, providing the spiritual heat necessary for this stage of transformation, as described by Jung's soul the previous September. As a result, a five-petal lotus flower begins to emerge from the water, sending

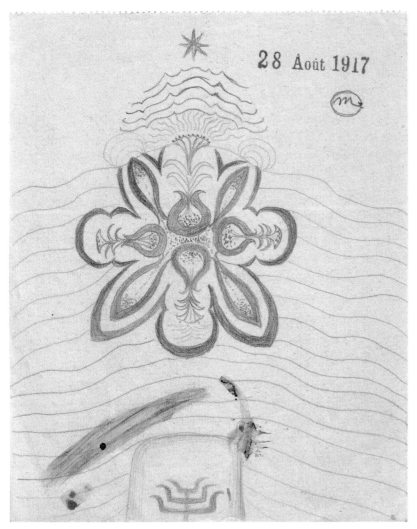

Cat. 90. Mandala sketch 14, August 28, 1917. Colored pencil, graphite, and ink on paper, 20.3 × 14.9 cm (8 × 5⅞ in.), Jung Family Archive

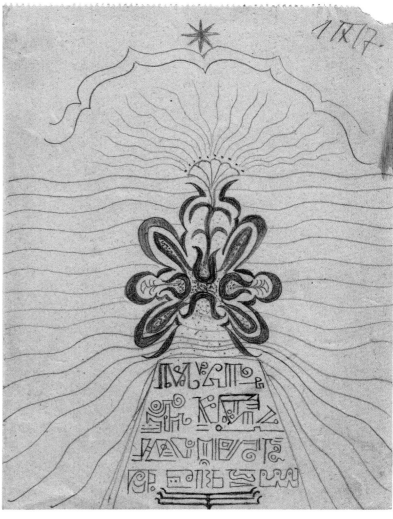

Cat. 91. Mandala sketch 15, September 1, 1917. Colored pencil, graphite, and watercolor on paper, 18.2 × 12.4 cm (7³⁄₁₆ × 4⅞ in.), Jung Family Archive

stamen-like rays of light to touch the airy canopy. In conjunction with this emergent blossom, the eight-rayed star, an embryonic form in the upper vessel of sketch 11, has now risen in the heavens, replacing the hexagon star. Jung added the astrological sign for Scorpio in graphite pencil below the stamped date of the sketch. What was first in the depths, in sketch 5, has now ascended.

In sketch 15 (cat. 91), the lower chamber has become a tablet. The light-tree has generated four lines of runes, symbolic signs that, as Jung's "I" was later instructed, narrate the perpetual struggle to unite and separate the upper and lower suns.[66] The tablet has collided with the mandala. With its bottom lobe forced apart, the flower in the lower vessel has disintegrated, scattering seed toward the tablet. At the top, the flower's flame-rays elongate toward the spreading canopy below the eight-rayed star.

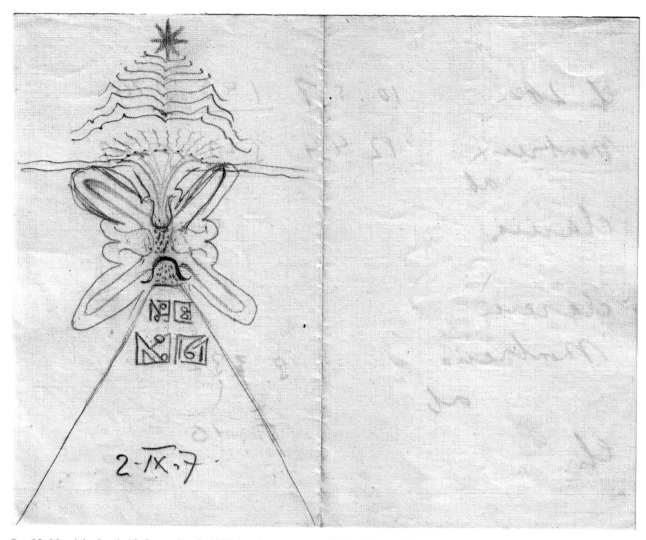

Cat. 92. Mandala sketch 16, September 2, 1917. Graphite on paper, 12.4 × 18.2 cm (4⅞ × 7³⁄₁₆ in.), Jung Family Archive

Jung continued to experiment with these elements over the next four days, varying the tablet's size and shape and inscribing it with new runes, see sketches 16–18 (cats. 92–94). The mandala also changes. As its diagonal vessels continue to elongate, the horizontal vessels shrink, causing the mandala to transform into an *X*-like form. Sketch 18 summarizes this phase of the mandala sketches, with the main elements—phallus/tablet, water, mandala, blossoming flower, and fiery rays—outlined in purple ink.

Images of Energy: Sketches 19–21 (September 5–6)

Once the golden flower has blossomed, Phanes is born, and, as the "cosmogenic principle,"[67] flies ahead. As Jung's soul had explained, this allows the world to blossom from the new individual. Thus, in the next three sketches, a new source of creative libido appears: energy streaming and converging between the mandala, chthonic tablet, and cosmic star, and converging between them. Here Jung pictures the regeneration of life that follows the birth of Phanes as an energic process involving both

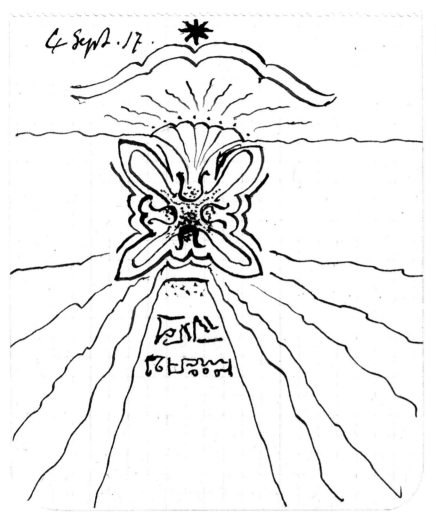

Cat. 93. Mandala sketch 17, September 4, 1917. Ink on paper, 10 × 9 cm (3¹⁵⁄₁₆ × 3⁹⁄₁₆ in.), Jung Family Archive

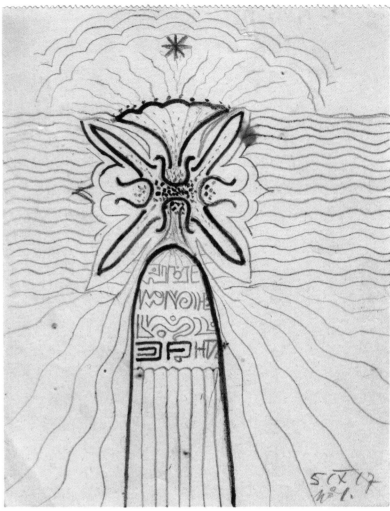

Cat. 94. Mandala sketch 18, September 5, 1917. Colored pencil and ink on paper, 18.2 × 12.4 cm (7³⁄₁₆ × 4⁷⁄₈ in.), Jung Family Archive

a "creative act of highest love" and "an act of the Below." By contrast, in Jung's earlier commentary following the sacrifice of the divine child—the image of God's formation—in *The Red Book*, they are separate actions: his soul's "creative act of highest love" generates the God; then, through the sacrificial murder of the divine child, "an act of the Below," assisted by evil, human life is regenerated.[68]

In sketch 19 (cat. 95), the rune-inscribed tablet has become a spirit-phallus. It ejaculates rays toward those released from the seedbed of the mandala's lower vessel. Thus the mandala—Jung's monad—is now an active participant in the *coniunctio* in the watery matrix. This is mirrored by the aerial *coniunctio*, where rays from the mandala's upper vessel rise to meet those cascading from the star: "as below, so above; and as above so below."[69]

By sketch 20 (cat. 96), done on the same day, the spirit-phallus has withdrawn, replaced by the rising tablet with the light-tree. The lower *coniunctio* continues, but the upper *coniunctio* is replaced by penetrating action, as the cometlike star descends toward the mandala, generating an energy field that whips up crest-capped waves on the watery surface.

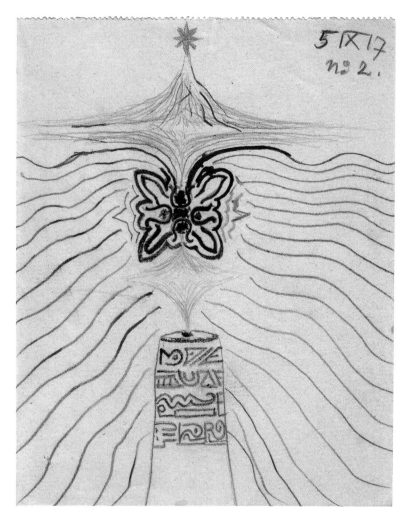
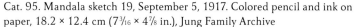

Cat. 95. Mandala sketch 19, September 5, 1917. Colored pencil and ink on paper, 18.2 × 12.4 cm (7³⁄₁₆ × 4⅞ in.), Jung Family Archive

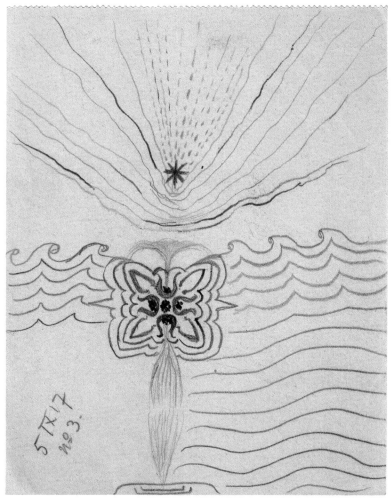

Cat. 96. Mandala sketch 20, September 5, 1917. Colored pencil and ink on paper, 18.2 × 12.4 cm (7³⁄₁₆ × 4⅞ in.), Jung Family Archive

Sketch 21 (cat. 97), done the next day, depicts the culmination of this phase. In the watery matrix of the unconscious, the earlier *coniunctio* between the tablet and mandala has separated, driving them apart and generating two new streams in the void that pair with the original ones to form a double *coniunctio*. The mandala is suspended between the highly charged chthonic-spiritual forces of the vertical axis and the undulating bands of water expanding along the horizontal axis, the first manifestations of emerging terrestrial forms.

Creation of the New World: Sketches 22–25 (September 9–14)

What then is the light of man? Self is his light. It is by the light of the self that a man rests, goes forth, does his work and returns.[70]

The next four sketches depict the mandala in the midst of extroverting energic forces driving the creation of the new world.[71] In sketch 22 (cat. 98) the mandala remains fixed between the

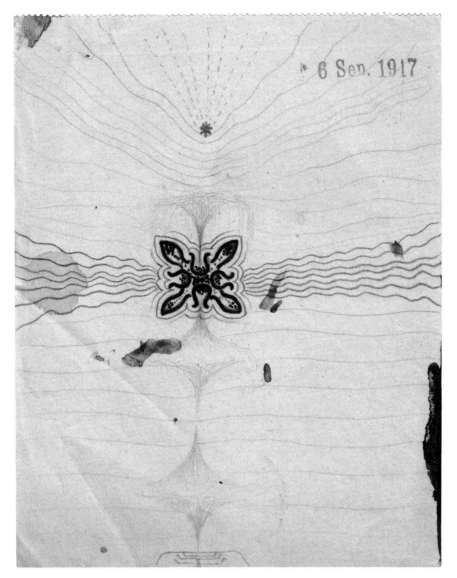

Cat. 97. Mandala sketch 21, September 6, 1917. Colord pencil, watercolor, and ink on paper, 18.2 × 12.4 cm (7³⁄₁₆ × 4⁷⁄₈ in.), Jung Family Archive

tablet and star on the vertical axis. The underwater rays of energy have become two interlocking cones at the surface of the depths. Their union reinforces the separation of earth from water, enabling the creation of vegetative life that is watered by the river of life flowing forth from the vessels on the mandala's horizontal axis. Above the mandala a broad arc separates the air from the empyrean with its eight-rayed star. Runes, formerly in the chthonic depths, now occupy the arc. They emit seven rays that form a cone, which converges on the apex of a small triangle on the mandala's frame, as if animating it with an ancient incantation.[72] The diamond-shaped seed vesicle mirrors the mandala's dynamic X-like shape.

Sketch 23 (cat. 99), done the next day, makes only minor changes. A zigzag band now separates water and earth, and the floating arc has descended, enclosing the sky like a shell. Its lower edges meet the river of life, now encased in a wavy band above the vegetative world. The arc's runes narrate an experiential journey.[73] Within the mandala, rays extend from its quadrated seed vesicle.

To encompass the extroverting life-forms in the next two sketches, Jung rotated his drawing pad. From the spiky mandala in sketch 24 (cat. 100), an elongated river of life divides the earth

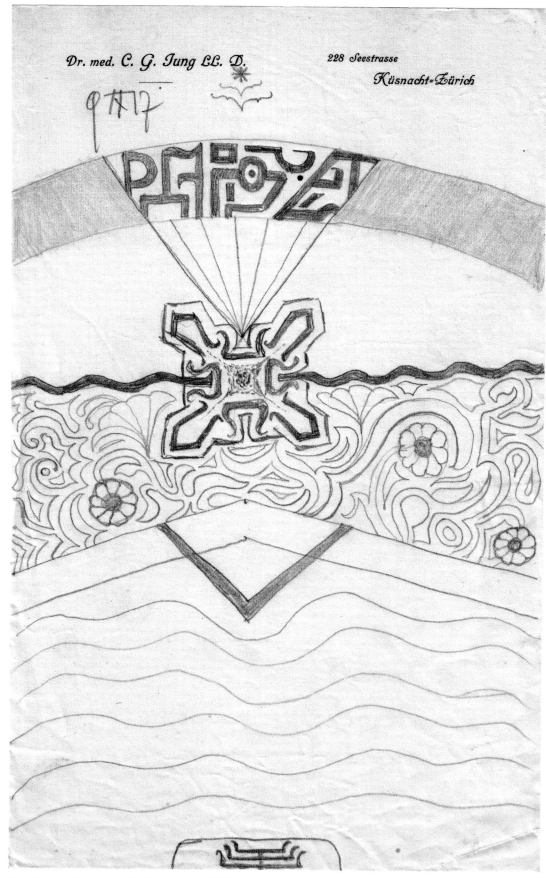

Cat. 98. Mandala sketch 22, September 9, 1917. Colored pencil on paper, 18.2 × 12.4 cm (7³⁄₁₆ × 4⁷⁄₈ in.), Jung Family Archive

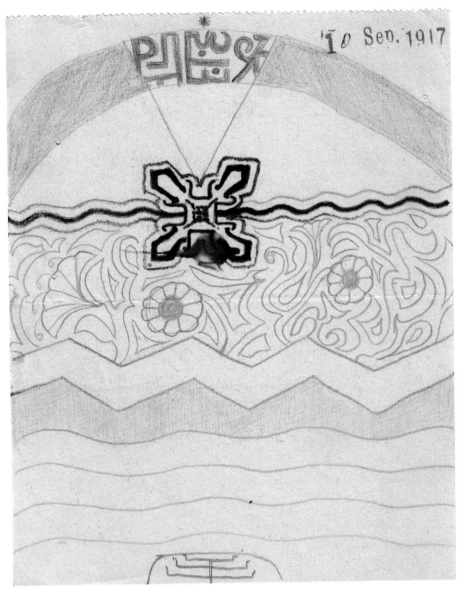

Cat. 99. Mandala sketch 23, September 10, 1917. Colored pencil and ink on paper,
14.9 × 12.1 cm (5⅞ × 4¾ in.), Jung Family Archive

horizontally into two zones: teeming vegetation above and animal forms below, similar to the protoplasmic life-forms of sketch 1. All are enclosed in an ellipse that floats in the wavy spaces between the light-tree, tablet, and eight-rayed star on the mandala's vertical axis. The runes march along the upper edge of the ellipse, recounting the struggles of Jung's "I" with the upper and lower suns and their respective cones.

Three days later, in a burst of extroverting energy, the ellipse has split, heated by three flames rising from the light-tree, now liberated from the tablet below (sketch 25 [cat. 101]). The star's cone of astral rays seems to generate the runes on the upper part of the ellipse. Below the river of life, primitive life-forms suggestive of crawling, standing, and flying creatures contract toward the center of the mandala.

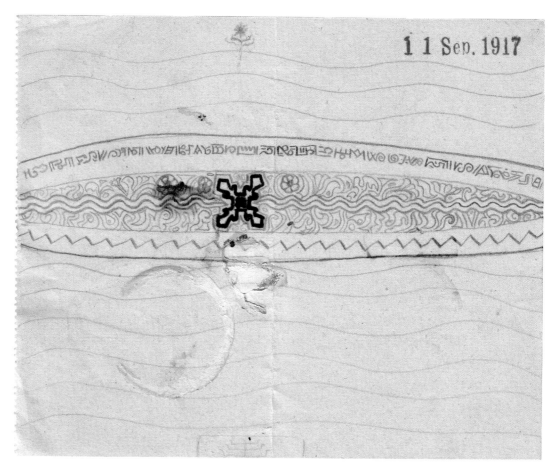

Cat. 100. Mandala sketch 24, September 11, 1917. Colored pencil, watercolor, and ink on paper, 12.1 × 15.2 cm (4¾ × 6 in.), Jung Family Archive

"Eternal re-creation." The Cosmic Egg: Sketches 26–29 (September 15–26)
By the next day (sketch 26 [cat. 102]), a new introverting balance is established. The ellipse has contracted, enclosing the mandala and its life-forms, but not the river of life. An energic globe has formed around the ellipse. From above, an astral ray pierces the globe, penetrates the mandala, and is transformed into a stream, droplets, and flames as it descends to the life-tree on the tablet. Thus the vertical axis comprises the five elements: ether, air, earth, water, and fire.

Sketch 27 (cat. 103) is an image of the reconciling symbol. The ellipse and globe of the previous sketch have become magic circles protecting the mandala. Having received energy in sketch 27, the mandala now generates it. Flames from the vesicle rise to the star, and plunge to the light-tree, but the river of life flows outward toward infinity. In the outer circle, water circulates below the river of life, and runes are written above it. Rays around the outer circle interweave with the horizontal waves of the surrounding space, creating a cosmic web of intersecting energies.

In the penultimate sketch, sketch 28 (cat. 104), done six days later, introverted energies are reversed into extroverted ones. The line between the spiritual and chthonic poles has dissolved. The upper and lower realms, bounded by broad arcs, curve away from the mandala and each

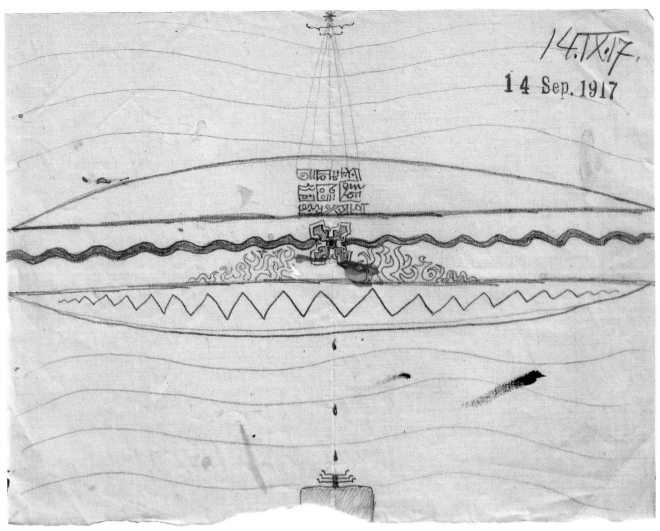

Cat. 101. Mandala sketch 25, September 14, 1917. Colored pencil, watercolor, and ink on paper, 12.1 × 15.2 cm (4¾ × 6 in.), Jung Family Archive

other. In the space between them, jagged diagonal and horizontal bands of Shiva-like lightning energy radiate from the mandala, replacing the river of life, as if pushing the two realms apart. Zigzag lines forming introverting and extroverting cones decorate the arcs and the mandala's outer frame. Runes decorate the chthonic tablet and have replaced the star in the upper realm.

The Cosmic Egg is fully re-created in the final mandala sketch that Jung made on September 26, sketch 29 (cat. 105), reversing the centrifugal energies of sketch 28. On the vertical axis, the eight-rayed star and light-tree are now inside the Egg's thick shell, which is decorated with the motif of introverting and extroverting cones. The mandala—microcosmic monad and gateway through which "the procession of the Gods passes [...] the stream of life flows [...] the entire future streams into the endlessness of the past"[74]—floats in the center of the Egg's amniotic fluid. Energy radiates between the star, mandala, and light-tree, constellating an upper and lower *coniunctio*, as in sketch 19. On the horizontal axis, the river of life flows forth from the mandala, nourishing the life-forms within the eggshell.

In the lower quadrants, Jung included three zodiacal symbols: Pisces on the left, Leo above it, and Scorpio on the right. A psychological and cosmogonic process conceived in the watery depths of the Fishes, a sign denoting "the end of the astrological year and also a new

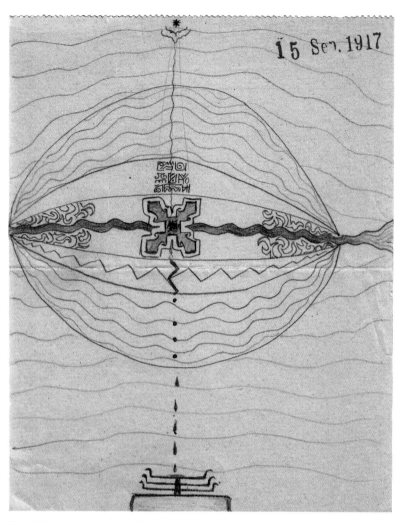

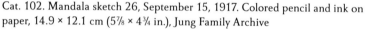

Cat. 102. Mandala sketch 26, September 15, 1917. Colored pencil and ink on paper, 14.9 × 12.1 cm (5⅞ × 4¾ in.), Jung Family Archive

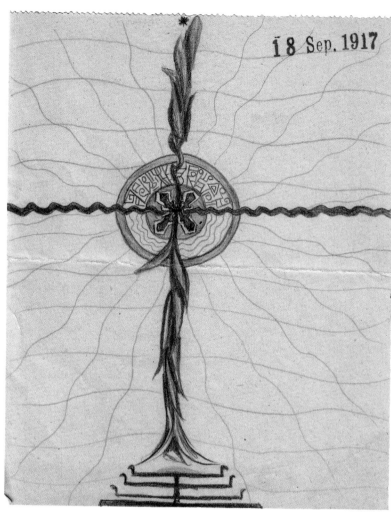

Cat. 103. Mandala sketch 27, September 18, 1917. Colored pencil and ink on paper, 14.9 × 12.1 cm (5⅞ × 4¾ in.), Jung Family Archive

beginning";[75] and heated in Leo, sign of the greatest summer heat, has been completed in Scorpio, an autumnal sign.[76] However, the runic tablet remains in the depths beneath the Egg, waiting to rise and destroy its shell in the service of new creation.

AFTERMATH

When Jung returned to Küsnacht after October 2, 1917, he decided to incorporate some of the mandala sketches into *The Red Book*, rather than continuing the transcription of the text interrupted by his departure for Château-d'Oex. He immediately set to work and had completed images 80 through 83 before October 14, when he made image 84, a testimony to the continued intensity of his involvement with the mandala material. Between October 1917 and January 1919, he painted eighteen mandalas, of which fifteen are related to the original twenty-six designs for the sketches.[77] The majority were made while Jung was working on the handwritten and typed drafts of *Scrutinies*, the third part of *Liber Novus*, between November 1917 and 1918.

The painted mandalas thus form their own visionary chapter within *The Red Book*. Like the second layer of *Liber Novus*, however, they represent a reworking of Jung's experience with the mandala sketches. Their design and execution, involving significant simplifications, changes, new material, and symbolic colors, belong to the subsequent chapter in Jung's engagement with the

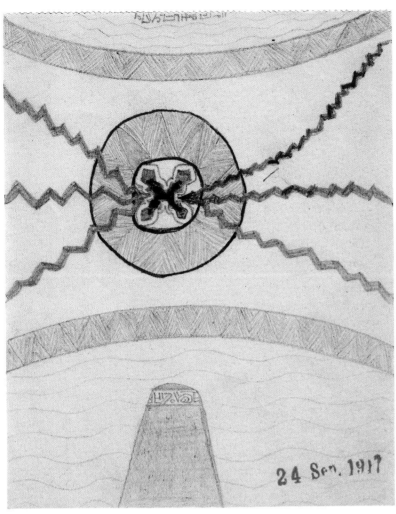

Cat. 104. Mandala sketch 28, September 24, 1917. Colored pencil and ink on paper, 14.9 × 12.1 cm (5⅞ × 4¾ in.), Jung Family Archive

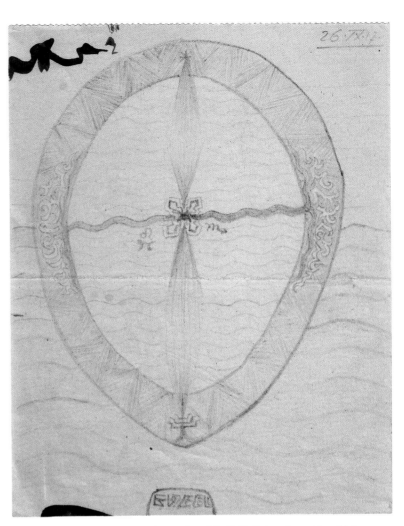

Cat. 105. Mandala sketch 29, September 26, 1917. Colored pencil and ink on paper, 14.9 × 12.1 cm (5⅞ × 4¾ in.), Jung Family Archive

mandala as a prime symbol for his developing psychological concepts, a process that would take him the next thirteen years.

Within this context, the detailed study of the genesis and development of the mandala sketches outlined above contrasts significantly with Jung's version of the episode recounted to Aniela Jaffé forty years later, when he said that he made a daily sketch during his sojourn at Château-d'Oex that provided a psychological photograph of each day.[78] As is evident from Jung's own dating of the sketches, however, they were only begun two months after his arrival and remained thematically interrelated, whether there were significant gaps in their production or several drawn in one day. Moreover, by entitling the first sketch "Phanes," "Metabolism in an individual," Jung identified the process that would subsequently be documented in images over the next seven weeks—the birth of Phanes in himself.

Thus the mandala sketches are the visual representations of Jung's direct experience of the self and the birth of the new God. With their evolving symbols of formation and transformation, they inform the sections of Scrutinies that Jung added in November 1917, as he began to comprehend the centrality of the self and of the God-image: "Not the self is God, although we reach the God through the self. The God is behind the self, above the self, the self itself, when he appears"; yet "I must free myself from the God."[79]

NOTES

1. "The Houston Films," in *C.G. Jung Speaking: Interviews and Encounters*, ed. William McGuire and R.R.C. Hull (Princeton: Princeton University Press, 1993), pp. 327–28.

2. *The Secret of the Golden Flower: A Chinese Book of Life*, tr. Richard Wilhelm, Commentary C.G. Jung, tr. into English Cary F. Baynes (London: Kegan Paul, Trench, Trubner & Co., 1931), p. 96; C.G. Jung, *The Collected Works of C.G. Jung*, 21 vols., ed. Herbert Read, Michael Fordham and Gerhard Adler, exec. ed. William McGuire, tr. R.F.C. Hull (New York: Bollingen Foundation/Pantheon Books, 1953–1967: Princeton: Princeton University Press, 1967–1978), 13, § 31.

3. C.G. Jung, *Dream Analysis: Notes of The Seminar Given in 1928–30*, ed. William McGuire (Princeton: Princeton University Press, 1984), pp. 120, 304.

4. *CW* 13, § 33.

5. Ibid., § 34.

6. Ibid.

7. Jung anonymously included three of his painted mandalas from *The Red Book* among the examples of European mandalas accompanying his commentary: Jung, *Golden Flower*, plates 3, 6, 10; *CW* 13, plates A3, A6, A10.

8. *CW* 13, §§ 35, 36.

9. For a detailed discussion of this period in Jung's life, see Sonu Shamdasani's introduction to C.G. Jung, *The Red Book: Liber Novus*, edited and introduced by Sonu Shamdasani, tr. Mark Kyburz, John Peck, and Sonu Shamdasani (New York: W. W. Norton, 2009), pp. 119–211, 225.

10. Barry Jeromson, "The Sources of Systema Munditotius," in *Jung History* 2 (2007), pp. 20–22.

11. There are at least thirty-five references to Eastern texts: *CW*, suppl. vol. B.

12. *CW*, suppl. vol. B, § 223.

13. Jung lists "prayer" and "incantation" among the meanings for Brahman, linking them to psychological states of overflowing innervations induced by withdrawing attention from the opposites, thereby allowing unconscious contents of a cosmic and superhuman character to become activated: *CW* 6, § 336. This is analogous to the process of introversion involved in creating a mandala. In vol. 32 of *Sacred Texts of the East*, ed. Max Muller (Oxford: Oxford University Press, 1891), owned by Jung, the Vedic hymns are entitled Mandalas.

14. *The Red Book*, pp. 284–85. Hereafter *RB*. *The Incantations* belong to the second layer of *The Red Book*, written between the summer of 1914 and 1915: *RB*, p. 225.

15. "[E]ight is a double quaternity and, as an individuation symbol in mandalas, plays almost as great a role as the quaternity itself": *CW* 10, § 692.

16. *RB*, p. 345 and note 72.

17. *Septem Sermones ad Mortuos* were written between January 30 and February 8, 1916; *RB*, pp. 346–54.

18. For the relations between the *Sermones* and the *Systema Mundi Totius*, see Barry Jeromson, "Systema Munditotius and Seven Sermons: Symbolic Collaborators in Jung's Confrontation with the Dead," in *Jung History* 2 (2005/06), pp. 6–10; *RB*, pp. 205–6.

19. For an explanation of the term *Pleroma*, see *RB*, p. 347, note 82.

20. The term *Anthropos* does not appear in *The Red Book*. For its multiple references and meanings in Jung's writings, see the index volume *CW* 20 (keyword), "Anthropos."

21. *RB*, pp. 349, note 93, and 350, and Appendix C, pp. 370–71.

22. Jung associated the lower world of Abraxas with 5, "the number assigned to the 'natural man,'" "(the twice-five rays of his star)": *CW* 9/I, § 680; *RB*, p. 364; C.G. Jung, *Visions: Notes of the Seminar Given in 1930–1934*, vol. 2, ed. Claire Douglas (Princeton: Princeton University Press, 1997), pp. 820–21.

23. September 25, 1916, *Black Book* VI, pp. 104–6, in *RB*, pp. 354–55, note 125.

24. The tree of light is associated with "the spiritual number 3 (twice-three flames with one large flame in the middle)": *RB*, p. 364. Its lights symbolize "illumination and expansion of consciousness": *CW* 13, § 308 and Fig. 3.

25. Jung had discussed the tree of life in *Psychology of the Unconscious, CW*, suppl. vol. B, §§ 335–39. The fourth sermon in *Sermones* explains: "the tree of life [. . .] greens by heaping up growing living matter [. . .] [it] grows with slow and constant increase through measureless periods of time [. . .] good and evil unite in it": *RB*, p. 351. There are only two visual examples in *The Red Book* before 1916: *RB*, pp. ii and 22.

26. In the border of *RB*, p. 29, there are two light-trees. One supports a half-reclining figure, and the other holds an oval with a figure inside: Phanes in the Cosmic Egg. In the left border Phanes appears again, now within the winged egg. A seven-branched light-tree decorates the small red vessel above the horned Izdubar in *RB*, p. 36, and appears in *RB*, pp. 48, 49, and at the bottom of image 59. For the significance of Phanes in Jung's cosmology, see Shamdasani, *RB*, p. 301, note 211.

27. September 28, 1916, *Black Book* VI, pp. 104–6, in *RB*, p. 354, note 125.

28. The beetle is the main image in *RB*, p. 29, chapter vi, "Death," in *Liber Secundus*. In the border of the image, a beetle carries a human figure in its central cavity.

29. See Donald Harms, "Geometry of the Mandala," in *Jung Journal: Culture & Psyche* 2 (2011), pp. 84–101; "The Geometry of C.G. Jung's Systema Munditotius Mandala," in *Jung Journal: Culture & Psyche* 3 (2011), pp. 145–59. *Geometric Wholeness of the Self* (Napa, California: privately printed, 2016), pp. 127–51.

30. Jung published *Systema Mundi Totius* anonymously in 1955: "Mandalas," in *Du: Schweizerische Monatsschrift* 4 (1955), pp. 16, 21; *CW* 9/I, §§ 707–12, where he published it as the frontispiece, entitled "Mandala of a Modern Man."

31. Jung had used the winged serpent as a repeating motif for the background of Izdubar: *RB*, p. 36, finished on Christmas Day 1915.

32. See introduction by Ernst Falzeder, in *The Question of Psychological Types: The Correspondence of C.G. Jung and Hans Schmid-Guisan, 1915–16*, ed. John Beebe and Ernst Falzeder (Princeton: Princeton University Press, 2013), pp. 29–32; *RB*, p. 210.

33. *CW* 6, § 326.

34. See ibid., § 827.

35. C.G. Jung, *Psychology and Religion* (New Haven: Yale University Press, 1938), p. 96; revised by Toni Wolff and augmented by Jung in 1940; revised with alterations in translation in *Psychology and Religion: West and East* (1958/1977), *CW* 11, § 136.

36. *CW* 6, § 427, pp. 825–28. Jung wrote "The Transcendent Function" in November 1916 but only revised it for publication in 1958: *CW* 8, §§ 131–93.

37. *RB*, p. 1 (eye), p. 22 (tree), p. 32 (egg/circle), pp. 37 and 40 (Shiva/Shakti), p. 40 (wheel and tree), pp. 50–63 (incantations incorporating numerous symbols), p. 69 (circles), p. 72 (cones), p. 75 (circles, cones, golden flower) and p. 79 (circles containing the four opposites).

38. C.G. Jung, *The Psychology of Kundalini Yoga: Notes of the Seminar Given in 1932*, ed. Sonu Shamdasani (London: Routledge, 1996), p. 73.

39. See Jung, *Visions*, I, p. 365.

40. Protocols of Aniela Jaffé's interviews with Jung for *Memories, Dreams, Reflections*, 1956–1958, Library of Congress, Washington, DC, p. 165. Hereafter *Protocols*, p. 172; Jung, *Memories*, pp. 210, 218, 220. For Jung, the difference between a "work of art" and a "work of nature" was of prime importance for his emerging theory of analytical psychology. "The

products of the unconscious are pure nature," he stated in 1918 in *The Role of the Unconscious*: *CW* 10, § 34. In *Psychological Types*, he asserted that the artist does not grasp his work's real significance as "a symbol that promises a renewal of life. In order to transform it from a purely aesthetic interest into a living reality, it must be assimilated into life and actually lived." *CW* 6, § 310. For relations between Moltzer and Jung, see Shamdasani, "Memories, Dreams, Omissions," in *Spring: Journal of Archetype and Culture* 57 (1995), p. 9; also Shamdasani, *Cult Fictions. C.G. Jung and the Founding of Analytical Psychology* (London: Routledge, 1998), pp. 16, 56–75.

41. *Protocols*, pp. 171–72.

42. The sketch was done in two stages; first with a fine graphite pencil, and then partially reinforced with a thicker one. Initially dated 3 & 4 VIII 17, Jung amended the date to 2 VIII 17.

43. See *CW* 13, plate A6.

44. Jung related the terms "systolic" and "diastolic" to introversion and extroversion in *Psychological Types*, *CW* 6, § 7; see also Paul Bishop, *Analytical Psychology and German Classical Aesthetics: Goethe, Schiller, and Jung*, vol. 1 (London: Routledge, 2008–2009), pp. 102–9.

45. Jung later called such ring motifs "drops": *CW* 9/I, § 551 and Fig. 2.

46. By February 1917, Jung had created a similar flower growing above an egg in *RB*, p. 60, decorating the eleventh incantation for the rebirth of Izdubar, and he used the motif again in *RB*, pp. 64 and 75.

47. *CW* 13, plate A6.

48. *RB*, p. 75, bears a striking resemblance to Jacob Boehme's mandala in *XL Questions Concerning the Soul*: *CW* 9/I, § 704. Jung depicts the irrational reconciling symbol of the new God and the renewed attitude arising in the void between the two circles representing the un-united opposites: *CW* 6, § 301.

49. These are similar to the design of *RB*, iv (v), done in 1915: see above, note 1.

50. Jung calls the star man's individual fate and the symbol of individuation: Jung, *Visions*, I, p. 322; II, pp. 766, 1158. In *Concerning Mandala Symbolism*, *CW* 9/I, § 679, he notes that the number six signifies creation and evolution, being a *coniunctio* of 2 × 3, and thus, according to Philo Judaeus, the number most suited to generation. See also *The Philosophical Tree*, *CW* 13, § 336, where he states that "the number six (the *senarius*) was considered in ancient times 'aptissimus generationi' (most fit for generation)."

51. Jung did not reproduce sketch 2 in the series of *RB* mandalas derived from the 1917 mandala sketches, perhaps because it was too similar to *RB*, p. 75.

52. See *CW* 13, § 38.

53. Jung observed that such petals, when positioned outside the mandala's "magic circle," could also symbolize "incoming intrusions or assaults"; with the indentations between them attempting to penetrate it: *Visions*, II, p. 1165.

54. Jung later remarked that when the influence and importance of the outside world are becoming so strong they can bring about an impairment and devaluation of the mandala, it may break down or burst: *CW* 9/I, § 609 and picture 11.

55. Jung, *Memories*, p. 221.

56. Information from unpublished letters. Jung Family Archive.

57. These are legible when the sketches are oriented in the same direction as sketches 1, 3, and 4. The *n* outside petal 2 (moving clockwise) on sketch 6 may be the astrological sign for Saturn. The symbol outside petal 2 on sketch 8 may signify Sagittarius, and the *XY* outside petal 3 Pisces and Aries. In *The Red Book* and other writings of the period, Jung used astrological signs in a variety of ways: as symbols of the months and planets related to the twelve houses of the zodiac with their particular qualities and as referents of individual horoscopes.

58. C.G. Jung, "A Study in the Process of Individuation" (1939), in *The Integration of the Personality*, tr. Stanley M. Dell (New York: Farrar & Rinehart, 1939), pp. 38–40. This was first given as a talk at Eranos in 1933, and published as "Zur Empirie des Individuationsprocesses," in *Eranos-Jahrbuch* (Zurich: Rhein-Verlag, 1934), pp. 210–14; enlarged and revised as "A Study in the Process of Individuation" (1950/59), in *CW* 9/I, §§ 559, p. 567. Jung's original phrase in the manuscript of his 1933 Eranos talk, "ein [. . .] Bild von einer schwebenden Sphäre, in welche von unten ein schwarzes, phallusartiges Gebilde eindringt" (ETH Zurich University Archives, Hs 1055: 96 1) was edited by Toni Wolff to read "auf dem die Schlange von unten heraufkommt" in the *Eranos-Jahrbuch 1933* (1934, p. 210), and translated as "serpent rising from below" in the English publication (1939, p. 38). In CW 9/I, § 599 (1950/59), Jung corrected the phrase to its original wording, "penetrated *from below* by a black phallus-like object."

59. Jung, "A Study in the Process of Individuation" (1939), p. 49; this passage is not included in *CW* 9/I.

60. The two smudged forms in blue pigment directly above Scorpio and Mars may have been added later. Jung used a similar color in Mandala *RB*, p. 83, which is based on this sketch. They are similar in form to the "devilish monster" and the "larva" in *Systema Mundi Totius*.

61. *CW*, suppl. vol. B, § 500.

62. See ibid., §§ 499–503.

63. This is the first appearance of runes in the mandala sketches. Although their exact meaning is unclear, their basic forms are identified in Jung's fantasy of October 7, 1917, regarding the runes in sketch 15: *RB*, p. 291, note 155. Jung had already used other types of hieroglyphic imagery in *The Red Book*, beginning with the glyphs on *RB*, p. 15. In a letter to Sabina Spielrein from Château-d'Oex on September 13, 1917, Jung referred to hieroglyphs as symbols of "primal images"; adding "the new development that will come announces itself in an old language, in symbolic signs," one of Jung's underlying precepts in *The Red Book*: "The letters of C.G. Jung to Sabina Spielrein," in *Journal of Analytical Psychology* 46 (2001), pp. 187–88.

64. See *CW* 12, fig. 160; *CW* 10, § 771.

65. In *The Red Book*, Jung had previously used complex ogive lines to form containers and canopies: RB, pp. 48, 50, 51. On the verso of sketch 9, Jung wrote associations from an unrecorded dream, including references to figures in *The Red Book* and astrology; in particular, he mentions "Löwe des Elias, Macht, Löwe mit Scorpion im Monde ♏ = Herbstzeichen; nach der Analyse nach Erscheinung des Sterns" (Leo of Elias, Might, Leo with Scorpio in the moon ♏ = autumn sign; following analysis after appearance of the star).

66. The tablet is related to Jung's dream of finding a red tablet with runes on it imbedded in his bedroom wall, but not understanding their meaning: *Protocols*, p. 172; thus the dream may predate sketch 15. See *RB*, p. 291, note 155, for the meaning of these runes, explained to Jung's "I" in a fantasy of October 7, 1917, by the magician Ha.

67. *CW*, suppl. vol. B, § 223.

68. *RB*, p. 291.

69. *Tabula smaragdina* of Hermes, first quoted by Jung in *Psychology of the Unconscious*, *CW*, suppl. vol. B, § 97. The same idea is expressed in *RB*, p. 34, and *Incantations*, pp. 51–52, 58.

70. Brihadāranyaka Upanishad, IV, 3, 6: C.G. Jung, "The Spirit of Mercurius" (1948), *CW* 13, § 301.

71. Following Augustine, Jung equated knowledge of the self with the first day of creation, which is then succeeded by knowledge of the firmament,

earth, sea, plants, stars, animals of water, air and land, and of man him-
self, concluding with the seventh day of rest, in God, a sequence similar
to that unfolding in his remaining mandala sketches. *CW* 13, § 301.

72. These runes remain undeciphered. The central rune, a cosmic dot within
a circle with armlike appendages, looks like a god creating the universe
below.

73. The runes in sketch 23 are explained in *Black Book* VII, October 7,
1917, which Jung appended to 10 September, the date of this sketch: *RB*,
p. 292, note 156.

74. *RB*, p. 354.

75. *CW* 9/II, § 177.

76. Jung used similar zodiacal imagery to express the hero's journey: *CW*,
suppl. vol. B, § 606. Jung called Scorpio an autumn sign in his associa-
tions to an undocumented dream on the verso of mandala sketch 9 (note
65 above).

77. *RB*, pp. 80–97. In the margin of *RB*, p. 103, Jung wrote the date 26 I
1919, a terminus ante quem for the mandala paintings related to the
1917 sketches.

78. *Protocols*, pp. 172–74; Jung, *Memories*, p. 220.

79. *RB*, pp. 338–39. Shamdasani notes the close relation between *The Red
Book* mandalas and the "experience of the self and the realization of its
centrality as depicted in *Scrutinies*": *RB*, pp. 225–26, 336, note 17.

Details from *The Red Book*, pages 80 (above) and 81 (below)

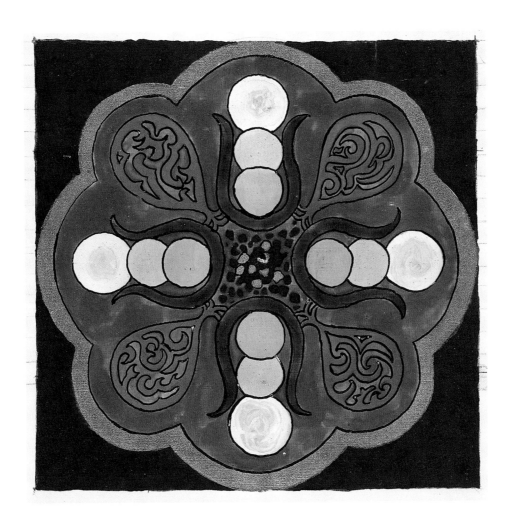
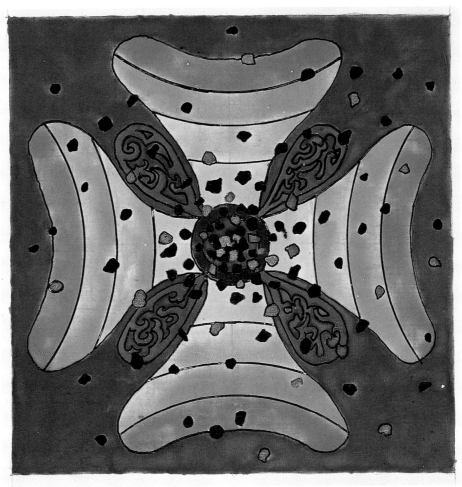

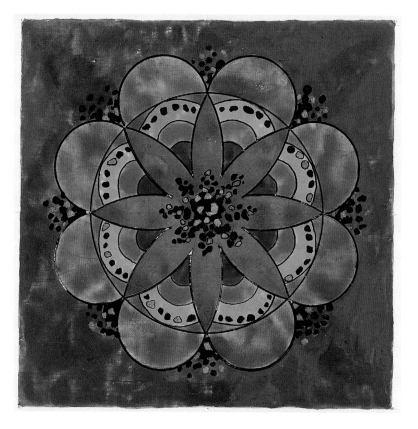

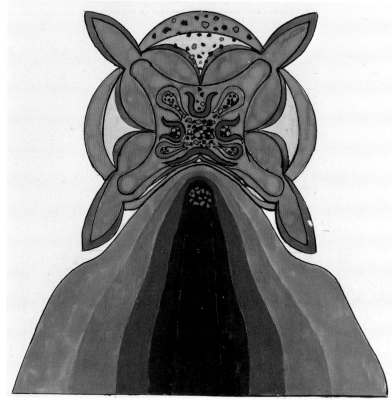

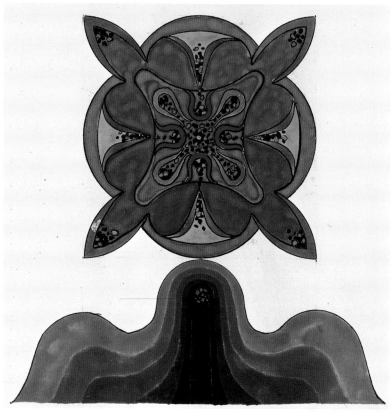

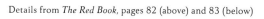

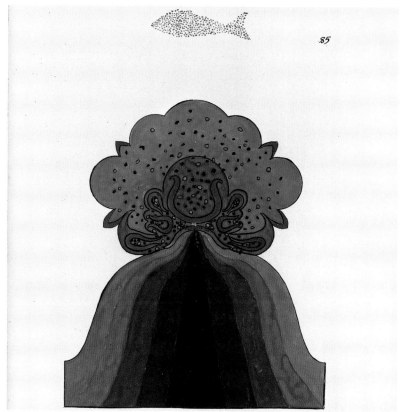

Details from *The Red Book*, pages 82 (above) and 83 (below)

Details from *The Red Book*, pages 84 (above) and 85 (below)

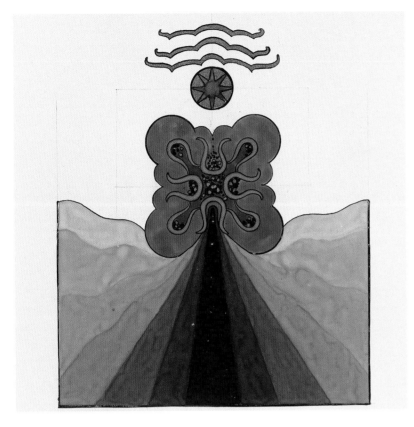

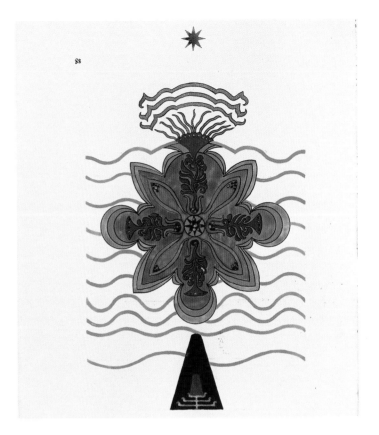

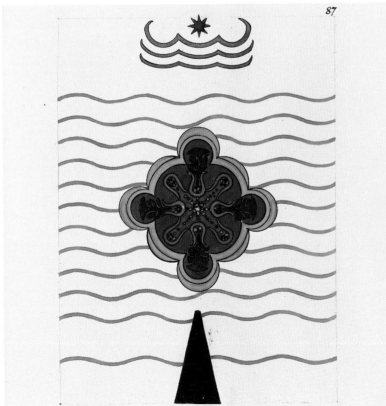

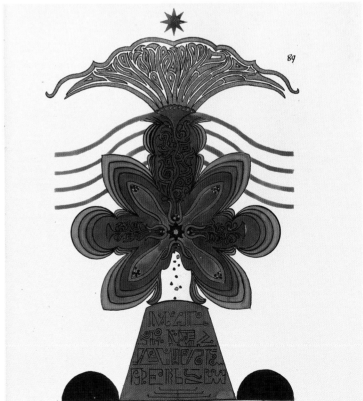

Details from *The Red Book*, pages 86 (above) and 87 (below)

Details from *The Red Book*, pages 88 (above) and 89 (below)

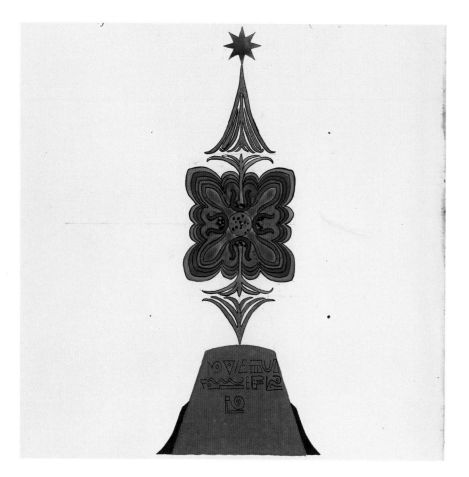

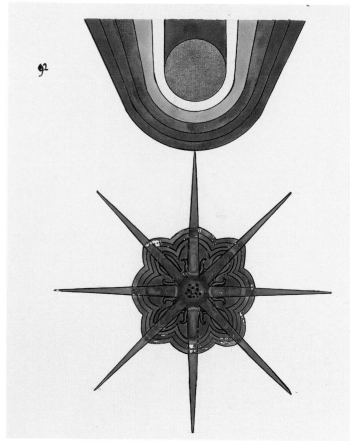

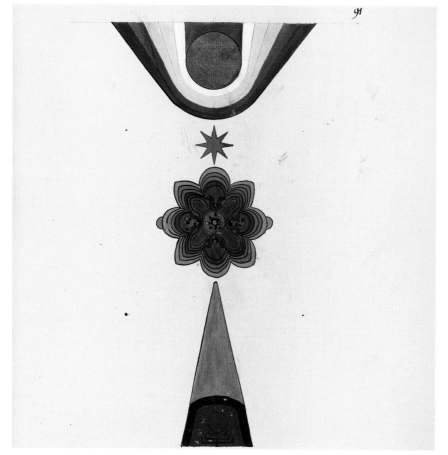

Details from *The Red Book*, pages 90 (above) and 91 (below)

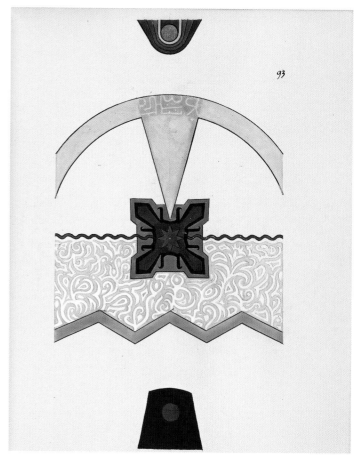

Details from *The Red Book*, pages 92 (above) and 93 (below)

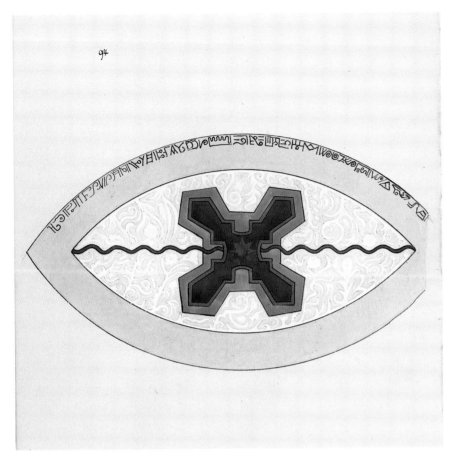

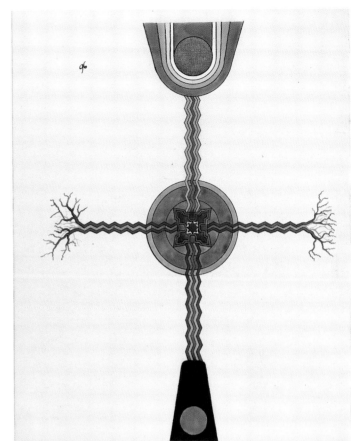

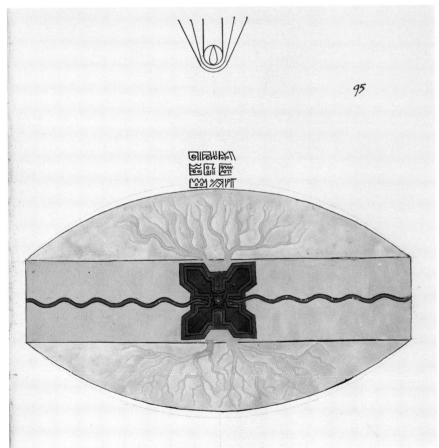

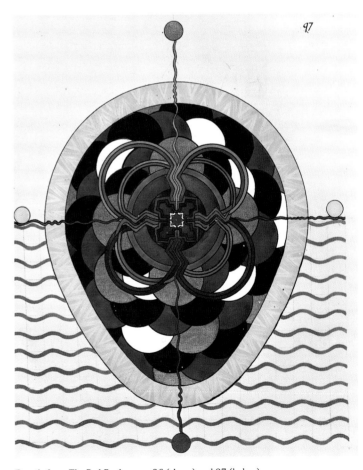

Details from *The Red Book*, pages 94 (above) and 95 (below)

Details from *The Red Book*, pages 96 (above) and 97 (below)

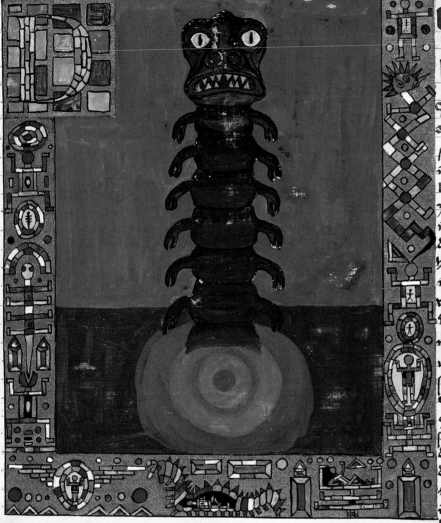

er tod ·

cap · vi ·

Und da folgenden Nacht wanderte ich zu nordischen Lande und fand mich unter grauem Himmel in nebeldunstiger kühlfeuchter Luft. Ich strebe jener Niederung zu, wo die Ströme matt laufen und breit spiegeln aufleuchtend, da sie dem Meere sich nähern, wo alle Kraft des Fließens sich mehr und mehr dämpft, und wo alle Kraft und alles Streben sich dem unermeßlichen Umfang des Meeres vermählt. Spärlich werden die Bäume, weite Sumpfwiesen begleiten die still trüben Wasser, unendlich und einsam ist der Horizont, von grauen Wolken umhangen. Langsam, mit verhaltenem Atem, mit der großen bangen Erwartung dessen, der wild herabschäumte und sich in das endlose verströmte, sage ich mein Bruder, der Wasser, leise kaum merklich ist sein Fließen.

Und da nähern wir uns stetig dem seligen und höchsten Umarmen, um einzugehn in der Schoß des Ursprungs, in die grenzenlose Ausdehnung und unmeßbare Tiefe. Dort erheben sich niedere gelbe Hügel. Ein toter weiter See dehnt sich an ihren Fuße. An ihn entlang wandern wir leise, und die Hügel öffnen sich zu einem dämmerhaft, unsagbar fernem Horizont, wo Himmel und Meer zu der ewig unendlichkeit verschmolzen sind.

Dort, da auf der letzten Düne steht einer, er trägt einen schwarz faltigen Mantel, er steht bewegungslos und schaut in die Ferne. Ich trete zu ihm, er ist mager und blaß und der letzte Ernst liegt in seinem Zuge. Ich rede ihn an:

Laß mich eine kleine Weile bei dir stehn, dunkler. Ich kannte dich von weit. So steht mir einer, wie du, so einsam und auf der letzten Ecke der Erde.

Er antwortete:

Fremder, wohl magst du bei mir stehn, wenn es dich nicht friert. Du siehst, ich bin kalt, ein Herzschlag rührt mir nicht mehr.

Ich weiß, du bist Eis und Ende, du bist die kalte Ruhe des Steines, du bist der höchste Schnee der Gebirge und der äußerste Frost des leeren Weltraumes. Das muß ich fühlen und darum nahe bei dir stehn.

Was führt dich zu mir her, du lebender Stoff? Lebendige sind hier nie zu Gast. Wohl kommen sie alle in dichten Scharen trauernd hier vorbeigeflossen, alle, die dort oben im Lande des lichten Tages den Abschied

MATTER AND METHOD IN
THE RED BOOK: Selected Findings

JILL MELLICK

> The object, which is back of every true work of art, is *the attainment of a state of being*, a state of high functioning, a more than ordinary moment of existence. In such moments activity is inevitable and whether this activity is with brush, pen, chisel, or tongue, its result is but a by-product of the state, a trace, the footprint of the state.[1]

Disciple and master of art media and techniques, C.G. Jung explored and mapped the inner realm through word and image. Required in school to draw "prints of Greek gods with sightless eyes"[2] and a "picture of a goat's head,"[3] he was declared devoid of talent; in fact, he felt and was already expressing a natural affinity with media and techniques, which he used both traditionally and innovatively. He also knew he could only work in them when imagination was stirred.[4]

By the time he penciled his first drawing on the parchment of *Liber Primus*, he had been writing prolifically and had worked in pencil, pen, ink, pastel, gouache, watercolor, clay, wood, stone, mixed media, and water-based media, which he mastered in *The Red Book*. During and after the years he worked on *The Red Book*, he also worked extensively and intensively with wall painting, bas relief, freestanding sculpture, and masonry. In each he worked with self-taught expertise. With rare exceptions[5] he worked alone. His generativity astonishes.

Selected from extensive discoveries[6] about the context, materials, and techniques Jung chose for *The Red Book*, even these few examples will show Jung's ability to create a stunning palette and effects: his choice of tools, pigments, and binding medium; his design choices for pages and mosaic-like color fields; his combining transparent and opaque techniques; and his rendering of light, form, and dimensionality.

MEDIA, TOOLS, AND SUPPORTS

When Jung decided to make *The Red Book* in the style of an illuminated manuscript, he carefully chose and ordered the finest materials and learned or honed techniques. He sketched designs in pencil and used inks[7] for calligraphy. For historiated[8] or decorated[9] capitals and his illuminations,[10] he chose mineral pigments (fig. 71). These he mixed with gum Arabic[11] as binding medium[12] and water as carrier. Years later, he used varnish for future illuminations.[13]

He needed fine sable brushes with good bellies: round brushes with a fine toe; flat brushes with crisp ends and corners; and script, liner, or detail brushes for miniature work. He also used calligraphy pens, of quill or with metal nibs, and a fountain pen for capitals.[14]

The Red Book, page 29

217

Fig. 71. A powdered mineral pigment Jung ordered from Keim, a German manufacturer. Photograph by Matt Mimiaga. © Jill Mellick

Together with these he would have used an awl to prick several sheets at once for ruling;[15] a ruler, compass, protractor; a pencil-sharpening tool; heavy paper or cardboard to place under his hand to protect sections from smudging, stray paint, and hand oils; glass containers for water in which he could dip and clean brushes frequently; and at least one glass container in which he could dip the toe of his brush to dilute pigment-rich mixtures. He needed at least one tall container in which to store brushes, handle down, so toes would keep their shape as they dried; and sealable glass containers in which to keep paint wet between uses.[16] His pigments usually had high specific gravity and sank out of suspension. Jung would have had to shake each mix vigorously before use to redistribute pigment particles in their binding medium.

To sketch designs for *The Red Book*, Jung used fine quality, heavy rag paper (fig. 72).[17] He chose thin parchment for *Liber Primus* and heavy vellum[18] paper for *Liber Secundus*.

By the thirteenth century, illuminators were purchasing rather than preparing powdered pigments from apothecaries and stationers. Jung likewise purchased pigments prepared by manufacturers. However, he did not buy what one would expect.

When Jung decided to make *The Red Book*, manufacturers had long been preparing powdered pigments for techniques such as gouache and watercolor. Each required a different grind; conversely, different grinds created different effects. Watercolor pigments are finely ground, mixed with gum arabic as a binding medium, and applied using water. They create luminosity, transparency, smoothness. Pigment particles appear to have dissolved. In fact, the particles have not; they are still in suspension in the gum arabic and carrier, as well as on the support. However, they are so finely ground that they appear to be in solution. Gouache pigments are more coarsely ground, contain a filler such as titanium dioxide, calcium carbonate, or zinc oxide, use gum arabic as binding medium, and water as carrier. They create opacity and retain slight graininess. When dry, gouache looks like what it is: particles in suspension bound to one other and to the support. Tempera techniques mix finely ground pigments with egg, glue, honey, water, or casein,[19] and a variety of plant gums.

Manuscript illuminators mainly used tempera but also used gouache and watercolor. Jung did not use tempera, preferring watercolor and gouache to render a range of effects from transparent to opaque.

Jung could easily have purchased finely ground, powdered pigments for transparent and semitransparent work and more coarsely ground pigments and filler for semi-opaque and opaque work. He did not. Rather, he chose high-quality, powdered mineral pigments, the breathtakingly intense hues of which he could use to approximate the glow and brilliance of medieval manuscripts.

Jung took on a significant technical challenge with these remarkable pigments. Manufacturers provided careful specifications for binding medium, application, and supports. Many pigments Jung chose were recommended for use on firm supports. Jung, however, decided to use them on flexible supports: parchment and vellum.

He knew he was departing from technical specifications because he later used these same pigments according to their specifications for wall painting.[20] In using them on *The Red Book*'s parchment and vellum, he constantly risked flaking; the bond between paint and support was weak. Jung would have seen his paint flaking off parchment and vellum soon after he laid it down. Only much later did he find a solution: after completing much of the manuscript, he later varnished some illuminations, eliminating flaking.

In addition to intentionally taking on this technical challenge, Jung had to become intimate with the personality of each pigment so he could devise ways to elicit each pigment's unique characteristics to create optimal effects, from transparency to opacity. For example, Jung would have seen quickly that minerals in certain pigments refracted less light; being more transparent, they were good candidates for watercolor techniques. Minerals in other pigments refracted more light so were better candidates for opaque techniques. Too, he would have noticed quickly that each pigment, with its unique elemental composition and specific gravity, behaved differently in suspension; these unique behaviors also influenced the effects he wanted to create. Jung was adept at playing up a pigment's strengths and playing down its limitations.

In choosing pigments that had not been ground specifically for watercolor use, Jung discovered that, when he used a heavy load of pigment, he not only increased the saturation of a hue—an effect he sought consistently—but also increased opacity. He was constantly brokering an uneasy peace among intensity, transparency, and opacity. To do this, he invented techniques.

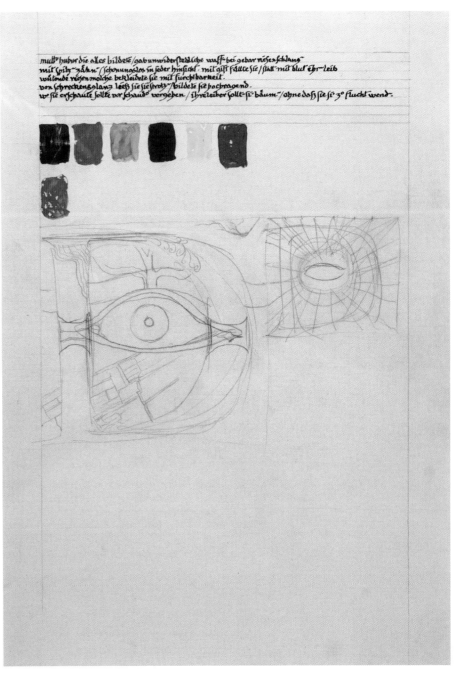

Fig. 72. Jung's rough sketch for page 1, *Liber Secundus, The Red Book*, shows his bounding lines and frame ruling for his mise-en-page, trial calligraphy, design for the majuscule D, and color palette.

SCRIBE, RUBRICATOR, ILLUSTRATOR, ILLUMINATOR

In the late Middle Ages, a team of specialists divided the intensive, prolonged labor required to illuminate a manuscript: a scribe wrote black minuscules; a rubricator designed and rendered majuscules, diminuendos, and important minuscules; an illustrator painted designed majuscules, decorations, and images; often a separate illuminator added the precious metals that gave the manuscripts their name.

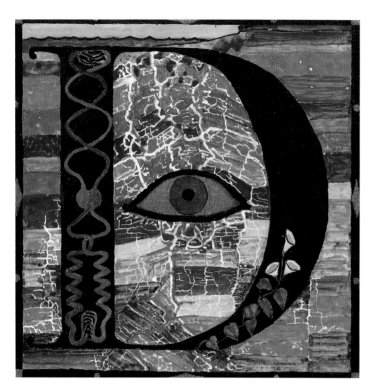

Fig. 73. Decorated majuscule, detail
from *The Red Book*, page 1

Fig. 74. Folio v, verso, *The Red Book*.
The lower left column shows where
bas-de-page decoration from the right
column of folio V, recto, is visible
through the parchment. The decorated
majuscule B, with its diaper pattern,
and the illuminated column picture, top
right, show flaking. Neither red nor blue
diminuendo letters following the B,
nor the black calligraphy, show flaking.
Liber Primus shows no pinpricks.

Jung became his own scribe, rubricator, illustrator, and illumina-
tor. In the tradition of his medieval counterparts, Jung first designed
pages. He allocated bounding lines, determined proportion of word
to image; determined sizes for calligraphy; allocated spaces for major
and minor initials, rubrication, decoration, image, and illumination.
He experimented with and selected color palettes for pages. He
planned almost every line in every majuscule, decoration, and illu-
mination, noting center and dividing lines, circles, angles, shapes. He
did this with the patient exactitude of his artistic exemplars.[21]

For his preparatory sketch for page 1 of *Liber Secundus* Jung
used three mediums. On heavy, cold-press rag paper, he planned
in pencil his bounding lines and line spacing for the hand he was
using; he sketched the majuscule *D*, even indicating pattern, shape,
and angle for its mosaic background. Using ink and calligraphy pen,
he also experimented with the hand[22] by writing five lines of unre-
lated text and visually noted his palette for the recto.

Only when he had planned each detail, line, and palette for a
page did he permit himself disciplined spontaneity: he let himself
alter elements somewhere between original sketch, underdrawing,
and rendering. Regardless of when he changed the design of the
decorated majuscule, he retained its original elements and mosaic patterning (fig. 73).

To render the thirteen pages of *Liber Primus*, Jung used pencil, ink, and opaque techniques
on parchment.[23] He used black ink and calligraphy pens to write the minuscules and red and
blue pigment inks to rubricate smaller majuscules and selected minuscules. Jung purchased inks
that had been ground so finely they appeared to be in solution, not in suspension. When he first
laid these inks down on the parchment, the parchment would have appeared to absorb them;
however, when the inks dried, he would have seen that, in fact, the ink's fine particles were, in
fact, bound successfully to one another and to and between the fibers of the support. His black
and red inks flowed and distributed more uniformly than the blue (fig. 74).

When Jung prepared and used opaque paints to create historiated and decorated initials
and to decorate, illustrate, and illuminate, his mix of pigment, filler, and gum arabic medium did
form a bond with the parchment but the bond was fragile and the paint flaked.

Parchment presented him with a second challenge. As soon as he turned over his first recto,
he would have seen that his parchment was so transparent that calligraphy and illuminations
showed through on the verso side. Moreover, he chose to use only gouache techniques in *Liber
Primus*; these paints, with high refractive indices, were more opaque than the parchment. For
example, after determinedly writing over an area in the lower left verso column of folio V that
had been darkened by the recto painting, Jung placed, designed, and painted, in the top right
verso column, an illumination to exactly cover the illumination showing through from the recto.
While illuminated manuscripts showed just such transparency, Jung apparently neither liked it
nor saw his solution as viable or sustainable. It seemed to confine his design choices and com-
promise visual integrity (see fig. 74).

These pervasive, intrusive concerns—flaking of the paint and transparency of the support—
doubtless contributed to Jung's decision to use vellum paper as the support for *Liber Secundus*.

Mysterium

Begegnung. cap. ix

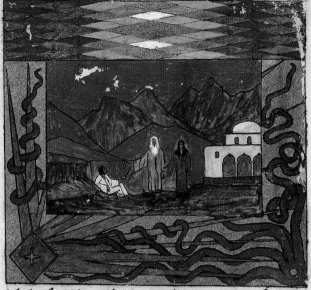

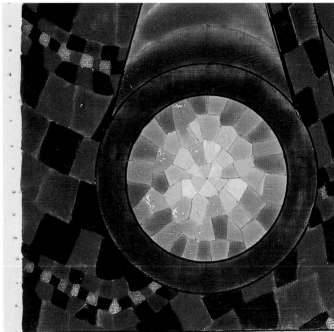

Fig. 75. Detail from *The Red Book*, page 109, showing pencil lines beneath transparent and semitransparent paint. Jung followed some lines exactly; others, he ignored as he painted. He left the pencil visible.

Fig. 76. Detail from *The Red Book*, page 72, showing pinpricks for ruling on the left side of the page.

He ordered heavy-weight, fine-quality vellum for *The Red Book*, banishing unwanted transparency. Using vellum also reduced flaking; his transparent and opaque paints and inks adhered better to vellum—providing he did not overload binding medium with pigment.

Jung left his pencil work, including corrections and changes, for calligraphy and underdrawings visible. At times, he also used original pencil lines as final outlines for mosaic cells (fig. 75). Whether he ever erased any pencil work has not been determined, but pages show changes to illuminations where Jung could have erased without stressing the support, so it is unlikely. Certainly, Jung would have observed that medieval manuscripts left bounding lines, guidelines, and line spacing visible. Doubtless, too, he would have seen that some contemporary artists were deciding to retain process as part of product.

Often, using a ruler, and probably other mechanical devices, on the first recto of several recto leaves, he defined the outside boundaries of the page with lines. Then he penciled in points on the right and left to indicate where he would draw parallel guidelines for later calligraphy (fig. 76). After he prepared this first of several recto pages, he would position the book to align leaves of vellum beneath. Using guidelines on the top recto, he used his awl to prick, at the end of each line, fine holes through several leaves. On later pages, using these pricks, he then ruled horizontal pencil guidelines for calligraphy. He planned each page but appears not to have planned several pages in advance because he regularly used an already pricked, even pencil-lined page for a partial or full illumination. Pricks are not visible on later leaves in the manuscript. While it is possible his decision not to register later groups of pages was an aesthetic one, it was more likely a practical one because Jung still left pencil lines visibly extending beyond bounding lines of completed illuminations.

For both transparent and opaque effects, Jung almost exclusively used a wet-on-dry technique. He would fill the belly of a carefully selected sable brush with just enough paint to allow gravity to produce uninterrupted flow from brush to parchment or vellum—if he applied just

the right pressure. Not once in the entire manuscript did he bloat the belly of the brush causing paint to overflow its boundaries when it touched the support. He constantly, automatically, and unerringly estimated the amount of paint in the belly of the brush, the pressure of his hand, and the receptivity of the vellum. So experienced and careful was he with this technique that one sees paint straying beyond a pencil boundary only when his hand-eye coordination occasionally faltered by a millimeter. Given his small strokes and the tiny areas in which he was working, his unfailing accuracy amazes.

Jung married his intimate understanding—of the characteristics of each pigment, each brush, the binding medium, the carrier, and the supports—to his skills and concentration. He perfected a confluence among eye, hand, paint, and surface: his tiny mosaiclike cells required perfectly bounded fields of color. Each cell was a discipline, an irrevocable commitment, a painting in itself.

MOSAIC FIELDS

If the visions Jung explored in *The Red Book* arrived both invited and uninvited, his techniques for painting them were their perfect complement. He chose techniques that were controlled, exacting, precise, disciplined, laborious. Too, Jung's detailed pencil underdrawings and choice of palettes would indicate that he would have been able to focus on a particular section while still being aware of the design and unity of the whole page. He used techniques and styles that differed radically throughout the manuscript—even within the same illumination—yet each is an unmistakable member of the same visual family.

Building large illuminations from small cells was one such technique. What influenced him to choose this most labor intensive of techniques lies outside this discussion.[24] However, his decision could not have had bigger technical implications for him.

First, he chose to commit untold hours to drawing, in pencil, each side of each tiny cell. He built most illuminations from hundreds, usually thousands, of these. He did not draw a single cell at random. It seems that no patterned field of cells was accidental. He selected creative constraints for a field and then, while working within these chosen constraints, drew each cell freehand and spontaneously. To draw each cell, he needed concentration, discipline, and constant adaptation to the evolving form of the field.

Beyond the fact that he drew each cell individually before painting it, any commonality between Jung's rendering of cells ends. He invented many variations, each based on self-imposed limitations. Among the creative constraints Jung imposed on himself were shape, size, palette, color, and outlining.

Shape

Jung changed the shapes of his cells from illumination to illumination—and even within the same illumination. He used a myriad of organic and geometric shapes for fields or entire illuminations (fig. 77). Frequently, he populated a field by combining three-, four- and five-sided shapes (fig. 78). Except

Fig. 77. Detail from *The Red Book*, page 135

Fig. 78. Detail from *The Red Book*, page 107

Fig. 79. Detail from *The Red Book*, page 79. Jung used different mosaic cell shapes, sizes, and colors in this mandala. He completed four smaller circles using different tones of a single hue. Cells radiate from the center, increasing in size and in number of sides. He populated fields with tones of a single hue, gold paint, or the same tone in contiguous cells.

for straight lines, circles, or specific angles, he completed all freehand.

Size

Jung chose cell size based on design for the page and/or on the proximity of cells to central points. For example, on both page 72 (fig. 76) and 79 (fig. 79), he drew three-, four-, and five-sided cells. On page 72, he chose large cells for outer fields; in each of the six circles, he designed his cell pattern to radiate from the center, increasing size as he approached the bounding lines. On page 79, he drew smaller cells but did not reduce size as he approached the central field; rather, he changed proportions of each color to increase focus and intensity as the eye approaches the center.

Color

Without exception, Jung used a single hue for each cell. Sometimes he used transparent paints; sometimes, opaque. Sometimes he used both—in hundreds of contiguous cells. Only rarely did he mix pigments together. When he did, the result was often uneven. The pigments preferred to be separate and equal; because of their different properties, they did not cohabit well. So Jung almost always used one pigment at a time, often varying transparency, opacity, or intensity even within a single cell. Sometimes he separated similarly colored cells; at other times, he completed a field of cells using two or three tones of the same hue, adding more carrier or white filler or both; at still others, he used the same hue in the same saturation in contiguous cells (see for example fig. 79).

Outlining

Jung used outlining to create radically different effects and affects with and within each illumination. He used a wide variety of outlining styles intentionally varying tool, medium, width, color, and function.

He experimented with complex mosaic techniques on page 72 (see fig. 76). Because the mandala reads as a whole, it is easy to miss the thousands of decisions Jung made to effect this wholeness. In each field, he varied cell shape, size, color, opacity, transparency, and style of outline. He conducted this symphony of changes masterfully; at no time does any mosaic field compete with the dominant cross and circles; however, these dark fields deny relegation to a kind of busy negative

space. Rather, they teem with life potentiating; shapes and colors manifest form in void.

Jung outlined last. On both page 72 (see fig. 76) and 79 (see fig. 79), he used mechanical instruments to draw straight and circular outlines and, in so doing, was able to smooth out slight unintentional variations in painted edges. On page 72, he used black to outline the vertical, horizontal, and circular lines, the outer circle's ornamentation, and the straight, inner sections of the cross. He thinned the outline around the inner circle; adjusted outlines of some painted, woven areas freehand; chose not to outline the larger of the central circles but to outline the star. The overall symmetry resulting from these small decisions is remarkable.

To create thin, steady black lines, Jung used either a fine calligraphy pen or a thin outlining or detailing brush. On page 79, he outlined freehand, in black, each side of each cell in the large circles—outlining even the darkest cells. Beyond the large circle, he did not outline dark, distal cells.

Varying his outlining technique further, Jung outlined the illumination on page 115 (fig. 81) using unique techniques. He outlined some areas in silver and black and others, in gold and black. In both, he used the black line as a cast shadow—the only place in the manuscript where he did this; other areas, he did not outline.

Fig. 80. Detail from *The Red Book*, page 135

TRANSPARENCY AND OPACITY

Jung seamlessly and ceaselessly moved among transparent and opaque techniques. Composition and color palette determined which technique he used, and he expertly used their opposite techniques of application. While he only used opaque techniques in *Liber Primus*, he used the full range—from transparency to opacity—to achieve luminosity, perspective, dimensionality, planarity, and texture in *Liber Secundus*.

In the center of page 135 (fig. 80), Jung used four techniques—transparent, semitransparent, semi-opaque, and opaque—in an area of less than two square centimeters. He chose transparent and semitransparent techniques for the pale blue, outer, organically shaped cells; and heavily pigmented the darkest areas portraying absence of light and absolute depth. Finally, in a rare use of layering, he used filler to paint the bright, jagged shafts and long, thin rays of light emanating from the center.

To portray luminosity, he varied pigment load—in every cell. He first selected an area in each cell to paint with diluted mix, thus ensuring his support would stay visible. Then he increased pigment load in the same cell to render depth, form, or shadow.[25]

His pigments lent themselves better to opacity. So when Jung used opaque techniques, he found himself on easier ground—literally. He either added filler or changed the ratio of pigment to filler—or both—to indicate light and dark. His opaque techniques were pigment-heavy, so much so that the dense distribution of particles allowed little to no parchment or vellum to show

through. To highlight or lighten, he added filler. He added lightest areas last (as opposed to transparent watercolor technique, which protects "light" first). Occasionally, he employed a technique rare for him: a thin, semi-opaque, unevenly distributed, glaze of white filler over darker, opaque paint to indicate light (see fig. 79).

Jung's preference for pigment-rich paint confronted him with his greatest technical challenges. When he heavily loaded gum arabic with pigment, the mix frequently cracked on drying; he had not provided enough binding medium to let pigment particles hold together or adhere to the support. He observed this phenomenon early in *Liber Primus* but continued to push the ratio throughout the manuscript—with varied success depending on the pigment. With more naturally opaque pigments, Jung did not have to load as much pigment to achieve intensity of hue. With less naturally opaque pigments, Jung pushed concentration to its limit and beyond. One might assume Jung preferred risking craquelure to sacrificing intensity. He continued to attempt a balance between intensity and cracking, and eventually found that a coat of varnish over the completed, dried painting successfully resolved the problem.

PERSPECTIVE AND DIMENSIONALITY

In pencil drawings, architectural sketches, early paintings, and *The Red Book*, Jung shows easy understanding of, although he did not strictly adhere to, techniques for rendering perspective, light and shadow, and dimensionality.

At times, he departed radically and intentionally from these conventions. In the illumination on page 115 (see fig. 81), he used light and shadow in abstracted, stylized, symbolic ways, which obeyed no laws of the outer world. Light sources appear and disappear: the figure is fluid, stylized, casts no shadow; black shadows on the left of the gold verticals to the left of center imply light from the right; black shadows to the right of the gold verticals to the right of center imply light from the left; the horizontal gold ceiling lines imply a light source in front of the image. This mix of illusionism and abstract design is as unsettling as the subject matter.

If Jung's portrayal of light and shade in this illumination is unsettling, his distortion of perspective dizzies. Nothing is as it first appears. Sidewalls, floor, and ceiling recede. But beyond this nod to perspective, any resemblance to a three-dimensional world ends. While Jung painted sidewalls whose tiles diminish as they recede, he also drew many of the tiles as parallelograms, so they are not in perspective. However, the floor recedes traditionally and angles join sidewalls, floor, and ceiling three-dimensionally.

Fig. 81. Detail from *The Red Book*, page 115

The rear wall is the most unpleasantly disorienting. Jung created an initial impression of either a patterned flat wall with a mandala or a receding hallway becoming a tunnel. However, he allowed the eye no rest. Planes change and contradict one other. Side squares indicate a flat surface; upper and lower squares on "floor" and "ceiling" recede faster than the black and white floor or closer ceiling, giving a kinaesthetic experience of rapid recession that is almost claustrophobic.

Jung gave the circular design in the "dead" center of the painting some relationship with the diagonals, directing the eye toward it, but intentionally disrupted the rhythmic design of the surrounding spokes. With relief the eye finally rests on the gold circle at the center, separated—by a single black line—from the surrounding, syncopated, relentless chaos.

He disrupted light, perspective, and planarity, yet also, by concentrating pigment in areas, indicated shape in each tile. He used opaque black and white paint to render the floor, conveying predictability, solidity. However, he intentionally drew the figure's feet from two different viewpoints. Each foot, viewed alone, could be imagined as touching the floor; viewed together, they ignore gravity and distort perspective.

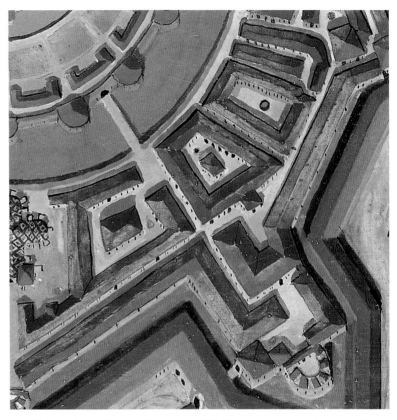

Fig. 82. Detail from *The Red Book*, page 163. One of the slopes of each roof is painted darker to indicate shadow. Each building also casts a shadow.

Shadows

Jung depicted almost no shadows in *The Red Book* (nor did his medieval counterparts)—with one exception. In the mandala on page 163 (fig. 82), he studiously cast shadows from each building. The pattern of the cast shadows could be as it is only if the light were, in fact, cast from Jung's own eyes, which were looking at buildings below and in front of him; shadows on the sixteen roofs in the outer circle of buildings adjacent to the moat indicate progressive distance from the light source. However, Jung also gave priority to and stylized shadows so that his mandala appears to consist of quadrants that mirror each other. In fact, they do not at all.

However, like the medieval illuminators, Jung often mixed naturalistic and mannered styles and combined two- and three-dimensional areas. In the figure of Philemon on page 154 (fig. 83), Jung used crosshatching on the figure's arms to model roundedness. He painted Philemon's robe one-dimensionally in front but added light and dark vertical lines on the lower half of the robe to model body and robe. He shaped Philemon's feet in a stylized way by increasing saturation.

Jung modeled the building, lighting the front and shading each side equally. Equal shade on each side would be possible only if the light on the walls and dome were directly in front of and on the same horizontal plane. Jung did not model the trees on either side of Philemon but painted them in a two-dimensional, decorative style.[26] He lightened the palm trees and green ground as they recede toward the horizon and lightened the sky along the horizon. So the background is

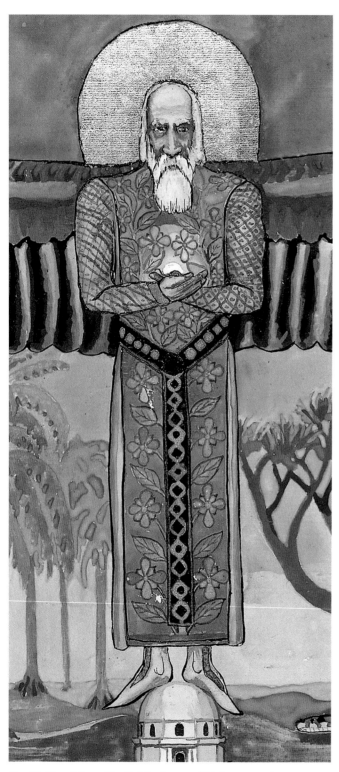

Fig. 83. Detail from *The Red Book*, page 154. Jung uses deeper shades and crosshatching in the figure of and environment around Philemon to model and indicate distance but renders the environment in a stylized manner.

lit from behind while Philemon and the building are lit from the front. Such symbolic abstraction is found cross-culturally across millennia. Despite these conventions and precedents, Jung's use of it for the Philemon illumination could, nevertheless, have proven as disturbing as his mix of styles on page 115. Yet, with the Philemon illumination, Jung achieved the opposite effect: the illumination steadies the breath and the eye.

Jung's exquisite, formal dance with naturalism, abstraction, and decoration on page 131 exemplifies yet another use of light and shadow and perspective (fig. 84).

In this illumination, Jung chose one light source. This he depicted high and centered vertically. This otherworldly light appears at first to emanate from behind the tree. However, Jung painted certain radiating rays in front of branches and others, behind. By inference, the light emanates from a deep space within the great tree itself.

Jung combined transparency and opacity again in this illumination. He used transparent technique to scatter pale, translucent hues across the central field of light. This delicate, mysterious, transparent field is one of the few where Jung used a wet-on-wet technique; onto a tiny area of vellum he had already lightly coated with water, he would have dipped the toe of a lightly pigmented brush. As soon as the toe met the thin film of water, he would have quickly lifted the brush and watched the thin wash spread, according to molecular characteristics, into the damp field, finding its natural boundary where the wet vellum met the dry. He did this repeatedly. After these transparent areas dried, he outlined each with a slightly darker, still transparent shade of the same hue.

He designed sixteen rays emanating from the light source and chose to render these in the most tedious, perilous way imaginable. He knew well how—and it would have been technically safer and easier—to add fine lines, using opaque white filler, to the illumination at the end; after all, he had done it before (see fig. 81). Instead, he chose the ultimate— and ultimately difficult—transparent technique to create these slim, compositionally crucial light rays. When he began this illumination, he penciled in the sixteen long thin pairs of lines. Then, with great accuracy, he built every cell and field around these long, thin spaces defined by each pair of lines. Not once did an adjoining color field intrude on unpainted areas.[27]

Further complicating interplay of light and shadow, Jung chose semi-transparent technique to paint eight concentric fields of light surrounding the central light source. Rather than depicting light fading naturally as it moved away from the source, he abstracted and stylized its emanation by creating these encircling fields. He also changed the shape of each: the further each field was from the light, the less organic and more

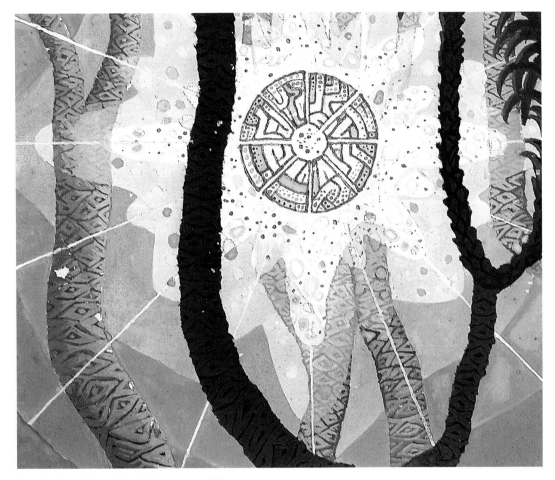

Fig. 84. Detail from *The Red Book*, page 131

geometric Jung made its form. And every time Jung created a new encircling field, he lessened the strength of light falling on any branch that moved through the field.

To model branches, Jung began naturalistically, painting the side of the branch closest to the light in the lightest tone and progressively darkening the tone as he turned the form of the branch away from the light. However, instead of simply modeling the branch in a naturalistic way, he chose a more difficult, time-consuming, and exacting way to do it. He designed yet another mosaic pattern for the tree bark. This he drew first in pencil, designing scores of tiny diamonds within diamonds; next, he painted the outline of each diamond with one or two lines in deeper tones; last, he curved the area enclosed by each diamond by using shading to indicate whether each tiny area of bark turned away from or toward the light.

Then, working in a way both naturalistic and stylized, he treated the fissured bark's innumerable diamond shapes to an even more difficult and time-consuming process; he rendered every single diagonal bark plate three-dimensionally. Using opaque techniques, he used darker lines to indicate the bark's deep fissures and lighter lines to indicate the outer cork. So, in fact, he modeled each diamond-shaped area of bark as well as modeling the whole branch—each in an almost mathematical relationship to the eight changing concentric fields of light falling on

them. The interplay of visual, artistic, and mathematical awareness required to do this defies easy imagination.

Jung chose a style for the background that was the perfect opposite of his exacting, double-diamond, mosaic rendering of the foreground tree. Using gold pigment,[28] he laid down a simple, thin swath of light along the horizon. Then he linked dark earth to sky by trees that he rendered with spare, black impressionistic gestures.

In this complex illumination, the protagonist of which is *lumen* itself, Jung left the ground unfinished. He devoted almost all the space to light and its flow through space and around form. The simple, monochromatic undulating lines of the foreground tree's dark roots descend into unfilled space at fundament. And below this? Only presentiments: two mechanically drawn, angled pencil lines and undulating, freehand pencil lines. Their being left *in medias res* in this space, forever held *in potentia* on vellum, complements the rest of the so highly wrought illumination. The pencil lines intimate the lingering presence of skills, imagination, consciousness, breath, all of which underlie, hold, and support the vision above them.

In conclusion, even these few aspects of Jung's creative choices—his spectacular mineral colors, meticulous planning of calligraphy and mosaic-like illuminations, expert use of transparency and opacity, and varied rendering of perspective and dimensionality—permit a deeper understanding of Jung's slow, demanding, taxing, irrevocable, risky, disciplined process in making *The Red Book*. He devoted years to exercising technical and artistic skills, focus, and patience. In so doing, he became not only his own master and student but master of matter and method.

NOTES

1. Robert Henri, *Artists on Art* (New York: Pantheon Books, 1945), p. 401.
2. C.G. Jung, *Memories, Dreams, Reflections*, recorded and edited by Aniela Jaffé, tr. Richard and Clara Winston (New York: Pantheon Books, 1963), p. 29.
3. Ibid.
4. Ibid.
5. Jung invited and acknowledged participation, for example, of others in the ceiling mural of the Jung, Rauschenbach, and his sons-in-law's family crests at Bollingen.
6. This material is excerpted and adapted from two sources. My manuscript *The Red Book Hours* (Zurich: Scheidegger & Spiess, 2018) documents, in word and image, discovery and identification of pigments and binding mediums Jung used for *The Red Book* and wall paintings; analysis of high resolution files created by DigitalFusion, Los Angeles; discoveries about the context in which Jung worked; and conclusions about his creative process. My report *Pigment and Binder Analysis of Jung's Pigments and Paint Fragments from The Red Book* (prepared for the Foundation of the Works of C.G. Jung, 2013) that documents results of pigment and paint analyses commissioned from Jennifer Mass (Senior Scientist and Laboratory Director, Scientific Research and Analysis Laboratory, Winterthur Museum, Delaware).
7. Whether Jung used pigment or dye inks has not been determined; he probably used the former because they, like his pigments, were permanent.
8. An example of an historiated capital is the *D* in *RB*, fol. i (r).
9. An example of a decorated initial is the *D* in *RB*, p. 15.
10. In common usage *illumination* and *illuminated* refer to any embellished manuscript; originally, the words only described areas to which precious metals had been added.
11. Gum arabic is a hardened gum made from two species of acacia.
12. While *medium* is commonly used to describe artists' materials, it technically denotes only the binding agent.
13. Personal communication from Jost Hoerni, 2013.
14. "Pen capitals" use no paints.
15. Dots resembling pencil dots are visible in the facsimile edition of *Liber Secundus*. They are, in fact, pinpricks. Personal communication from Hugh Milstein.
16. One such container is preserved in the Estate of C.G. Jung.
17. This premise is based on the single extant sketch found for *The Red Book*.
18. *Vellum* refers to both calfskin and the kind of paper Jung used.
19. Casein is the main protein in milk.
20. Manufacturer guidelines for using pigments for wall painting are extant at Bollingen.
21. That Jung planned each page is evidenced by visible pencil underdrawings on almost every page, his half-finished page 169, and the extant sketch for page 1.
22. *Hand* refers to the style of calligraphy, e.g., Blackletter.
23. Whether Jung's parchment was made from calf, goat, or sheep skin has not been determined.
24. Why Jung might have chosen the processes and techniques he did for *The Red Book* is explored in depth by the author in *The Red Book Hours*.
25. Fig. 76 also shows this technique.
26. Jung renders branches on pages 154 and 131 in opposite ways.
27. The possible reasons why Jung chose this painstaking, exacting approach lie beyond the scope of this explication and are discussed by the author in *The Red Book Hours*.
28. Scientific tests on particles from *The Red Book* identified no pure gold or silver. Jung appears to have used mineral pigments resembling precious metals for most illuminating and gold leaf only occasionally.

C.G. JUNG THE COLLECTOR

THOMAS FISCHER

Jung often described and interpreted symbolic representations in his works, sometimes including images he published with the credit line "collection of the author."[1] Photographs of his living and working spaces show a diverse collection of art and craftwork. Of particular interest is their connection to Jung's own visual and literary works. After Jung's death, most of the objects were distributed among family members and others close to him and today his collection is dispersed among various owners.

There is no doubt that the objects with which he surrounded himself, some given to him as gifts, some that he himself collected, held special significance. We can safely assume that this is doubly the case for objects seen in the historical photographs of his library in the house in Küsnacht.[2]

From the age of four, Jung lived in a parsonage of the Reformed Church in Kleinhüningen, near Basel. His earliest memories of visual art stretch back to this time:

> The house where my parents lived was the eighteenth-century parsonage, and in there
> was a dark room. Here all the furniture was good, and old paintings hung on the walls.
> I particularly remember an Italian painting of David and Goliath. It was a [. . .] copy
> from the workshop of Guido Reni; the original hangs in the Louvre. How it came into
> our family I do not know. There was another old painting in that room [. . .]: a landscape
> of Basel dating from the early nineteenth century.[3] Often I would steal into that dark,
> sequestered room and sit for hours in front of the pictures, gazing at all this beauty. It was
> the only beautiful thing I knew.[4]

In the same passage, he also recalls how during his youth, on a visit with an aunt, he discovered almost accidentally the collection of antiquities in the Basel art museum, which impressed him deeply:

> Suddenly I was standing before these marvelous figures! Utterly overwhelmed, I opened my
> eyes wide, for I had never seen anything so beautiful. I could not look at them long enough.[5]

Later, as a secondary-school student, Jung often returned to the Basel collection. It was around this time that he started to collect prints:

> I was already very enthusiastic about Holbein and Böcklin when I was a student and
> all the early Netherlandish masters, I loved them very much. I have myself put together

Fig. 85. Jung holding his pipe as he sits on a chair in his library at home. A Tibetan Thangka hangs on the wall behind him. © Dmitri Kessel/The LIFE Picture Collection

233

a collection of copperplate engravings. In Basel everybody went for art, because of the influence of J[acob] Burckhardt. I own works on paper by Boucher and some of the oldest aquatints. [. . .] I have two prints by Dürer, a woodcut and a copper engraving.

I know the copperplate engravings of the eighteenth century quite well. When I was in Paris,[6] I was in the Louvre just about every day, and I looked at *La Gioconda*[7] I don't know how many times. I talked to the copyists a lot and had a Frans Hals copied for myself. Later in Florence, I had the picture *Vieillesse et jeunesse*[8] [. . .] copied and the *Madonna in the Forest* by Fra Filippo Lippi. For an entire year, I was consumed by art. Before I came to the Burghölzli. Then I didn't have the time any more. I also collected tinted German woodcuts. I got to know Egyptian art in the Louvre. [. . .] I went to the museums [in Paris] until the point of exhaustion and absorbed the works of art into myself.[9]

Jung came into contact with antiques when, after the death of his father, he partly financed his studies "by helping an aged aunt dispose of her small collection of antiques. I sold them piece by piece at good prices."[10]

Jung moved to Zurich in 1900 for his dissertation. There he decorated his room in the employee accommodation wing of the psychiatric clinic Burghölzli with selections from his collection of old prints. After Jung married Emma Rauschenbach, the daughter of industrialists, in 1903, the two lived for a time in a house at Zollikerstrasse 198 in Zurich. With the help of her wealthy parents, the young couple were able to live very comfortably.[11] On becoming assistant medical director, Jung became entitled to a bigger apartment in the clinic Burghölzli, to which they moved in 1904, shortly before the birth of their first daughter.

Upon moving in 1909 to Küsnacht on Lake Zurich, the couple furnished the house, designed by the architect Ernst Fiechter,[12] with commissioned, made-to-order furniture, rugs, pictures, and other furnishings, as was customary among the haute bourgeoisie at the time. Jung lived in this house until the end of his life, in 1961, by which time it was decorated with numerous works of art and crafted objects from a wide range of continents and cultures.

Over the decades the collection grew to become decidedly diverse. Copies of Old Masters, produced in Paris and Florence, exemplify Jung's early taste in art. The difference between the original and the copy appears to have had little significance for Jung, though he was certainly aware of it. In his library, there was a plaster bust of Voltaire (fig. 86)[13] next to a small bronze Buddha seated on lotus flowers, alongside examples of Japanese calligraphy, Persian miniatures, and copies of medieval stained glass. A ceremonial staff crowned by a figure, made by the Fang people of Gabon, was especially fine; it is shown in a photograph of about 1951, hanging from the handle of the door to the balcony (fig. 87). Zoological and geological objects also appear in the house (fig. 88).

While lists of Emma's trousseau and the couple's wedding gifts, which included art, have been preserved,[14] no complete catalogue of the objects Jung collected is known, nor can any certainty be offered about how many objects came into his possession. Nevertheless, certain categories can be identified, reflecting the history of the collection:[15]

Ancestral portraits and copper engravings, shields with coats-of-arms, old land maps, and city maps;

Plaster casts of historical persons (Nietzsche, Voltaire, Scipio, Homer) and antique reliefs;

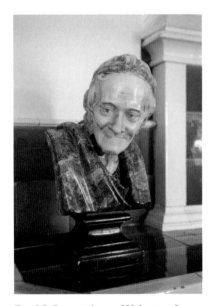

Fig. 86. Portrait bust of Voltaire, after Jean-Antoine Houdon, plaster and marble. This bust was originally in Jung's library, later in the waiting room of his house. © Foundation of the Works of C.G. Jung, Zurich/Alex Wydler

Copies of classic European paintings from the Louvre and the Uffizi, for example Frans Hals
 (today attributed to Pieter Claesz Soutman), *Half Portrait of the Beresteyn-van der Eem
 Family*, and Fra Filippo Lippi, *The Holy Family*;

Ethnological objects from various cultures (Africa, India, America);

East Asian art (bronze and porcelain figures, vases, wall hangings, mandalas, calligraphy,
 miniatures);

European art of the twentieth century (paintings by Yves Tanguy, Peter Birkhäuser, and
 Erhard Jacoby, as well as the bronze head of a young woman by Hermann Hubacher);

Jewelry and craft objects (signet rings, walking sticks);

A collection of old alchemical prints.

Fig. 87. Jung in his library, 1949. Hanging from the door handle is a carved ceremonial staff from the northern Fang region of Gabon, Africa. © Dmitri Kessel /The LIFE Picture Collection

Fig. 88. The wooden Fang staff Jung kept in his library, ca. 1920. Private collection © Foundation of the Works of C.G. Jung, Zurich/Alex Wydler

Fig. 89. Jung regarding his collection, arranged on top of the covering for the central heating in his library, 1957. Next to mythological animal and divine figures are a refined rock crystal, the skull of an ape, and other artifacts. Gelatin silver print, Jung Family Archive. Tim Nahum Gidal © The Israel Museum, Jerusalem

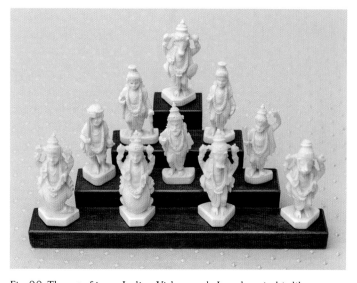

Fig. 90. The set of ivory Indian Vishnu gods Jung kept in his library. Private collection. © Foundation of the Works of C.G. Jung, Zurich/ Alex Wydler

The objects in the first three groups featured in the early décor of C.G. and Emma Jung. They served to display the owners' humanistic education and values, and at the same time acted as memento mori (ancestral portraits, busts of philosophers, the skull of an ape . . .). These objects, acquired mostly before 1908, evince a conventional taste in art. The notable difference of the remainder of the collection raises the question of what criteria Jung used to build it over the following decades. Jung's apparently unmethodical collection of objects contrasts sharply with the systematic and passionate collection of Sigmund Freud. Freud was a well-known collector of antiquities who filled his living and professional quarters with more than three thousand objects, especially figures of humans and animals, but also bowls, vases, and early jewelry, antiquities from the Mediterranean, small Egyptian and Persian sculptures, and pieces from China's earliest dynasties.

The meaning of Jung's collection, and the motivation for its expansion after 1908, become clearer in the context of his research goals. First, Jung was specifically interested in everything that scientific thought of his time disdained and dismissed as occultism,[16] which drove his constant search for seemingly lost knowledge, across all cultures and times, from which he hoped to draw new insights for his comparative psychological research.

Relatedly, Jung was heavily involved with comparative symbology and the systematic discussion of mythology, first broached in his 1912 book *Wandlungen und Symbole der Libido* (Transformations and Symbols of the Libido).[17] From that point on, symbolic objects appear more frequently in his collection. In 1915, he painted the first picture in *The Red Book*, wherein he found a symbolic visual language. At this time, by his own account, he developed the idea of the Collective Unconscious[18] and began to formulate his theory of Archetypes. Both concepts fundamentally drew upon his research into the history and the forms of expression of human symbols.

Expansive cultural, historical, and ethnographic interests led Jung to undertake various research trips to other continents between 1920 and 1940, each of which had a direct impact on his collection (fig. 91). Destinations included North Africa, Tunisia, and Algeria (1920/21), the pueblos of North America (1924/25), and Mount Elgon in East Africa (end of 1925).[19] Jung hoped to gain insight into the psyche of people who lived still largely untouched by modern civilization while visiting the indigenous peoples of the Pueblos and Mount Elgon. In contrast, when he accepted an invitation to India at the end of 1937, he used the three-month trip to focus primarily on the rich symbolism in pictorial and architectural representations of this centuries-old civilization.[20]

Jung's interest in foreign cultures and indigenous lifestyles revealed itself early[21] and stayed with him throughout his life, as his library ably demonstrates.[22] Jung traveled to different parts of the world as a researcher, not a tourist.[23] Traveling provided an opportunity to see Europe "from the outside"—to some extent, from an Archimedean point of view:

We always require an outside point to stand on, in order to apply the lever of criticism. This is especially so in psychology, where by the nature of the material we are much more subjectively involved than in any other science. How, for example, can we become conscious of national peculiarities if we have never had the opportunity to regard our own nation from outside? Regarding it from outside means regarding it from the standpoint of another nation. To do so, we must acquire sufficient knowledge of the foreign collective psyche, and in the course of this process of assimilation we encounter all those

Fig. 91. Wooden stool, East Africa. Jung brought this four-legged stool home from his trip to Kenya and Uganda in 1925. Private collection. © Foundation of the Works of C.G. Jung, Zurich/Alex Wydler

incompatibilities which constitute the national bias and the national peculiarity. [. . .]

I understand Europe, our greatest problem, only when I see where I as a European do not fit into the world. [. . .]

When I contemplated for the first time the European spectacle from the Sahara, surrounded by a civilisation which has more or less the same relationship to ours as Roman antiquity had to modern times, I became aware of how completely, even in America, I was still caught up and imprisoned in the cultural consciousness of the white man. The desire then grew in me to carry the historical comparisons still farther by descending to a still lower cultural level.[24]

Furthermore, Jung intended to prove his theories of Archetypes and the Collective Unconscious through empirical material and his own observations.[25] For that purpose, during his travels, he acquired a considerable collection of images (reproductions, postcards, newspaper clippings, and other sources), which, among other things, were introduced into the richly illustrated revised edition (1952) of *Symbols of Transformation*.[26]

In the category of observational material, throughout his career Jung collected an enormous number of patients' drawings, which documented his research into the psychological fundaments of humanity.[27]

Jung's interest in the symbolic representation of psychological processes culminated in his collection of old alchemical prints, acquired systematically from the mid-1930s. Jung desired them principally for their picture cycles and allegories, which allowed psychological interpretation. He collected meticulously, encouraging dealers to seek out alchemical treatises for him.[28] Less concerned with owning them as a bibliophile and more interested in the knowledge they contained, Jung was nonetheless aware of the outstanding quality of his collection[29] and eager to show it to visitors. In a certain sense, the alchemical treatises synthesize the collecting of books, pictures, and objects (fig. 92).

Jung also engaged with early East Asian and Chinese art, and, toward the end of his life, a shift in emphasis from the European tradition to non-European art appears. Readings in East Asian philosophies and religions expanded his views as early as the 1920s.[30] A collaboration with his friend the Sinologist Richard Wilhelm, who had translated into German the ancient Taoist treatise *The Secret of the Golden Flower*, first exposed Jung to a new world of images and symbols.[31] Jung explained his interest in a letter from 1935 to Ernst Benz, a philologist and professor of church history in Marburg. Jung wrote to thank Benz for copies of pictures in the library of Strasbourg University:

I may well assume that you are in the picture when I tell you that I am especially interested in what in the East is called the *mandala*, since these things play a not insignificant role in the psychology of the unconscious. I have collected such things for years and have found that they are closely related to the mystical rose, to the Melothesia, and the so-called pilgrim's circles or the *Troyaburgen* [labyrinths] of the early middle ages. I found

Fig. 92. Jung looking through a folio, 1946. In the bookcase behind him is his alchemical collection. Gelatin silver print, The Israel Museum, Jerusalem, Tim Nahum Gidal Collection. Tim Nahum Gidal © The Israel Museum, Jerusalem

Fig. 93. Carl Jung in his library at home in Küsnacht, Switzerland, 1957. Gelatin silver print, The Israel Museum, Jerusalem, Tim Nahum Gidal Collection. Tim Nahum Gidal © The Israel Museum, Jerusalem

two or three in the *Lucca Codex* of Hildegard von Bingen. I suspect that they are still present in the Rosicrucian or philosophical-alchemical texts.[32]

The symbol of the mandala is a frequent theme in Jung's visual and written works. It is therefore not surprising that wall hangings from the Far East found their way into the collection, among them a now-lost representation of the Bodhisattva Samantabhadra from Japan, an early eighteenth-century Tibetan mandala, and another Tibetan Thangka wall hanging, seen on the right in a photograph of the library taken in 1960 (figs. 85, 93, 94, and 101).[33]

Pieces of modern European art visible in the same photograph may at first seem out of place. In his 1958 essay "Flying Saucers: A Modern Myth of Things Seen in the Sky," however, Jung discusses two pictures by Yves Tanguy and Peter Birkhäuser, together with one by Erhard Jacoby,[34] addressing both the symbolism of the mandala and its analogies to "Things Seen in the Skies."[35] Jung traced an inner connection between these superficially different objects.

The relationship between Jung's collection and his own creative works cannot be overlooked. In *The Red Book*, he gradually distanced himself from naturalistic art in favor of a symbolic

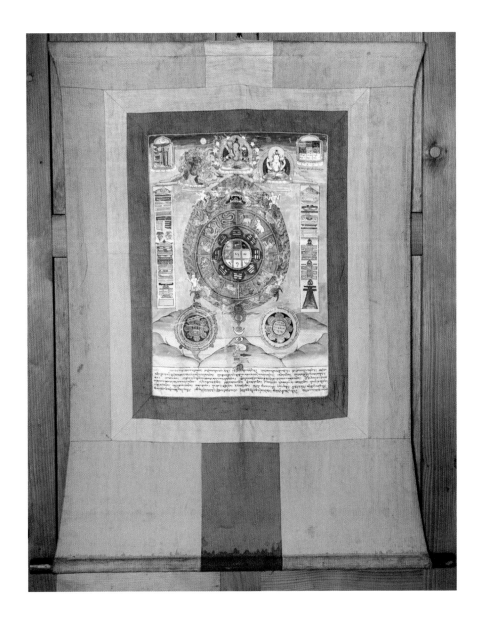

Fig. 94. Tibetan Thangka. Private collection. © Foundation of the Works of C.G. Jung, Zurich/Alex Wydler

means of expression. The hybrid figure with the original African fetish (cat. 45), demonstrates an actual melding of his collection and his own art. The signet ring (fig. 95) that Jung always wore, featuring the Agathodaimon (a benevolent spirit snake) on the top side and the powerful lion on the underside, refers directly to the gnostic symbolism of the *Systema Mundi Totius* (cat. 41).[36] He explored the mandala theme, as previously discussed, in numerous lectures, seminars, and texts—indeed, the first pictures from *The Red Book* to be published (anonymously in 1931) were described as "Examples of European Mandalas."[37]

If one considers "collecting" to be the systematic pursuit, acquisition, and preservation of things, Jung cannot be called a collector in the usual sense (an exception is his library of rare alchemical prints). Possibly his work on *The Red Book* inspired him to acquire certain objects selectively, but in the second half of his life especially he received a sizable number of gifts from friends who were aware of his interest in symbolic representations (fig. 96).[38] Jung's collection

Fig. 95. Jung's gold Egyptian signet ring, with the Gnostic Agathodaimon snake on the front and the powerful lion on the back. Private collection. © Foundation of the Works of C.G. Jung, Zurich/Alex Wydler

Fig. 96. Rosa Gerber-Hinnen (1907–1997), *The Sermon on the Mount*, embroidered wall hanging, ca. 1940. Gift of the Psychology Club of Zurich for Jung's seventy-fifth birthday, Psychologischer Club, Zurich. © Foundation of the Works of C.G. Jung, Zurich/Alex Wydler

Fig. 97. Jung's desk around the time of his death in 1961. Under the writing instruments, his pipe-tamper figure, which was possibly carved by Jung himself. Gelatin silver print, The Israel Museum, Jerusalem, Tim Nahum Gidal Collection. Tim Nahum Gidal © The Israel Museum, Jerusalem

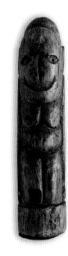

grew organically over time and included items representing ethnology, zoology, anthropology, anatomy, geology, and history, acquired as occasional purchases, souvenirs, found objects, gifts, and everyday goods (figs. 97 and 98). The collection may well be compared to the art collections and cabinets of curiosities of Renaissance princes. Nevertheless, viewing the collection in the larger context of his research interests makes clear that Jung collected primarily *knowledge*—especially apparently lost, discarded, or hitherto inaccessible knowledge—about the human psyche and its collective roots, assembled with a systematic desire, indeed a passion.

Fig. 98. Wooden pipe-tamper figure. Private collection. © Foundation of the Works of C.G. Jung, Zurich/Alex Wydler

Fig. 99. Walking stick. Private collection. © Foundation of the Works of C.G. Jung, Zurich/Alex Wydler

Fig. 100. Jung in conversation with the British journalist Gordon Young of the *Sunday Times* (London), Jung's garden, July 1960. Jung provided the following information about this walking stick: "[It] is a Malacca-cane with a leather-covered handle, the top of which is crowned by a silver knob from China, representing the Dragon that is seeking the precious pearl which is in his tail and which he never attains to." (Letter from Aniela Jaffé to Don W. Hunter, March 17, 1961, ETH Zurich University Archives, Hs 1056: 29630.) Gelatin silver print, The Israel Museum, Jerusalem, Tim Nahum Gidal Collection. Tim Nahum Gidal © The Israel Museum, Jerusalem

NOTES

1. See especially *The Collected Works of C.G. Jung*, 21 vols., ed. Herbert Read, Michael Fordham, and Gerhard Adler; exec. ed. William McGuire; tr. R.F.C. Hull (New York: Bollingen Foundation/Pantheon Books, 1953–1967; Princeton: Princeton University Press, 1967–78), 5, 9/I, and 12. Hereafter *CW*.

2. See Andreas Jung et al., *The House of C.G. Jung: The History and Restoration of the Residence of Emma and Carl Gustav Jung-Rauschenbach*, ed. Stiftung C.G. Jung Küsnacht (Wilmette: Chiron Publications, 2008).

3. Sebastian Gutzwiller's landscape of 1835 shows the view of the Gempenstollen through a roof window.

4. C.G. Jung, *Memories, Dreams, Reflections*, recorded and edited by Aniela Jaffé, tr. Richard and Clara Winston (New York: Pantheon Books, 1963), p. 31. These two paintings later came into Jung's possession. A posthumous photograph of the Küsnacht house shows the Basel landscape. See A. Jung, *The House of C.G. Jung*, p. 96.

5. See Jung, *Memories*, p. 31. His aunt had actually taken him to visit the natural history section of Basel museum, where they overstayed, so that after closing they had to find an exit through the neighboring antiquities gallery. At that time, the natural history museum, the art museum, and the collection of antiquities were housed in the same building.

6. At the end of 1902, Jung went on a three-month student visit to Paris and London after finishing his dissertation, before marrying Emma Rauschenbach in February 1903.

7. *La Gioconda* refers to Leonardo da Vinci's famous portrait of the wife of the Florentine merchant, Lisa del Giocondo, the so-called *Mona Lisa*.

8. It is not clear which picture is referred to here. It could be Domenico Ghirlandaio's painting *Portrait of an Old Man with a Young Boy* (ca. 1490) in the Louvre, of which Jung possessed a copy.

9. Protocols of Aniela Jaffé's interviews with Jung for *Memories, Dreams, Reflections*, 1956–1958, Library of Congress, Washington, DC, p. 164. Hereafter *Protocols*.

10. Jung, *Memories*, p. 117.

11. The first acquisitions of furniture and art are from this period.

12. See Jung's own early sketches and plans in A. Jung, *The House of C.G. Jung*, pp. 32–35; cats. 32–34).

13. On the bust of Voltaire, Jung wrote in a letter to the Basel neurologist Theodor Bovet on November 9, 1955: "I gladly look into the mocking face of the old cynic, who reminds me of the futility of my idealistic aspirations, the dubiousness of my moral standards, the baseness of my motivation, the human, all too human. That's why Monsieur Arouet de Voltaire always stands in my waiting room, so that my patients won't let themselves be fooled by the dear old doctor. My shadow is in fact so large that I couldn't overlook it in my life plan; yes, I have to view it as an essential part of my personality, draw the consequences from this insight, and take the responsibility upon myself." ETH Zurich University Archives, Hs 1056: 21788.

14. Among other things, a relief by Donatello of the Adoration and his painted bust of Niccolò da Uzzano are mentioned. Jung Family Archive.

15. Examples of the object groups named here are represented in historical photographs in A. Jung, *The House of C.G. Jung*, pp. 68–83.

16. Jung's interest is already shown in the topic of his dissertation, *On the Psychology and Pathology of So-Called Occult Phenomena*. Cf. Wouter J. Hanegraaff, *Esotericism and the Academy: Rejected Knowledge in Western Culture* (Cambridge: Cambridge University Press, 2012), pp. 285ff.

17. Revised edition (1952), translated as *Symbols of Transformation*, *CW* 5. In *Symbols of Transformation*, Jung on the whole used sources from ancient Babylon, India, classical antiquity, the Christian Middle Ages, as well as from the indigenous peoples of North America and Africa. There are as yet no references in *Symbols of Transformation* to Chinese culture and art.

18. "Rede anlässlich der Gründungssitzung des C.G. Jung-Institutes Zürich, am 24. April 1948" (Address on the Occasion of the Founding of the C.G. Jung Institute, Zurich, April 24, 1948): *CW* 18/II, § 1131.

19. Jung brought home various objects from these trips, among other things, two small kachina dolls from New Mexico and a four-legged stool, and a primitive stone age axe from East Africa. He presumably found an antique scimitar in a snakeskin sheath on a later trip to India. The Indian scimitar can be seen on the left edge of a photograph of the veranda taken in 1961. See A. Jung, *The House of C.G. Jung*, p. 98.

20. See Jung's sketches of Indian palaces and buildings in a book of alchemical excerpts, in Sonu Shamdasani, *C.G. Jung: A Biography in Books* (New York: W. W. Norton and The Martin Bodmer Foundation, 2012), pp. 178–87.

21. Jung found it hard to choose between studying the sciences or the humanities: "Then again, I was intensely interested in everything Egyptian and Babylonian, and would have liked best to be an archaeologist. But I had no money to study anywhere except in Basel, and in Basel there was no teacher for this subject." Jung, *Memories*, p. 104.

22. Jung's library included a large number of ethnographic texts and travel literature from the nineteenth and early twentieth centuries, among them, for example, books by the German ethnologist Leo Frobenius, whose publications were counted among the fundamental sources on ethnology. In addition, the library had books by the Africanist Hermann Baumann and the art historian Carl Einstein, whose 1915 book *Negerplastik* (Leipzig: Verlag der weissen Bücher, 1915) [*Negro Sculpture*, tr. Patrick Healy (November Editions, bilingual ebook, 2014)] is thought to be the earliest standard work on African art. Dozens of annual publications of the Bureau of American Ethnology demonstrate Jung's lively interest in research on the living conditions of Native North Americans. The fifty-volume edition of *Sacred Books of the East* shows Jung's turn to the realm of East Asian art in the 1920s.

23. In March–April 1933, Jung took what was supposed to be purely a pleasure trip with a friend across the eastern Mediterranean, from Genoa to Sicily, Athens, Istanbul, Rhodes, Cyprus, Palestine, Jerusalem, and on to Cairo and Luxor; nevertheless, many impressions from this trip appear in his books and seminars.

24. Jung, *Memories*, p. 275.

25. At the time of his death, Jung's library contained more than five thousand books from an extremely diverse range of fields. It offers a panorama of his wide-ranging interests: classical literature, ancient philosophy, psychology, psychiatry, medicine, the interpretation of dreams, Gnosis, the Early Church Fathers, ancient mystery religions, Egyptian mythology, Early Christian symbolism, Jainism, Buddhism, psychological novels, ethnography, art history, and much more. Even in his later years, Jung expanded his library further in new specialized areas such as cabalistic mythology and the literature on flying saucers.

26. Parts of this collection of picture reproductions are found today scattered among Jung's papers in the ETH Zurich University Archives and in the picture archives of the C.G. Jung Institut Zurich. *Das Buch des Bilder Schätze aus dem Archiv des C.G. Jung Instituts Zürich*, ed. Ruth Ammann, Verena Kast, and Ingrid Riedel (Ostfildern: Patmos, 2018).

27. At the time of his death, Jung's collection of patients' drawings comprised some four thousand pictures. Today it can be found in the archive of the C.G. Jung Institute Zurich.

28. A comprehensive correspondence with book dealers has been preserved in the collection of the Foundation of the Works of C.G. Jung, Zurich.

29. Thomas Fischer, "The Alchemical Rare Book Collection of C.G. Jung," in *International Journal of Jungian Studies* 2 (2011), pp. 169–80.

30. During a stay in London in the summer of 1919, Jung became acquainted with the Chinese oracular book the *I Ching*. He referred to this Chinese philosophy for the first time in his 1920 *Psychological Types*. See *CW* 6, §§ 358–66.

31. Compare Shamdasani, *C.G. Jung: A Biography in Books*, pp. 150–58.

32. Jung to Ernst Benz, January 29, 1935, ETH Zurich University Archives, Hs 1056: 3764.

33. The large silk wall hanging that depicts Bodhisattva Samantabhadra was for many years on the wall of Jung's library. Its current whereabouts are unknown.

34. For this, see Thomas Fischer and Bettina Kaufmann, "C.G. Jung and Modern Art," in the present publication (pp. 19–31).

35. *CW* 10, §§ 619–22.

36. In a conversation with Miguel Serrano, Jung elaborated on his ring as follows: "It is Egyptian. Here the serpent is carved, which symbolizes Christ. [Above its head, twelve rays]; below the number 8, which is the symbol of the Infinite, of the Labyrinth, and the Road to the Unconscious. I have changed one or two things on the ring so that the symbol will be Christian. All these symbols are absolutely alive within me, and each one of them creates a reaction within my soul." *C.G. Jung Speaking: Interviews and Encounters*, ed. William McGuire and R.F.C. Hull (London: Thames & Hudson, 1978), p. 468. The illustrations numbered 203 and 204 in *CW* 12 also show the "Agathodaimon" as used in Jung's *Collected Works* and the Chnupis snake with, respectively, 7- and 12-numbered aureoles and the snake's tail as a horizontal 8.

37. *CW* 9/I, Fig. 6, §§ 654f.; Fig. 28, § 682; Fig. 36, § 691.

38. A well-documented example is the wall hanging *Bergpredigt* (Sermon on the Mount) by the Swiss textile artist Rosa Gerber-Hinnen. In 1946/47, Jung wrote a short interpretation of this tapestry, which had been given to him by the Psychology Club for his seventieth birthday: *Bemerkungen zu einem Wandteppich* (Remarks on a Wall Hanging) (ETH Zurich University Archives, Hs 1055: 836).

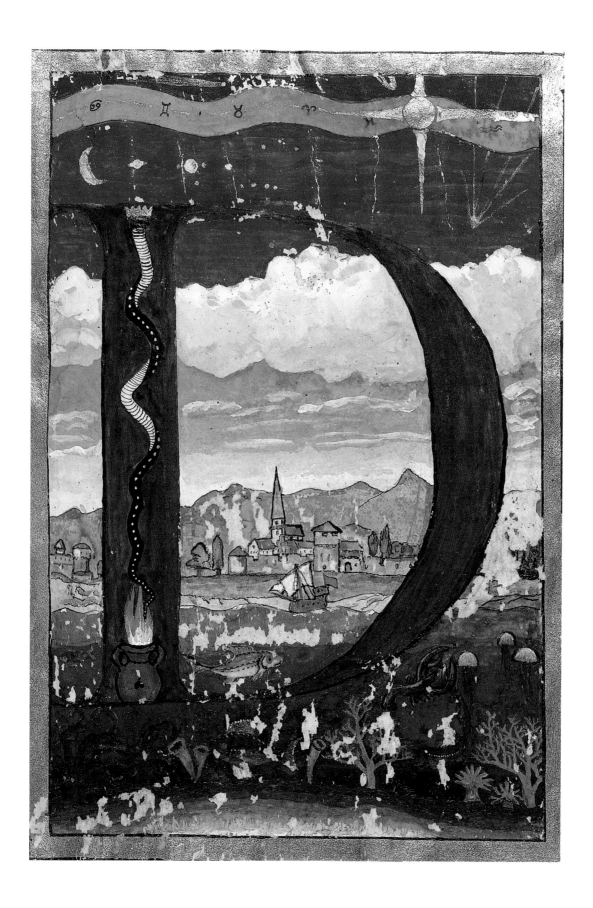

A SELECTION OF ILLUMINATED INITIALS IN *THE RED BOOK*

ULRICH HOERNI

The Red Book is a composition of linguistic and visual elements in which illuminated initials combine language, text, and image. European writings follow phonetic spellings. A letter stands for something invisible, a sound. All the same, letters do have strong visual qualities, which—together with the content of the text of *The Red Book*—obviously stimulated Jung's fantasy in the sense of Active Imagination, inspiring sixty-nine varied small works of illuminated initials (those initials that are emphasized only by size or color are not counted here). Some are limited to the embellishment of a letter, others are more complex images enriched with additional pictorial motifs.

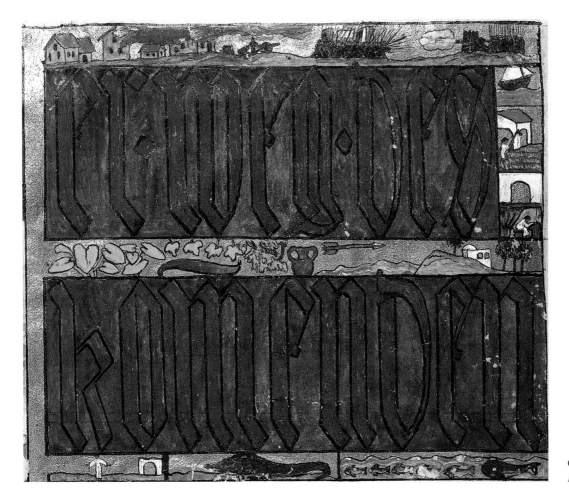

Opposite and left: Detail from *The Red Book*, fol. i[14]

245

Decorated initials are "the most interesting and unique creation of the early (European) Middle Ages."[1] They are typical of precious biblical manuscripts, but are also to be found in secular volumes.[2] Jung explicitly followed the medieval tradition. He confessed: "I must catch up with a piece of the Middle Ages—within myself."[3] And: "I always knew that those experiences [i.e. inner images] contained something precious, and therefore I knew nothing better than to write them down in a 'precious,' that is to say, costly book and to paint the images that emerged through reliving it all—as well as I could."[4]

Jung sees two main tendencies for use of the material obtained through Active Imagination: "One is the way of *creative formulation*, the other the way of *understanding*."[5] He himself followed both tendencies. However, during his lifetime he commented on only a few images he had made himself. Jung did not make personal comments on the meaning and motifs of the illuminated initials in *The Red Book*. Some of the initials may be partly understood in reference to his other visual or literary works, but in the absence of any firsthand information a final interpretation is ultimately impossible.

Initially, one might expect that the content and form of the initials would consistently relate to the corresponding passages in the text. However, this does not always seem to be the case, as a variety of relationships occur:

The motif is immediately recognizable, so the reference to the text and the meaning are clear;[6]

The motif is immediately recognizable, but the reference to the text and the meaning are unclear;[7]

The motif is recognizable, but is unintelligible;[8]

The composition of the motif is nonobjective and a possible specific meaning remains unclear.[9]

The way Jung uses the stylistic elements is manifold. Often, but not always, the illuminated letter is placed in the center of the motif,[10] while the background images of the letters may present one or a mixture of the following categories: a naturalistic scene, a motif of the real world, painted in three-dimensional perspective;[11] a symbolic image with surreal elements, painted realistically in two dimensions;[12] or an abstract composition, only non-representational forms and colors.[13]

Interestingly, in terms of chronology the application of these variations roughly follows the stylistic development of classic European modern art.

SELECTED INITIALS FROM THE RED BOOK

LIBER PRIMUS

pp. 244–45: fol. i Der Weg des Kommenden (The Way of What Is to Come)
p. 248: fol. i (v) Wenn ich im Geiste [. . .] (If I speak in the spirit . . .)
p. 248: fol. ii Die Wiederfindung der Seele (Refinding the Soul)
p. 248: fol. ii (v) Seele & Gott (Soul and God)
p. 248: fol. iii Über den Dienst an der Seele (In the Service of the Soul)
p. 249: fol. iii (v) Die Wüste (The Desert)
p. 249: fol. iv höllenfahrt in die Zukunft (Descent into Hell in the Future)
p. 249: fol. iv (v) Zerspaltung des Geistes (Splitting of the Spirit)
p. 249: fol. iv (v)[1] heldenmord (Murder of the Hero)
p. 250: fol. v (v) mysterium • Begegnung (Mysterium. Encounter)
p. 250: fol. iv (v)[2] Gottes Empfängnis (The Conception of the God)
p. 250: fol. vi Belehrung (Instruction)

LIBER SECUNDUS

p. 251: p. 1 Die Bilder des Irrenden (The Images of the Erring)
p. 251: p. 2 Der Rothe (The Red One)
p. 251: p. 5 Das Schloss im Walde (The Castle in the Forest)
p. 252: p. 11 Einer der Niedrigen (One of the Lowly)
p. 252: p. 15 Der Anachoret (The Anchorite)
p. 252: p. 22 Dies II • Ich erwache [. . .] (Dies II. I awaken . . .)
p. 252: p. 29 Der Tod (Death)
p. 253: p. 32 Die Reste früherer Tempel • Und wieder [. . .] (The Remains of Earlier Temples. Yet another . . .)
p. 253: p. 37 Erster Tag (First Day)
p. 253: p. 40 Ich wanderte [. . .] (I wandered . . .)
p. 253: p. 46 Zweiter Tag (Second Day)
p. 254: p. 48 So fand mein Gott Rettung [. . .] (Thus my God found salvation . . .)
p. 254: p. 49 Alles gewinnst Du vom Gotte [. . .] (You gain everything from God . . .)
p. 254: p. 62 Ich bin aber nicht bereit [. . .] (However, I am not ready . . .)
p. 254: p. 65 die eröffnung des eies • am abend des dritten Tages [. . .] (The Opening of the Egg. On the evening of the third day . . .)
p. 255: p. 73 Die Hölle (Hell)
p. 255: p. 76 Der Opfermord (The Sacrificial Murder)
p. 255: p. 98 Die göttliche narrheit (Divine Folly)
p. 255: p. 126 Die gabe der magie (The Gift of Magic)
p. 256: p. 152 Warum lachst du [. . .] (Why are you laughing . . .)
p. 256: p. 153 O herr des gartens [. . .] (Oh master of the garden . . .)

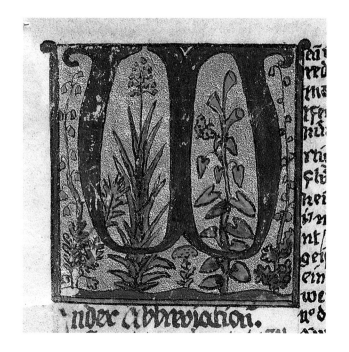

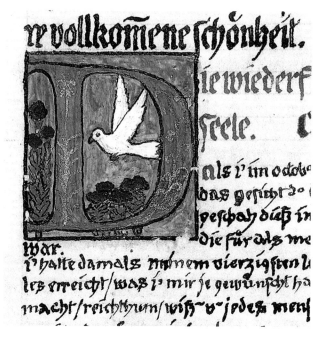

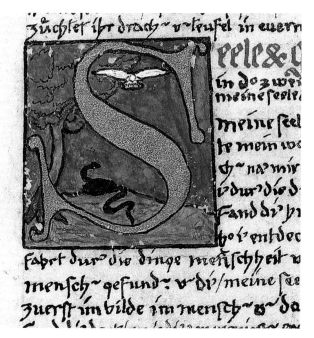

Wenn ich im Geiste [. . .][15] (If I speak in the spirit . . .)
Die Wiederfindung der Seele[16] (Refinding the Soul)
Seele & Gott[17] (Soul and God)
Über den Dienst an der Seele[18] (In the Service of the Soul)

Die Wüste[19] (The Desert)
höllenfahrt in die Zukunft[20] (Descent into Hell in the Future)
Zerspaltung des Geistes[21] (Splitting of the Spirit)
heldenmord[22] (Murder of the Hero)

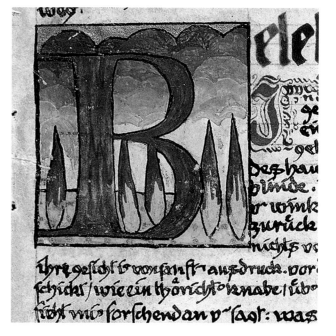

mysterium • Begegnung[23] (Mysterium. Encounter)
Gottes Empfängnis[24] (The Conception of the God)
Belehrung[25] (Instruction)

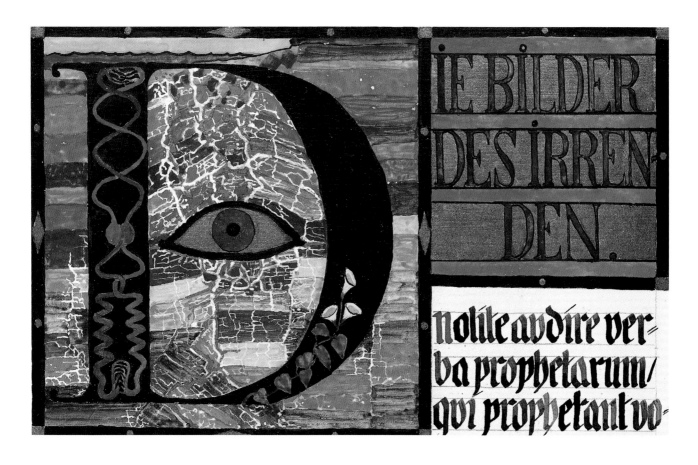

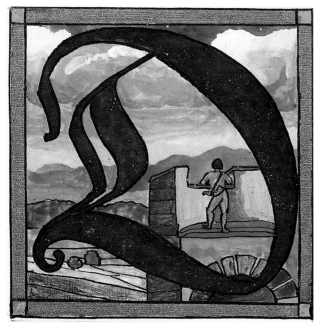

Die Bilder des Irrenden[26] (The Images of the Erring)
Der Rothe[27] (The Red One)
Das Schloss im Walde[28] (The Castle in the Forest)

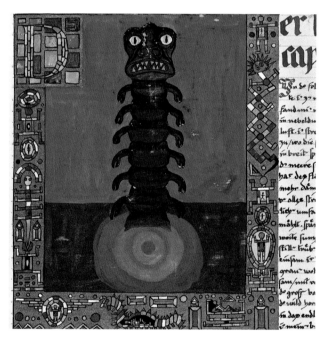

Einer der Niedrigen[29] (One of the Lowly)
Der Anachoret[30] (The Anchorite)
Dies II • Ich erwache [31] [. . .] (Dies II. I awaken . . .)
Der Tod[32] (Death)

Die Reste früherer Tempel • Und wieder [. . .][33] (The Remains of Earlier Temples. Yet another . . .)
Erster Tag[34] (First Day)
Ich wanderte [. . .][35] (I wandered . . .)
Zweiter Tag[36] (Second Day)

So fand mein Gott Rettung [. . .][37] (Thus my God found salvation . . .)
Alles gewinnst Du vom Gotte [. . .][38] (You gain everything from God . . .)
Ich bin aber nicht bereit [. . .][39] (However, I am not ready . . .)
die eröffnung des eies • am abend des dritten Tages [. . .][40] (The Opening of the Egg. On the evening of the third day . . .)

Die Hölle[41] (Hell)
Der Opfermord[42] (The Sacrificial Murder)
Die göttliche narrheit[43] (Divine Folly)
Die gabe der magie[44] (The Gift of Magic)

Warum lachst du [. . .]⁴⁵ (Why are you laughing . . .)
O herr des gartens [. . .]⁴⁶ (Oh master of the garden . . .)

NOTES

1. Peter Meyer, *Europäische Kunstgeschichte*, vol 1, *Vom Altertum bis zum Ausgang des Mittelalters* (Zurich: Schweizer Spiegel Verlag, 1947), p. 151.
2. Jung knew the so-called Great Heidelberg Collection of Ballads (Codex Manesse, fourteenth century).
3. C.G. Jung, *The Red Book: Liber Novus*, edited and introduced by Sonu Shamdasani, tr. Mark Kyburz, John Peck, and Sonu Shamdasani (New York: W. W. Norton, 2009), p. 330. Hereafter *RB*.
4. *RB*, Epilogue, p. 190, translation p. 360.
5. C.G. Jung, *The Transcendent Function*, *CW* 8, §§ 172.
6. See *RB*, fol. ii, iii (v)-iv (v)[1]; pp. 2, 5, 22, 29, 32, 46, 152.
7. See *RB*, fol. i, i (v), iii, iv (v)[2], vi; pp. 1, 15, 37, 40.
8. See *RB*, p. 48, 49, 73, 76, 126, 152.
9. See *RB*, fol. v (v), vi; pp. 62, 65, 66, 98, 100, 102, 108, 114, 124, 139.
10. Fonts *Antiqua* or *Fraktur*, in some cases also in creatively modified form.
11. See *RB*, fol. iii; p. 2, 5.
12. See *RB*, fol. ii, iii-iv (v)[1,2], iv (v); pp. 1, 15, 22, 29, 32, 37, 40, 46, 48, 49, 73, 76, 126, 152, 153.
13. See *RB*, fol. v (v), vi; pp. 62, 65, 66, 98, 100, 102, 108, 114, 139.
14. Title page of *Liber Primus*. Of note are the fine details, particularly in the margins around the letters on the right-hand side of the page. The motifs cannot be attributed to a specific section in the text; rather they seem to depict a story of their own.
15. The depiction of the letter *W* and the plant motif are reminiscent of the initials in the Great Heidelberg Collection of Ballads.
16. The bird embodies an aspect of the soul.
17. The bird and snake embody two aspects of the soul.
18. The castle motif does not appear explicitly in the text of chapter III, but it ends with the words: "I looked into myself, and the only thing I found within was the memory of earlier dreams, all of which I wrote down." This could refer to a dream of 1912, which is described in Jung's *Memories*, p. 195: "There I sat, looking out into the distance, for the loggia was set up high up on the tower of a castle." The castle motif also appears in a memory from school years, of which Jung recalled that it was "the first systematic fantasy of my life" (*Memories*, p. 99). The composition of the landscape in the background of the initial also recalls the picture cat. 18.
19. The snake motif does not appear in chapter IV, but plays an important role in chapter V.
20. The background motif probably depicts the "red stream of blood, thick red blood" in chapter V.
21. The image symbolizes splitting. The initial becomes part of the motif.
22. Coffin and candles refer to the confrontation with death.
23. The first initial of the *RB* in which the background is an abstract composition.
24. The flower motif is not mentioned in chapter VIII, but it is to be found in the very first mandala in the *RB*, fol. iv (v).
25. The flame motif appears several times in the text of chapter X.
26. *RB*, p. 1. Title page of *Liber Secundus*. The back is reminiscent of a cross section through geological layers whose structure is disturbed in the area of the eye. The red-blue drawing on the vertical bar of the *D* resembles a scheme of blood circulation.
27. The motif in the background of the initial refers directly to the text of chapter I. The image composition is similar to *RB*, fol. ii (v) and the work cat. 18.
28. The motif in the background of the initial refers directly to the text of chapter II. On the one hand, it shows similarity to *RB*, fol. ii (v) and Jung's youthful castle drawings; on the other, it is a stunning anticipation of Jung's Tower at Bollingen, which did not exist at the time.
29. The depiction of the letter is reminiscent of those in the Great Heidelberg Collection of Ballads. The background is an abstract color mosaic without any clear reference to the *RB*.
30. The background here is the letter *D*, which is surrounded by a wide frame with hieroglyphic ornaments without identifiable figures. A reference to the text of chapter IV exists insofar as the depicted scene is set in the Egyptian desert. The theme of hieroglyphs or runes appears in the *Black Books* around 1917, in the *RB* for the first time on page 89, see notes on pp. 291–92.
31. The initial does not mark the first letter of the title, but the beginning of the running text. The picture is a visual composition of elements from the text of chapters IV and V: heaven and earth, sunrise and sunset, scarab, snakes, reddish stones, time, up and down; "I became a greening tree that stands alone and grows" (*RB*, translation p. 273, cf. *RB*, p. 270, note 57). The structuring of the sky by different abstract blue ornaments in quadrants may indicate the cardinal directions. The red ornaments in the ground evince human and animal forms, as well as various objects.
32. Chapter VI of the *RB* (pp. 29–31 and translation pp. 273–75) is a confrontation with death and war. The fearful being which is about to rise up from the glowing earth resembles the "devilish monster" in the *Systema Mundi Totius* (see cat. 41), which is of a later date. Therewith it is the first of several similar representations of that figure. The figure is framed on three sides by a golden bar that is reminiscent of the work of medieval goldsmiths. It shows a sequence of motifs that bear a partial resemblance to the *Systema Mundi Totius*. At the very bottom in the center, there is a multifooted monster in whose abdomen lies a human being; continuing to the left and upward, there are a winged egg that contains a god(?); a human being spewing out a crocodile-like monster with candles on both sides of its tail; an egg that contains a six-footed monster; a human being balancing an egg on its head. To the right of the bottom center and upward: a human being on a multilevel bed flanked by two candles; a multi-armed human being holding an egg in which stands or lies another human being; above, a smaller egg containing a child; a human being with a child in its belly; a toy-like monster; a human being with a salamander in its belly. These motifs are missing from the text. The composition indicates a tendency for a movement from the bottom upward.
33. The initial *U* does not mark the first letter of the title, but the beginning of the running text. For once the initial stands *next* to the picture, not in the center or inside the colored field. It shows a circular blue cartouche like a mosaic on the background of a dark-gray square field. Inside the circular mosaic, there are two smaller oval cartouches, which again contain a red and a bluish human being, respectively. The third sentence of chapter VII (*RB*, p. 32, translation, p. 275) says: "I come across two strange journeymen—probably two completely accidental companions," namely the *Red One* and *Ammonius*.
34. Initial *E* is painted in a deep-blue sky with the constellations of the Great and Little Dipper. The big star in the center of an enlarged black spot, because of its position, must be the polar star. A yellow spiral or snake curls around it, a sign for rotation. In the margin on the right-hand side, a human being carries a vessel on its head, from which a fire-breathing(?) snake rises. The text of chapter VIII does not mention these figures explicitly. The whole composition, however, is reminiscent of the mandala motif (see Jung, "Concerning Mandala Symbolism," in *CW* 9/I, §§ 627–712, especially § 646). The polar star as the center point of the Earth's rotation here possibly also symbolizes the psychological center of the personality.
35. The initial does not mark a title nor a chapter, but a new text section. The image is related to *Liber Secundus*, p. 37, but comes closer to a perfect mandala form because of its additional symmetries. The letter *I* in the central axis covers the center point of the rotation, which is indicated by a spiral and six golden rays (two more rays on the central axis may be

covered by the letter *I*). The four corners of the image are each occupied by an insect, which could be dragonfly larvae. In the margins on the left and right, worms with two heads—presumably tapeworms—border the composition. There are no references to these motifs in the text.

36. The letter *Z* subdivides the image detail. The background is composed of two stylized trees whose branches are intertwined with each other; at the bottom lies an egg. The motif may refer to the text of *RB*, p. 48, translation, p. 283: "I hide Izdubar under the drooping branches of a tree [. . .] I return to the garden and with no difficulty squeeze Izdubar into the size of an egg and put him in my pocket."

37. The background to the letter *S* is a wall with a gate, possibly "the welcoming house" referred to in the text on *RB*, p. 48, translation, p. 283. The green figure in front of the wall encloses a golden egg in the lower and a black egg in the upper part.

38. Some of these figures are reminiscent of the *Systema Mundi Totius*.

39. The letter merges with its background. The ornamentation corresponds with the type, which can be seen in many images (*RB*, pp. 52–70).

40. See note 39.

41. The most important topic of chapters XI and XII is evil. It could be expected that the background motif would reflect this. However, its meaning, and thus the connection between text and image, remains unclear.

42. The background shows a new type of ornament. Whether it signifies something specifically—for example, the unconscious—is not known.

43. The design of the initial is an abstract composition of multicolored surfaces, without any content. This also applies to the following initials: *RB*, pp. 100, 102, 108, 114, 139.

44. Vegetal and animal motifs can be recognized in the seemingly abstract composition, including, among other things, two salamanders. A direct reference to the text of chapter XIX seems to be missing.

45. The very fine and careful execution of the letter could indicate a particular importance of the text section. The striking ribbon motif is not explained in the text.

46. The palmette motifs in the background seem to have an exclusively decorative function.

CARL GUSTAV JUNG—LIFE AND WORK

1875	Born July 26 in Kesswil on Lake Constance, Switzerland. Parents: Johann Paul Achilles Jung (1842–1896, pastor) and Emilie Jung-Preiswerk (1848–1923).
1876	Family moves to Laufen at the Rhine Falls.
1879	They settle in Kleinhüningen, near Basel.
1884	Birth of his sister Gertrude (†1935).
1886–1895	Secondary school (Gymnasium) Basel.
1895–1900	Studies in natural sciences and medicine at the University of Basel. Séances with his cousin Helene (Helly) Preiswerk as a psychic medium.
1896	Death of his father. Family moves to Binningen near Basel.
1900	Medical degree. Orientation toward psychiatric studies. Assistant doctor (*Assistenzarzt*) at the psychiatric clinic Burghölzli, Zurich, under director Eugen Bleuler.
1902	Medical dissertation at the University of Zurich: *On the Psychology and Pathology of So-called Occult Phenomena*.
1902–1903	(Winter term) studies abnormal psychology at the Salpêtrière, Paris, with Pierre Janet. Study visit to London.
1903	February 14, marriage to Emma Rauschenbach (1882–1955); they have five children: Agathe (married Niehus, 1904–1998), Gret (married Baumann, 1906–1995), Franz (Jung-Merker, 1908–1996), Marianne (married Niehus, 1910–1965), Helene (married Hoerni, 1914–2014).
1903–1905	Experimental research on word association at the clinic Burghölzli.
1905	Assistant medical director at the Burghölzli clinic; research on schizophrenia: *The Psychology of Dementia Praecox* (1907).
1905–1913	Lecturer at the medical faculty of the University of Zurich; courses on psycho-neurosis and psychology.
1906	Meets Sigmund Freud.
1908	Participation at the First International Congress for Psychoanalysis, Salzburg, Austria.
1909	Leaves the Burghölzli clinic and begins private practice in his newly built home in Küsnacht. Beginning of intensive studies in mythology. September, invitation to the United States (together with Freud), lecture at Clark University, Worcester, Massachusetts, where he receives honorary degree. Editor of the *Jahrbuch für psychoanalytische und psychopathologische Forschungen* (until 1913).

1910 President of the International Association for Psychoanalysis.

First encounter with Toni Wolff (1888–1953), as a patient.

1910–1939 Lecture tours to the United States and various European countries.

1912 Publication of *Transformations and Symbols of the Libido* in two parts 1911/12 (published in English in 1916 under the title *Psychology of the Unconscious: A Study of the Transformation and Symbolisms of the Libido*).

Fordham University lectures, New York, on psychoanalytical theory.

1913 Separation from Freud and the psychoanalytical movement, founding of Analytical Psychology.

Relinquishes lectureship at University of Zurich.

Confrontation with the unconscious, documented in *The Black Books* (until 1919) and aesthetically elaborated in words and images in *The Red Book*.

1914 Resigns presidency of the International Association for Psychoanalysis.

First visit to Ravenna, on a cycling tour through northern Italy with Hans Schmid-Guisan.

1914–1919 During the First World War, military service as medical officer (captain) for extended periods each year in different places in Switzerland.

1916 Founding of the Psychology Club Zurich.

First description of the method of Active Imagination in *The Transcendent Function*.

First use of the terms *personal* and *Collective Unconscious, anima, animus, self,* and *individuation* in *The Structure of the Unconscious*.

Private publication of the *Septem Sermones ad Mortuos*.

Creation of the *Systema Mundi Totius* ("Mandala of Modern Man").

1917 Exchange of programmatic letters with Hans Schmid-Guisan on the question of psychological types.

First mandala sketch series (cats. 81–105) while on duty as commander of the military camp for British war internees at Château-d'Oex, Switzerland.

1919 First use of the term *Archetype* ("primordial images") in *Instinct and the Unconscious*.

Visit with Maurice Nicoll at St. Bartholomew's Hospital, London. First carvings of Atmavictu figures (cats. 67–70).

1920 Trip to North Africa (Tunisia and Algeria).

1921 Publication of *Psychological Types*.

1922 Purchase of land in Bollingen on Lake Zurich to start building the "Tower."

1923 Death of his mother.

1924–1925 Trip to the Pueblo Indians of New Mexico, with Jaime de Angulo.

Psychology Club Zurich, seminar on Analytical Psychology (1925).

1925–1926 Trip to the Elgonyis in Eastern Africa (Bugishu-Expedition to Kenya and Uganda, return via Sudan and Egypt), with Helton Goodwin (Peter) Baynes and George Beckwith.

1928 Collaboration with Richard Wilhelm on the Chinese treatise *The Secret of the Golden Flower* (published 1929); beginning of psychological studies in alchemy.

First extension of the Tower at Bollingen.

1928–1930 Psychology Club Zurich, seminar on Dream Analysis.
 1930 Death of Richard Wilhelm.
 Vice-President of the (Germany-based) General Medical Society for Psychotherapy.
1930–1934 Psychology Club Zurich, seminar series on the Interpretation of Visions.
 1931 Second extension of the Bollingen Tower.
 1932 Second visit to Ravenna, with Toni Wolff.
 Psychology Club Zurich, seminar on the Psychology of Kundalini Yoga (with Jakob Wilhelm Hauer).
 Publication of the "Ulysses" and "Picasso" essays.
 Literary prize of the City of Zurich.
 1933 Cruise in the Eastern Mediterranean (including stops in Cyprus, Rhodes, Palestine, Egypt, Athens, and Constantinople/Istanbul), with Hans Eduard Fierz-David.
 President of the (Germany-based) General Medical Society for Psychotherapy.
 Participation in the First Eranos Conference, Ascona.
 Beginning of lecture series on Modern Psychology at the Federal Institute of Technology in Zurich (ETH Zurich).
 1934 Founding and Presidency of the International General Medical Society for Psychotherapy (until 1939/40), editor of the *Zentralblatt für Psychotherapie und ihre Grenzgebiete*.
1934–1939 Psychology Club Zurich, seminars on the Psychological Analysis of Nietzsche's Zarathustra.
 1935 Nomination as Titular Professor (visiting senior professor) at the ETH Zurich.
 Lectures at the Institute of Medical Psychology, Tavistock Clinic, London, on the Theory and Practice of Analytical Psychology.
 Third extension of the Bollingen Tower.
 1936 Harvard University, Cambridge, Massachusetts; invitation to lecture at the Harvard Tercentenary on Psychological Factors Determining Human Behavior, honorary degree.
 Bailey Island, Maine, seminar Dream Symbols of the Individuation Process (part I).
 1937 Yale University, New Haven, Connecticut; Terry Lectures on Psychology and Religion.
 New York, seminar Dream Symbols of the Individuation Process (part II).
 Trip to India at the invitation of the British India government (winter 1937/38).
 Honorary degrees from the Universities of Hyderabad, Benares, Allahabad, and Calcutta.
 1938 Honorary degree from the University of Oxford. Participation in the International Medical Congress for Psychotherapy.
 1939/40 After the outbreak of the Second World War, resignation from all functions with the International Medical Society for Psychotherapy.
 1941 Collaboration with Karl Kerényi on *Introduction to a Science of Mythology*.
 1942 Einsiedeln, Switzerland, commemoration lectures on Paracelsus (Theophrastus von Hohenheim).
 Resignation from teaching at ETH Zurich.

1943 Honorary member of the Swiss Academy of Medical Sciences (*Schweizerische Akademie der Medizinischen Wissenschaften*).

Nomination as a full professor of medical psychology at the University of Basel.

1944 Seriously ill after heart attack, has near-death experience.

Resignation from the chair at the University of Basel, retreat to a more private and secluded life.

Publication of *Psychology and Alchemy.*

1945 Seventieth birthday, honorary degree from the University of Geneva.

1948 Founding of the C.G. Jung Institute in Zurich.

1950 Creation of the so-called Bollingen Stone at the Tower.

1951 Publication of *Aion: Researches into the Phenomenology of the Self.*

1952 Collaboration with Wolfgang Pauli on the concept of synchronicity in *The Interpretation of Nature and Psyche.*

Updated and revised edition of *Transformations and Symbols of the Libido* under the title *Symbols of Transformation*, including numerous illustrations of symbolic material.

Recurrence of serious illness.

Publication of *Answer to Job.*

1953 Death of Toni Wolff.

First volume of *Collected Works*, Bollingen Series, New York.

1955 Eightieth birthday, honorary degree in natural sciences from the ETH Zurich.

Collaboration with Marie-Louise von Franz on "Mysterium Coniunctionis" (I & II).

November 27, death of Emma Jung-Rauschenbach after severe illness.

1956 Fourth extension of the Bollingen Tower.

1957 Beginning of the interviews with Aniela Jaffé for the book on Jung's memoirs *Memories, Dreams, Reflections* (published posthumously in 1962).

1958 Study of the phenomenon of UFO sightings: *Flying Saucers: A Modern Myth of Things Seen in the Skies.*

1960 Eighty-fifth birthday, honorary citizen of his hometown, Küsnacht.

1961 Last written contribution, "Approaching the Unconscious" (posthumously published in *Man and His Symbols*, 1964).

June 6, Jung dies after a brief illness in his house at Seestrasse in Küsnacht.

SELECTED BIBLIOGRAPHY

Ammann, Ruth, et al. *Das Buch der Bilder. Schätze aus dem Archiv des C.G. Jung Instituts Zürich*. Ostfildern: Patmos, 2018.

Bair, Deirdre. *Jung: A Biography*. Boston: Little, Brown and Company, 2003.

Beebe, John, and Ernst Falzeder, eds. *The Question of Psychological Types: The Correspondence of C.G. Jung and Hans Schmid-Guisan, 1915–16*. Princeton: Princeton University Press, 2013.

Eveno, Betrand. "Jung's 'Multicolored Arabesques': Their Renderings and Intentions in the Pictorial Vocabulary of the Red Book." In *Psychological Perspectives: A Quarterly Journal of Jungian Thought* 58, 1 (2015), pp. 5–33.

Fierz-David, Hans Eduard. *Goethes Farbenlehre als psychologisches Problem*. Zurich: Psychology Club, typescript, 1940.

Fischer, Thomas. "The Alchemical Rare Book Collection of C.G. Jung." In *International Journal of Jungian Studies* 2 (2011), pp. 169–80.

Gaillard, Christian. *Le Musée Imaginaire de Carl Gustav Jung*. Paris: Stock, 1998.

Häberlin, Paul. *Symbol in der Psychologie und Symbol in der Kunst*. Bern: Drechsel, 1916.

Hannah, Barbara. *Jung, His Life and Work: A Biographical Memoir*. New York: Putnam, 1976.

Hillman, James, and Sonu Shamdasani. *Lament of the Dead: Psychology after Jung's Red Book*. New York: W. W. Norton, 2013.

Hodin, Joseph P. *Modern Art and the Modern Mind*. Cleveland: The Press of Case Western Reserve University, 1972.

Itten, Johannes. *Kunst der Farbe: Subjektives Erleben und objektives Erkennen als Wege zur Kunst*. Ravensburg: Otto Maier, 1966.

Jaffé, Aniela, ed. *C.G. Jung. Bild und Wort*. Olten/Freiburg im Breisgau: Walter, 1977.

———. *Word and Image*. Princeton: Princeton University Press, 1979.

Jeromson, Barry. "The Sources of *Systema Munditotius*." In *Jung History* 2, 2 (2007), pp. 20–22.

———. "Systema Munditotius and Seven Sermons: Symbolic Collaborators in Jung's Confrontation with the Dead." In *Jung History* 1, 2 (2005/06), pp. 6–10.

Jung, Andreas, et al. *The House of C.G. Jung: The History and Restoration of the Residence of Emma and Carl Gustav Jung-Rauschenbach*. Edited by Stiftung C.G. Jung Küsnacht. Wilmette: Chiron Publications, 2008.

Jung, C.G. *C.G. Jung Speaking: Interviews and Encounters*. Edited by William McGuire and R.F.C. Hull. London: Thames & Hudson, 1978.

———. *Commentary on the Secret of the Golden Flower*. In *CW* 13, § 1–84; first published as "Europäischer Kommentar," in *Das Geheimnis der Goldenen Blüte: Ein chinesisches Lebensbuch*. Munich: Dorn, 1929, pp. 7–88.

———. *The Collected Works of C.G. Jung*, 21 volumes. Edited by Herbert Read, Michael Fordham, and Gerhard Adler; executive editor William McGuire; tr. R.F.C. Hull. New York: Bollingen Foundation/Pantheon Books, 1953–1967; Princeton: Princeton University Press, 1967–78.

———. "Concerning Mandala Symbolism." In *CW* 9/I, §§ 627–712; first published as "Über Mandalasymbolik," in *Gestaltungen des Unbewussten*. Zurich: Rascher, 1950, pp. 187–235.

———. *Dream Analysis: Notes of the Seminar Given in 1928–30*. Edited by William McGuire. Princeton: Princeton University Press, 1984.

———. *Introduction to Jungian Psychology: Notes of the Seminar on Analytical Psychology Given in 1925*. Edited by William McGuire; rev. ed. edited by Sonu Shamdasani. Princeton: Princeton University Press, 2012.

———. *Jung on Active Imagination: Key Readings Selected and Introduced by Joan Chodorow*. London: Routledge, 1997.

———. *Letters*, vol. 1. Edited by Gerhard Adler; translated by R. F. C. Hull. Princeton: Princeton University Press, 1973.

———. *Letters*, vol. 2. Edited by Gerhard Adler; translated by R. F. C. Hull. Princeton: Princeton University Press, 1975.

———. "Mandalas." In *CW* 9/I, §§ 713–18; first published in *Du. Schweizerische Monatschrift* 4 (April 1955), pp. 16, 21.

———. *Memories, Dreams, Reflections*. Recorded and edited by Aniela Jaffé; translated by Richard and Clara Winston. New York: Pantheon Books, 1963.

———. "Picasso." In *CW* 15, §§ 204–14; first published as "Picasso," in *Neue Zürcher Zeitung*, November 13, 1932.

———. *Psychological Types*. In *CW* 6; first published in English as *Psychological Types, or, The Psychology of Individuation*. London: Kegan Paul, Trench, Trubner, 1923.

———. *Psychology and Religion*. In *CW* 11, §§ 1–168; first published as *Psychology and Religion*. New Haven: Yale University Press, 1938.

———. *The Psychology of Kundalini Yoga: Notes of the Seminar Given in 1932*. Edited by Sonu Shamdasani. Princeton: Princeton University Press, 1996.

———. "The Psychology of the Transference." In *CW* 16, §§ 353–539; first published as *Die Psychologie der Übertragung*. Zurich: Rascher, 1946.

———. *The Red Book: Liber Novus*. Edited and introduced by Sonu Shamdasani, translated by Mark Kyburz, John Peck, and Sonu Shamdasani. New York: W. W. Norton, 2009.

———. "A Study in the Process of Individuation." In *CW* 9/I, §§ 525–626; first published as "Zur Empirie des Individuationsprozesses," in *Eranos Jahrbuch 1933*, Zurich: Rhein-Verlag, 1934, pp. 201–14.

———. *Symbols of Transformation*. In *CW* 5; first published in English as *Psychology of the Unconscious*. New York: Moffat Yard and Co., 1916.

———. "The Transcendent Function." In *CW* 8, §§ 131–93; first published as "Die transzendente Funktion." In *Geist und Werk*. Zurich: Rhein-Verlag, 1958, pp. 3–33.

———. "'Ulysses'—A Monologue." In *CW* 15, §§ 163–203; first published as "'Ulysses'—Ein Monolog." in *Europäische Revue* 8 (September 1932), pp. 547–68.

———. *Visions: Notes of the Seminar Given in 1930–1934*. 2 vols. Edited by Claire Douglas. Princeton: Princeton University Press, 1997.

Le Livre Rouge de Jung, special issue of *Cahiers Jungiens de Psychanalyse* 134. September 2011.

Mellick, Jill. *The Red Book Hours: Discovering C.G. Jung's Art Mediums and Creative Process*. Zurich: Scheidegger & Spiess, 2018.

Morgenthaler, Walter. *Ein Geisteskranker als Künstler*. Bern: E. Bircher, 1921.

Prinzhorn, Hans. *Bildnerei der Geisteskranken: Ein Beitrag zur Psychologie und Psychopathologie der Gestaltung*. Berlin: Julius Springer, 1922.

Read, Herbert. "Carl Gustav Jung." In *Zum 85. Geburtstag von Professor Dr. Gustav Jung, 26. Juli 1960*. Zurich: Rascher, 1960, pp. 7–29.

———. *The Forms of Things Unknown: Essays Towards an Aesthetic Philosophy*. New York: Horizon Press, 1960.

The Red Book. Special issue of *Jung Journal: Culture & Psyche* 5, no. 3 (Summer 2011).

The Red Book: Reflections on C.G. Jung's Liber Novus. Edited by Thomas Kirsch and George Hogenson. London: Routledge, 2014.

Shamdasani, Sonu. *C.G. Jung: A Biography in Books*. New York: W. W. Norton and the Martin Bodmer Foundation, 2012.

———. *Cult Fictions: C.G. Jung and the Founding of Analytical Psychology*. London: Routledge, 1998.

Shamdasani, Sonu, and Nathalie Bazin. *Le Livre Rouge de C.G. Jung, récits d'un voyage intérieur*. Exh. cat., Musée des arts asiatiques Guimet, Paris, 2011.

Sherry, Jay. "A Pictorial Guide to *The Red Book*": https://aras.org/sites/default/files/docs/00033Sherry.pdf (accessed April 9, 2017).

van den Berk, Tjeu. *Jung on Art: The Autonomy of the Creative Drive*. London: Routledge, 2012.

Wehr, Gerhard. *An Illustrated Biography of C.G. Jung*. Boston: Shambhala, 1989.

Worringer, Wilhelm. *Abstraktion und Einfühlung: Ein Beitrag zur Stilpsychologie*. Munich: R. Piper & Co, 1911; *Abstraction and Empathy: A Contribution to the Psychology of Style*. Translated by Michael Bullock. Chicago: Ivan R. Dee 1997.

Zuch, Rainer. *Die Surrealisten und C.G. Jung: Studien zur Rezeption der analytischen Psychologie im Surrealismus am Beispiel von Max Ernst, Victor Brauner und Hans Arp*. Weimar: VDG, 2004.

Exhibitions

Helmhaus, Zurich, *C.G. Jung 1875–1961*, March 14–April 13, 1975.

Rubin Museum, New York, *The Red Book of C.G. Jung*, October 7, 2009–February 15, 2010.

Hammer Museum, Los Angeles, *The Red Book of C.G. Jung*, April 11, 2010–June 6, 2010.

Library of Congress, Washington, DC, *The Red Book of C.G. Jung*, June 17–September 25, 2010.

Museum Rietberg, Zurich, *C.G. Jung: Das Rote Buch*, December 18, 2010–March 20, 2011.

Musée des arts asiatiques Guimet, Paris, *Le Livre Rouge de C.G. Jung*, September 7–November 7, 2011.

Fondation Bodmer, Geneva, *C.G. Jung: Le Rouge et le Noir*, November 26, 2011–March 25, 2012.

La Biennale di Venezia—55. Esposizione Internazionale d'Arte, Venice, Il Palazzo Enciclopedico, June 1–November 24, 2013.

Auf dem Weg zur Erleuchtung. Der Indien-Mythos in der westlichen Kultur 1808–2017, Lugano, Museo d'arte della Svizzera italiana (MASI), September 24, 2017–January 21, 2018.

CONTRIBUTORS

Thomas Fischer, PhD, since 2013 director of the Foundation of the Works of C.G. Jung, studied history, political science, and public and international law at the Universities of Zurich and Brussels, with a specialization in diplomatic history of the Cold War. He is a great-grandson of C.G. and Emma Jung.

Medea Hoch, an art historian with interdisciplinary interests, is a research assistant with the Foundation of the Works of C.G. Jung. She is currently collaborating on the edition of the Sophie Taeuber-Arp letters at the Zürcher Hochschule der Künste.

Ulrich Hoerni became the first president and director of the newly established Foundation of the Works of C.G. Jung in 2007 and is a former manager of the Executive Committee of the Community of Heirs of C.G. Jung. He earned a degree in architecture at the Swiss Federal Institute of Technology Zurich (ETH). He is a grandson of C.G. and Emma Jung.

Bettina Kaufmann, PhD, studied art history, journalism, constitutional and international law at the Universities of Fribourg, Siena, Madrid, Boston, and Oslo. She works as a freelance writer and provenance researcher in Zurich and has been a collaborator of the Foundation of the Works of C.G. Jung since 2013.

Jill Mellick, PhD, professor emerita of the Institute of Transpersonal Psychology in Palo Alto, California, is a clinical psychologist in private practice, as well as an author and an artist. Her most recent publication is *The Red Book Hours: Discovering Carl Jung's Art Mediums and Creative Process* (Zurich: Scheidegger & Spiess, 2018).

Diane Finiello Zervas is an art historian and senior training analyst and supervisor with IGAP in private practice in London, specializing in the interface between creativity, analysis, and the arts. Her art historical publications include numerous articles and two major books on Florentine medieval and Renaissance art, and on Jungian concepts in Odilon Redon's early works and in Paul Klee's late images for *Harvest*.

ABOUT THE TRANSLATORS

Paul David Young's translations, with Carl Weber, of Heiner Müller's *Anatomy Titus Fall of Rome* and *Macbeth* were published as *Heiner Müller: After Shakespeare*. A playwright and critic, he is a contributing editor at *PAJ* (MIT Press) and writes regularly for *Hyperallergic*.

Christopher John Murray is a UK-based freelance editor specializing in the fine arts, history, and cultural history.

Fig. 101. Jung in his library discussing an early eighteenth-century Tibetan mandala, 1949. © Dmitri Kessel/The LIFE Picture Collection

INDEX

Page numbers in *italics* refer to illustrations.

Abraxas, 116–17, 183–84, 188, 208*n*
abstraction, abstract art, 22, 25, 45, 47
Abstraction and Empathy (Worringer), 22, 47
Abstrakte und Surrealistische Malerei und Plastik (exhibition), 26
Active Imagination, 12, 13, 14, 19, 25, 29*n*, 30*n*, 35–36, 38–39, 47, 48*n*, 245–46
Adagiorum Epitome (Erasmus), 99
Africa, 108, 117, 137
 ethnological art of, 176*n*–77*n*, 235, 236, *236*, 239, 243*n*
Agathodaimon snake, 239, *239*, 243*n*
alchemy, alchemists, 175, 177*n*
 art of, 235, 237, *237*, 238, 239
 color symbolism in, 35, 36, 43, 45
 identification of colors in, 42–45
 images of, 14, 162, 164, 172
 mandalas and, 179, 181
 psychology and, 42–45
Alte und Neue Kunst, 47
Amiet, Cuno, 35
Analytical Psychology, (seminar), 30*n*, 47, 102, 158, 209*n*
Angwusnasomtaqa, *23*, 30*n*
anima, *104–8*, 107–8, 156
Anleitung zum Unterricht in Zeichnen für textile Berufe (Taeuber-Arp), 35
antiquity, art of, 15, *163*
archaeology, 15, 243*n*
Archetypes, 14, 22–23, 26, 35, 39, 47, 65, 107, 120, 179, 236–37
architecture, 12, 15, 99, 173
Armory Show (1913), 21–22, 25, 26, 29*n*
Arp, Hans, 24, 26, 34, 45–46
art collection, of Jung, 15, 20–21, 26, 28, 232–42, 242*n*–43*n*
"Artfully Tied Knot, The" (Jung), *141*, 142
Artistry of the Mentally Ill (Prinzhorn), 25, 30*n*
Art of Criticism, The (Read), 27–28
Arts and Crafts Museum, Zurich, 27, 35
aurum philosophorum (golden star), 99
Asiatische Kunst aus Schweizer Sammlungen (exhibition), 27
Asklepios (Asclepius), *163*, 165
astrology, 42, 209*n*
Atmavictu (plaster; Jung), *150*, 153
Atmavictu (shell-limestone; Jung), *149*, 153
Atmavictu (wood; Jung), 142, *148*
Atmavictu and other figures, 142, *148–51*, 152–53

Augustine, Saint, 209*n*
Aurora consurgens (Jung), 43–44, *44*, 49*n*

Babylonian art, 15, 243*n*
Ball, Hugo, 24, 34, 46–47
Barlach, Ernst, 27, 31*n*
Barr, Alfred H., 26
Basilica of Saints Peter and Paul, Reichenau, *70*, 80
Battle Scene (Jung), *55*, 62
battle scenes, *52–61*, 62–65
Baumann, Hermann, 243*n*
Baynes, Helton Godwin, 130, 260
Bearded Figure (Atmavictu?) (Jung), *148*
Beckmann, Max, 35
beetles, 184, 208*n*
Benz, Ernst, 237
Bertine, Eleanor, 156
Bhagavad Gita, 147, 177*n*
Bingen, Hildegard von, 238
Birkhäuser, Peter, 26, 31*n*, 235, 238
Black Books (Jung), *110*, 116, 117, 128–29, 146, *178*, 182, 183, 185, 191, 219*n*, 260
Böcklin, Arnold, 21, 80
Bodhisattva Samantabhadra, 238, 243*n*
Bollingen Foundation, 10
Book Dedication for Emma Jung-Rauschenbach in Swiss Chronicle by Johannes Stumpf (Jung), *168*, 172–73
Bovet, Theodor, 242*n*
British Museum, 20
Bronze Grotesque (Crowley), *26*
Brooch (Jung), *115*, 118, 184
Buber, Martin, 27
Büchel, Emanuel, *65*
Buddhism, 184, 191
Burger, Fritz, 22, 29*n*
Burghölzli hospital, Zurich, 20, 24, 102, 234
Byzantine art, 22, 47

Cabaret Voltaire, 24, 34
Cabiri (dwarf gods), 137, *141–42*, 142
calendar, 117, 118
calligraphy, 102, 103, 220, 225, 230
Campendonk, Heinrich, 34
candelabra, 116, 117, 183
Cartouche above Entrance (Jung), *96*
Castle Ruin (Jung), *72–73*, 80
Castle and Town I (Jung), *57*, 62
Castle and Town II (Jung), *58*, 62
castles, *52–65*, 62–65, 257*n*
caterpillars, 117–18

Augustine, Saint, 209*n*
"C.G. Jung and Modern Art" (Fischer and Kaufmann), 15, 19–28, 29*n*–31*n*
C.G. Jung Institute Zurich, 169
"C.G. Jung's Concepts of Color in the Context of Modern Art" (Hoch), 13, 33–47, 48*n*–49*n*
"C.G. Jung the Collector" (Fischer), 15, 232–42, 242*n*–43*n*
Chagall, Marc, 36–37
Château-d'Oex, 185, 206–7, 209*n*, 260
China, 10, 42, 45, 65, 194, 236, 237, 243*n*
Chinese characters, *172*
Christianity, 42
 color symbolism in, 36, 41
 images of, 107–8
 mandalas in, 39
Christmas Card (Jung), *60*, 63
Chthonic Penetration sketches (Jung), 190–95
Church of Saint George, Reichenau, 80
circle motif, 137, 140
Cliffs at the Sea (Jung), 80, *88*, 91
"Clouds above a Seine Landscape" (Jung), *85*, 87
coat-of-arms, 46
 Jung family, 13, 99, 173, 231*n*
Codex Manesse (Zweter), *60*, 63
Collectanea Adagiorum (Erasmus), 99
Collected Works, The (The New Edition) (Jung), 10, 27
Collective Unconscious, 14, 15, 22, 120, 260
 art and, 236–37
color and form, Kandinsky on, 34
colors:
 in alchemical symbolism, 35, 36, 43, 45
 in context of modern art, 13, 33–47, 48*n*–49*n*
 of heaven and earth, 36–37
 identification in alchemy of, 42–45
 Jung's concept of, 33–47, 48*n*
 in landscapes, 36, 37, 80
 pure, 38
 symbolism and, 38–39, 45, 130, 137, 139, 184
color wheel (Goethe), 33, *34*
"Concerning Mandala Symbolism" (Jung), 10, 120–21, 139
"Confrontations with the Unconscious" (Jung), 12, 102, 185, 260
consciousness, 22, 35, 36, 38, 45, 49*n*, 120, 156, 180, 183, 230
"Contribution to the Study of Psychological Types, A" (Jung; lecture), 47
Corinthians, *107*, 173
Cosmic Egg, *123*, 129, 182, 184, 185, 204–6, 208*n*, 257*n*, 258*n*

Cosmological Schema in Black Book V, 110, 117, *179,* 183, 184
cosmology, 116, 182–84, 198
 see also *Systema Mundi Totius*
Costume Design (Taeuber-Arp), *23*
Couleurs symboliques dans l'Antiquité, le Moyen-Age et les Temps modernes (Portal), 39
Country Road with Trees (Jung), *84*
Cranwell Farm, sketch of (Jung), *149,* 152–53
creation myths, 128, 182, 209*n*–10*n*
Crowley, Alice Lewisohn, 25
Crowley, Herbert, 25–26, *26,* 30*n*
Cultic Scene I (Jung), *124,* 130, 165
Cultic Scene II (Jung), *126,* 130
Cultic Scene with Phanes (Jung), *125,* 130, 165

Dada, Dadaists, 24, 25, 30*n,* 34–35, 45–47
Dalí, Salvador, 25
Davos Kunstgesellschaft, 26–27, 31*n,* 116
death, Jung's contemplation of, 172–73, 175, 257*n*
Delphi, oracle at, 99
Demeter, 107
Devilish Monster (Jung), *113,* 117–18, 239, 257*n*
Dittmann, Lorenz, 41
divine child motif, 116, 130, 191, 199
Donatello, 243*n*
Doors of Perception, The (Huxley), 36, 48*n*
Dorn, Gerhard, 45
dragon, 62, 117, 139, 153, 242
Dream Analysis (Jung; seminar), 179, 261
dreams, dream images, 16*n,* 107, 137, 139–40, 146, 210*n,* 257*n*
 colors and, 35–36, 38
 roots of *The Red Book* in, 209*n*
 symbolic interpretation of, 13, 14, 36
Duchamp, Marcel, 21, *21,* 25, 26, 30*n*
Dürer, Albrecht, 234

East Asia, art of, 235, 237
Eggenberger-Jung, Susanne (Jung Family Archive), 8
Egypt, art of, 15, 22, 234, 236, 243*n*
Eidgenössische Technische Hochschule, 25, 33
 Jung's lectures at, 25, 33, 42, 45, 48*n*
Einstein, Albert, 165
Einstein, Carl, 243*n*
Elementary Forms: Vertical-horizontal Composition (Taeuber-Arp), *46*
Eliade, Mircea, 27
Elijah, 103, 146, 175
empathy, 22, 25, 47
England, Jung's stays in, 152–53, 156
Entwicklung der Malerei seit dem Impressionismus (Gäumann-Wild), 27
Eranos Conference, 14
Erasmus of Rotterdam, 99
Erikapaios, *see* Phanes
Erni, Hans, 19
Eros, 128
Evans, Richard, 179

"Examples of European Mandalas" (Jung), 10, 208*n,* 239
Ex Libris C.G. Jung (Jeanneret),6, *98,* 99
extroversion, 47, 209*n*

Fang staff, 234, *235*
Fantastic Art, Dada, Surrealism (exhibition), 26
fantasy images, 1–2, 12, 13, 14, 16*n,* 62–63, 103, 142, 153, 182, 275*n*
 conversations with, 146, 173, 175, 183–84
 as nature or art, 185, 189
Farbe und ich, Die (A. Giacometti), 35
Farmers' Houses and Clouds (Jung), *74,* 80
feeling, color and, 33, 35–36
Female Half Figure (Jung), *105,* 107
Fiechter, Ernst, *94,* 99, 234
Fiechter, Sophie, 24
Fierz-David, Hans Eduard, 33
Fischer, Thomas, 15, 19–28, 48*n,* 233–42
flaking, 219, 220, *220*
Flight Out of Time, (Ball), 46, 47
flower images, 139
Flying Saucers: A Modern Myth of Things Seen in the Skies (Jung), 44–45, 137, 238
Fondation Bodmer, Geneva, 12
Foote, Mary, 26, 31*n*
Forest with Small Pond (Jung), *86,* 87
Formation II (Giacometti), *35*
Franz, Marie-Louise von, see von Franz, Marie-Louise
Freud, Sigmund, 14, 102, 182, 236
Frobenius, Leo, 243*n*

Gabon, Africa, Fang region, 234, *235*
Galerie Dada, 34, 47
Galla Placidia, 42
Gaugin, Paul, 35
Gäumann-Wild, Doris, 27, 31*n*
Geigy, J. R., 27
Gerber-Hinnen, Rosa, 27, 31*n,* *240,* 243*n*
"germinal vesicle," 180–81, 186
Gestaltungen des Unbewussten, 120
Ghirlandaio, Domenico, 21, 242*n*
Giacometti, Augusto, 24, 34–35, *35*
Giacometti, Giovanni, 35
Gioconda, La (*Mona Lisa*; Leonardo da Vinci), 234, 242*n*
Gnome (Jung), *114,* 117, 153
Gnosticism, 42, 117, 183–84, 239
God, Jung on, 14–15, 207
Goethe, Johann Wolfgang von, color theory of, 33–34, *34,* 38, 80
gold, in alchemy, 43, 45
"Gottes Empfängnis," 182
gouache techniques, 12, 13, 36–37, 218, 220
Grave Figure for a Dog (Jung), *151,* 153
Greece, 15
Grossmünster, 35

Häberlin, Paul, 22, 38
Hades, 107
Half Portrait of the Beresteyn-van der Eem Family (Soutman, after Hals), 235
Haller, Hermann, 26
Hals, Franz, 21, 234, 235
Hammer Museum, Los Angeles, 12
Handbook of German Superstition, The, 39
Handbuch der Kunstwissenschaft (Burger), 29*n,* 33
Hannah, Barbara, 26, 31*n*
Hauer, Jakob Wilhelm, 14
Heemskerck, Jacoba van, 34
Helmhaus Zurich, 11, 27
Hephaestus (Loki), *119,* 120–21
Heraclitus, 45
heraldry, 46
Hinkle, Beatrice M., 156
Hiranyagarbha, 182, 185
history, Jung's use of, 14
Hoch, Medea, 13, 33–47
Hodin, Joseph Paul, 21, 28, 31*n,* 36, 42
Hodler, Ferdinand, 24, 29*n,* 30*n,* 80
Hoerni, Konrad, *90*
Hoerni, Ulrich, 10–15, 48*n,* 245–58
Hoess, Eugen Ludwig, 21
Hollmann, Werner, 27
Holy Family, The (Lippi), 235
Holy Grail, 169
Homberger, Lorenz, 8, 176*n*
Hopi costumes, 23, *23, 24,* 30*n*
Horn, Andras, 22–23
Hornberg Castle (Jung), *54,* 62
Houdon, Jean-Antoine, *234*
Houses in the Countryside (Jung), *83,* 87
Hubacher, Hermann, 26, 235
Huningue Fortress, 65, *65,* 176*n*
Huxley, Aldous, 36, 48*n*

I Ching, 243*n*
images, Jung's approach to, 14–15
"Images from the Unconscious: An Introduction to the Visual Works of C.G. Jung" (U. Hoerni), 10–15, 16*n*
Imagination of Spring (Jung), *127,* 130
Impressionism, 27, 35
Incantations, 130, 156, 182
India, 15, 184
 ethnological art of, 49*n,* 235, 236, 243*n*
individuation, 42–43, 121, 182, 183, 208*n*
inner images, 14–15, 25, 102–3, 183–84
 interpretation of, *see* Active Imagination and *The Red Book,* 100–101, 103
Institute of Contemporary Art, Washington, DC, 27
International Association of Psychoanalysis, 102
"Intimations of the Self: Jung's Mandala Sketches for *The Red Book*" (Zervas), 13, 178–207, 208*n*–10*n*
"Introduction to Comparative Symbolism, An/Fundamental Ideas of Humanity/An

Overview of Various Cultures and Individu-
als" (lecture; Jung), 14
introversion, 47, 182, 208n, 209n
I'she, 23, 30n
Italy, 15, 41, 260
Itten, Johannes, 27, 30n, 34, 35, 38
Izdubar (Gilgamesh), 182, 184, 208n, 258n

Jacoby, Erhard, 26, 235, 238
Jaffé, Aniela, 11, 137, 173, 175, 176n, 207
Janet, Pierre, 87
Japan, art of, 234, 238
Jeanneret, Claude, 98, 99
Jones, Robert Edmond, 25–26
Joyce, James, 19, 26
Jugend (periodical), 21, 29n
Jung, Agathe, 259
Jung, C.G.:
 children of, 149, 169, 173, 234, 256
 chronology of life and works of, 259–62
 death of, 99, 173, 175, 241, 243n
 desk of, 241
 diverse collections of, 15, 20–21, 26, 28, 29n,
 233–42, 242n–43n
 early roots of interest in art, 16n, 20–21,
 62–63, 217, 233–34
 eightieth birthday of, 172
 Gidal photos of, 235, 237, 238, 242
 Kessel photos of, 232, 266
 and grandson, 61
 grave of, 173
 in his library, 232, 235, 237
 at Küsnacht, 238
 in Küsnacht garden, 242
 lectures declined by, 26–27
 library of, 15, 21, 22, 26, 28, 34, 35, 38, 39,
 48n, 49n, 233, 235, 236, 243n
 marriage of, 87, 169, 234, 242n, 259
 medical and psychiatric career of, 12, 14, 15,
 30n, 87, 99, 102, 234, 236, 243n
 as military commander, 185, 190, 260
 near-death experience of, 175, 262
 periods of turmoil and chaos of, 16n, 182, 185,
 189
 prizes awarded to, 26
 travels of, 15, 20, 21, 31n, 41, 80, 108, 117, 137,
 152–53, 156, 234, 236–37, 242n, 243n
Jung, C.G., visual works, 19, 50–175, 176n–77n
 as anonymous artist, 10–11, 30n
 authentication of, 11
 chronological and thematic grouping of, 12–13
 concept of color of, 33–47
 early works of, 12, 16n, 20, 62, 152
 as images of the unconscious, 10–15
 lost, 13, 16n
 media of, 13
 phases of, 12–13
 public exposure of, 11–12, 30n
 as self-taught, 217

techniques and craftsmanship of, 13–14, 209n,
 217–30, 231n
Jung, Ernst, 13
Jung, Gertrud (Gret), 173, 259
Jung, Helene, 149, 259
Jung, Johannes Paul Achilles, 13, 65, 173, 234
Jung, Marianne, 149, 259
Jung: His Life and Work (Hannah), 31n
Jung Family Grave (Jung; concept) 171, 173
Jung-Merker, Franz, 91, 171, 173, 177n
Jung-Merker, Lilli, 177n
Jung-Preiswerk, Emilie, 80, 173, 177n
Jung-Rauschenbach, Emma, 24, 80, 118, 130, 147,
 154, 169, 177n, 234, 236, 242n
 book dedication for, 168, 172–73
 picture dedication for, 76, 83, 85, 127
 death of, 13, 169, 175
 letter from Jung to, 149
 letters to, 152
 memorial for, 169, 170, 172–73
Jung's Song Folder of the Student Association
 Zofingia, 59, 63

Kabir, 162
kachina figures, 23, 23, 30n, 243n
Kandinsky, Wassily, 33–34
Kaufmann, Bettina, 8, 15, 19–28
Keim, 218
Kenya, 236
Kerényi, Karl, 128, 130
kingfisher, 146
Klee, Paul, 24, 26, 31n, 34, 35
Kloster Rheinau, 44
Knackfuss, Hermann, 22
Koeppel, Reinhold, 21
Kokoschka, Oskar, 31n
Kore, 107
Kundalini yoga, 14, 261
Kunst der Farbe (Itten), 35
Kunstgewerbeschule, Zurich, 35
Kunsthaus Ball, 23
Kunsthaus Zurich, 24, 25, 26, 27, 29n, 30n, 33
Künstlermonographien, 22
Kunstmuseum Basel, 20, 21, 29n
Kunstsalon Wolfsberg, 35
Kunst und Naturformen, 27
Küsnacht, Jung home in, 92–98, 99, 102, 169,
 185, 206, 234, 236, 238
 art collection at, 21, 233
 garden at, 11, 152–53, 172, 242

Landscape (1899; Jung), 19, 37, 66, 80
Landscape (1904; Jung), 79, 80
Landscape (ca. 1900; Jung; in Foundation of the
 Works of C.G. Jung), 69, 80
Landscape (ca. 1900; Jung; in Jung Family
 Archive), 68, 80
Landscape (ca. 1900; Jung; in private collection),
 71

landscapes, 12, 36–37, 66–79, 80, 87, 130, 176n,
 233, 257n
Landscape with Castle (Jung), 57, 75, 80
Landscape with River (Jung), 78, 80
Landscape with Snowy Mountains (Jung), 67, 80
Landscape with Stream I (Jung), 76, 80
Landscape with Stream II (Jung), 77, 80
Lapis philosophorum (philosopher's stone), 43,
 162–65, 164
Leonardo da Vinci, 33, 39, 234, 242n
Liber Novus (The Red Book; Jung), 102, 182, 185,
 206
Liber Primus (The Red Book; Jung), 176n, 182, 217,
 218, 220, 220, 225–26, 247, 248–50, 257n
Liber Secundus (The Red Book; Jung), 176n, 182,
 184, 208n, 218, 219, 220, 222, 225–26, 248,
 251–56, 257n
Lippi, Filippo, 21, 234
Loki/Hephaestus (Jung), 119, 120–21
Louvre, 20, 21, 234, 235, 242n
Lucca Codex (Bingen), 238
Lyceum Club, Zurich, 27

Macke, August, 34
Madonna in the Forest (Lippi), 234
Madonna with Child (Jung), 103, 103
Maeder, Alphonse, 30n
mandalas, 14, 25, 38, 102, 109, 119, 120–21,
 139–40, 176n, 177n, 179, 257n
 European, 10, 87, 181, 208n, 239
 Indian, 49n
 Jung and, 179–82
 Jung's first, 109, 116, 183, 260
 Jung's knowledge of, 182–83
 psychological process in, 37, 208n
 in Red Book, see Red Book (Jung), mandalas in
 symbolism of, 38–39, 179–85, 209n, 237–38
 Tibetan, 10, 238–39
Marées, Hans von, 21
MASI, Lugano, 12
Matisse, Henri, 36–37
"Matter and Method in The Red Book: Selected
 Findings" (Mellick), 13, 217–30, 231n
medieval art:
 avant-garde influenced by, 45–46
 decorated initials in, 46, 246
 as inspiration for Jung's symbolic painting,
 38–39, 41, 45, 80, 238–39, 243n, 246, 257n
 techniques in The Red Book derived from, 16n,
 41–42, 63, 80, 179, 182, 217, 219–23, 231n
 traditional division of duties in, 219–20
Mellick, Jill, 13, 217–31
Memorial for Emma Jung-Rauschenbach (Jung),
 169, 170, 172–73
Memorial for Toni Wolff (Jung), 166, 167, 172
memorials, 166–72, 172 73, 174, 175
Memories, Dreams, Reflections (Jung), 11, 12, 13,
 62–63, 65, 80, 146, 162, 176n, 183, 243n,
 257n
mescaline experiments, 36, 48n

Meyer-Amden, Otto, 25, 30*n*
Michelangelo Buonarotti, 24
Model Ship (Jung), 90
modern art:
 color use in, 36–37
 European, 235, 238, 246
 Jung's aesthetic and psychological interpretation
 of, 19–28, 29*n*–31*n*
 Jung's concept of color in, 33–47, 48*n*–49*n*
 Jung's negative response to, 15, 21, 24–25, 28,
 30*n*, 31*n*, 42, 48*n*
 as similar to visual expression of Jung's patients,
 19–20, 25, 28, 31*n*, 48*n*
Moderner Mythos, Ein (Jung), 26
Moltzer, Maria, 30*n*, 185, 189, 209*n*
Morgenthaler, Walter, 25, 30*n*, 31*n*
Moritz, Karl Philipp, 33
mosaics, 41, 47, *224*
 Red Book techniques of, 220, 223–25, 230
Muche, Georg, 34
Mühlbrecht, Fritz, 21
Münter, Gabriele, 34
Musée Guimet, Paris, 12
Museum of Modern Art, New York, 26
Museum Rietberg, Zurich, 12
Mysterium coniunctionis (von Franz), 42, 44, 262
mythology, Jung's use of, 14, 128, 236

Naeff, Erna, 26, 31*n*
nature, art and, 47, 208*n*–9*n*
Negerplastik (C. Einstein), 243*n*
Neue Leben, Das, 24
Neue Zürcher Zeitung, 19, 27, 33
Nicoll, Maurice, 152
Niehus, Ludwig, 11
Nijinski, Romola, 36, 48*n*
Nijinski, Vaslav, 48*n*
North America, ethnological art of, 23, *23*, 30*n*,
 235, 236, 243*n*
Noyer Indifférent (Tanguy), 26, *27*
Nude Descending a Staircase (Duchamp), 21, *21*, 30*n*

occultism, 236
On the Nature of the Psyche (Jung), 39
On the Spiritual in Art (Kandinsky), 34
On Symbolism in Mandalas (Jung), 49*n*

Paris, *81–86*, *87*, 169
 Jung's stays in, 12, 20, 242*n*
Paris, the Seine (Jung), *81*, 87
Paris, View toward Panthéon (Jung), *82*, 87
Pasha (dog), *151*, 153
patients, psychiatric, 48*n*, 166, 243*n*
 visual expressions of, 14, 19–20, 25, 28, 30*n*,
 31*n*, 36, 48*n*, 179, 181, 182, 237, 243*n*
Persephone, 107
phallic images, 190–92, 209*n*
Phanes, 2–8*n*, 116, *122–27*, 128–30, 153, 165,
 182, 184, 186, 187, 198, 207, 208*n*
Phanes I (Jung), *122*, 130, 165

Phanes II (Jung), *123*, 130, 165
Philemon, 16*n*, 128–29, *143–46*, 146–47, 153,
 227–30, *228*
Philemon Flying (Jung), *143*, 147
Philemon in Flight (Jung), *144*, 147
philosopher's stone (*Lapis philosophorum*), 43,
 162–65, *164*
Picasso, Pablo, 21, 26, 33, 34
 Jung's controversial interpretation of, 19–20,
 25–27, 31*n*, 48*n*
pipe-tamper figure, *241*
Pleroma, 164, 183–84
Portal, Frédéric, 39
Prajapati, 182
Preiswerk, Auguste, 63
principium individuationis, 183
Prinzhorn, Hans, 25, 48*n*
Proclus, 117
Protocols (Jung), 152, 153, 178*n*
proto-mandalas, 182
psychoanalytical movement, 102
Psychological Types (Jung), 45, 47, 182, 184, 209*n*,
 243*n*
psychology, roots of, 42
Psychology and Alchemy (Jung), 42
Psychology Club, Zurich, 23, 25, 27, 30*n*, 31*n*, 47,
 48*n*, 166, 169, *240*, 243*n*
Psychology of Kundalini Yoga (seminar), 14, 261
Psychology of the Unconscious: A Study of Transfor-
 mation Symbols of the Libido (Jung), 14, 182,
 191, 208*n*
Pueblo Indians, 23, *23*, 30*n*, 236, 260

quadratura circuli, 179

Raphael, Max, 22
Rauschenbach, Jean and Bertha, 169
Rauschenbach family, 177*n*
Read, Herbert, 27–28, 31*n*
Red Book, The (Jung), 11, 22–24, 30*n*, *32*, *33*, 35,
 40, *41*, 63, *63*, *64*, 65, *65*, *90*, *100*, *101*, *103*,
 107, *107*, 108, *108*, *112*, *119*, 120, *122*, 130,
 137, *137*, 139, *139*, *140*, 142, *142*, 146, 147,
 150, 156, *157*, *158*, *159*, 163, *164*, 165, 166,
 173, *174*, 175, 182, *182*, *185*, *187*, 208*n*, *210*,
 212, *213*, *214*, *215*, 217, 220, 222, 223, *224*,
 225, *226*, 227–39, *228*, *229*, 245
 facsimile editions of, 11–13
 illuminated initials in, 244–56, *248–56*,
 257*n*–58*n*
 inner images and, *100–101*, 102–3, *103*
 inspiration for, 14, 16*n*
 materials and techniques for, 217–30, 231*n*
 Philemon in, 146–47, *228*
 publication and expositions of, 11–12, 239
 relation of Jung's art collection to, 238–39
 as unfinished, 102, 173, 175
Red Book, The (Jung), mandalas in, 12, 65, 102,
 108, 116, 118, *119*, 120–21, 176*n*, 177*n*,
 178–207, *203*, 208*n*–10*n*

aftermath of creation of, 206–7
 Blossoming of the Golden Flower sketches,
 196–98
 Cosmic Egg sketches, 204–6
 Creation of the Golden Flower sketches,
 190–95
 Creation of the New World sketches, 200–203
 Floating Gestation sketches, 195–96
 Images of Energy sketches, 198–200
 intimations of the self in, 178–210
 origins of symbolism of, 182–85
 sketches, *180*, *181*, *186*, *187*, *188*, *189*, *191*,
 192, *193*, *194*, *195*, *196*, *197*, *198*, *199*, *200*,
 201, *202*, *204*, *205*, *206*, *207*
Red Book, The (Jung), materials and techniques of,
 217–30, 231*n*
 media, tools, and supports in, 217–19
 medieval illuminated manuscript style of,
 41–42, 63, 80, 179, 217, 219–23
 mosaic fields in, 223–25
 ordinary handwriting in, 175
 perspective and dimensionality in, 226–30
 self-imposed constraints in, 223–25, 228–30,
 231*n*
 transparency and opacity in, 219, 222–23,
 225–26
Redon, Odilon, 21, 26, 28, 35
Reformed Church, Kleinhüningen, 233
Reichenau Island (Jung), 70, 80
Reichenau Island (photograph), *70*, 80
Reni, Guido, 233
Richards, Ceri, 28
Rig Veda X, 182
Riklin, Franz Beda, 24–26, 30*n*, 35, 38
Riklin, Sophie, 38
Rinderspacher, Ernst, 26
Role of the Unconscious, The (Jung), 30*n*, 209*n*
Rosarium Philosophorum, 14
Rosicrucians, 99, 238
Rubin Museum of Art, New York, 12
runes, 197, 199, 201, 209*n*, 210*n*, 257*n*

Sacrament of the Last Supper, The (Dalí), 25
sailboats, *90*, 91
Salome, 103, 146, 175
Salpêtrière hospital, 87
Sandreuter, Hans, *20*, 21, 29*n*, 80
Satanas, 116
schizophrenia, 19, 48*n*
Schlegel, Erika, 23–24, 26, 30*n*, 31*n*, 35, 48*n*
Schlegel, Eugen, 24
Schlegel, Leonard, 223
Schmid-Guisan, Hans, 30*n*, 41
Schopenhauer, Arthur, 33
Schweizerischer Werkbund, 35
Scrutinies (Jung), 102, 206–7
seascapes, 80, *88–90*, 91
Sea with Sailboat (Jung), *89*, 91
Seashore (Sandreuter), *20*, 21

Secret of the Golden Flower, The (Wilhelm and Jung), 10, 14, 29*n*, 38, 42, 65, 120, 139, 175, 177*n*, 179–80, 185, 237
Segal, Arthur, 35
Segantini, Giovanni, 21, 28, 29*n*, 35
"Selection of Illuminated Initials in *The Red Book*" (U. Hoerni), 245–56, 257*n*–58*n*
self, 139, 207
 mandalas as intimations of, 179–207, 208*n*–10*n*
Septem Sermones ad Mortuos, 116, 130, 183
Sermon on the Mount, The (Gerber-Hinnen), 31*n*, 240, 243*n*
Shamdasani, Sonu, 12, 24, 30*n*, 176*n*, 210*n*
Sherry, Jay, 22
Shiva-Shakti, 185
Sigg, Hermann, 175, 177*n*
signet ring, Egyptian, 239, *239*, 243*n*
Sketchbook (*Schülerzahlheft der III. und IV. Klasse von Kleinhüningen*; Jung), *52–53*, 62
Sketches for the Memorial for Emma Jung-Rauschenbach (Jung), *170*, 173
Sketches for the Memorial for Toni Wolff (Jung), *167*
Sketch of Imaginary Castle and Helmets (Jung), *56*, 62
Sketch of Imaginary Town (Jung), *56*, 62
Sketch of Men with Hat (Jung), *82*
Sketch for Systema Mundi Totius (Jung), *111*, 117, 118
Small Castle (Jung), *61*, 63, 65
Snake (Jung), *155*, 156
snakes, 103, 116, 117, 130, 147, *154–55*, 156, *157–59*, 175, 185, *239*, 243*n*, 257*n*
 winged, 137, 141–42, *141–42*, 142, 208*n*
Society of the Heirs of C.G. Jung, 11
soul, 130
 color symbolism and, 43, 45
 as feminine, 107
 Ka-, 16*n*
 as snake and bird, 156, 183
 in *The Red Book*, 156
 see also anima
Southeast Façade (1907; Jung), *92*, *93*, *94*, 99
Southeast Façade of the House in Küsnacht (Jung), *92*, *93*, *94*, 99
Southeast Façade with Garden (1906; Jung), *93*, 99
Southeast Façade with Garden (1908; Jung), *95*, 99
Soutman, Pieter Claesz, 235
Sphere and Snake (Jung), *154*, 157
Spheric Vision I (Jung), *131*, 142
Spheric Vision II (Jung), *132*
Spheric Vision III (Jung), *133*
Spheric Vision IV (Jung), *134*, 137, 142
Spheric Vision V (Jung), *135*, 137, 147
Spheric Vision VI (Jung), *136*, 137
spheric visions, *131–37*, 137
stained glass, 26, 35, 41, 234
Star (Jung), *138*, 140
stars, 121, *138–40*, 139–40, 182–83, 191
 polar, 257*n*
Statuette of a Woman (Jung), 103, *104*, 107
Steiner, Rudolf, 33, 38, 48*n*

Stele (Jung), *112*, 117
Stone at Bollingen (Jung), 11, 142, *160–61*, *162–65*, *163–64*, 165, 177*n*, 231*n*
Strathmann, Carl, 21
Study in the Process of Individuation, A (Jung), 43, 209*n*
Stückelberg, Ernst, 21
Stumpf, Johannes, *168*, 173
Surrealisten und C.G. Jung, Die (Zuch), 24
Swiss Chronicle (Stumpf), *168*, 173
"Symbol in der Psychologie und Symbol in der Kunst" (Häberlin), 22, 38
Symbolists, 21, 25, 28
symbols, symbolism:
 in art, 27, 236, 243*n*
 color and, 38–39, 45, 130, 137, 139, 184
 reconciling, 184–85, 191
Symbols of Transformation (Jung), 237, 243*n*
synthesis, dissolution and, 42
Systema Mundi Totius (Structure of the whole world; Jung), 10, 16*n*, *109–15*, 116–18, 129, 142, *142*, 176*n*, 183–84, 239, 257*n*, 258*n*

Taeuber-Arp, Sophie, 23–24, 31*n*, 48*n*
 artworks of, 26, 35, 45–47, *46*
 Hopi costume design by, 23, *23*, 24
Talisman in Pillbox (Jung), *115*, 118, 194
Tanguy, Yves, 26, *27*, 235, 238
Tantric philosophy, 185
Taoism, 42, 184, 237
Telesphoros, 162, *163*, 165
Thangka, Tibetan, *233*, 238, *239*
Thenaud, Jean, 37, *37*
Theory of Colors (Goethe), 33
Thoma, Hans, 21
Thucydides, 62, 99
time, as fourth dimension, 165
Tote Tag, Der, 1. Akt (Barlach), 27, 31*n*
Tower at Bollingen, 11, 12, 13, 26, *90*, 172, 257*n*, 260, 261
towns, *52–61*, 62–65
Traité de la cabale (Thenaud), manuscript illumination, 37, *37*
transcendent function, 184
Transcendent Function, The (Jung), 14, 38, 260
transference, 14
Transformations and Symbols of the Libido (Jung), 102
transmutation, 43
Traumsymbole des Individuationsprozesses (Jung), 37
Treatise on Painting (Leonardo da Vinci), 39
tree of life, 116, 184, 208*n*
tree of light, 183–84, 196, 197, 203, 208*n*
Type-Problem in Poetry, The (Jung), 184
Tzara, Tristan, 24

Über die bildende Nachahmung des Schönen (Moritz), 33
Uffizi, 235

Uganda, *236*
"Ulysses" (Jung), controversy over Jung's interpretation of, 19–20
unconscious thought:
 conscious vs., 14, 36
 Jung's "confrontation with," 102
 Jung's early interest in, 63
 modern art and, 30*n*, 47

Vauban, Sébastien Le Prestre de, 65, *65*
Veiled Woman (Jung), *106*, 108
Venice Arts Biennale (2013), 12
Vieillesse et jeunesse (Ghirlandaio), 234
Villanova, Arnaldus de, 162, 177*n*
Vischer, Adolf L., 19
Vishnu collection, *235*
Visions seminars, 14, 116–17
Voltaire, bust of, 234, *234*, 242*n*–43*n*
von Franz, Marie-Louise, 42, 44, 262
Von Monet zu Picasso (Raphael), 22

Waddesdon Manor, UK, *149*, 152
Waldau asylum, Bern, 25, 30*n*
walking stick, 235, *242*
Wandlungen und Symbole der Libido (Jung), 128, 236
Wartmann, Wilhelm, 27
"Way of What Is to Come, The" (first part of *The Red Book*; Jung), 102
weathervane, at Küsnacht, *97*, 99
"We Fear and We Hope" (Jung), *145*, 147
Wiggle Much, The (Crowley), 25
Wilhelm, Richard, 10, 29*n*, 38, 65, 175, 177*n*, 179, 237
Window into Eternity (Jung), *140*
Wittgenstein, Ludwig, 33, 38
Wolff, Anton and Anna Elizabeth, 166
Wolff, Toni Anna, 24, 26, 31*n*, 42, 107, 130, 147, 166, 175, 185, 209*n*
 memorial for, *166*, 172
Wölfflin, Heinrich, 22
Wölfli, Adolf, 25, 30*n*
wooden stool, East African, *236*
World War I, 34
Worringer, Wilhelm, 22, 25, 47

yantras, 49*n*
Young, Gordon, *242*

Zentralbibliothek Zurich, 44
Zervas, Diane Finiello, 13, 102, 178–210
zodiac signs, *123*, 177*n*, 190, 205–6, 209*n*, 210*n*
Zofingia association, 22, *59*, 63
Zuch, Rainer, 24
Zürcher Amtshaus I, 24, 35
Zurich, 24, 26, 27, 34–35
Zurich, Lake, 11, 16*n*, 99, 177*n*, 234
Zurich University medical school, 102
 Jung's dissertation for, 10, 234, 243*n*, 259
Zweter, Reinmar von, *60*, 63

For information about permission to reproduce selections from this book,
write to Permissions, W. W. Norton & Company, Inc., 500 Fifth Avenue, New York, NY 10110

For information about special discounts for bulk purchases, please contact
W. W. Norton Special Sales at specialsales@wwnorton.com or 800-233-4830

Manufacturing by Worzalla
Book design by Laura Lindgren
Production manager: Julia Druskin

ISBN 978-0-393-25487-7

W. W. Norton & Company, Inc., 500 Fifth Avenue, New York, N.Y. 10110
www.wwnorton.com

W. W. Norton & Company Ltd., 15 Carlisle Street, London W1D 3BS

1 2 3 4 5 6 7 8 9 0